The Master of
The Amsterdam Cabinet, or
The Housebook Master,
ca. 1470–1500

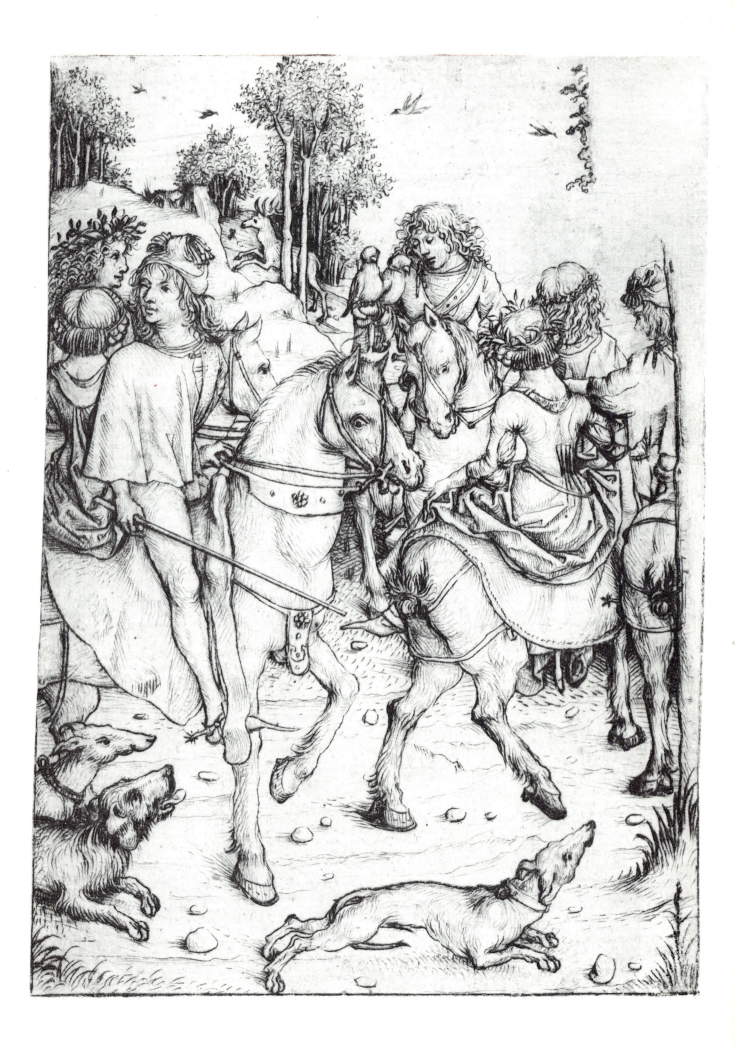

The Master of
The Amsterdam Cabinet, or
The Housebook Master,
ca. 1470–1500

Compiled by J.P. Filedt Kok

Introductions and appendixes by K.G. Boon,
J.P. Filedt Kok, M.D. Haga, Jane Campbell
Hutchison, M.J.H. Madou, Keith P.F. Moxey and
Peter Moraw.

Rijksprentenkabinet/Rijksmuseum – Amsterdam
Published in association with Princeton University Press,
Princeton, New Jersey, 1985.

This edition sold in all English-speaking countries by Princeton University Press, 41 William Street, Princeton, New Jersey, 08540.

In the United Kingdom: Princeton University Press, Guildford, Surrey.

Library of Congress Cataloging in Publication Data
's Levens felheid. English.
 The Master of the Amsterdam Cabinet, or,
The Housebook Master, ca. 1470-1500.

 Translation of: 's Levens felheid.
 Catalogue of an exhibition held in the
Rijksprentenkabinet, Rijksmuseum, Amsterdam,
Mar. 19-June 9, 1985.
 1. Master of the Housebook, 15th cent.–
Exhibitions. I. Filedt Kok, J.P. II. Rijksmuseum
(Netherlands). Rijksprentenkabinet. III. Title.
N6888.M3455A4 1985 709'.2'4 85-6359
ISBN 0-691-04035-4 (alk. paper)

Clothbound editions of Princeton University Press books are printed on acid-free paper, and binding materials are chosen for strength and durability.

Published in conjunction with an exhibition in the galleries of the Rijksprentenkabinet, Amsterdam, March 14 - June 9, 1985.

The publication of this volume was aided by a subsidy from the Prince Bernhard Foundation Prof. Hutchison's research was funded by the American Council of Learned Societies and the University of Wisconsin graduate school.

Edited by Gary Schwartz and J.P. Filedt Kok
 with the assistance of Els Verhaak.

Dutch edition edited by J.P. Filedt Kok with the assistance of
 Els Verhaak, Marjanka Huygen-van Meyel and Machteld
 Löwensteyn.
Dutch manuscript and part of English manuscript typed by
 Femke Koens and Brigit Taling.

Translations from the Dutch and German by
 Arno Pomerans (pp. 11-39, 79-88, 94-143),
 Gary Schwartz (pp. 7-8, 89-93,144-91) and
 Patricia Wardle (pp. 193-216, 245-302).

Index by Els Verhaak and Frans van der Avert.

Designed by Henk Hoebé (Studio Dumbar).
Jacket designed by Princeton University Press.
Produced by the Rijksprentenkabinet/Rijksmuseum
 and Gary Schwartz.
Lithography by Litho de Lang BV, Zwanenburg.
Filmset and printed by Rosbeek BV, Nuth.
Bound by J.A. van Waarden, Amsterdam.
Printed in the Netherlands.

Jacket illustration: *Stag hunt* [**67**].
Frontispiece: *Departure for the hunt* [**72**] (2x actual size).

CONTENTS

Lenders to the exhibition

AMORBACH/ODENWALD
Fürstlich Leiningensche Sammlungen-
Heimatsmuseum **136**

ASCHAFFENBURG
Stiftsmuseum der Stadt Aschaffenburg **137**

BERLIN
Staatliche Museen Preussischer Kulturbesitz,
Kupferstichkabinett, Berlin-Dahlem **52**a, **111**a,
96.1, **112**a.1, **114**, **121**, **123**, **124**, **125**

BOSTON
Museum of Fine Arts, Boston (Katherine Eliot
Bullard Fund, 1966) **82**, **83**.1

CLEVELAND
The Cleveland Museum of Art **119**

DÜSSELDORF
C.G. Boerner **8**b
Graphische Sammlung Kunstmuseum **26**.1

ERLANGEN/NÜRNBERG
Graphische Sammlung der Universität **40**a, **129**

FRANKFURT AM MAIN
Städtische Galerie im Städelschen Kunstinstitut
131d
Graphische Sammlung im Städelschen
Kunstinstitut **26**a, **75**a, **110**a-b
Museum für Kunsthandwerk **126**

THE HAGUE
Rijksmuseum Meermanno-Westreenianum
142.1-2

HAMBURG
Kunsthalle, Kupferstichkabinett **29**.1, **63**a, **113**,
116, **121**a

HEIDELBERG
Universität-Universitätsbibliothek **118**

KARLSRUHE
Badisches Landesmuseum **138**
Kupferstichkabinett, Staatlichen Kunsthalle **109**

LEIDEN
Museum Boerhaave **141**

LONDON
The British Museum, Department of Prints and
Drawings **33**, **57**, **103**.2

MAINZ
Mittelrheinisches Landesmuseum Mainz **132**d,e

MUNICH
Bayerische Staatsbibliothek **140**
Staatliche Graphische Sammlung München **61**c,
97.1, **99**, **107**.1, **111**.1

NEW YORK
The Metropolitan Museum of Art:
Department of Prints and Photographs **106**
The Cloisters **134**

OXFORD
The Ashmolean Museum (lent by the Visitors)
101, **108**.1

PARIS
Bibliothèque Nationale, Départment des
Estampes et de la Photographie **6**, **25**, **75**, **91**, **91**b,
115.2, **128**

ROTTERDAM
Museum Boymans-van Beuningen **10**a, **80**a

VIENNA
Graphische Sammlung Albertina **1**, **2**.1, **3**, **22**a, **58**d,
61d-i, **75**e, **91**a, **93**.1, **98**, **104**.3

WEST GERMANY
Private collections **117**, **135**

ZÜRICH
M. Feilchenfeldt **130**

PREFACE

¶ While the Rijksmuseum as a building owes part of its inspiration to the architecture of the Middle Ages, the art of that period has never ranked high among the priorities of the museum as an institution. And that is putting it mildly. The strength of the collections – especially the paintings and drawings, but to a lesser degree the sculpture and decorative arts as well – lies so apparently in later periods, that no serious attempt has ever been made to bring the medieval collection up to the same level. That makes it all the more remarkable that the Rijksmuseum should house nearly the complete remaining work of one of the greatest masters of early European printmaking. Because the identity of this late medieval master is still unknown, he is often named, after the unlikely repository of his work, the Master of the Amsterdam Cabinet.

¶ The artist confronts us with one of the great unsolved puzzles of art history. Who was he? How has he been able to preserve his anonymity for so long? Why have eighty of the approximately 120 known impressions of his prints come down to us in a single collection?

¶ In the hundred years since Max Lehrs called international attention to the Master, scholars have been searching, at times frantically, for the answers to these questions. Although they have not yet found them, their investigations have not been fruitless. One of their most important discoveries is that the same master must also have been responsible for many of the illuminations in another monument of late medieval art, the manuscript known as the Housebook.

¶ The reader should not expect to find a solution to the riddle in the present catalogue. The compiler, J.P. Filedt Kok, has chosen deliberately not to seek conclusions for the complex problems concerning the Master. His aim has been to define the artistic importance of the work and to survey present-day scholarship on it. The form of the publication follows a trend that, we are happy to say, is steadily gaining ground: it is a scholarly monograph but also, most emphatically, a help for the visitor to the exhibition.

¶ The exhibition itself, held in the galleries of the 'Amsterdam Cabinet,' is the first occasion when the Master's complete production is to be assembled: all the prints except a single unavailable one in the German Democratic Republic, the Housebook, and a selection of paintings, drawings, stained-glass panels and illustrated books. The exhibition offers the first opportunity in the five hundred years since their creation to view the original works by this mysterious artist side by side, an opportunity that will certainly not occur again in our generation, and perhaps never. The confrontation with the works may provide scholars with fresh insights that, we hope, will lead some day to the disclosure of the Master's secret. It will in any case capture the imaginations of thousands of visitors, making visible to them the total surrender of late medieval *joie de vivre* and religious devotion alike. A quality which the Dutch historian Johan Huizinga, in *The waning of the Middle Ages*, called *'s levens felheid* – intensity of life – a phrase we adopted for the Dutch title of the exhibition.

¶ This unique confrontation could only be realized thanks to the unstinting cooperation of many museums and other institutions, as well as several private individuals who are the owners or caretakers of works of late medieval art. Of essential importance to the exhibition is of course the presence of the famous Housebook. Only once before has it been exhibited in public, and we are deeply grateful to its owner for his willingness to allow it to come to Holland to be shown – at a safe distance, of course – to a large audience. This is the appropriate place, we feel, to thank Prof. Willibald Sauerländer as well, for his efforts in this matter.

¶ From the start, all concerned were aware that the publication accompanying the exhibition could

benefit greatly from contributions by other specialists in addition to the compiler himself. At this point, we would like to express our heartfelt thanks to those who acceded so spontaneously to our request and broadened the scope of our undertaking with their knowledge: Prof. Jane Hutchison, who continued to study the Master intensively even after concluding an exhaustive doctoral dissertation devoted to him; Prof. Keith Moxey, whose iconographic interpretations have given voice to the meanings of so many prints; and, from our own country, K.G. Boon, who was willing to place his vast experience and great familiarity with fifteenth-century art at the service of an exhibition he himself had striven to organize many years since. Peter Moraw provided us with an historical panorama of the areas of medieval Europe where the art of the Master and his circle flourished.

¶ The costume in the Master's prints was studied for us by an expert in the field, Mrs. Mireille Madou. For all questions pertaining to stained glass we relied on the authority of Prof. Rüdiger Becksmann. That we were able to extend our investigation to the important area of underdrawing is due to a campaign conducted together with J.R.J. van Asperen de Boer.

¶ In the relatively short time available for preliminary research, many museums, printrooms and libraries had to be visited, and photographs ordered from many different sources. The cooperation of these institutions and many of their staff members, whom we cannot thank here by name, was indispensible to the success of our project, and we wish to express to all of them once more our sincere thanks.

¶ The exhibition and catalogue bring to new life an artist five hundred years old. He may not yet have a name, but what matters more is that he does have a strong and original personality that still impresses us deeply today.

S.H. Levie

Director-general
of the Rijksmuseum

J.W. Niemeijer

Director of the
Rijksprentenkabinet

ABBREVIATIONS OF FREQUENTLY CITED LITERATURE

Anzelewsky 1958 — Fedja Anzelewsky, 'Das Gebetbuch der Pfalzgräfin Margarethe von Simmern,' *Berliner Museen*, N.F. 8 (1958), pp. 30-35.

Baer 1903 — Leo Baer, *Die illustrierten Historienbücher des 15. Jahrhunderts*, Strasbourg 1903.

Becksmann 1968 — Rüdiger Becksmann, 'Das 'Hausbuchmeisterproblem' in der mittelrheinischen Glasmalerei,' *Pantheon* 26 (1968), pp. 352-67.

Bernheimer 1952 — Richard Bernheimer, *Wildmen in the Middle Ages: a study in art, sentiment and demonology*, Cambridge, Mass. 1952.

Bossert and Storck 1912 — Helmuth T. Bossert and Willy F. Storck, *Das mittelalterliche Hausbuch nach dem Originale im Besitze des Fürsten von Waldburg-Wolfegg-Waldsee*, Leipzig 1912.

Buchner 1927 — Ernst Buchner, 'Studien zur Mittelrheinischen Malerei und Graphik der Spätgotik und Renaissance,' *Münchner Jahrbuch der bildenden Kunst* N.F. 4 (1927), pp. 229-325.

Filedt Kok 1983 — J.P. Filedt Kok, 'The prints of the Master of the Amsterdam Cabinet,' *Apollo* 117 (1983), pp. 427-36.

Friedländer — Max J. Friedländer, *Early Netherlandish painting* (English edition), 14 vols. Leiden 1967-76.

Frommberger-Weber 1973 — Ulrike Frommberger-Weber, 'Spätgotische Buchmalerei in den Städten Speyer, Worms und Heidelberg,' *Zeitschrift für Geschichte des Oberrheins* 121 (1974), pp. 35-145.

Frommberger-Weber 1974 — Ulrike Frommberger-Weber, 'Spätgotische Tafelmalerei in den Städten Speyer, Worms und Heidelberg (1440-1500),' *Kunst in Hessen und am Mittelrhein* 14 (1974), pp. 49-79.

Fuchs 1958 — Reimar Walter Fuchs, 'Die Mainzer Frühdrucke mit Buchholzschnitten 1480-1500,' (Archiv für Geschichte des Buchwesens, 10), *Börsenblatt für den Deutschen Buchhandel* 14 (1958), nr. 75a, pp. 1129-64.

Glaser 1910 — Curt Glaser, 'Zur Zeitbestimmung der Stiche des Hausbuchmeisters,' *Monatshefte für Kunstwissenschaft* 3 (1910), pp. 145-56.

Husband 1980-81 — Timothy Husband with the assistance of Gloria Gilmore-House, *The wild man: medieval myth and symbolism*, New York 1980-81.

Husband 1985 — Timothy Husband, 'The Master of the Amsterdam Cabinet, The Master of the Housebook and a stained glass painting at the Cloisters,' *Corpus Vitrearum, United States: Occasional Paper I, Studies on medieval stained glass* (edited by Madeline H. Caviness and Timothy Husband), New York (Metropolitan Museum of Art) 1985.

Hutchison 1964 — Jane Campbell Hutchison, *The Hausbuchmeister: sources of his style and iconography* (dissertation, University of Wisconsin 1964; unpublished typescript).

Hutchison 1966 — Jane Campbell Hutchison, 'The Housebook Master and the folly of the wise man,' *The Art Bulletin* 48 (1966), pp. 73-78.

Hutchison 1972 — Jane Campbell Hutchison, *The Master of the Housebook*, New York 1972.

Hutchison 1976 — Jane Campbell Hutchison, 'The Housebook Master and the Mainz Marienleben,' *Print Review* 5 (1976): *Tribute to Wolfgang Stechow*, pp. 96-113.

Kirschbaum — Engelbert Kirschbaum (ed.), *Lexikon der christlichen Ikonographie*, 8 vols., 1968-76.

Legenda Aurea — *Die Legenda Aurea des Jacobus de Voragine*, aus dem Lateinischen übersetzt von Richard Benz, Köln-Olten 1969.

Lehrs — Max Lehrs, *Geschichte und Kritischer Katalog des Deutschen, Niederländischen und Französischen Kupferstichs im XV. Jahrhundert*, 9 vols., Vienna 1908-34.

Lehrs (Dover) — Max Lehrs, *Late Gothic engravings of Germany and the Netherlands* (682 copperplates from the 'Kritischer Katalog'), New York (Dover Publications) 1969.

Lehrs 1893-94 — Max Lehrs, *Der Meister des Amsterdamer Kabinetts*, Berlin (Internationale Chalkographische Gesellschaft). 1893-94.

Lehrs 1899 — Max Lehrs, 'Bilder und Zeichnungen vom Meister des Hausbuchs,' *Jahrbuch der königlich preussischen Kunstsammlungen* 20 (1899), pp. 173-82.

Naumann 1910 — Hans Naumann, *Die Holz-*

schnitte des Meisters vom Amsterdamer Kabinett zum Spiegel Menschlicher Behältnis, Strasbourg 1910.

Panofsky 1953 Erwin Panofsky, *Early Netherlandish painting*, 2 vols., Cambridge, Mass. 1953.

Ringbom 1965 Sixten Ringbom, *Icon to narrative: the rise of the dramatic close-up in fifteenth-century devotional painting*, Abo 1965 (second edition 1984).

Schmitz 1913 Hermann Schmitz, *Die Glasgemälde des Königliche Kunstgewerbemuseums in Berlin. Mit einer Einführung in die Geschichte der deutschen Glasmalerei*, 2 vols., Berlin 1913.

Schneider 1915 Hans Schneider, *Beiträge zur Geschichte des niederländischen Einflusses auf die oberdeutschen Malerei und Graphik um 1460-80* (inaugural dissertation), Basel 1915.

Schramm Albert Schramm, *Der Bilderschmuck der Frühdrucke*, 23 vols., Leipzig 1925-43.

Schreiber W.L. Schreiber, *Handbuch der Holz- und Metallschnitte des XV. Jahrhunderts*, 8 vols., Leipzig 1926-30.

Shestack 1967-68 Alan Shestack, exhib.cat. *Fifteenth century engravings of northern Europe from the National Gallery of Art, Washington D.C.*, Washington 1967-68.

Shestack 1971 Alan Shestack, *Master LCz and Master WB*, New York 1971.

Solms-Laubach 1935-36 Ernstotto Graf zu Solms-Laubach, 'Der Hausbuchmeister,' *Städel-Jahrbuch* 9 (1935-36), pp. 13-95.

Stange 1955 Alfred Stange, *Deutsche Malerei der Gotik*, vol. 7: *Oberrhein, Bodensee, Schweiz und Mittelrhein*, Berlin 1955.

Stange 1958 Alfred Stange, *Der Hausbuchmeister*, Baden-Baden/Strasbourg 1958.

Stewart 1977 Alison G. Stewart, *Unequal lovers: a study of unequal couples in northern art*, New York 1977.

Storck 1909 Willy F. Storck, 'Die Zeichnungen des Hausbuchmeisters,' *Monatshefte für Kunstwissenschaft* 2 (1909), pp. 264-66.

Valentiner 1903 W.R. Valentiner, 'Der Hausbuchmeister in Heidelberg,' *Jahrbuch der königlich preussischen Kunstsammlungen* 24 (1903), pp. 291-301.

Waldburg-Wolfegg 1957 Johannes Graf Waldburg-Wolfegg, *Das mittelalterliche Hausbuch*, Munich 1957.

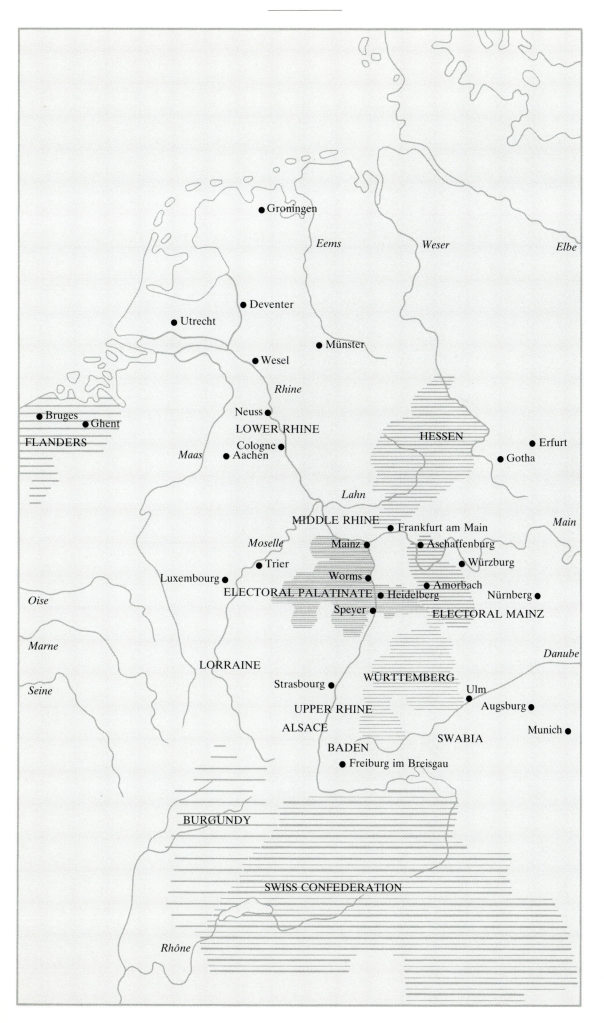

Fig. 1
The Rhine area about 1480
(drawing by Dick Letema
gvn).

THE MASTER OF THE AMSTERDAM CABINET OR THE MASTER OF THE HOUSEBOOK AND HIS RELATIONSHIP TO THE ART OF THE BURGUNDIAN NETHERLANDS

K.G. Boon

¶ Long before 1888, when Max Lehrs, the director of the Dresden printroom, introduced the name Master of the Housebook into art-historical literature,[1] the engraver whose work is described in this catalogue was known as the Master of the Amsterdam Cabinet, or sometimes as the Master of 1480. He had acquired the latter names because the greater part of his engravings (originally 82 or 83 in number) was to be found in Amsterdam.[2] For Lehrs, an expert on early engraving, the older name had an unwelcome implication: it recalled attempts to assign the work of this artist, whom he considered an honor to German art, to the realm of the Burgundian Netherlands. Since it now appeared that the engraver was also responsible for the drawings in the *Housebook* [117], Lehrs held that the older name should no longer be used.

THE HOUSEBOOK

¶ The so-called Housebook, with its illustrations of life in and around a princely court during the late Middle Ages, does indeed provide a most valuable record of German culture at the time. The book has been in the collection of the south German Waldburg-Wolfegg family since the seventeenth century, and according to a note on one of the pages in the sixteenth century it was owned by Ludwig Hof, who settled in Innsbruck. There is no doubt that the book also originated in Germany.

¶ The name 'Housebook' gives only a faint idea of the widely divergent subjects that fill the volume. According to Johannes, Graf Waldburg-Wolfegg, a recent writer on the Housebook, a more suitable name is that suggested by the historian Retberg in 1865: the manual of a 'Büchsenmeister,' a master of munition and of arms.[3] In fact the greater part of the collection consists of drawings of cannon and other instruments of war, illustrations of army encampments and of military equipment, of mining, of a smelting-furnace and of hydraulic engineering instruments (fols. 35b-56b). This predominantly technical section is preceded by scenes of courtly life (fols. 18b-25a): tournaments (*fig. 2*), a bathhouse, and a series on aristocratic pleasures in the country, hunting, as depicted in the late Middle Ages in manorial tapestries or murals, and even more extensively in manuscripts intended for the nobility.

¶ Only in the representation of a bronze or iron smelting-furnace (fol. 35b) and on the page devoted to mining (*Bergwerk*; fol. 35a) is attention also paid to the work of artisans. In contrast to the jousting scenes, which conformed to strict rules, the foreground of the *Bergwerk* page (*fig. 9*) depicts a Brueghelian brawl involving four roughnecks, thus emphasizing the difference in manners and behavior with the nobility. However, quite apart from the great diversity of subject matter shown in the Housebook, its pages, some heightened with watercolor and some drawn with pen only, differ so much in both technique and style that few of the authors who have written about the Housebook Master have considered it the work of a single hand. Most specialists tend to ascribe it to more than one draftsman.

¶ The pages that most closely resemble the prints of the Master of the Amsterdam Cabinet are the seven planet illustration (fols. 11-17) preceding the diversions of the nobility. In the liveliness of portrayal and in the sometimes very humorous characterization of the temperaments of the planets' children, these seven pages surpass the standard, by no means low, of the rest of the manuscript. There are striking differences in the woodcuts of the two versions, the German and the Dutch, of the printed planet book, which dates back to the 1460s and could occasionally have served the draftsman as a model.[4]

¶ The disorderly pattern of small, busy figures in the woodcut books are succeeded by exquisitely arranged small groups distributed over the pages

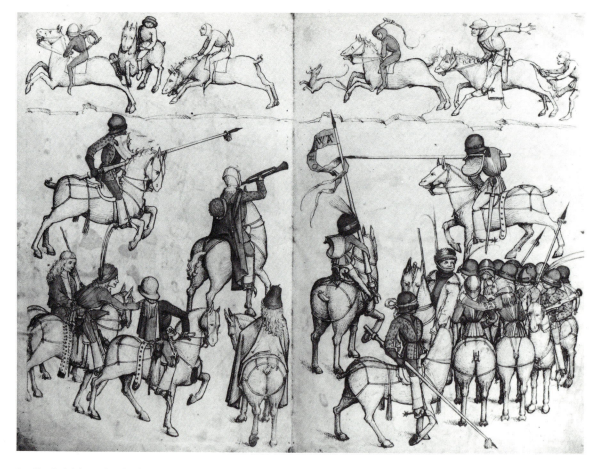

in diminishing size in the series of drawings by the Housebook Master. Moreover, while the woodcuts depict various random figures at their occupations, the Housebook Master illustrates the specific type of person born under each planet. Not even the richly executed Italian engravings of the planets' children rival his rendering of these human temperaments.

¶ Thus the Housebook Master depicts Saturn's children (fol. 11) precisely as they are described in the accompanying verse: rude, indolent, cross, sad and clumsy, depending on the situation in which they find themselves. Mars's children (fol. 13) are quick-tempered; their expressions are fierce and their feelings easily roused. Sol's children are refined and polite, as well as modest (fol. 14). Their expression resembles that of Venus's children (fol. 15); both groups are members of the upper class. The draftsman is at his most subtle in his portrayal of Luna's children (fol. 17). Here we see a juggler playing a wily game with an unsuspecting spectator, whose mouth drops open

with surprise.[5] A townsman tries to take in the credulous peasants with his patter. Here the draftsman displays a Brueghelian verve in interpreting the words of the traditional rhyme, which attributes to Luna's children inconstancy and lack of even an elementary sense of decency. It is above all the draftsman's humor, his lack of pedantry and moralizing, and his ability to see through human behavior that make these planet drawings stand out far above all else in this collection.

THE PRINTS

¶ We find the same qualities in the prints of the Master of the Amsterdam Cabinet; to a lesser extent, naturally, in his religious representations, although even here his sense of humor can at times break through. Thus, in his *Circumcision* [**11**] the sacral significance of the scene is almost subordinated to the commentary on the small groups of older and younger sons of the Covenant. Similarly, the *Holy Family by the rosebush* [**28**] loses some

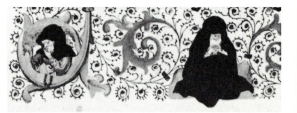

of its sacred aura because the engraver draws too much attention to the little game with the apple that Joseph is playing with the Child.

¶ The artist gave an even freer rein to his imagination in his secular prints. Like some of the religious representations, most are fragments, suggestive of notes in a sketchbook. However, it is a modern idea that fifteenth-century artists occasionally noted down scenes from daily life with the aim of giving them more durable form at a later date. This idea does not belong to the world of the late Middle Ages, still strongly bound to tradition.

¶ Motifs such as the playing children, the flute and shawm players, the scratching dog, the wild woman on a stag, the stag hunt, even the nuns and monks reading their breviaries and the *Three living and three dead kings* were not new inventions, but the way they were rendered suggests that the artist had held them up to the mirror of reality. All the motifs are derived from an established repertoire, that of the miniaturists, especially the illuminators of the borders of books of hours and breviaries, formerly known as vignettists.[6]

THE MASTER OF THE AMSTERDAM CABINET AND THE ART OF THE MINIATURE

¶ There was a late flowering and a remarkable renewal in this branch of the art of decorating Gothic manuscripts in the northern and southern Netherlands during the fifteenth century, partly through the influence of Eyckian miniatures. At present it is generally assumed that before 1450 the Utrecht miniaturists played a leading role in this revival.

¶ The Master's motifs that have just been mentioned (and their number is greater when his religious themes are included) appear repeatedly in the borders of Utrecht manuscripts from 1440 to 1460. Ernstotto, Graf zu Solms-Laubach, was the first to draw attention to this fact, after having examined a Utrecht book of hours in Berlin (ms. germ. oct. 648 in the Preussische Staatsbibliothek).[7] In 1935, when he wrote his article, the oldest manuscript with this type of border was not yet known.[8] Otherwise Solms-Laubach would surely have mentioned the books made in the workshop of the Master of Catherine of Cleves, in which these new and realistic border decorations

first appeared in Netherlandish manuscripts. The important role of that workshop in the transmission of Eyckian motifs is best illustrated by the *Hare hunt* in the lower border of fol. 67 of the *Hours of Catherine of Cleves (fig. 3)*. A similar hunting scene also appears in the lost part of the *Très Belles Heures* made in the workshop of the van Eycks.[9] The Master of the Amsterdam Cabinet employed the same motif in his *Stag hunt* [67] and, developing it further, he added a second motif that could equally have been borrowed from the miniaturists, namely, that of a stag disappearing into a wood. The reading and listening monks and nuns depicted in the Master's prints [68 and 69] can also be found in the pages of various books of hours, accompanying the prayers for the dead, the *Vigils* (in the New York manuscript, for instance, on p. 206, *fig. 4*). Some of these vigils also use the motif of the *Three living and three dead kings (fig.5; cf. 57)*.[10] Does his borrowing of such motifs mean that the Master was in contact with artistic circles that had adapted the Eyckian iconography, which led to a new form of marginal decoration, as in the Utrecht miniatures?

¶ The answer might be that the presence of motifs from the repertoire of the Dutch book illuminators' workshops does not necessarily indicate a *direct* influence by the latter. The motifs may also have been spread by passing them from hand to hand. That would, for example, explain the resemblance between some animals in the borders of the *Hours of Catherine of Cleves* and those on the prints by the Master of the Playing Cards from the upper Rhine. However, these common motifs were not copied meticulously from the Utrecht books; rather were they interpreted by the engraver in his own particular way. Yet, some of them – the scratching dog in an Utrecht book of hours, for example, dating to between 1450 and 1460 *(fig.7)*, which must be assigned to the workshop of the Master of Catherine of Cleves (ms. 10 F50 in the Meermanno-Westreenianum Museum in The Hague, fol. 160b) – are extremely rare. In which case it then must be concluded that the engraver was in direct contact with the miniaturist's workshop.

¶ The rather un-German character of the Master's prints is not confined to the motifs. Their style also differs from that of the German prints, and

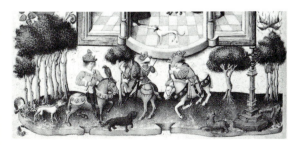

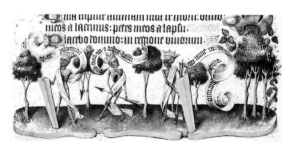

Fig. 5
The Hours of Yolande de Lalaing, Utrecht, ca. 1460-65, fol. 57b-58a, bas de page: *Three dead and three living kings*. Oxford, Bodleian Library, ms. Douce 93.

the same is true of his silverpoint and pen draw-ings. Although these drawings differ so much that it is at times difficult to determine their place in the artist's total oeuvre (for instance, the drawing entitled *Emperor Maximilian's peace banquet in Bruges*, dated 1488 [**124**],[11] they all can be distin-guished from the German drawings and prints by their spontaneity and natural expression. These qualities are largely absent from the carefully stylized drawings and prints of Schongauer and his upper Rhenish school. They are also absent from middle Rhenish drawings, for instance those by the Master b x g or by the illustrator of the Herpin manuscript. Even in the freer drawings of the Cologne school – from Stephan Lochner to the Master of the Aachen Altar – spontaneity and natural expression are not as prevalent as they are in the Housebook.

¶ This was also the conclusion of Ernstotto, Graf zu Solms-Laubach in the article he contributed to the *Städel Jahrbuch* in 1935-36.[12] In it, he called the relationship with Netherlandish miniatures 'the crux of the problem of the Housebook Master.' In support of this view he cited H. Schmitz, who in his catalogue of the Berlin stained-glass roundels drew attention to the fact that the circle of the Housebook Master borrowed motifs from manu-scripts by Jean Tavernier of Oudenaerde dating back to about 1460.[13] Pursuing this line of research, Solms came upon a page from a Taver-nier manuscript of about the same date, namely

Le débat de l'honneur. The walking couple (*fig. 8*) in the foreground of one of its miniatures resembled an almost identical pair in the foreground of the *Bergwerk* (fol. 35, *fig. 9*) in the Housebook.[14]

¶ However, Solms pointed out that the figures in the Housebook have an even closer resemblance in type and representation to figures in prayer books and Bibles made in the bishopric of Utrecht and in Guelders. As proof, he reproduced a number of miniatures from the above-named Berlin book of hours of about 1460. Solms could also have drawn attention to a book of hours in the same style in Oxford (ms. Douce 93), in which appears a tournament (*fig. 10*) on fol. 100v in the manner of the Housebook (fols. 7, 21b-22a, *fig. 2*). He further pointed out that whenever identical motifs appear, the rendering of the Master is very free and natural.

¶ Although the resemblance between the represen-tations of the Dutch miniaturists mentioned by Solms and those of the Housebook cannot be denied, I believe that this similarity does not pro-vide positive proof that the work of the miniaturists was the source of the Master's draw-ing style. If this talented draftsman was indeed an apprentice in Utrecht, he must have had contacts with more ambitious men than the artists of the above-mentioned books. The Master's drawing style, in particular, suggests that he had a freer hand when he started; the minuscule figures of the Utrecht miniaturists are still too reminiscent

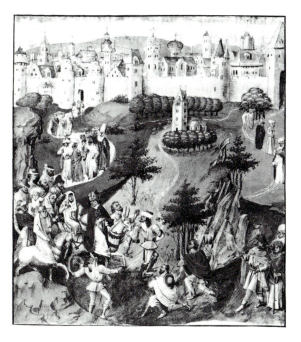

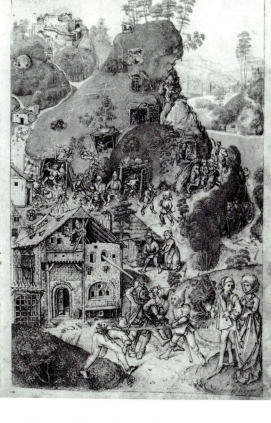

Fig. 8
(Jean Tavernier,) *Le débat de l'honneur*, Brussels, 1449-50, fol. 45a. Brussels, Royal Library, mss. 9278-80.

Fig. 9
Housebook [**117**], fol. 35, *Bergwerk*.

of miniatures by the school of van Eyck. Their movements are wooden, and consequently they lack elan.

¶ Mention has already been made of the fact that Graf zu Solms-Laubach was not acquainted with the manuscripts from the workshop of the Master of Catherine of Cleves. As early as about 1440 there originated in this workshop a new style of marginal decorations with small vignettes of one or two figures, and more extensive drawings in the *bas de pages*. The books Solms consulted do not give an adequate idea of the importance of this new style. The decorations in them are mere shadows of what the Master of Catherine of Cleves tried to achieve in the first half of the fifteenth century.

¶ To appreciate the new style more fully, we can do no better than look at the large and richly-deco-

rated book of hours in the Pierpont Morgan Library in New York[15] or at the *Book of Hours of Catherine of Lochorst* in the Münster Museum.[16] In both books, the figures are modelled entirely by brush in strong, angular lines. This is the style of the head of the workshop, the Catherine Master, who also began a third book from this workshop (ms. 10 F 50 in the Meermanno-Westreenianum Museum in The Hague).[17] He made the six large miniatures in the book and some of the marginal decorations (mainly his work up to p. 87), leaving the rest of the borders to a younger, talented assistant who introduced another style of drawing. His marginal decorations are easily distinguished from those of the older master by the slender figures moving freely between the volutes and having greater variety than those of the master. Most were designed in detailed drawings such as

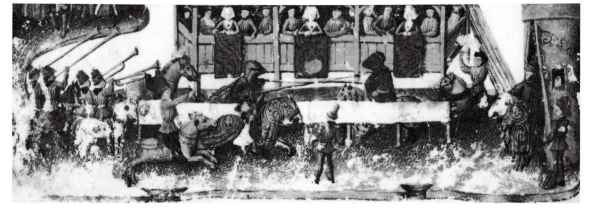

Fig. 10
The Hours of Yolande de Lalaing, Utrecht, ca. 1460-65, fol. 100b, bas de page: *Tournament*. Oxford, Bodleian Library, ms. Douce 93.

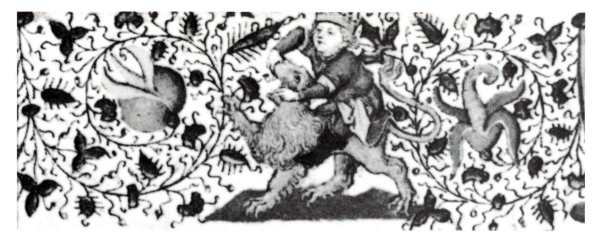

Fig. 11
The Hours of Catherine of Cleves, Utrecht, ca. 1440-45, fol. 213, border illustration: *Samson and the lion.* New York, Pierpont Morgan Library.

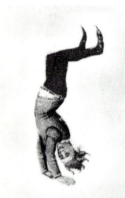

Fig. 12
The Hours of Mary of Burgundy, Brussels, ca. 1460-70, fol. 106 and fol. 162, bas de page: *Acrobat* and *Juggler.* Vienna, Österreichische Nationalbibliothek, Codex Vind. 1857.

that of the scratching dog on fol. 160v (*fig. 7*).

¶ The Hague book was made between 1455 and 1460. After 1465, the drawing style and the figures of the second miniaturist reach a peak in a number of Bruges manuscripts. The books were made for Charles the Bold and his stepbrother, Anthony of Burgundy, and, after 1469, chiefly for Louis of Bruges, lord of Gruthuse. Almost the same marginal decoration can also be found in the Hague book of hours.

¶ It used to be thought that Philippe de Mazerolles[18] was the miniaturist of these books, but in his commentary on one of the richly decorated volumes from this workshop, a book of hours in the Vienna National Library (cod. 1587), Antoine de Schryver was able to show that the illuminator must have been not Mazerolles but Lieven van Lathem, who was trained in Ghent and enrolled as a painter in Antwerp in 1462.[19] De Schryver's view that Lieven van Lathem originally pursued the craft of miniaturist in Utrecht seems more probable than the belief that Mazerolles, a Frenchman, should have moved to that remote city.

¶ Be that as it may, the style of the marginal decorations in the Hague manuscript, in the splendid pages of van Lathem's later books – the *Histoire de la conquête de la toison d'or* (Bibliothèque Nationale, ms. fr. 331), *L'histoire du bon roi Alexandre* (Collection Dutuit, Petit Palais), both in Paris – and in the three parts of the Froissart manuscript in Breslau,[20] in the preparatory drawing no less than in its spontaneity, is much closer to the planet figures of the Housebook than to those of the Utrecht manuscripts mentioned by Solms.

¶ The postures and proportions of van Lathem's figures and also his horses, which are strongly reminiscent of those of the planets, suggest possible contacts with van Lathem in Utrecht, and perhaps later in Bruges as well.

¶ If we assume that the Housebook Master was first trained in Utrecht, and that van Lathem was involved in his training there, then the impressions the Master carried away from this flourishing center of miniaturists should clearly be seen

in his prints. Of the religious motifs, *Simson slaying the lion* [**5**] is the only one in which this is apparent. This motif appears in both the *Hours of Catherine of Cleves* (fol. 213; *fig. 11*) and in the Hague book of hours (p. 198 by the hand of van Lathem). I have already mentioned the borders of the Utrecht miniatures, and particularly the scratching dog motif, which appears nowhere else.

¶ Just as important as the latter motif, in my view, is the little acrobat doing a handstand, a motif the Master used twice in his heraldic prints [**88** and **89**]. Lieven van Lathem had used the motif before him: a similar figure appears twice in the borders of a Vienna book of hours (cod. 1857, on fol. 100a and b; *fig. 12*). Many of the small figures in that manuscript adopt an attitude surprisingly similar to that of the planets' children.[21]

THE PAINTINGS

¶ Most critics who have studied the Master have assumed (in my view, correctly) that a considerable number of his prints had been made before he was commissioned to execute altar paintings. That was certainly the case with the *Life of Mary* cycle for a church in Mainz, one panel of which is dated 1505 [**132**]. The work was probably completed after his death. On the altar of a church in in Speyer [**131**], possibly painted in the second half of the 1470s, the influence of Netherlandish art is much less than Solms believed it to have been. I can therefore sympathize to some extent with Alfred Stange, compiler of the latest oeuvre catalogue of the Housebook Master,[22] who rejects almost entirely the idea of any Netherlandish influence on the work of one whom he considers an integral part of the German heritage. Stange believes that the Master was trained in the upper Rhineland (among other places, in Colmar and Strasbourg), and in his book of 1958 he attaches little importance to the fact that the Master was familiar with such Netherlandish paintings as the *Columba Altar* of Rogier van der Weyden, and the panels of an altar of Bouts (now in Munich) that he could have seen in Cologne churches.

¶ On the other hand, Solms-Laubach does acknowledge this influence and also mentions Ouwater as a source of inspiration, but does not develop it further, even though he believed that the problem of the Housebook Master could be solved by identifying the Master as a Netherlandish painter, Erhard Reuwich of Utrecht.

¶ I shall be returning to Solms's hypothesis. He was certainly not the first to formulate it, since as early as 1891 it was put forward as a possibility by Adriaan Pit, one of the directors of the Rijksmuseum.[23] Solms-Laubach did, however, elaborate Pit's idea with extensive corroborative material.

¶ Before exploring this question, I would like to stress the old-fashioned character of some of the panels in the Master's earliest altar, the *Speyer Altar* [131], which different authors have dated between the second half of the 1470s and the first half of the 1480s. At a time when the influence of the Netherlandish models in Cologne and the middle Rhine was already marked, the Master gave two of his altar panels, the *Washing of Christ's feet* and the *Last Supper*, interiors with sharply receding walls and an upwards-sloping floor. In the restricted space that resulted, the figures are sometimes crowded together so closely as to be reduced to near-silhouettes.

¶ These two panels bring to mind interior scenes in manuscripts, and one wonders whether their old-fashioned aspect is not connected with the artist's apprenticeship in Utrecht. Signs of that training can also be seen in other parts of this altar. Solms, and Hans Schneider before him in 1915, remarked on Bouts's influence in the nocturnal scene of the panel depicting *Christ before Caiphas* on the *Speyer Altar*.[24] Bouts is also said to have influenced the *Resurrection* on the same altar. That the Netherlandish artist had some influence on the composition of this panel is undeniable, though the

attitude of the sleeping soldier in the left foreground was not taken from Bouts. When the Master drew this figure, he must have used a miniaturist's model, for a sleeping soldier with precisely the same attitude can be found in a Utrecht book of hours (the *Hours of Gijsbrecht of Brederode*, Liège, fol. 66v, dating to before 1460; *fig. 13*).[25]

¶ The Master introduced a much more common motif from the miniaturist's repertoire into another panel of the altar in Speyer, namely, the kneeling figure in the foreground. In the *Hours of Catherine of Cleves* in New York and in the so-called *Vronensteyn Hours* in Brussels, similar figures appear on fols. 68 and 38b, respectively.[26]

¶ Hence it is not just the interiors of the *Speyer Altar* but also the use of miniaturists' models that convince me that the Master must originally have trained as a miniaturist. In fact that training stood him in good stead in the execution of the miniatures in the Cleveland *Gospels* [119].

THE MASTER OF THE AMSTERDAM CABINET OR THE HOUSEBOOK MASTER: ERHARD REUWICH

¶ To what extent can the above view of the Master be reconciled with Solms-Laubach's identification of the Housebook Master as Erhard Reuwich of Utrecht, illustrator of the travels to the Holy Land of Bernhard von Breydenbach, dean of Mainz, and two noblemen from his circle? On the surface, the connection seems obvious. An artist who must have had contacts with workshops in Utrecht and who also must have worked in Heidelberg, Speyer, and above all in Mainz, might easily have been the same person as the painter Reuwich, who from 1483 (and perhaps many years earlier?) until 1488 can be traced back to Mainz. Reuwich came from Utrecht and was probably the son of the painter Hillebrant (van) Reewijk, who worked between 1456 and 1465 for

Fig. 13
The Hours of Gijsbrecht van Brederode, Utrecht, ca. 1460, fol. 66b, bas de page: *Resurrection*. Liège, University Library, ms. Wittert 13.

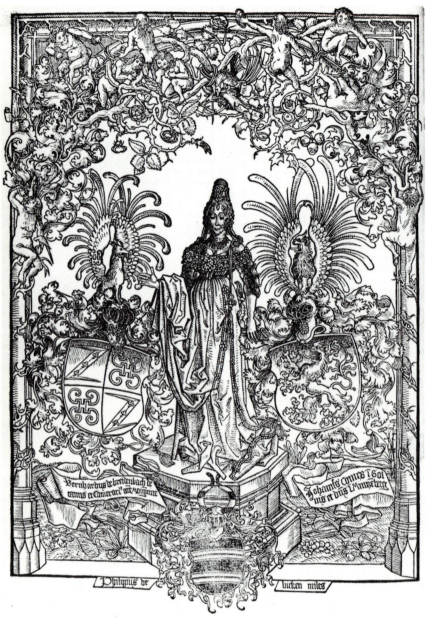

Fig. 14
Peregrinationes in Terram
Sanctam [142], Mainz 1486,
frontispiece woodcut.

¶ For the book, Reuwich made six large panoramas of the cities and islands through which the company passed: Venice, Parenzo, Corfu, Modon, Candia (Crete) and Jerusalem. At the end of the book, he added a print of Rhodes to illustrate the account of the Turkish siege of that island. This section of the book also contains the woodcut with the Turkish and Genovese cavalcade (*fig. 15*) which in 1891 reminded Pit so strongly of the Master's *Turkish rider* (**74**, *fig. 16*).

¶ Besides this cavalcade and the panoramas, the book also includes illustrations of the various nationalities the company encountered in the Holy Land, and a page of animals, among them a unicorn, which the painter claimed to have seen on his travels. The style of the figures in the three editions, the Latin, the German of 1486, and the Dutch of 1488, which were printed in Mainz at the painter's workshop, as the colophon of the book tells us, is quite different.

¶ The title page with Lady Venice standing on a plinth, flanked by two heraldic shields and surrounded by a detailed frame of rose and pomegranate bushes with naked frolicking children, is cut into the woodblock with the utmost subtlety, clearly following the design of a draftsman who insisted on the faithful reproduction of his work. Solms has adduced a host of arguments to show how closely this woodcut resembles the style of the Master's prints and drawings.

¶ The woodcuts of a Jewish market trader, of the Greeks and Abyssinians, and of the Syrians in a vineyard make quite a different impression. Perhaps they were executed by a less accomplished hand, so that the design was distorted, thus making Solms's comparison with the Master's prints and drawings less convincing.

¶ However, the seven panoramas on large, fold-out pages form the greatest stumbling block to an acceptance of Solms-Laubach's hypothesis. In the woodcuts of cities and islands, and especially in the detailed print of the *Church of the Holy Sepulchre and its surroundings*, the laws of perspective are strictly observed. As a result, these woodcuts make a much more modern impression than the interiors painted on the altar at Speyer. Solms did not take this striking difference seriously and made light of it with the remark that 'in this case, the painter was given a quite different task.' The way in which the city of Jerusalem and the Holy Land including Mount Sinai are represented is indeed topographical and partly cartographical, and therefore reflects a different tradition from that of the landscapes in the paintings. However, Solms's remark is less applicable to the townscapes and island views.[28] In the woodcut of Venice, for example, the city is much more carefully incorporated into the surroundings. How-

the Utrecht Buurkerk, and in 1470 was dean of the Utrecht guild. Erhard (Everard?) may therefore have moved to the Rhineland as early as 1470, settling in Mainz as a painter.[27]

¶ After executing a commission for Dean von Breydenbach, he travelled with the latter via Venice to Jerusalem, and from there through barren and neglected country to the tomb of St. Catherine on Mount Sinai, mountain of wisdom and light and according to tradition one of the dwelling places of God. The account of this journey, which has no title, although it is usually called the *Peregrinationes in Terram Sanctam* [142], has a richly decorated front page depicting the coats of arms of Breydenbach, chamberlain to the archbishop of Mainz, Johann, Graf zu Solms-Laubach and the knight Philipp von Bicken, the three men who made the journey to the Holy Land, accompanied by an interpreter and the painter Reuwich (*fig. 14*).

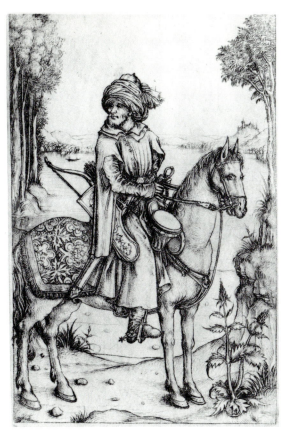

Fig. 16
Turkish rider [**74**.4], drypoint, ca. 1485-90.

Fig. 15
Peregrinationes in Terram Sanctam [**142**], Mainz 1486, fol. 76: *Turkish riders*, woodcut.

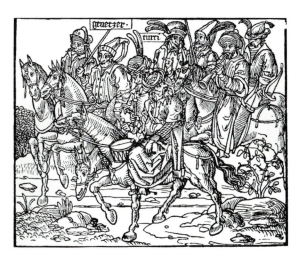

ever, even here some of the cartographical character can be discerned.

¶ In 1935, it did not occur to Solms-Laubach that the Master might have been trained in Utrecht. He apparently assumed that in the fifteenth century it took little effort for a painter to familiarize himself with models from the workshops of miniaturists. It was not as simple as that, however. Painters and illuminators were members of different guilds, and each of these professions worked from models of their own.

¶ It is therefore quite unlikely that Reuwich, a painter from Utrecht, should have been acquainted with a manuscript by Tavernier produced in about 1449-50, as Solms supposed, if only because that manuscript would not have stayed long in the miniaturist's workshop.

¶ The situation in Utrecht was probably somewhat different from that prevailing in Bruges, where Tavernier worked. It is known that in one case, there was contact between a painter and a miniaturist in Utrecht.

¶ Having this example in mind, we can imagine that the Master and Reuwich had repeated con-

tacts at the time they both were staying in Mainz, in which case the Master could have designed the title page of the *Peregrinationes* for Reuwich. Solms's arguments in attributing this page and the shield-bearer at the end of the book to the Master are thus sound. Moreover, the Master might have profited from Reuwich's knowledge of the Holy Land and borrowed details for his *Turkish rider* from the latter's drawings.

¶ However, as long as our knowledge of Reuwich's work remains confined to the *Peregrinationes* and the *Gart der Gesundheit* ('Garden of health') [**141**], it does not seem possible to me to identify the Master with Reuwich. Therefore we shall have to continue to use the provisional name the artist has been given. Whether that name is the 'Housebook Master' or 'Master of the Amsterdam Cabinet' depends on how we evaluate the German against the Netherlandish influences in his work. I myself am inclined to attach greater importance to the close contact with Utrecht than to the contacts with Swabian or upper Rhenish art, which German sources tend to stress.

1. Max Lehrs, *Katalog der im Germanischen Museum befindlichen deutschen Kupferstiche des XV. Jahrhunderts*, Nürnberg 1887-88, p. 30.
2. In addition to the eighty prints now in Amsterdam, in the National Library in The Hague there were at least another two prints by the Master of the Amsterdam Cabinet (**6** and **75**, and possibly also **25**) before the confiscation carried out

by the curator of the Bibliothèque Nationale on behalf of that institution in 1812. When restitution was made by Paris in 1816, however, these two prints were not returned. Cf. Filedt Kok 1983, pp. 427-28.
3. Waldburg-Wolfegg 1957, p. 7.
4. F. Lippmann, *Die Sieben Planeten* Berlin etc. (Internationale chalcographische Gesellschaft) 1895 (German version in the

Kupferstichkabinett, Berlin). Another, perhaps earlier, Dutch version (with Latin inscriptions) in Copenhagen was published by M.J. Schretlen, "Blokbogen 'De syv Planeten,'" *Kunstmuseets Årsskrift* 16-18 (1929-31), pp. 1-15.

5. This representation is reminiscent of that of Hieronymus Bosch, known only through copies, of which the best is in the Museum of Saint Germain-en-Laye.

6. G. Hulin de Loo, 'La vignette chez les enlumineurs gantois entre 1480 et 1500,' *Bulletin de la Classe des Beaux Arts de l'Académie Royale de Belgique* 21 (1939), pp. 158-80; L.M.J. Delaissé, *A century of Dutch manuscript illumination*, Berkeley and Los Angeles 1968, pp. 40, 82ff.

7. Solms-Laubach 1935-36, pp. 18-22.

8. Cf. Friedrich Gorissen, *Das Stundenbuch der Katharina von Kleve, Analyse und Kommentar*, Berlin 1973, pp. 104 ff.; Delaissé, op. cit. (note 6), p. 40, fig. 83.

9. Gorissen, op. cit. (note 8), pp. 1040-41.

10. The *Hours of Yolande de Lalaing*, in the Bodleian Library, Oxford (Douce 93), fols. 57b and 58a.

11. The attribution of this drawing, the subject matter of which A. Warburg was able to identify as the banquet given for Emperor Maximilian in 1488 by the city of Bruges, is by M.J. Friedländer. It is generally accepted. The particularly spontaneous character of the drawing is not rivalled even by the drawing of the *Three men in discussion* [123]. Moreover, the drawing is also remarkable for the characterization of the various reactions of the bystanders and the contrast between the curious throng of local burghers and the haughty attitude of the courtiers, for instance that of the page in the foreground.

12. Solms-Laubach 1935-36, p. 16 and p. 93.

13. Schmitz 1913, vol. 1, pp. 101-23, especially pp. 105-06.

14. The *Bergwerk* page in the Housebook is no longer generally attributed to the Housebook Master. It is the *only* drawing in the Housebook in which the treatment of the trees and the castle architecture bears some resemblance to such details in Reuwich's landscapes for the *Peregrinationes* [142]. It therefore must have been the artist of this page (or the miniaturist) who had contact with the workshop of Jean Tavernier from Oudenaerde (active between 1454 to 1467), perhaps during Tavernier's stay in Bruges, at least if Solms-Laubach's assumption that the walking couple in the *Bergwerk* was taken from *Le débat de l'honneur* is correct. Such walking couples, are also found elsewhere, however. See note 21.

15. John Plummer, *The Hours of Catherine of Cleves: introduction and commentaries*, London 1966.

16. Paul Pieper, 'Das Stundenbuch der Katharina von Lochorst und der Meister der Katharina von Kleve,' *Westfalen: Hefte für Geschichte, Kunst und Volkskunde* 44 (1966), pp. 97-157.

17. K.G. Boon, 'Nieuwe gegevens over den Meester van Catharina van Kleef en zijn atelier,' *Bulletin van de Koninklijke Nederlandsche Oudheidkundige Bond*, 6th series, 17 (1964), pp. 242-54.

18. Mazerolles was first suggested by Paul Durrieu in his article, 'L'histoire du bon roi Alexandre,' *Revue de l'Art Ancien et Moderne* 13 (1903), pp. 49-64, 103-21.

19. *Gebetbuch Karls des Kühnen vel potius Stundenbuch der Maria von Burgund Codex Vindobonensis 1857 der Österreichischen Nationalbibliothek* (Codices selecti vol. XIV), Facsimile und Kommentar (Étude de l'enluminure par Antoine de Schryver), Graz 1969, commentary, pp. 90-102.

20. Arthur Lindner, *Der Breslauer Froissart*, Berlin 1912; for the other manuscripts, see Paul Durrieu, 'Livres de Prières peint pour Charles le Témeraire par son enlumineur en titre Philippe de Mazerolles,' *Monuments et Mémoires de la Fondation Eugène Piot* 22 (1916), fasc. 1, pp. 71-130; Friedrich Winkler, 'Studien zur Geschichte der niederländischen Miniaturmalerei des XV. und XVI. Jahrhunderts,' *Jahrbuch der Kunsthistorischen Sammlungen, Wien*, 32 (1915), pp. 38-342, especially pp. 292 and 299 ff.

21. *Gebetbuch ... Codex Vindobonensis 1857*, op. cit. (note 19), fol. 106a and b: *Jugglers*, and fol. 98a: *Walking couple*. Van Lathem may also have provided the model for the miniaturist who decorated the *Missal of Margaretha von Simmern* [120] with richly ornamented borders. In an article in *Berliner Museen* N.F. 9 (1958), pp. 30-34, F. Anzelewsky has attributed these border decorations to the Housebook Master on the basis of similarities between his work and the figures in the *Missal*. This attribution has, however, met with a poor response in the literature. Inasmuch as there are similarities, they can also be explained by the common source to which both can be traced, namely the art of the miniature in the Burgundian Netherlands. The differences between the work of the miniaturist and that of the Housebook Master are too striking to be ignored, especially the humor and subtlety of the latter, completely lacking in the former. This is best made clear by a comparison. Both artists used the motif of the *Young man and death*, the miniaturist on fol. 160, and the Housebook Master in his print, **58**. The miniaturist kept to the traditional conception, *Youth wrestling with death*, but the Housebook Master added a touch of irony to the motif: he has the frivolous 'man of the world' turn towards warning death with a smile and youthful recklessness. The miniaturist of the *Simmern Missal* was probably of a younger generation than the Master of the *Housebook*.

22. Stange 1958, p. 19. Lehrs 1932, p. 74, called the upper Rhenish origins of the Housebook Master 'problematic.'

23. A. Pit, 'La gravure dans les Pays Bas aux XVme siècle,' *Revue de l'Art Chrétien* 34 (1891), pp. 486-97, especially p. 494.

24. Schneider 1915, p. 58. Schneider also points to the possible resemblance of **26** to Jan van Eyck's so-called *Maelbeke Altar*, and to the theme of the so-called John-charger [**36**], which derives from Dutch models. He also adopts Kristeller's suggestion that the print of the Good Shepherd [**17**] was borrowed from a Dutch woodcut. These very occasional borrowings, however, do not constitute sufficient evidence for an unmistakable contact with Netherlandish art.

25. *Livre d'heures de Gysbrecht de Brederode, évêque élu d'Utrecht: reproduction de 38 pages enluminées du Manuscrit Wittert 13 de la Bibliothèque de l'Université de Liège*, publiées avec une introduction de Joseph Brassine, Brussels 1923, plate 20.

26. See Plummer, op. cit. (note 13), fig. 58, and for the *Vronensteyn Hours*, Bibliothèque Royale, Brussels, ms. II 7619, Delaissé, op. cit., pp. 45-48 and fig. 105. This prayer book was made for Jan van Amerongen and is dated 1460.

27. The details of Erhard Reuwich's stay in Mainz are taken from the report of Bernard von Breydenbach's journey from 25 April 1483 to January 1484. The third edition of Breydenbach's *Peregrinationes* was published in 1488 in Dutch. In the first Latin edition Reuwich is described as a 'pictor artificiosus et subtilis.' This description could equally have honored the Housebook Master, although it did not mean very much more than a customary *epitheton ornans*. The text also states that Reuwich printed the book in his house. The details about the Reuwich (Reewijk) family in Utrecht are taken from the *Bijdragen en Mededelingen van het Historisch Genootschap te Utrecht* 3 (1880), passim, and K.G. Boon, 'Een Utrechts schilder uit de 15de eeuw, de Meester van den Jesse in de Buurkerk,' *Oud Holland* 76 (1962), pp. 51-60.

28. These woodcuts differ in essence from the equally detailed views of the cities of Bruges, Ghent and Dunkirk in the Froissart manuscript of the miniaturist Lieven van Lathem. If the Housebook Master had travelled to the Holy Land with Breydenbach, then his townscapes, like van Lathem's miniatures, would have been less sweeping, and the woodcuts would have been crowded with the small incidents which in the work of Reuwich were always of only subordinate importance.

THE DEVELOPMENT OF FIFTEENTH-CENTURY GERMAN ENGRAVING AND THE DRYPOINT PRINTS OF THE MASTER OF THE AMSTERDAM CABINET

J.P. Filedt Kok

¶ The first prints from engraved copper plates on paper were probably made in the 1430s in the German Rhine valley.[1] For centuries, gold and silversmiths had practiced the art of engraving metal objects for ornamental purposes, and probably also made incidental use of this technique, taking impressions on paper of the drawings they had engraved in metal after filling the engraved lines with ink. The drawings could then serve as models for later use. At the beginning of the fifteenth century, when more paper became available more cheaply, artists probably realized what new possibilities engraving offered for the reproduction of illustrations. Woodcuts, previously adapted for textile decoration, had first been used for the same purpose not so long before.

¶ The first German paper mills having opened in Nürnberg in 1391, the manufacture of handmade paper began to make real progress in Germany at the beginning of the fifteenth century. This led to the emergence of new graphic techniques, and, slightly later, of book printing. The prevailing social and economic circumstances in the Rhineland, where these new media developed, were without doubt particularly propitious to them. The prosperous cities with their cultured artisan class, strong patrician element and busy artistic life fostered the love of illustration and of new learning to which the new means of reproduction were so well suited.[2]

¶ Like woodcuts, most early engravings were religious representations, above all of the Passion of Christ, the saints, and so on. They were chiefly sold at places of pilgrimage, in churches, and at fairs, and served devotional ends. Such prints, often hand-colored, were precursors of the later devotional pictures, some being issued against the payment of indulgences. The widely obtainable series of Passion scenes and of saints were often pasted into prayer books by the side of, or as substitutes for, miniatures. The quality of these prints was not high, especially when it came to reproducing the human figure, but this fact notwithstanding, there was a constant demand for this type of devotional print until well into the sixteenth century.

¶ In northern Europe, especially in Germany and to a lesser extent in the Netherlands, large numbers of engravings were produced in the fifteenth century, and impressions of more than three thousand have come down to us. Though the majority fall in the category of devotional prints, engraving offered much wider artistic possibilities. In the course of the century, the expressive possibilities were increased and refined so that the medium could here and there develop into what was qualitatively the graphic equivalent of the painting of the time. Until the 1460s, the engraver's art was largely confined to gold- and silversmiths, but later in the century some important painters (Martin Schongauer chief amongst them) were also active as engravers. It is true of Schongauer, as later of Dürer, that the artistic influence of his prints, which found a wide circulation, was greater than that of his paintings.

¶ Because the first engravers used fine lines to cut their designs, their plates wore out quickly and only a small number of good impressions could be taken from any one. Schongauer was the first to develop the engraver's technique to the point that it became possible to produce larger editions of good quality. However, we have a relatively greater number of early engravings than of woodcuts, albeit the latter came out in larger editions. Rarely has more than one copy of a woodcut come down to us, probably because engravings were treasured as more valuable objects. The limited circle of admirers of such prints must, no doubt, have included artists and specialist craftsmen, for it was these prints above all which played an essential role in the transmission of artistic formulae and ideas. The composition of many of the earlier engravings was in all probability based on painted or drawn models, and in their turn they

served as models for other artists. Later in the century, by contrast, the new compositions, designs and models used in prints often came from the leading fifteenth-century engravers themselves. Because these original designs, too, were often and quickly copied in print, it is sometimes difficult to determine whether a given reproduction is based on one of the copies or on the 'original' print.

THE MASTER OF THE PLAYING CARDS

¶ The first important representative of fifteenth-century engraving in Germany was the Master of the Playing Cards, whose work has been dated to between 1435 and 1455, and who is assumed to have worked in the upper Rhine valley between Strasbourg and Lake Constance. He is named after a partly preserved series of 39 playing cards, most of which, never used for card-playing, are in Paris and Dresden.[3] Although his technique is identical in principle with that of other early engravers, it has been applied in a very refined and pictorial manner: the contours have been drawn in the metal with a few lines, while the inner modelling consists of hundreds of parallel light strokes of the burin (*fig. 17*). This technique, in which shadows are indicated by concentrations of fine parallel 'strokes,' is also found in the silverpoint and brush drawings of the period.

¶ In comparison with the religious prints ('Life of Christ' and of the saints), which are usually of simple construction, the playing cards, often

printed from several plate segments, are surprisingly refined in their representations of flowers, birds, stags, lions, wild men, etc. It used to be generally assumed that these prints were original designs; nowadays opinion on the subject is divided. Many of the motifs also occur in the decorated borders of manuscripts that can be dated to between 1410 and 1430, and whose illustrations, it is believed, are based on so-called model books; one may deduce from this that the playing-card motifs, too, were borrowed from a similar source. These model books – collections of many different kinds of drawing models for artists and artisans – played an important role during the Middle Ages in maintaining and passing on artistic formulae and solutions. In the course of the fifteenth century this function was taken over by prints, which is why so many fifteenth-century engravings bear traces of paint, spots, and so on. But no matter where the artistic inspiration lay in this case: with the prints, with a – no longer extant – model book, or with the miniatures themselves, it is clear that soon after they made their appearance the playing cards themselves began to serve as models.[4] Of the prints that were actually used as playing cards a single example is all that has been preserved; the other cards were presumably worn out and thrown away.

MASTER E.S.

¶ The most important artist in the second generation of German engravers is Master E.S., who flourished – also in the upper Rhine region – between 1450 and 1467. He, too, is thought to have started as a goldsmith, since many of his prints show the frequent use of the goldsmith's punch, and since several are designed like goldsmiths' work.[5]

¶ The engraving method of his earliest dated prints links him to the Master of the Playing Cards; however, he rapidly developed a more effective and systematic engraving technique. The short, parallel, shading lines of the early engravers were lengthened and combined to form flowing systems of hatching, Master E.S. being the first engraver to make use of cross-hatching. So subtly, in fact, did he handle the burin that he was able to convert his hatching into a network of regular long lines. With an elaborate combination of shading, cross-hatching, short strokes and dots, he endowed his forms with a marked – sometimes sculptural – sense of volume (*fig. 18*).

¶ Besides prints with biblical themes, Madonnas and saints, which constitute the greater part of his work, there are playing cards by his hand, and in addition an alphabet made up of human figures and prints of profane themes reflecting in the

Fig. 17
Master of the Playing Cards, detail (2x actual size) from *Flower Queen B* (L. 49), engraving, ca. 1440-50. Vienna, Albertina.

main the 'courtly' culture of his day (see **75f**). We cannot determine with certainty, any more than we can with the Master of the Playing Cards, the degree of originality of Master E.S.'s frequently copied engravings. Master E.S. seems to have been very susceptible to the artistic influences of his contemporaries, although direct models for his prints can rarely be identified. It is believed that a number of his compositions are based on the work of the Master of the Karlsruhe Passion (Hans Hirtz?), who probably also worked as a designer of stained glass in Strasbourg between 1420 and 1460. The work of the sculptor Nicolaus Gerhaert van Leyden, active between 1460 and 1470 in Trier (Treves) and Strasbourg, was another important influence. In their turn, the next generation of sculptors, e.g. Pacher, Veit Stoss and Riemenschneider, were to use the prints of Master E.S. as models.[6]

MARTIN SCHONGAUER

¶ Martin Schongauer is the first German engraver we know by name and whose main biographical details are also known. The importance of Schongauer to late fifteenth-century northern art is comparable only to that of Dürer in the sixteenth century.[7] In all probability, he learned the engraver's art as a boy from his father, a goldsmith, but he trained at the same time as a painter. Tradition has it that his teacher was Isenmann, the town painter of his native Colmar, in the west of the lower Rhine valley. The influ-

ence of fifteenth-century Flemish art was already noticeable in Isenmann's work. For Schongauer himself, the paintings of Rogier van der Weyden were a constant source of inspiration. Schongauer's engravings, which are usually dated between ca. 1470 and 1491 (the year of his death), amount to 116 plates. In most cases, a reasonable number of good impressions has been preserved, perhaps thanks to a technique of cutting the lines more deeply into the copper plate. As a result the plate wore out more slowly and a greater number of impressions could be taken. Schongauer perfected the engraving technique of Master E.S. by combining deep modelling lines cut into the copper with carefully controlled systems of hatchings and cross-hatchings. In the lighter sections, these systems are more open and confined to fine short strokes, curved lines, etc. With this technique, Schongauer would attain an almost classical clarity and monumentality in his later engravings.

¶ In his early prints, for instance the *Death of Mary* (*fig. 19*), technical perfection and clarity still leave something to be desired. But though the fine touches and strokes of the burin are rather uncoordinated, they are very vivid and expressive; his attempt to attain a pictorial rather than a linear graphic effect reflects Schongauer's training as a painter. The composition is both varied and full of life as well as fairly complex.

¶ From the point of view of form, Schongauer aimed for simplicity and clarity, which is also reflected in the development of his engraving

Fig. 18
Master E.S., detail (2x actual size) from *Crucifixion with Virgin and St. John* (L. 32), engraving, ca. 1455-60.

Fig. 19
Martin Schongauer, detail
(2x actual size) from *Death of
the Virgin* (B. 33; L. 3),
engraving, ca. 1475.

painted work. He was the most important of the
first generation of painter-engravers, men whose
engravings and paintings are of comparable artis-
tic merit. Other late fifteenth-century artists of
whom the same can be said were, besides the
Master of the Amsterdam Cabinet in Germany,
Master LCz (flourished ca. 1480-ca. 1505) and
Master WB [**113-16**], and in the Netherlands Mas-
ter FVB (flourished 1480-1500 in Flanders; see
[**8a**]) and Master I.A.M. of Zwolle (flourished ca.
1470-90).

¶ Schongauer's engravings were of immense im-
portance for the development of fifteenth-century
art. They were not only put on the market in con-
siderable numbers (there are dozens of good
impressions of most of his prints), but they were
also quickly and widely copied by more or less
capable hands. Moreover, copies or partial imita-
tions in other media – painting, sculpture and
ornamental art – are countless.[8]

THE MASTER OF THE AMSTERDAM CABINET

¶ The engravings of the Master of the Amsterdam
Cabinet are at least of equal artistic importance
to those of his somewhat older contemporary,
Martin Schongauer. The differences between the
prints of these two artists are great – in subject
matter, in style, and above all in technique: while
Schongauer, by perfecting the engraving tech-
nique, rendered this medium suitable for larger
editions, the drypoint technique used by our
Master allowed of the taking of no more than a
handful of good impressions. Where Schongauer

technique. The *Annunciation* (*fig. 20*) is one of
Schongauer's last prints, made in 1490 or 1491.
The figures are placed against a light background
which enhances their plastic effect; the folds of
their robes are very sharply defined by the dis-
tribution of light and dark masses with the help
of clear, quite sparse systems of hatching and of
single and double cross-hatchings.

¶ Schongauer's prints, though generally not of a
large size, are as original and monumental as his

Fig. 20
Martin Schongauer, detail
(2x actual size) of the Virgin
from the *Annunciation* (B. 2;
L. 3), engraving, ca. 1490.

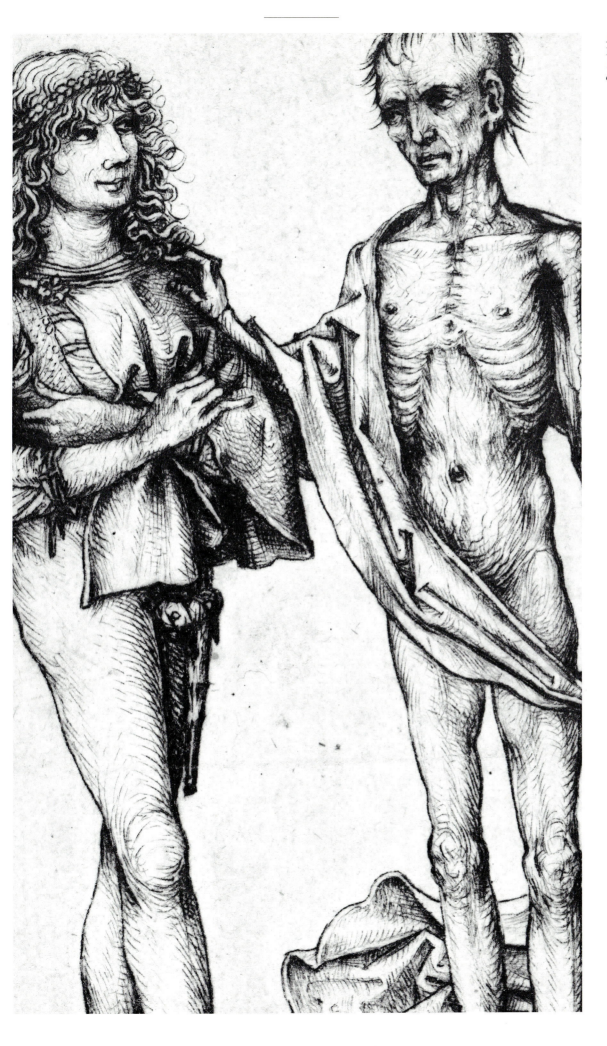

Fig. 21
Detail (3x actual size) from
Young man and death [**58**],
drypoint.

'cut' regular lines in the copper plate, our Master used a sharp needle to 'draw' on what was probably a much softer metal plate. In this technique, a small ridge of metal, the burr, is left alongside the furrow; as a result the ink not only collects in the furrow but is also retained by the burr. This gives the line on the print a velvety, 'deep black' quality (*fig. 21*), much more capable of suggesting pictorial effects than the hard engraver's line. The controlled use of strength that forms the basis of a well-engraved print is lost in the drypoint technique, and the line takes on a more spontaneous and sketchy character, much like a pen drawing.

¶ The great disadvantage of this technique is that the burr wears away fairly quickly and that the furrow by itself yields only very slight impressions. The technique is therefore not suitable for larger editions. We can only guess at the answer to the question of how our Master arrived at the idea of using the drypoint technique, but it is generally thought that, unlike most fifteenth-century engravers, he was not trained among goldsmiths. His method was not emulated by any of his contemporaries; Dürer did not produce his three drypoint prints until 1512 (*fig. 35*). The technique was taken up in the seventeenth century by Rembrandt, the greatest engraver among painters, but even in his day drypoint engraving was a rarely used medium. Only in the nineteenth century did a larger group of artists follow Rembrandt in using the technique.

¶ The few extant impressions are all we have to rely on when conjecturing at the precise working method used by the Master. In general, his drypoint prints were drawn on a metal plate of a relatively small size; only exceptionally did he use a slightly larger format. He probably used a material softer than copper, perhaps an alloy of copper and lead or tin. The surface, to judge by the impressions, was quite often flawed: pockmarks on the plate, scratches and in some cases even cracks. For drawing on the metal he used various pointed styli, sometimes with a fairly rounded, broad point and sometimes with an extremely sharp, fine point, and he also seems to have made use of a fine, sharp blade. Many plates have a very sketchy, almost slipshod character – the drypoint technique does not lend itself to corrections. The printing was probably done on a small hand press, which would explain why several of his larger sheets shifted slightly on the press during printing and came out blurred. The color of the ink in the impressions tends to vary from deep black to yellowish-brown, but it is difficult to determine whether such differences may not be the result of later restoration attempts.

¶ Until late into the nineteenth century, specialists believed that the Master's drypoint prints as a whole were created within a fairly short span of time. However, the marked differences in technical skill and in style make it likely that they were produced over quite a long period. None of the prints is dated and only occasionally do copies indicate a *terminus ante quem* – a date before which the print must have been made. The other works attributed to the Master – the 'Housebook,' the drawings, paintings and stained glass – also fail to provide any real indication of their possible date of origin, with the exception of the dedication page of a manuscript in Heidelberg, dated 1480 [**118**]. Hence all we can hope to do is to construct an overall chronology of the Master's graphic oeuvre based on stylistic considerations.

Fig. 22
Detail (2x actual size) from *Christ as the Good Shepherd* [**17**], drypoint, ca. 1470.

Fig. 23
Detail (2x actual size) from
Samson slaying the lion [5],
drypoint, ca. 1470-75.

¶ The most convincing chronology to date is that compiled by Glaser in 1911 for the prints, because it is completely unaffected by the countless attempts to identify the Master with an historical personality and thus to attribute other works to him as well. Because Glaser relied almost exclusively on the stylistic development of the prints themselves, his chronology was accepted by several generations of specialists, however divergent their other views of the Master may have been. The account given below and in the catalogue rarely differs in essence from Glaser's.[9] It is clear that the Master advanced into the new medium with faltering steps, the engravings of predecessors and contemporaries perhaps providing the model for his hatchings and compositions. It was only later in his development that Schongauer's prints affected him more directly and that he ventured upon larger formats and more intricate compositions.

THE EARLY WORK

¶ The early work was small in size, hesitant in its draftsmanship, simple in construction, and generally limited to one or two figures. A typical example is *Christ as the Good Shepherd* [17]: inside fairly heavy contours, simple, short, thin parallel lines, cross-hatched in the darker sections, have been scratched into the copper plate. Because the hatchings barely form a logical whole with one another and with the contours, they lend the figure little volume so that the overall effect is very flat (*fig. 22*). The angular fall of the folds does little to suggest depth and volume. The Master's awkwardness in this respect is particularly clear in the banderole, on which the hatchings are distributed in a decorative rather than logical manner. As also appears from the two – perhaps slightly later – Samson prints [5, 6], the figures in the early work are stocky, the anatomical structure faulty and the space around them limited; the simple hatchings allow the figures or their clothing little structure. At the same time, however, the events themselves are conveyed with impressive, almost naive, directness (*fig. 23*). Where his predecessors would stylize these incidents, our Master shows a predilection for typically individual details of posture, dress and the like. This appears with surprising effect in the small prints of *Infants playing* [59-61]. The dark dots by which the pupils of the eyes are indicated in the light, barely modelled faces, and the sparing use of parallel hatching in the figures, are typical of the early period. His powers of direct observation, and sense of humor, remain characteristic of the further development of the Master, who quickly acquired greater technical proficiency, especially in the use of hatching.

¶ The *Four prophets* [1-4] can be dated to the end of the early period. The proportions of the figures are more convincing; the folds are still rather angular, but the hatching, albeit simple enough, has been applied much more effectively (*fig. 24*).

¶ The early phase in the work of the Master we have just described can probably be dated to between ca. 1470 and ca. 1475. *Christ as the Good Shepherd* [17] is based on a Flemish woodcut of ca. 1470 [17a] and *Samson slaying the lion* [5] was used as the model for a woodcut that appeared as an illustration in the *Spiegel menschlicher Behaltnis* [140, 5a], published in about 1480 in Speyer.

THE MIDDLE PERIOD

¶ The middle period in the Master's work – the transition towards the more mature phase – is characterized by work of larger size, with larger figures and careful but fairly open hatching. The modelling consists chiefly of hatchings made up

of short, firmly curved lines. *Dog scratching himself* [**78**; *fig. 25*] has been drawn, with the help of a fairly broad stylus, using these comma-like curved lines – superimposed in the darker sections – to produce a convincing plastic effect. Not least because of the particularly telling observations of its posture, this dog is the most naturalistically depicted animal in fifteenth-century graphic art.

¶ In *St. Martin* [**38**; *fig. 26*], the body of the horse shows the same kind of hatching, but the clothing of the saint reveals a somewhat more elaborate pattern of hatching and cross-hatching, reminiscent of Schongauer's engravings. The Master's drypoint technique precludes the technical perfection of Schongauer's work, but this is perhaps offset by the effectiveness of the drypoint's direct appeal.

¶ In the more mature work we see a development towards a more positive suggestion of space, a greater refinement and delicacy and a more assured technique. The composition of the *Bearing of the Cross* [**13**; *fig. 27*] is fairly complicated in comparison with the early work, an impression of depth being created by the rocks placed to the rear of the main figures as repoussoirs, behind which a forest of lances suggests the presence of a large number of soldiers. But the spatial effect is also increased by a shrewd distribution of dark and light masses achieved by pronounced variation in hatching. In this print, too, we are struck

by the variety of strikingly characteristic attitudes.

THE SO-CALLED COURT PERIOD OR THE PERIOD OF PRINTS MADE WITH A FINE STYLUS

¶ The rich and careful modelling done with the aid of various systems of hatching reaches a peak in *Solomon's idolatry* [7] and in *Aristotle and Phyllis* [54], in which the figures are rendered with great liveliness and elegance (*fig. 28*). The variety of hatchings, often in several superimposed layers, is most clearly seen in the *St. Christopher* [32].

¶ *Solomon's idolatry*, like the *Pair of lovers*, was partly used as a model for the woodcuts of Hungarian nobles in the *Chronica Hongarorum* published in Augsburg in 1488. It is generally held that this date, and 1480, which appears on the dedication page of a Heidelberg manuscript [118] illustrated by our Master, mark the limits of the period during which, as far as the use of drypoint is concerned, he produced his most subtle work. On the drawing dated 1480, the manuscript in question, a translation of *Die Kinderen von Limburg*, is presented to the Elector Palatine, Philip the Sincere (1448-1508), by the court poet Johann von Soest. The drawing suggests that the Master was in touch with that court, and it is because some of the Master's most technically perfect prints depict 'courtly' themes in the most elegant manner that this period is sometimes referred to in the literature as the Master's 'court period.'

¶ Those who employ this term assume that the Master made these prints during a stay at the court of Philip the Sincere; the courtly themes would then be a reflection of the life and chivalrous ideals of that court. Other specialists, questioning this, have pointed to the affinity between the engravings made with a very fine stylus and silverpoint drawings, one of them speaking of the 'Feinstich' (fine point) period.[10] The prints display the use of a very fine drypoint, wielded very subtly, without the regular systems of cross-hatching still to be seen to the full in, for example, *Aristotle and Phyllis*: the transitions in the modelling are soft and fluid. A typical example is *Lady with owl and the 'AN' escutcheon* [86; *fig. 29*]: the hatching is light and delicate, the deep, full drapery folds of the earlier work are absent, but the folds are anything but schematic or flat: the fine, transparent hatching has a tonal effect.

¶ The courtly groups [66, 70, 73, 75] and the hunting scenes [67, 72] are for the most part executed in this refined technique. The figures are slender and fairly tall and very elegantly dressed: the men in shoes with fashionably elongated toes (the so-called 'cracows' or 'poulaines'), tight hose and slashed sleeves and doublets, the women in high-necked dresses. *Young man and death* [58; *fig. 30*] is an impressive depiction of the transitoriness of all this. The technique, a combination of very fine hatching with rather broad drypoint contours, is both extremely subtle and effective.

Fig. 27
Detail (2x actual size) from *The bearing of the Cross* [13], drypoint, ca. 1480.

THE LATE WORK

¶ The Master's stylistic development to the more mature work we have described is quite logical: from the technically awkward to a craftsman-like mastery of the drypoint, applied finally in a subtle and detailed manner. Because this refinement of the drypoint technique cannot be traced any further, it is generally assumed that the prints from which the systematic hatching is absent and the drypoint technique is used more freely constitute the Master's late work. The line on these prints is often nervous and restless: countless fine strokes appear to have been scratched hastily into the plate; some prints even have a distinctly sketchy character [16, 50, 77]. Even such fairly traditional, devotional representations as the *Adoration of the Trinity* [21], the *Virgin enthroned* [27], *St. Michael* [39; *fig. 31*] and *St. Mary Magdalene* [50], reflect this free, sketchy approach. In these prints, it is the deep black, velvety lines and planes created by the firm application of the drypoint rather than the hatching which determine the volumes and spatial effects. This painterly technique was also applied in larger, relatively complicated compositions, in which the space round the figures and the distribution of light and shadow played an important role. Although the linear perspective of the *Holy Family by the rosebush* [28; *fig. 32*] is not perfect, the distribution of light and shade creates a convincing atmospheric perspective which isolates the Holy Family from the background, thus emphasizing the intimacy of the scene remarkably. Because one of Dürer's earliest engravings, *Holy Family with the butterfly* [28a], usually dated 1495, is difficult to imagine without the model of our Master's print, *Holy Family by the rosebush* [28] must date from before 1495.

Fig. 28
Detail (2x actual size) from *Solomon's idolatry* [7], drypoint, ca. 1480-85.

Fig. 29
Detail (2x actual size) from *Lady with owl and the 'AN' escutcheon* [86], drypoint, ca. 1485.

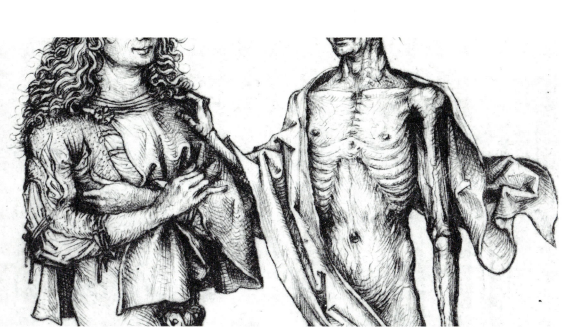

Fig. 30
Detail (2x actual size) from
Young man and death [**58**],
drypoint, ca. 1485.

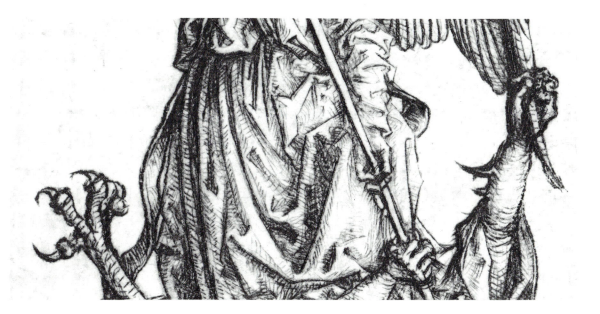

Fig. 31
Detail (2x actual size) from
St. Michael [**39**], drypoint,
ca. 1490-95.

¶ The late work also includes the *Adoration of the Magi* [**10**; *fig. 33*], a composition based in part on Roger van der Weyden, in which the soft *sfumato* of the drypoint areas binds the figures into a satisfying whole. In the representation of the figures the artist's purpose is not to idealize but to individualize, which sometimes leads to caricatured expressions, for instance of the Jews in the *Circumcision* [**11**]. The *Circumcision* and the *Adoration* are linked with the three panels the Master painted for the nine-part cycle of the *Life of the Virgin* in Mainz [**132**d,e,g]. Since the cycle as a whole is not by the Master's hand, we must take it that the other prints were made or finished by other artists, probably from his workshop and possibly after his death. The *Annunciation* in the cycle [**132** b], the composition of which is based on the Master's

print of the same subject [**8**], is dated 1505, presumably the year in which the cycle was completed [see **132**]. The prints we have mentioned, which probably belong to his late period, must therefore be dated from before 1505; for stylistic reasons we can even take it that the artistic activities of the Master, whose work shows no traces whatever of the influence of Dürer, must have come to an end in about 1495.

¶ While it appears quite possible to describe the broad outlines of the Master's stylistic development with the help of a number of characteristic models, it is much more difficult to put a precise date to all the prints. Indeed, there is reason for doubting whether there was any kind of consistent development, certainly not where differences in the nature of the subjects depicted and the size

of the prints could have exerted an influence on the formal language. This raises the question of the extent to which the Master's drypoint prints were intended as independent works of art for a wider distribution, or as models for himself and his fellow-artists.

DISTRIBUTION, NATURE AND FUNCTION OF THE DRYPOINT PRINTS

¶ The small number of impressions – 122 – of the Master's prints that has come down to us (seventy of the eighty-nine prints being known in only one impression) suggests that they enjoyed a very limited distribution. For various reasons it seems likely that more than one impression was made of many prints of which we have just a single impression, although drypoint technique does not lend itself to large editions. We have late impressions of a few prints [26, 50, 55], from which it is clear that the burr had wholly or largely worn away; on others, known in more than one impression, the burr seems to have remained reasonably unimpaired throughout the edition. This second group of prints was mainly of profane subjects made during the court period. The number of extant impressions is rarely more than three or four, but few fifteenth-century prints with profane themes have been preserved in greater number. We can assume from this that these prints were published in small editions of, for example, a dozen. The clear connection that can be established between the number of extant impressions and the subject of the print makes it of interest to enter briefly into the content of the various thematic groups in the Master's engraving work.

¶ The themes of the religious prints with a narrative character are limited to a number of episodes from the life of Mary and the Passion of Christ and a few events from the lives of the saints. In the biblical prints emphasis is generally laid on intimate details in the life of Mary and of Christ, which played an important role in late medieval mysticism, since the arousal of 'empathy' with these incidents led to a heightening of religious fervor. Prints of the Virgin [23-27, 30] and of the Passion of Christ [19-22] served much the same purpose and are related to the many painted and sculpted *Andachtsbilder* (devotional images) of that period. Such images, which emphasized the emotional content of the themes, played a large part in the devotion and faith of the late Middle Ages. A number of the prints, for instance those of the standing prophets [1-4] and saints [35, 41, 46, 47], are so reminiscent of sculptures that they must have been based on sculptural models. Apart from the unusual iconographic details and the startling directness with which the ideas are

rendered, the Master's religious subjects fit into the standard repertoire of the late fifteenth-century German sculptor or painter. Although a few prints were used as models for paintings, they were rarely copied.

¶ Prints with profane themes exerted a much greater influence. In view of the number of copies and imitations this aspect of the Master's work must have been of considerable importance for his contemporaries. The smaller prints, dating back for the most part to the early period, of wild men, playing children, peasants, gypsies and the like, are most closely related to the decorated borders of late medieval manuscripts (see pp. 12-18). In a number of these themes, and certainly in the so-called coats of arms [79-82], the satirical intention is obvious but difficult to interpret precisely.

¶ In the case of prints with 'courtly' themes, the general belief, as was said earlier, is that they reflect forms of courtly culture in which chivalrous ideals played an important role. It is of these prints, which in view of their content were intended for a small and exclusive circle, that the greatest number of impressions has been preserved. They, no doubt like the earlier engravings, were treated as valuable objects and hence more carefully looked after than the devotional prints. It nevertheless remains an open question whether so few impressions of the Master's religious prints have come down to us because the others wore out through devotional use. It seems more likely that these prints, with their drypoint technique and sometimes markedly sketchy character, were never intended for wider distribution. Unfortunately there is no evidence to support the assumption that the Amsterdam collection of the Master's prints (see pp. 89-90), consisting almost entirely of the only preserved impressions, came from the Master's own collection, but it is very probable that they were used in a painter's workshop.

¶ Many of the Amsterdam impressions are spotted with paint, and in a number of cases gray ink washes have been applied with a brush [e.g. 18, 19, 32], or the impression has been over-handled [66, 79, 80, 85]. In one case the contours have been pricked [45], and in another they have been traced through. The use of engravings as models in artists' or craftsmen's workshops was not unusual, which perhaps also explains why the playing cards by the Master of that name have been preserved.

¶ Whether it was the Master himself who preserved his prints for use in his workshop, or whether one of his contemporaries collected them for use as models at a later stage, is something we can no longer tell. A number of the sketchier plates such as the *Infants playing* [59-61], *Dog scratching himself*

[78], *Study of two heads* [77] and similar work, are reminiscent of drawings in so-called model books.[11]

¶ It is open to question to what extent the prints were made as models; in other words, whether or not the drypoint enabled our Master without too great an effort to put a few figures and compositions onto the plate and to reproduce them in small numbers as models. The answer might at the same time explain why an artist who, to judge from the character of his work, was trained more as a painter than as an engraver should have resorted to drypoint technique. As was remarked earlier, it seems likely that the artist was trained first as a miniaturist;[12] the use of hatching and angular lines in depicting folds is as much part of the formal language of engravers as it is of that of miniaturists, as we can see from the *Four evangelists* in the Cleveland *Gospels* [119]. The underdraw-

ings in the Master's paintings (see pp. 295-302) are, in their use of various hatching systems, related to the drypoint prints. Hatching placed across angular lines cannot, for instance, be found in engravings by the Master's contemporaries, but are present in the underdrawing in his own paintings. The many points of correspondence between the Master's drypoint prints and his drawings [121-122, 124] also suggest that the artist drew on the plate in the same direct manner as he did on paper or parchment.

¶ These observations lead one to suppose that it could not always have been the artist's intention to circulate his prints. His intention must rather have been to lay down figures and compositions in a modest way of his own for the needs of his own workshops and perhaps for a few colleagues. The sketchy character of many of the Master's prints points in the same direction, as does the

Fig. 32
Detail (2x actual size) from
The Holy Family by the rosebush
[28], drypoint, ca. 1490.

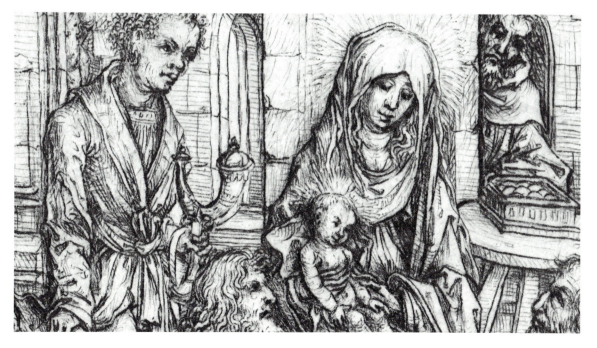

Fig. 33
Detail (2x actual size) from
The Adoration of the Magi [10],
drypoint, ca. 1490-95.

neglected state of the metal plates with which the impressions were made. In more than one print it appears that the plate was badly scratched, contained many small pockmarks or was even cracked. This too suggests that the sheets were not meant for publication.

¶ Another possible use has been suggested elsewhere (p. 59) in respect of the small pages with saints and similar subjects, namely that they were made for pasting into the margins of prayer-books. No examples of such a use have come down to us. Of the use of the Master's prints as models for marginal illustrations in manuscripts, too, there is just one extant example, namely the *Infant sitting* [**60**]; the correspondence between a number of motifs in the drypoint prints and in such marginal illustrations (e.g. in **120**) lends slightly stronger support to the assumption that the prints were partly intended as models.[13]

¶ On the basis of the extant impressions and the known copies of the prints we must conclude that on the whole it was only the prints with profane and courtly themes that enjoyed a somewhat wider distribution. In most of these there are no signs of the carelessness and technical imperfections found in so many of the Master's prints. This supports the conclusion that these prints were intended for sale in small editions.

¶ The remarkable fact that none of the prints bears the artist's monogram or sign indicates, in any case, that the artist never entertained the ambition of making his name as an engraver, or considered himself a match for Schongauer or Meckenem.

¶ This suggested distinction between those prints intended for internal use in the artist's workshop and those meant for sale, brings us to a final question, namely to what extent this distinction may also have influenced the artist's attention to detail and the care with which he handled the drypoint. In other words, were the prints made whith a fine point during the 'Feinstich' or court period confined to that period, or did some of them originate at the same time as the more freely drawn sheets, usually given a later date? For the present it is difficult to find an answer to that question.

THE MASTER'S INFLUENCE ON HIS CONTEMPORARIES

¶ In this section we shall be discussing those of the Master's contemporaries whose work has been linked to his own: Master b x g, Wenzel von Olmütz, Israhel van Meckenem and Master WB. The first three copied work by our Master, while the four engravings of Master WB are original works created in our Master's sphere of influence. Separate sections in the catalogue are devoted to both Master WB and also to Master b x g (**92-112** and **113-16** respectively), since they were probably

in direct contact with our Master and since their work is allied to his.

¶ The engravings of Master b x g consist first of all of copies of five prints from Schongauer's Passion series and of a number of prints by our Master: it is thanks to his engravings that the greater part of our Master's *Infants* [**61** b-f] has been preserved in copy. Like the work of other copyists of our Master, his copies are confined to profane themes. It is not, however, certain that all profane prints with the monogram b x g are in fact copies. This seems most unlikely in the case of the Rohrbach escutcheon [**111**], but in other prints, too, it is possible that the engraver was also the inventor – the designer – of the print. From the escutcheon of the Rohrbach family of Frankfurt [**111**] we can take it that Master b x g worked in Frankfurt in about 1480; on the basis of his engraving technique and of several ornamental prints with his monogram it has been deduced that he must have been a goldsmith, albeit no convincing suggestion of his identity has ever been made. In all cases in which models by our Master can be compared with copies by Master b x g, it appears that the copyist has faithfully translated the drawing into a powerful linear engraving style in which there are found, as well as parallel and cross-hatching, curved, finer, lines to indicate the ground and the lighter folds.[14]

¶ *Israhel van Meckenem* flourished as a goldsmith between 1465 and 1503, mainly in Bocholt after ca. 1475. He was probably the most productive of fifteenth-century engravers: his more than 620 prints are largely copies of the work of others. To begin with he copied Master E.S., whose apprentice he probably was: he made more than 200 exact copies of his prints, over and above the 41 copper plates by that Master which he reworked and reprinted. In addition he also copied work by Schongauer, by our Master and even of the young Dürer. Most of the copies of our Master's work [**53**a, **55**a-**56**a, **75**c, **89**a] were probably taken directly from his drypoint prints, but in the case of the 'infants' [**61**g] the models were copies of Master b x g after our Master [**60**a, **61**a-f]. Meckenem's admittedly effective but not very subtle engraving technique was, in general, unsuited to conveying the refined and subtle character of the Master's prints; for all that, Meckenem's copies undoubtedly helped to make our Master's designs more widely known. Much more successful in artistic respects than the above-named copies were Meckenem's late prints of profane subjects, for which the *Infants playing* [**61**h-i] served as models. In these prints Meckenem uses a more personal, rather painterly engraving style, placing the light figures against a dark, hatched background.[15]

¶ *Wenzel von Olmütz* is known exclusively as a copyist, above all of Schongauer's prints: he worked in Olmütz (Olomucz) near Prague in about 1475-1500, and his engravings bear the monogram W. His three copies of the Master's prints [**64**b, **65**b and **75**b] reveal him as a faithful copyist, but one who had little feeling for subtle nuances.[16]

¶ *Master WB*, like our Master, was painter, draftsman, stained-glass designer and probably book illustrator as well. The series of painted panels with incidents from the life of St. Sebastian in the Cathedral of Mainz, as well as the illustrations from the *Chronecken der Sachsen* (Saxon Chronicles) probably designed by him, make it seem likely that Master WB worked in Mainz or its surroundings, perhaps at the same time as our Master.[17] His four engraved portraits (heads) are so closely related to the work of our Master that in 1910 Baer considered them to be the work of the latter, printed from plates that had been provided with the monogram WB by a publisher in about 1500.[18] The relationship is mainly reflected in the

typical faces and the landscape in two of the prints; on the other hand, however, Master WB has an unmistakable style of his own, which also appears in his paintings, drawings and in the glass-paintings attributed to him. While the large number of fine hatchings on the faces of the figures are reminiscent of the late prints of our Master, the engraving technique of Master WB is less sketchy and quite powerful; the placing of the figures before a dark background indicates the influence of the late Meckenem.

THE YOUNG DÜRER

¶ Albrecht Dürer was born in 1471, the son of a Nürnberg goldsmith. It is possible that he was given instruction by his father before he entered the workshop of the painter Michael Wolgemut as an apprentice in 1486. In 1490, having served his apprenticeship, he set off on a journey through Germany, partly in order to visit Martin Schongauer in Colmar. We do not know what delayed him during his travels in Germany, and perhaps also in the Netherlands, but it was not until the

Ex ungue leonem:

THE HISTORY OF THE 'HAUSBUCHMEISTERFRAGE'

Jane Campbell Hutchison

¶ 'Es geht mir mit unserem Hausbuche, wie mit der Edda, dem Nibelungenliede, der Gudrun oder dem sogenannten Gebetbuche des Kaisers Max und den übrigen Werken unseres herrlichen Meisters Dürer, oder Goethe's Faust oder den Stichen nach Cornelius...'

Ralf von Retberg, *Kulturgeschichtliche Briefe* (1865)

¶ Ralf von Retberg wrote the above when scholarship on the Wolfegg Housebook and the related prints in Amsterdam was yet in its infancy. A more appropriate comparison, as it turns out, might have been made with the Lorelei, for only that other famous navigational hazard in the Rhine valley has caused more expeditions to come to grief. The anonymous late-fifteenth-century artist who created the best of the Wolfegg drawings, as well as the cache of eighty drypoint engravings owned by the Rijksprentenkabinet, has been a source of endless fascination for Dutch and German connoisseurs and art historians since the mid-nineteenth century, when the freshness of his observation and the experimental quality of his technique first began to be appreciated. When it became apparent that his art had served as a formative influence upon the youthful Albrecht Dürer, who had left important written references to such earlier artists as Stephan Lochner and Martin Schongauer, concerted efforts were made to discover the historical identity of the mysterious draftsman, with the result that he was provided over the years with more than a dozen identities, from that of a Burgundian goldsmith named Gillekin van Overheet[1] to such German luminaries as Matthias Grünewald and the elder Holbein. To date, the efforts to solve the riddle of the Master's identity have revealed more about changing fashions in art history than about the Master himself.

¶ The Wolfegg manuscript has remained in the same princely collection in southern Swabia since its acquisition in the seventeenth century by the Reichserbtruchsess Maximilian von Waldburg, who founded the family library (and as a part of the library the print collection) at Wolfegg Castle.[2]

THE AMSTERDAM DRYPOINTS AND THEIR ANONYMOUS ARTISTS

¶ The provenance of the Rijksmuseum's drypoints can be traced no further than the eighteenth-century collection of Pieter Cornelis, Baron van Leyden and Lord of Vlaardingen (1717-88),[3] which formed the nucleus of the Dutch national collection after its acquisition from the Baron's daughter by Louis Napoleon (see also p. 91).

¶ Carl Heinrich von Heinecken (1706-91), who directed the Royal Saxon print collection in Dresden from 1746 until 1763, was the first art historian to refer to the work of the anonymous printmaker. In his description of the four impressions in Dresden and Vienna with which he was familiar, he labelled the artist Monogrammist A.N. [86].[4] During his visit to the Netherlands in 1768, he had been the house guest of Baron van Leyden for three days and the following year had published a description of the most notable prints in the Baron's collection.[5] In it, Heinecken did not mention the portfolio of anonymous prints by the fifteenth-century artist, possibly because neither he nor his host considered them to be of comparable interest or importance to the many works of superb quality by Rembrandt and other famous masters. Adam Bartsch, curator of the Imperial collection in Vienna, was the Baron's guest in 1784, by which time a complete inventory of the collection listing the eighty drypoints had been made.[6] He too remained silent on the work of the anonymous master and, like Heinecken, later failed to recognize the same hand in his description of the Vienna impressions.[7]

¶ Jean Duchesne aîné, of the Cabinet des Estampes

at the Bibliothèque Royale in Paris and director in the time of Louis Philippe, was the first to recognize the individual style of the artist, enabling him to identify works by the same hand in the German, Austrian and English collections which he visited as well as in Amsterdam. He had studied the majority of the Amsterdam prints with some care during their four-year captivity in Paris (1812-16). During that period, when Holland was incorporated into France, the best of the Baron's former collection, which his daughter had sold to Louis Napoleon, was taken to Paris from the Royal Library in the Hague. In his *Voyage d'un iconophile* (Paris 1834), written eighteen years later, Duchesne called the anonymous artist the 'Master of 1480,' identifying him as the earliest known printmaker of Dutch origin, and listing impressions by his hand in Vienna, Dresden, the Nagler collection (Berlin), Stowe Palace and the British Museum, as well as in Amsterdam, where Baron van Leyden's prints now formed the nucleus of the Rijksmuseum's print collection. Remarking on the great rarity of work by the artist, Duchesne promised to publish in the near future a catalogue of his prints and those of his predecessor, the 'Master of 1466' (Master E.S.), a project which unfortunately was never realized.[8]

¶ The next to study the work of the Master of 1480 was Johann David Passavant, the former Nazarene history painter and engraver who became inspector of the Städelsches Kunstinstitut in Frankfurt in 1840, and who was himself a print collector of taste and discernment. In his article on the earliest known engravers, published in the initial volume of *Deutsches Kunstblatt* (1850),[9] and in his comprehensive updating of Bartsch (1860), Passavant listed the Master of 1480 as 'peintre distingué de l'école de van Eyck.' He cited the large number of copies after the Master by Israhel van Meckenem and 'Barthel Schoen' (Master b x g) as evidence that he must have been highly esteemed in his own time.[10] Passavant also called attention to the large number of 'sujets de la vie commune, ou autres représentations profanes,' and commented upon the unusually pale color ('teint pâle') of some of the impressions (p. 255). He distinguished three different hands in the prints, which he dated to the last quarter of the fifteenth century. Among the works he assigned to the Master himself, Passavant mistakenly included engravings by Master FvB (L.8), LCz (L.11), E.S. (L.216), W B (L.3) and Wenzel von Olmütz (L.57). Taking exception to Duchesne's designation of the Master as 'Hollandais,' he pointed out that the only evidence of Dutch origin was the fact that the majority of the prints had come to light in a single Dutch collec-

tion. Passavant endorsed the opinion previously expressed in 1856 by H.A. Klinkhamer, the keeper of the Amsterdam print collection,[11] that in style of composition as well as in the manner of execution the drypoints were much more reminiscent of Flemish than of Dutch art, most notably reflecting the style of Hans Memling. In the early decades of Belgian independence, this was a sensitive issue.

¶ Gustav Friedrich Waagen, the first director of the Berlin Gemäldegalerie, described in his *Treasures of art in Great Britain* (1854) all but one of the British Museum's drypoints by the Master as Netherlandish. The exception was the *Turkish rider* [74], which he attributed to a German hand.[12] In his later book on the Vienna collections, published after Passavant's catalogue had appeared, he too adopted the term Master of the van Eyck school, also remarking upon the pervasive influence of Hans Memling.[13] Like Passavant, Waagen was a member of the Romantic generation. Although not a practicing artist himself, as Bartsch and Passavant had been, he was the son of a Hamburg painter and had a wide circle of friends among the modern German Romanists. Educated in Heidelberg and Berlin, he had been introduced to fifteenth-century German and Netherlandish painting by Sulpiz Boisserée, whose superb collection, amassed in Cologne when church property was secularized, was later bequeathed to the Alte Pinakothek in Munich. Waagen had been trained by the inventor of modern art history, Carl Friedrich von Rumohr, and his early monograph on the van Eyck brothers, published in 1822, was the first scholarly study of the subject. Despite his sophistication in dealing both with the previous van Eyck literature and with the question of signed and unsigned paintings, Waagen still included in the oeuvre of Jan van Eyck a number of works which are now given to Roger van der Weyden, Memling, Geertgen and Dirk Bouts. His belief that Jan van Eyck lived until about 1470 lent further credibility to the idea that the printmaker was a member of the van Eyck 'school,' which must be interpreted as a very general and regional term.[14]

¶ Up to this point, in the mid-nineteenth century, discussion of the Amsterdam drypoints had been conducted only by museum officials, all of whom were connected with institutions owning prints by the anonymous master. Their publications were basically simple descriptions of the known prints for the convenience of other connoisseurs and collectors. Physical description of works of art was of critical importance in the days before the advent of accurate photographic reproduction. Interest in works by anonymous artists was still relatively new, and there was always the hope

that good descriptions would lead to the discovery of further work by the same hand, perhaps with an identifying mark or monogram.

THE REDISCOVERY AND PUBLICATION OF THE HOUSEBOOK

¶ Nearly seventy years elapsed between Heinecken's initial mention of the anonymous Master A.N. and the first publication disclosing the existence of the Wolfegg Housebook, in a Swabian travel memoir of 1855 by Conrad Dietrich Hassler.[15]

¶ This may seem curious in view of the tremendous interest in medieval German art and literature during this period. Beginning in the late eighteenth century with Goethe's tribute to Erwin von Steinbach, the architect of Strasbourg Cathedral, and Herder's *Von deutscher Art und Kunst* (1773), the field gained in importance during and after the Napoleonic wars and the secularization of ecclesiastical property on the left bank of the Rhine in 1803. The study and collection of medieval manuscripts took on particular importance for the foundation of the new science of *Germanistik*, which encompassed the comparative analysis of historical and regional German dialects, folklore and judicial case material, as well as medieval poetry.

¶ The lectures of A.W. Schlegel in Bonn, Joseph Görres in Munich and Hegel in Berlin; the publications of the Grimm brothers, Karl Lachmann and Karl Müllenhoff in scientific theology and *Alterthumskunde*; Ludwig Uhland's monograph on Walther von der Vogelweide (1822) and the lyric poetry of Heinrich Heine's early *Buch der Lieder* (1827) are but a few indications of the depth and breadth of medieval studies in early nineteenth-century Germany. Heine was later to claim that his very first act upon arriving in Paris in 1831 had been to rush to the Bibliothèque Royale to see the Codex Manesse,[16] the most famous of all German secular manuscripts, which had been in the possession of the French since its removal from Heidelberg Castle during the Thirty Years' War.

¶ There were several reasons why, in the midst of the vogue for things medieval (and until 1820 'medieval' still included Albrecht Dürer), the Wolfegg Housebook still languished undiscovered. First and most obvious was its relative inaccessibility. Wolfegg Castle stands in the Allgäu in southern Swabia, far from the major centers of Romantic scholarship. It was then, and is still inhabited by the princely and Catholic descendants of Georg, Truchsess von Waldburg, supreme commander of the Swabian League and scourge of the peasants in the *Bauernkrieg* (1525). Since the initiators of the Romantic cult of the Middle Ages were almost exclusively Protestants from northern Germany, Schloss Wolfegg lay geographically and socially beyond their purview. More importantly, however, the contents of the manuscripts militated against its publication so long as scholarly and literary opinion held the Middle Ages (including the fifteenth century) to have been characterized by religious fervor, knightly altruism and high seriousness of purpose. A manuscript containing occasional German words transliterated into Hebrew characters but no direct reference to Christianity, and which made light of courtly love in such risqué drawings as the *Minneburg* (fol. 19b-20a) – a castle of love turned into a brothel – a coeducational *Bathhouse* (fol. 18b-19a), and a satirical *Feast in the garden of love* (fol. 24b) did nothing to enhance the image of the German past which the Schlegel brothers and their contemporaries had been anxious to create. While the drawings in the manuscript do, indeed, include depictions of such knightly activities as a stag hunt and jousting with both bare and tipped lances (fol. 20b-21a), the text also includes such practical but unromantic information as how to administer a purgative to one's horse (fol. 31a: *Pfert leibig zu machen*), a remedy which Parzival's horse seems not to have required. Still more detrimental to the knightly image are the several recipes for aphrodisiacs and lubricants of a rather personal nature which the manuscript contains, some of which feature quite surprising ingredients,[17] not to speak of the copious technical information relating to the minting of coins, the deployment of heavy artillery and the concoction of explosives. As stated in the text (fol. 57a), this portion of the manuscript was a manual of practical information assembled by and for a *Büchsenmeister* (munitions officer).[18] Nor can the scholarly discovery of the Housebook be seen as a manifestation of the Romantic revival of interest in medieval German literature and illuminated manuscripts, for the illustrations are drawings rather than miniature paintings, and the text is in high German. The brief verses accompanying the drawings of the Planets' Children (fol. 11-17) are neither original compositions nor of any particular merit from the literary point of view. The initial interest in this entirely worldly manuscript was stimulated rather by the widespread acceptance of Positivism which, by the 1840s, had given rise to the new science of *Kulturgeschichte*, through which a more all-encompassing interest in the mundane aspects of life in the fifteenth century was stimulated. Conrad Dietrich Hassler (1803-72), the first to publish a reference to the Wolfegg manuscript, described it as 'a sort of quodlibet for the cultural history of the fifteenth century.'[19]

¶ Hassler's journey to Wolfegg was undertaken in 1854, in connection with the compilation of a

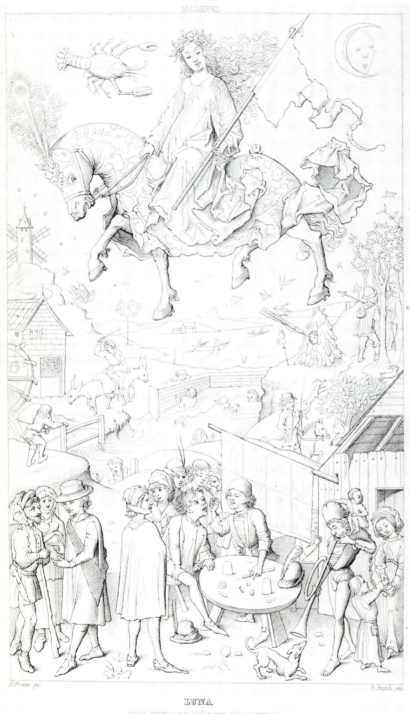

Fig. 36
R. Petzsch, Facsimile of the *Luna* in the Housebook [**117**, fol. 17], in E. Förster, *Denkmale Deutscher Kunst*, 1857.

LUNA
VON EINEM SCHWÄBISCHEN MEISTER
DES XV. JAHRH.

even the construction of the new palace of Hohenschwangau (1832-36) in Bavaria in Gothic style. Hassler himself was one of the group of leading citizens of Ulm that initiated the restoration and completion of the late Gothic Münster in that city in 1844. He was *Oberstudienrat* at the Ulm Gymnasium, having been trained in oriental languages, including Hebrew, and had conducted extensive research in Paris among the manuscripts of the Bibliothèque Royale. He was also a collector of Swabian prints, paintings and incunabula, and was thus well qualified to assess the historic importance of the library at Wolfegg, as well as of the castle itself.[20] Hassler's report, published in the proceedings of the local antiquarian society, was unillustrated.

¶ Ernst Förster (1800-85), who followed Hassler to Wolfegg two years later, also stressed the importance of the manuscript for the study of cultural history, particularly as it cast light upon the transition from religious to secular subject matter. He praised the artist's ability to capture 'real life' in a way which compared favorably with the genre paintings of a later age.[21] His account, published in 1857 in the third volume of his monumental series on German art and architecture, contained an illustration of the *Luna* drawing (*fig. 36*) engraved by R. Petzsch after a drawing made by the author himself. Förster, the son-in-law of the popular Romantic author Jean Paul Richter, had studied painting under the former Nazarene, Peter Cornelius, and was the creator of the mural decorations in the aula at the university of Bonn (1824-25). He recognized stylistic differences among the drawings in the Housebook, considering the best of them (including the *Planetenkinder Luna, Mars* and *Venus* [**117**, fol. 17, 13, 15] and the double-paged drawings of tournament and hunt) to be the work of an artist working very much in the manner of Martin Schongauer. He saw the illuminated initials as the work of an itinerant Flemish miniaturist, and the technical drawings as by yet another hand. Förster suggested a date between 1450 and 1460 for the manuscript (thus considerably before Schongauer's first dated work, which we now know to have been from 1469), and classified it as Swabian, influenced by 'the school of Ghent.'[22] The *Planetenkinder* verses as well he thought were of South German authorship.

register of historic buildings in southern Swabia. The sudden expansion of the German economy shortly before mid-century had made possible the systematic restoration of such medieval monuments as the cathedrals of Bamberg, Speyer and Regensburg, and of a large number of castles, including Heidelberg and the Wartburg, as well as the completion of the cathedral of Cologne, and

THE ARTIST OF THE DRYPOINTS AND THE HOUSE-BOOK: BARTOLOMAUS ZEITBLOM OF ULM OR HOLBEIN THE ELDER?

¶ Ernst Georg Harzen's monographic study of 1860 was the first to attribute the Wolfegg drawings and the Amsterdam drypoints to the same artist, and to suggest a historical identity for that

artist.[23] The author, writing shortly before his death, had been the leading Hamburg art dealer and print collector for over forty years. An amateur etcher himself, he was one of the first connoisseurs to specialize in fifteenth-century German engravings, an area which Bartsch had only partially understood, and he bequeathed his own superb collection of works by the Master of the Amsterdam Cabinet, Schongauer, Master E.S. and other early monogrammists to the newly-founded Hamburg printroom when he died in 1863.[24] Harzen accepted Förster's dating of about 1450-60 for the Wolfegg manuscript, which he too had examined.[25] He also knew the Amsterdam drypoints at first hand, having paid a lengthy visit to the Netherlands in 1838. Nevertheless, he attributed them to the same hand as the monogrammed copperplate engravings of Master b x g and W B, explaining their stylistic dissimilarities in terms of the difference between media. He identified as the creator of this composite corpus the leading Swabian painter of the late fifteenth century, Bartolomaus Zeitblom of Ulm, on grounds that 'b x g' should be read 'b x s' – for Seitblom – and W B (*fig. 37*) should be read 'V V S B' – for Bartolomaus Seitblom spelled backward (as would happen when an engraver neglects to take into account the reversal of inscriptions when they are transferred from plate to paper in the process of printing). Harzen commented upon the Upper Rhenish characteristics of his composite Master, and quoted Johannes Capistrano's sermon, preached in Ulm in 1461, denouncing *Schnabelschuhe* (shoes with extravagantly long toes), and indecently short tunics of the sort worn by young men in the Master's prints and drawings of the 1480s. His argument, published without illustrations, was accepted by Waagen,[26] Retberg[27] and others before being refuted by Karl Schnaase in 1879.[28] Harzen's thesis was never accepted outside Germany, however, due in part to the fact that it appeared in the same year as Passavant's volume dealing with the Amsterdam prints as Flemish work from the van Eyck school. Harzen had published in German, while Passavant, with the international market in mind, wrote his *Peintre-graveur* in French as Adam Bartsch had done as well. Bartsch's successor in the Albertina, Moriz Thausing (1838-84), the foremost Austrian Dürer scholar,[29] and such important German experts as Karl Woermann, director of the Dresden Museum, and Alfred Woltmann, the young Holbein specialist, continued to regard the master as Flemish and to refer to him as the 'Master of 1480.'[30]

¶ Ralf von Retberg (1802-85), author of the first monographic study of the Wolfegg Housebook (1865), still found Zeitblom a viable candidate for the artist behind the manuscript, but had decided on the basis of internal heraldic evidence that the Housebook was associated with the city of Augsburg. He therefore mentioned in passing the elder Holbein as a possible alternate.[31] Retberg, a retired army officer living in Munich, was a print collector, amateur painter and a very considerable authority on fifteenth-century cultural history and military science. He knew Hassler's publication, and had personally examined the Housebook and had journeyed to Hamburg to confer with Harzen and to Amsterdam to see the prints. His detailed observations on the iconography of the Housebook drawings are still of tremendous value. He also called attention to the landscape style as prefiguring the manner of Dürer, and shrewdly noted a certain inconsistency in the handling of perspective, noting that the fountains and perspective views of technical equipment seemed more characteristic of the sixteenth than of the fifteenth century. Because he dated all of the costumes portrayed to the fifteenth century, he attributed the other differences to a continuation of the manuscript over a long period of time by a single artist rather than several. He identified the writer of the text as either north German or Netherlandish, on the ground that Frankish word forms had been used, and prudently cautioned against showing certain portions of his book to ladies (p. 11).

¶ Retberg's monograph had originally been written for publication by the Germanisches Nationalmuseum in Nürnberg, to be accompanied by a full set of engraved illustrations. In the event, however, the plates – engravings by Heinrich Ludwig Petersen – were published separately a year later with a brief and unsigned text dividing the Housebook drawings among several hands, the best of whom was said to be Zeitblom.[32]

NATIONALIST FEELINGS AND MODERN CONNOISSEURSHIP

¶ Hausbuchmeister studies during the last quarter of the nineteenth century were deeply influenced by three important, nearly simultaneous events of the spring of 1871. The first of these was the fateful exhibition and symposium on the art of the Holbein family held in the Dresden Museum, during the course of which it was discovered that, of the forty-six works attributed to Holbein the Younger assembled for the loan exhibition, only fourteen were genuine. This focused attention in a particularly dramatic way upon the primacy of authenticity over beauty in the judgment of works of art, and caused a number of prominent art historians to examine with fresh attention works which had heretofore been regarded as unremarkable. Ten prominent art historians who attended the three-

Fig. 37
a. Monogram of Master b x g
b. Monogram of Master W B.

day symposium signed a statement affirming the Darmstadt version of Holbein's *Madonna of Burgomaster Meyer* to be the authentic one, and the Dresden Museum's more stately composition to be a seventeenth-century copy.[33] Of those ten, eight were later to publish opinions regarding works associated with the Hausbuchmeister: most notably Wilhelm Lübke, Jakob Burckhardt's collaborator, who pronounced the Housebook a Swabian-Alemannic manuscript originating in Konstanz (1891),[34] and Friedrich Lippmann, director of the Berlin printroom, who had studied the Amsterdam prints when they were sent to Berlin to be reproduced, and who sought to identify them as juvenilia of Hans Holbein the Elder (1894).[35] Lippmann's case for the senior Holbein rested in part upon Retberg's tentative suggestion of 1865 (see above), and in part upon his conviction that the author of the prints, like the elder Holbein, had been incapable of sustaining strong religious emotion. Lippmann was also under the impression that the iconography of the *Planetenkinder*, as it appears in the Wolfegg Housebook and in earlier Dutch and German blockbooks, was Italian in origin, an assumption later disproved by Aby Warburg, who discovered that the imagery was directly dependent on the German verses accompanying the depictions of the planets and their 'children.'[36]

¶ Lippmann's Holbein thesis was discredited twice in the same year. First an anonymous critic, signing himself 'Historicus,' called attention to the depiction in the Housebook of the encampment of Friedrich III at Neuss during the campaign against Charles the Bold in 1475 [**117**, fol. 53]. He pronounced it to be of great historical accuracy, a testimony that the artist was a member of the Imperial forces.[37] This eliminated the elder Holbein, who was then about ten years old. In 1894 the future Dürer bibliographer, Hans Wolfgang Singer, also published an article criticizing Lippmann's hypothesis on grounds of incompatability of style and temperament between Holbein and the anonymous printmaker.[38]

¶ The second momentous event of 1871 was the four-hundredth anniversary celebration of Albrecht Dürer's birth, which generated a new interest in the sources of his style. Moriz Thausing's major new monograph on Dürer (1876) noted the influence on the youthful Dürer of the 'engraver from the van Eyck school',[39] while Robert Vischer's more explicit study of the foundations of Dürer's art (1886), returning the anonymous printmaker to south Germany ('Rheinschwabe'), proposed an identification with the unnamed master resident in Strasbourg with whom Dürer had worked as a journeyman in 1493 or 1494.[40]

¶ Equally important for the immediate future of Hausbuchmeister studies, however, was the victory of the Prussian army over the French at Sedan, which resulted in the recovery of the Alsace, lost to France in 1792, and the long awaited unification of the German Reich under Kaiser Wilhelm I. These events called for the ceremonial recognition of the German cultural heritage, in military history as well as in art. Two publications that can be connected with this upsurge of historical militarism were the new edition of Albrecht Dürer's *Befestigungslehre* (Berlin 1872) and a source book on the history of firearms illustrated with reproductions from the Wolfegg Housebook, published by the Germanisches Nationalmuseum (Nürnberg 1872).[41] The re-Germanizing of the Rhineland stimulated an enormous interest in both Martin Schongauer and in the Isenheim Altar of Matthias Grünewald, now that Colmar no longer lay under French control. The flurry of publications on hitherto unattributed fifteenth- and early sixteenth-century paintings from the middle and upper Rhine valley included not only the pioneering studies on Grünewald, but also the first publications dealing with the panel paintings which later came to be associated with the creator of the Amsterdam prints: the various panels of an altar depicting scenes from the Passion, now in Freiburg, Frankfurt and Berlin [**131**] and the nine panels of a Life of Mary series in Mainz [**132**]. The *Resurrection* panel (Frankfurt; then in Sigmaringen) was brought into relation with Michael Wolgemuth,[42] others with the 'school' of Martin Schongauer.[43] The Mainz *Marienleben* was attributed to Grünewald himself,[44] before Max Friedländer proposed its assignment to the Master of the Amsterdam Cabinet (1894).[45]

¶ The most important publications of the Wilhelminian era, however, were those of the youthful Max Lehrs (1855-1938), Friedrich Lippmann's assistant in the Berlin printroom, who later became director of the printroom in Dresden. Lehrs had already begun his systematic study of all known fifteenth-century northern-European engravings, which would later result in the indispensible *Geschichte und kritischer Katalog* (10 vols., 1908-34), and it had already borne fruit with a catalogue of the Nürnberg printroom and a series of articles in *Repertorium für Kunstwissenschaft* cataloguing the fifteenth-century prints in smaller municipal printrooms and private collections.[46] In the articles dealing with the prints at Nürnberg and Wolfegg he accepted Robert Vischer's theory that our artist had been a native of Rhenish Swabia (i.e., the area between Basel and the Bodensee), and proposed that henceforth, in deference to his German origin,[47] he be called the

'Master of the Housebook' rather than the 'Master of the Amsterdam Cabinet.' Lehrs himself used this designation consistently in all of his subsequent publications, with the sole exception of his 1893 monograph for the International Chalcographic Society. In this case, since the book was to be published in an English as well as a German edition, he used the title 'Master of the Amsterdam Cabinet' after being advised by Lippmann that 'Hausbuchmeister' would prove unnecessarily awkward in translation.[48] In the monograph, Lehrs discounted the influence of the van Eyck school ('to me it appears very slight indeed') and remarked upon the surprising lack of influence from Martin Schongauer. Stressing the Master's great originality, he pronounced him superior to all other fifteenth-century engravers in freedom of drawing, and praised particularly his 'inclination to deal with incidents of ordinary life,' as well as his skillfully rendered landscape setting, his realistic portrayal of animals and his delightful humor – characteristics which, incidentally, were much admired in the salon paintings of the 1880s and '90s, the era of Fritz von Uhde, Lovis Corinth and Max Liebermann, and in the lithographs of Toulouse-Lautrec, whose work Lehrs began systematically collecting for the Dresden printroom in 1895.[49]

The young Dürer and the Housebook Master: Wilhelm Pleydenwurff

¶ Lehrs's 1893 monograph was a work of tremendous significance, not only for the impeccable scholarship which characterized its author throughout his professional life, but also for its full set of photoengravings made from the Amsterdam drypoints, the director of the Rijksprentenkabinet having permitted the shipment of the entire group to Berlin to be reproduced for this purpose. Since the previous edition (Kaiser 1866, reissued by Boland in 1883) had been illustrated only with modern engraved copies, Lehrs's publication had the effect of introducing the highly original style of the drypoints to a much wider audience than before. Whereas previous research on the anonymous master had remained the special preserve of museum men, and of those wealthy connoisseurs and collectors who had travelled to Amsterdam, the oeuvre was now brought to the attention – for better or worse – of university professors and their doctoral students, with the result that solutions to the riddle of the enigmatic master's identity soon reached epidemic proportions.

¶ The first graduate student to tackle the problem was Carl Hachmeister (Heidelberg, 1897), whose inaugural dissertation identified the anonymous printmaker as Wilhelm Pleydenwurff of Nürnberg, the stepson of Albrecht Dürer's teacher, Michael Wolgemuth.[50] Pleydenwurff's name occurs in the colophon of Hartmann Schedel's *Weltchronik*, published in Nürnberg in 1493 by Dürer's godfather, Anton Koberger, as one of its woodcut designers.

¶ Unfortunately, Hachmeister's conception of the paintings attributable to the younger Pleydenwurff was greatly distorted by the influence of the lectures of his major professor, Henry Thode and by the latter's book of 1891 on the Nürnberg school.[51] Nonetheless, Hachmeister's (unillustrated) dissertation performed a useful function in focusing attention upon the extent of the youthful Dürer's indebtedness to our printmaker in such drawings as the 1489 *Three lansquenets* (Winkler 18) and the *Cavalcade* [**57**a], the engraving of *The cook and his wife* (B. 84), *The oriental and his wife* [**65**c] and others.[52] The Pleydenwurff theory itself was quickly refuted by Max Friedländer (1898), who had already published an article pointing to the Mainz *Marienleben* as the closest counterpart to the style of the drypoints to be found in panel painting.[53] Friedländer felt that this firmly established the fact of the Master's presence in the middle Rhine region. Like Lippmann, Friedländer believed the drypoints to have been done within a relatively short space of time. It was his belief that they were the juvenilia of a German painter, done either for his own amusement or for the pleasure of a single patron.

¶ Eduard Flechsig (1897), the first scholar to attempt a full-dress study of the Master's possible activity as a painter, attributed to his hand the Gotha *Lovers* [**133**], the Oldenburg *Virgin and Child with St. Anne* [see **29**a], and the panels from the *Passion altar*. As the work of followers he introduced into the discussion altars in Seligenstadt, Bossweiler, Wachenheim and Wolfskehlen, all works of middle Rhenish provenance.[54] Max Lehrs (1899) endorsed the belief in the Master's extensive activity as a painter, but accepted only the panels belonging to the Passion altarpiece [**131**] as autograph work; he considered the Mainz series [**132**] (at that time still partially obscured by heavy overpaint) to be the product of a local Mainz workshop using several of the Master's drypoints as models.[55]

The origins of the style of Grünewald: Martin Hess of Frankfurt

¶ After the demise of Hachmeister's Wilhelm Pleydenwurff thesis, his Doktorvater, Henry Thode (1857-1920), put forward his own candidate – Martin Hess of Frankfurt – as part of his investigation into the origins of the style of Matthias Grünewald.[56] Thode had served as director of the Städelsches Kunstinstitut for three years (1889-

91) before taking up his professorship in Heidelberg. His specialty was the Italian Renaissance, but he had an interest in the Dürer circle dating from his student days in Vienna under Moriz Thausing, and was the author of a monograph on Nürnberg painting (see note 51).[51] His interest in German art of the fifteenth century, before the introduction of Italian Renaissance influence, was not unrelated to his devotion to the cult of Richard Wagner, his father-in-law, and to his belief in the racist theories of Houston Stewart Chamberlain's *Grundlagen des 19. Jahrhunderts* (1899-1901). Like his friend Hans Thoma (1839-1924), the anti-Impressionist painter of *Heimatkunst*, who was director of the Karlsruhe Kunsthalle, Thode believed that a mystical bond between artists and their birthplaces was the underlying cause of stylistic predispositions in the handling of chiaroscuro as well as in the choice of subject matter.[57] Thode was extremely popular as a lecturer, but was deservedly notorious for his misattributions, as his arch-enemy Franz Wickhoff (1853-1909), the founder of the 'Vienna School' of art-historical methodology, delighted in pointing out.[58] With Martin Hess, Thode was on relatively safe ground since none of the work of that fascinating painter had yet been discovered. Martin Caldenbach, called 'Hesse,' or Hess, was the recipient of personal greetings from Albrecht Dürer in letters of 21 March and 26 August 1509 to his client Jacob Heller of Frankfurt.[59] For sheer lack of evidence to the contrary, Martin Hess fared better than either Pleydenwurff, or the senior Holbein, and outlasted Eduard Flechsig's 1898 nominee, Nikolaus Schit, since the latter had inconveniently left behind a signed painting totally incompatible with the printmaker's style.[60] Martin Hess was accepted by both Leo Baer and Mela Escherich before being refuted by Carl Gebhardt in 1908.[61]

¶ Misinterpreting Dürer's praise of Martin Hess as an indication of his seniority, whereas in reality he was Dürer's own age, born about 1470, Thode adjusted the outer limits of the Hausbuchmeister's curriculum vitae to make him active by 1464, a date much earlier than any suggested since Förster's time. (Flechsig's Nikolaus Schit, for example, was thought to have made his debut only in 1480.) Leo Baer then caused the beginning date to recede even further, to 1458, in order to allow for a period of apprenticeship in the atelier of Master E.S., which he placed in Konstanz, explaining the Netherlandish features of the anonymous printmaker's art by means of a Netherlandish journey undertaken in 1476.[62]

Fig. 38
Illustration of the essay 'Ex ungue leone' in the periodical *Cicerone*, 1910.

EX UNGUE LEONEM: THE HOUSEBOOK MASTER AND THE MORELLIAN METHOD

¶ The course of the Housebook Master's stylistic development and the identifying marks of his manner had thus far been discussed almost exclusively in connection with individual theories of historical identity, and largely in the absence of visual evidence. The exacting methods of Morellian connoisseurship were brought to bear on the problem in 1910 when an anonymous 'Friend' (in reality, Eduard Flechsig) of the new periodical *Cicerone* published a quiz for connoisseurs. Pretending to have discovered a book illustrated with woodcuts, of middle Rhenish origin and dating between 1477 and 1488, the author invited attributions from the readership at large.[63] Bearing in mind Giovanni Morelli's successes in making attributions on the basis of hands and ears, Flechsig included two pages of outline drawings of thirty-one pairs of feet and legs, clad in footgear of various sorts but all featuring a characteristically high instep and bunion-like formation at the base of the toes (*fig. 38*). He specifically solicited expert advice from specialists in German art of the fifteenth century who might have seen these characteristics elsewhere in works of art. Answers to the quiz were submitted by Ludwig Kämmerer, Willy Storck, Max Geisberg and Hermann Voss, all of whom identified the artist as the Housebook Master, and by one anonymous respondent, who suggested Veit Stoss. Kämmerer also identified the book in question as Peter

SPRECHSAAL

Zu dem Aufsatz: „Ex ungue leonem"

72

Drach's *Spiegel menschlicher Behaltnis*, published in Speyer around 1478 [**140**], while Geisberg and Voss guessed the correct identity of the author of the quiz as well. In a dramatic conclusion, featuring a selection of eight feet reproduced from the Amsterdam prints, Flechsig revealed his own identity and that of the book, Drach's *Spiegel*, also thoughtfully providing a checklist of nineteen of the drypoints, keyed to the illustrations in Lehrs.

THE CAREER OF THE PRINTMAKER

A convincing chronology of the drypoints, based on close stylistic analysis of the printmaker's line work, was also published in 1910. The author was the neo-Romantic art historian, Curt Glaser (1879-1943), who for a time was Friedländer's assistant in the Berlin printroom.[64] Glaser accepted Thode's termini, 1465-1505, for the outer limits of the master's career, but worked almost entirely on the basis of internal evidence observed in the prints themselves. Since his eye for stylistic variation was extremely keen, and since his chronology neither stands nor falls with any specific theory of identity or nationality, it has formed the basis for every subsequent study of the Master's art, includig that of Max Lehrs (1932), and those of authors as ideologically diverse as Solms-Laubach, who spoke for an identification with Erhard Reuwich of Utrecht,[65] and Alfred Stange, who firmly believed in the artist's upper Rhenish origin.[66]

Glaser characterized the printmaker's development as a logical progression from the simple to the complex, accepting as the earliest works those which are small in size, limited in field of vision, insecure in draftsmanship and staffed with few and squat figures. He then saw a gradual development in technical refinement, partially under the influence of Martin Schongauer's engravings, with deeper drapery folds, more consistent use of chiaroscuro, better understanding of human proportions and more ambitious compositional arrangements. As a climax to this middle period he assembled the most refined of the prints which, largely secular in subject, are worked in so delicate a manner that they resemble the effect of silverpoint. He gave a terminal date of 1488 to this group, in recognition of Baer's important discovery that two of the figures had been used as prototypes for the portraits of King Andreas II and Queen Maria of Hungary in Johannes Thurocz's *Chronica Hungarorum* (Augsburg 1488)[67] [**7a** and **75**d].

Hachmeister had already been able to identify the clumsiest of the prints as early; Glaser's achievement lay in his recognition that the development of style is not necessarily a steady progression toward refinement. His chief innova-tion was in assembling the remaining twenty-one prints as typical of an aging master: precision and plasticity having been replaced by a sketchier and more painterly technique. In this group he noted the loss of preoccupation with youth and beauty and with courtly subject matter, which had typified the 'silverpoint' manner, and a reawakening of interest in religious themes. In spite of the physical imperfections in some of these works, he detected a profundity of feeling and interpretation and, in some cases, the use of more complicated spatial settings than he thought possible for the youthful artist.

Glaser's Hausbuchmeister was thus the first to enjoy a long and active career as a printmaker. He was not someone who had produced the drypoints as juvenilia before maturing as the painter of this or that altarpiece, but had continued to make the drypoints, without interruption, throughout a professional life having a clearly defined beginning, middle and end. Glaser's analysis of the chronology seems entirely credible to the modern reader, in light of the scholarship on the late works of such long-lived artists as Michelangelo, Titian and Donatello. His conception of the undated late style of the Hausbuchmeister, however, seems much influenced by such contemporary art-historical works as Carl Neumann's monumental biography of Rembrandt (Heidelberg 1902; 2nd ed. 1905),[68] which as Jan Emmens has shown, set an important precedent for the aging 'Maler der Seele' as well as for the rejection of conventional beauty. That Glaser glorifies the loose and sketchy linework of such prints as the *Holy Family by the rosebush* [**28**] as the ultimate in artistic experience rather than deploring it as early work showing incomplete control of the stylus, as Passavant and Hachmeister had supposed, seems hardly possible without the precedent of Richard Hamann's *Der Impressionismus in Leben und Kunst* (Cologne 1907).

In contradistinction to Henry Thode, who considered Impressionism inartistic, immoral and *undeutsch*,[69] Hamann (1879-1961) discerned an 'impressionistic' style of old age in Rembrandt, Beethoven and Goethe, as well as in the development of history itself. In each cultural epoch he perceived an ending in a pre-Spenglerian impressionistic phase.

HEIMATKUNST: HEINRICH MANG AND THE UPPER RHINE

Glaser's determination to discuss the drypoints only in terms of pure stylistic analysis should also be seen in relation to the general aversion to Positivism which characterized many other important books of the day – among them was

Ernst Heidrich's *Die altdeutsche Malerei* (Jena 1909), which Glaser himself was to bring out in a revised edition after Heidrich's death in World War I,[70] and his own *Zwei Jahrhunderte deutsche Malerei* (Munich 1916). In that book, Glaser regards the art of the fifteenth century as Thode had also presented it, as representative of the most purely 'Germanic' (*deutschesten*) phase of German art. Heinrich Alfred Schmidt's *Grünewald* (1907) and Wilhelm Worringer's *Formprobleme der Gotik* (1911) also show an escalating and increasingly nationalistic concern for the discovery of a specifically German vocabulary of form as a unifying trait. The search for the 'deutsch-volkstümlich' had been taken up in part as an antidote for industrialization, which in Germany had been compressed into a shorter period of time than was the case in Britain or the United States. The reaction to industrialization in Germany favored the promotion of historic preservation, the wearing of regional costume and the celebration in art and literature of the beauty of regional landscape and the virtues of the peasantry, as opposed to the dangerous and immoral milieu of the city. The artistic ideals of *Heimatkunst* were promoted most particularly through the publications and exhibitions of Ferdinand Avenarius's militantly tasteful Dürerbund, dedicated to the celebration of German cultural heroes of the past and, it was hoped, to the cultivation of proper artistic and moral standards among the nation's youth. Among the most honored members of the Dürerbund were Max Lehrs and Wilhelm von Bode, as well as Henry Thode, Hans Thoma, H.A. Schmidt and Heinrich Wölfflin, and the more radical Paul Schultze-Naumburg, whose later book, *Kunst aus Blut und Boden* (1934) was to form one of the cornerstones of National Socialist art theory.[71]

¶ A new and definitive publication on the Wolfegg Housebook, co-authored by Helmut Bossert and Willy Storck (Ph.D. Heidelberg 1910) was published in 1912. In it the drawings were reproduced, the complete text transcribed, and the provenance and pagination of the manuscript were discussed in full. Bossert had previously published an article in the journal of the Freiburg Dürerbund affiliate *Schau-ins-Land* (1910).[72] There he divided the Hausbuch drawings among three different hands, one of which he identified as 'Heinrich Mang,' the name which appears in reverse on the horse blanket of one of the two knights being armed for the tournament with crowned lances (**117**, fol. 21b). Heinrich Mang is now generally believed to have been a tournament hero rather than an artist: perhaps as Stange suggested Heinrich Mang von Hohenreichen, Marschall von Pappenheim.[73] Bossert,

who had previously read the name on the horse blanket as Lang (1910), came to the conclusion later that the name was Mang, and that the artist had been related to the Innsbruck goldsmith Conrad Mang. Like many other ideas generated during the era of the Dürerbund, 'Heinrich Mang' survived well into the Third Reich.[74] Certain features of Mang's imaginary curriculum vitae were recycled by Johannes Dürkopp for his nameless but upper Rhenish *Hausbuchmeister* (1932), in whom *Seelenmalerei* had been crossbred with Wilhelm Pinder's theory of generations, while Bossert's original Heinrich Lang was resuscitated in *Schau-ins-Land* in 1937.

¶ More specifically racial in orientation than Bossert's work was H. Weiszäcker's.[75] In his articles 'Die Heimat des Hausbuchmeisters' and 'Bodensee und Hausbuchmeister,'[75] he traced 'die starken Wurzeln seiner Kraft' to the Swabian-Alemannic 'Stammesbereich' of the shores of the Bodensee. A similar sort of regional determinism characterized the work of Alfred Stange (1894-1968), whose earliest publications during the 1920s had dealt with medieval German sculpture, and who began during the early years of the Third Reich to write his twelve-volume *Deutsche Malerei der Gotik*, using a regional system of organization. Although the volume dealing with the upper Rhine, Bodensee and middle Rhine from 1450 to 1500 was not published until after World War II, in 1955, as was his monograph on the Hausbuchmeister (1958),[76] Stange's working vocabulary was very much a mixture of *Heimatkunst* and *Seelenmalerei*, with a dash of Heidegger added for good measure. Stange in 1939 had publicly declared his allegiance to National Socialism[77] and had served as a member of the Stab Rosenberg in Paris during World War II.

MAX LEHRS: THE *GESCHICHTE UND KRITISCHER KATALOG*

¶ The definitive work on the Amsterdam prints was published by Max Lehrs in 1932, in the eighth volume of the *Geschichte und kritischer Katalog*.[78] Lehrs, who was then seventy-seven years old, had made northern European engravings of the fifteenth century the study of a lifetime. His magnum opus, compiled with the full co-operation of print curators and museum directors at home and abroad, presented a complete physical description of every known impression, including states and watermarks – some of them unknown to Briquet – as well as stylistic and iconographic analysis and valuable information regarding prototypes and copies. Although Lehrs had lent his name to the Dürerbund before World War I, as a number of other highly respected scholars had done with the noblest of intentions, he was never

infected by the xenophobia which characterized the writings of the group's extremists; he had, in fact, resigned his post in Berlin to return to Dresden by 1895, where museum acquisitions under the direction of Woldemar von Seidlitz were relatively free of the Kunstpolitik which began to become obtrusive in the Prussian capital.[79]

¶ In his new and much more intensive study of the drypoints, Lehrs once again termed the artist the 'Hausbuchmeister.' The reference to the 'Amsterdam Cabinet,' used in his earlier monograph for the convenience of the translator, he now considered misleading. He had long regarded the anonymous artist as south German (*oberdeutsch*), a decision which he based on the prevalence of the Master's influence in the art of the Rhine valley, his demonstrable but limited connections with certain works by Master E.S. and Schongauer, and above all his belief that the printmaker himself was responsible for the majority of the drawings in the Wolfegg Housebook. Dating the drypoints in basic agreement with Glaser's chronology, he regarded the Housebook drawings, like the prints, as work created over an extended period of time. In his lengthy and critical review of the previous literature, Lehrs wryly commented upon the excessive number of hypotheses with which the literature had become burdened,[80] and dealt with various attributions of paintings, drawings and designs for woodcut and stained glass which had accrued to the Master over the years.

A Dutch identity: Erhard Reuwich of Utrecht

¶ In his chapter on the woodcuts attributed to the Master by various scholars, beginning with Harzen (1860), Lehrs dismissed as 'not to be taken seriously'[81] the suggestion put forward in 1891 by the Dutch museum director Dr. Adriaan Pit[82] that the artist had also been responsible for the woodcut illustrations in Bernhard von Breydenbach's *Peregrinatio in Terram Sanctam*, published in Mainz in 1486 [**142**]. Other German scholars regarded it more favorably, and in 1935, Ernstotto Graf zu Solms-Laubach published a lengthy article in the *Städel-Jahrbuch* presenting evidence in favor of the Housebook Master's identification with Erhard Reuwich, who is named in the introduction to the *Peregrinationes* as the book's illustrator and publisher.[83] As that text further attests, Reuwich was a painter by profession and a native of Utrecht, resided in Mainz, and had accompanied Breydenbach, the dean of the Mainz Cathedral chapter, on a pilgrimage to the Holy Land in 1483. A year prior to the appearance of Solms-Laubach's article, in 1934, an excellent and detailed study of the pilgrimage group had been published by Frederick Uhlhorn

in the *Gutenberg-Jahrbuch*.[84] Working meticulously from documents, Uhlhorn had called attention to the youthful Count Johann zu Solms-Lich (1464-83) as the financial backer of the Mainz contingent of the pilgrimage, which took place very shortly after he came into his inheritance at age eighteen in 1482. Breydenbach, who had developed a close relationship with the young count during the latter's student days in Mainz, was his travelling companion, as was the knight Philipp von Bicken. Other members of the party, acting in the capacity of servants, were a cook, a guide and Reuwich. The artist's sketches of exotic people and animals and his accurate renditions of city views were later translated into the woodcut illustrations which made the Breydenbach travel memoir an instant success as a publishing venture.

¶ Solms-Laubach, a modern member of the same noble family as Breydenbach's young patron, made a case for the identification of Reuwich with the Housebook Master on the basis of influences from the Bouts workshop, and Utrecht miniature painting, as well as from the workshop of Jean Tavernier, on a large group of paintings, prints and drawings attributed to the Master. He further cited stylistic similarities, already noted by Pit, between the *Turkish rider* [**74**] and the drummer in Reuwich's *Turks from Rhodes* [**142**, fol. 76], noting that both artists were interested in street life, costuming and exotic peoples (e.g. the *Family of gypsies*, **65**]. Citing the documented presence in Mainz of Erhard Reuwich during the publication of the *Peregrinationes* in its several editions, and his influence on the illustrations for Peter Schöffer's *Hortus sanitatis* from 1485 [**141**] and *Missale Wratislawiense* from 1483 as well as the influence of the Housebook Master in Mainz painting and sculpture for the same period, and noting Reuwich's Dutch origin as parallelling the Netherlandish influences which he sought to identify in the anonymous artist's work, he drew the conclusion that the two artists had been one and the same. Solms rejected the theory of the Hausbuchmeister's upper Rhenish origin, citing the recent and convincing cleansing of the oeuvre by Ernst Buchner, Lilli Fischler and Otto Fischer. They had been able to reassign a number of spuriously attributed paintings and drawings to Nikolaus Schit, the Master of the Coburg Roundels, Hans Hirtz, the Master of Waldersbach and others.[85] However, Solms himself needlessly complicated the issue all over again by accepting the attribution to the maker of the Amsterdam prints of the *Bergwerk* drawing (*fig. 9*), one of the weakest in the Wolfegg manuscript, and by attributing to Erhard Reuwich a group of Mainz sculptures previously assigned to the

anonymous 'Master of Adalbert von Sachsen.' Reuwich's supposed authorship of the key work in the group – the votive relief of the *Wallfahrer-maria* (Mainz Cathedral, cloister) (*fig. 39*), dedicated by Breydenbach and Philipp von Bicken after their safe return from the pilgrimage on which their young friend and host, Count Solms, had died – is based upon Solms-Laubach's interpretation of the reference to Reuwich as 'Herrn Bernharts meler (i.e. maler) und *snytzer*' as meaning 'painter and sculptor' rather than painter and *Formschneider*.[86]

¶ The dates of Erhard Reuwich's birth, departure from Utrecht, and the date and place of his death are as yet unknown. Solms postulated an apprenticeship around 1450, dated the group of prints which Glaser had assigned to the Hausbuchmeister's earliest period between 1460 and 1465, and placed the first contact with Germany before the end of 1460s. The unusually early beginning date was motivated in part by Solms's belief that two Housebook drawings based on engravings by Master E.S. (fol. 3a and 24b-25a) were both by Erhard Reuwich, and that they must date before the end of Master E.S.'s career (1467). It was also related to his acceptance of Baer's attribution to the printmaker of the so-called *Alphabet of Mary of Burgundy* (Paris, Rothschild Collection), a set of drawings no longer associated with the Master. Solms further believed that the drawing known as *Maximilian at Mass* [124], which Warburg had brought into connection with the peace treaty of 1488, reflected instead Tavernier's *Philip the Good at Mass*, dated 1457 (*Traité aesthétique*, Brussels). Because his chronology left no room for a protracted term of residence in Heidelberg during the 1480s, Solms explained the courtly content of many of the prints of that period in terms of widespread patronage of Reuwich's Mainz workshop by aristocratic clients living as far away as Heidelberg and Speyer. Since he wished to make as strong as possible a case for early and pervasive Netherlandish influence upon the Master, Solms downplayed the very genuine, if limited, influence of Martin Schongauer; and since he did not accept the Mainz *Marienleben* paintings [132], one of which bears the date 1505, he surmised that Erhard Reuwich must have died or retired by 1490 – a full fifteen to twenty years before the dates suggested by Glaser, Lehrs and others. His case for Reuwich, then, presented a number of difficulties, some of which were his own invention.

¶ Solms's theory ran into major difficulties of two kinds. Art historians found it difficult to follow the leap of faith involved in the attribution of a substantial number of monumental sculptures to an anonymous printmaker heretofore regarded as the epitome of painterly draftsmanship. Aside from this, Solms was flying in the face of scholarly politics. His assertion that the supposedly indelible impression left upon our artist by his south German *Heimat* had been a figment of scholarly imagination could scarcely have been made at a less opportune moment. In 1937 the 'Germanness' of German art as opposed to distorted or 'degenerate' modern art was destined to become an issue of particular importance with the opening in Munich of the Hall of German Art by Adolf Hitler himself and the purging of German museums of modern works considered 'degenerate.' The tribal mythology of the 1920s, therefore, was perpetuated by Wilhelm Pinder in his book on the *Dürerzeit* (1940), wherein it is stated simply that a joyous and humorous nature like that of the Hausbuchmeister best reflects the speech patterns of 'Rheinfranken' and the Pfalz.[87]

¶ From the spelling of the name Heinrich as 'Henrich' on the celebrated horse-blanket in the Housebook, Helmuth Bossert deduced that his Heinrich Lang, whom he identified as the creator of the earliest of the Housebook drawings, 'von Geburt ein Süd- oder Mitteldeutscher sein muss,' but regretfully reported that there were as yet no documents to be found which would locate Lang more precisely.[88]

¶ Erhard Reuwich found support initially only at the lower end of the Rhine, in two books written during the German occupation of the Netherlands. The eighty-year-old collector J.C.J. Bierens de Haan (1867-1951), a retired surgeon and highly honored hero of World War I, was the first to acknowledge the Reuwich thesis as a strong possibility. In his new catalogue of the prints (1947), the first since 1894 to reproduce successfully the delicacy of the Amsterdam drypoints, he revived the name 'Master of the Amsterdam Cabinet.'[89] Bierens de Haan, who had begun work on his manuscript in 1944, after having been evicted from his Amsterdam home by the army of occupation, was the first to publish a monograph on the Master in the Dutch language.

¶ D.P.R.A. Bouvy, also publishing in 1947, fully accepted the identification of Reuwich, the Hausbuchmeister, the Adalbert Master and the printmaker, integrating the Solms theory in its entirety into his doctoral dissertation on Dutch sculpture.[90] Dirck Bax, in his first book on the iconography of Hieronymus Bosch (1949), noted the influence of Reuwich's woodcuts of exotic animals from the *Peregrinationes*, and also called attention once again to the parallels between the Housebook *Planetenkinder*, Dutch blockbook illustrations and Bosch's work.[91] Boon later was to present material bearing on Erhard Reuwich's

youth in Utrecht, proposing an identification of the Master of the Tree of Jesse (Utrecht, Buurkerk) as Hillebrant van Rewijk, who may have been Erhard Reuwich's father, rather than his brother as was formerly supposed.[92] He also suggested that the manuscript miniatures traditionally attributed to the Master of Evert Soudenbalch may have been Erhard Reuwich's youthful work.

¶ Within Germany there had been no serious discussion of Solm's Reuwich theory. Max Lehrs was eighty years old and had lost his eyesight before Solms's article appeared[93]; thus, although he lived until 1938 and, drawing on the meticulous notes which he had assembled over the years, had continued to publish until 1934 with the aid of his daughter-in-law, Dora Lehrs, he refrained from comment. Solms's thesis received a brief notice in the final volume of Thieme-Becker (1950), where it was found unacceptable.[94] Strong partisans, however, began to appear in the later 1950s. Fedja Anzelewsky of the Berlin printroom was an especially eloquent spokesman in favor of the identification. He attributed further miniatures to the Reuwich/Hausbuch/Amsterdam Cabinet Master, and related the view on the background of the Dresden *Lamentation*, one of the panels accepted as autograph work of the Hausbuchmeister by Max Lehrs and others, to Erhard Reuwich's woodcut of Jerusalem for the *Peregrinationes*.[95] Lottlisa Behling demonstrated parallels between the style of the drypoints and that of the woodcut illustrations in Peter Schöffer's *Hortus sanitatis* (Mainz 1485) [141],[96] long attributed to Reuwich. Behling also attributed further glass paintings to Reuwich, whose activities as a painter and installer of stained glass are incontrovertibly documented [see 136].

ALBRECHT DÜRER'S STRASBOURG MASTER REDIVIVUS: WOLFGANG PEURER

¶ Two further theories of identity were presented by German scholars after World War II: Walter Hotz's interesting case for Nikolaus Nievergalt of Worms (see below) and V.M. Strocka's brief essay nominating Wolfgang Peurer (1970).[97] Peurer is named in Albrecht Dürer's handwriting on the drawing in Gdansk (*fig. 40*), dated 1484, on which Dürer's own early engraving *Large Courier* seems to be based (*fig. 41*). Noting briefly his own conviction that the Hausbuchmeister was German rather than Dutch, Strocka suggested the possibility that Peurer, the Hausbuchmeister, and Dürer's unnamed teacher in Strasbourg might be one and the same. The Peurer drawing does have an undeniable and long-recognized connection with the early Dürer. Unfortunately, it is too coarse for the artist who

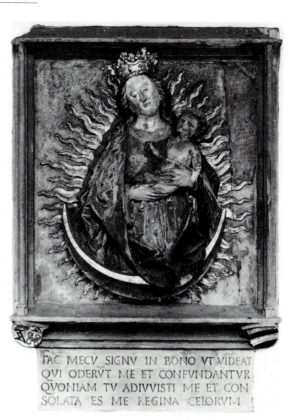

created the Amsterdam prints and the best of the Wolfegg Housebook. It does, however, have similarities with certain of the Erlangen drawings, that are sometimes attributed to the Master, most notably the *Seated archer* [129] and the *Sleeping man in a chair* [see also 129]. Walter Strauss has suggested the possibility that Master W B may prove to be Wolfgang Peurer, in view of the nearly interchangeable way in which the letters 'B' and 'P' were used in Dürer's day.[98] Master W B is known to have been active as a painter, engraver and creator of stained glass windows, most notably those of the Marienkirche in Hanau, dating from the late 1480s [see 113-16].[99]

NIKOLAUS NIEVERGALT OF WORMS

¶ An intriguing and richly-documented case for the Hausbuchmeister's identity as Nikolaus Nievergalt of Worms was presented in 1953 by a clergyman from Rheinheim, Walter Hotz, tucked away *Heimatkunst*-fashion in the regional journal, *Der Wormsgau*.[100] The Nievergalt identification was predicated upon a basically 'unitarian' view of the majority of the drawings in the Housebook — one endorsed by such important connoisseurs as Lehrs, Anzelewsky, Boon and the late Peter Halm, but disputed by most others. Hotz took into consideration the information given in a major section of the Housebook text — that which relates to munitions and military tactics — an aspect of the manuscript which the Reuwich thesis leaves largely unexplained. Hotz presented a great deal of previously unpublished material

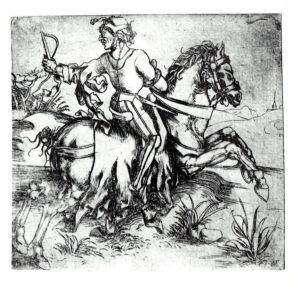

Fig. 40
Wolfgang Peurer, *Courier*.
Pen drawing with Dürer's
handwriting and the date
1484. Gdansk,
Stadtmuseum.

Fig. 41
Albrecht Dürer, *Large courier*,
ca. 1493-94. Engraving (B.
81). Vienna, Albertina.

from various archival sources in Speyer, Worms and Heidelberg relating to Nievergalt, who seems to have been a native of Speyer, born perhaps about 1445-50.

¶ As 'Clas Nyurgal von Spyr,' he was registered as a footsoldier in a detachment of infantry sent from Frankfurt to Kaiser Friedrich III's command in 1475; he was mustered out in May 1476 with serious wounds. It is therefore entirely possible, and even probable, that he took part in the campaign against Charles the Bold at Neuss (1475) that is pictured in the Housebook (fol. 53a-b). By 1483 Nievergalt had taken up residence in Worms, where he became a property-owner and a highly respected political figure, and where he was active as a painter – most notably of the murals of the Mint depicting the Siegfried saga, which were destroyed by the French in 1689. Nievergalt married a daughter of the Heidelberg mintmaster, which would have opened up opportunities for him to observe and experiment with intaglio techniques. He acquired as a brother-in-law the poet Johann von Soest, who is portrayed in an autograph colored drawing by the hand of the Amsterdam printmaker: the dedication miniature in Johann von Soest's *Die Kinder von Limburg*, showing the poet presenting his manuscript to the Pfalzgraf, Philip the Sincere [118].

¶ Nievergalt presents a number of advantages as a candidate. If not identical with the Master, he was almost certainly the Master's personal acquaintance through the connection with Johann von Soest. Nievergalt is also reported to have painted an altar (now lost) for the cathedral of Speyer in 1501. (The Housebook Master's altar, which is thought to have come from an unspecified church in Speyer [131] is generally thought to date from about 1475-80). Nievergalt's

major works have conveniently disappeared, and he has both humanistic and military connections. The only surviving work unquestionably by his hand is a woodcut dated 1505, showing the unpromising subject of a monstrous rabbit born with two bodies and a single head (*fig. 42*) which offers rather little to go on in the way of stylistic comparison. However, the bit of landscape in the background with its Schongauer-like woven fence is not unlike that depicted in the Housebook drawing of the *Halali* (fols. 22b-23a).

¶ Nievergalt's military experience very possibly may have placed him in close proximity to the author of the major portion of the Housebook text, who identifies himself as a *Büchsenmeister* (fol. 57a, munitions officer); however, it should be noted that service as a common infantryman by no means constitutes an automatic qualification for Nievergalt's creation of the quite sophisticated illustrations of military tactics and specialized equipment in the Housebook. The late dating of his major works (1492-93 for the Siegfried murals; 1501 for the Speyer commission), and the fact that he left minor children as survivors when he died in 1511 is difficult to reconcile with the image of the Amsterdam printmaker's career set forth by Glaser and Lehrs.

FURTHER GLASS PAINTINGS: REUWICH, NIEVERGALT AND/OR THE HOUSEBOOK MASTER

¶ While making his inconclusive case for Nievergalt,[101] Hotz also presented important new documents relating to the activity of Erhard Reuwich as a designer of stained glass, incontrovertibly proving Reuwich's responsibility for the design and installation of several glass paintings for the *Amtskellerei* in Amorbach [136]. Hotz also iden-

tified the glass acquired in 1939-40 by the Darmstadt Museum (formerly from Schloss Erbach) as being by the same hand.[102] Without illustrating the works in question, he declared them to be stylistically incompatible with the work of the Housebook Master, and argued that this eliminated Erhard Reuwich as a candidate for the authorship of the Amsterdam prints. Count Solms, however, soon afterward turned the selfsame glass paintings to Erhard Reuwich's advantage by publishing photographs of them and noting the similar treatment of faces, hair, hands and feet in Reuwich's St. Martin roundel [136] and the Amsterdam drypoint of the same subject [38]. He argued that the lack of an exact correspondence between the two works offered a positive argument for Reuwich's authorship of both.[103]

¶ In 1968 Rüdiger Becksmann published his discovery of an unusually large and handsome glass painting [135] showing a patrician tournament, identifying it as the work of the creator of the Housebook tournament drawings, and suggesting an identity of this hand with Nievergalt.[104] The glass painting has a Frankfurt provenance. As Becksmann noted, it represents a late fifteenth-century patrician (rather than knightly) tournament of the sort recorded in Bernhard Rohrbach's *Liber gestorum*, a chronicle of the Frankfurt patrician's company, 'Alt-Limpurg.' Becksmann's hypothesis is an attractive one; it should also be noted in this connection that Rohrbach's family has demonstrable ties with the Housebook Master's disciple, the monogrammist b x g, who engraved a plate depicting Bernhard Rohrbach's coat of arms together with that of his bride, Eilge Holzhausen, surmounted by the crown commemorating the Imperial privilege granted to Bernhard in 1470 [111: *Arms of the Rohrbach and Holzhausen families*].

THE HISTORICAL ERHARD REUWICH: REIMAR WALTER FUCHS

¶ A number of the difficulties surrounding Count Solms's identification of the Master with Erhard Reuwich arose from the additional and unconvincing attributions which he felt it necessary to make. Alfred Stange's monograph of 1958, which discounts the Reuwich thesis in favor of a traditional upper Rhenish *Heimat*, suffers from the same defect: the publication of two singularly unattractive Alsatian panels as the Master's supposed juvenilia.[105] In addition, Stange took an unusually restrictive view of the Wolfegg Housebook drawings and carefully avoided the issue of the Master's relationship to the arts of glass and woodcut design, which were Reuwich's proven areas of expertise.

¶ A definitive study of all known documents relating to Reuwich and his clients was included by Reimar Walter Fuchs in his doctoral dissertation on Mainz incunabula with woodcut illustrations, published in the same year as Stange's monograph (1958) in the scholarly journal of the bookdealer's trade.[106] The fact that Fuchs concluded his discussion of Reuwich by identifying him as the Hausbuchmeister is perhaps less important than his thorough and orderly reconstruction, from archival research of the activities of Reuwich, his employer, Bernhard von Breydenbach and the eighteen-year-old Count Johann zu Solms during the period of their mutual relationship. The remarkably small number and high quality of the illustrated books published in Mainz between 1480 and 1500 is emphasized, and the roles of Peter Schöffer, Bernhard von Breydenbach and Reuwich in the production of the *Peregrinationes* is clarified; since Reuwich had used Schöffer's printing equipment, as well as his type, it was Fuchs's opinion that Reuwich could no longer be considered the publisher of the book but that, in point of fact, Bernhard von Breydenbach must himself have been the publisher, since the financial responsibility was entirely his.[107] Fuchs endorses Uhlhorn's suggestion that Reuwich was the painter sent by Breydenbach to Count Solms's residence in Lich in February, three months before the beginning of the pilgrimage.[108] Breydenbach's correspondence with the young Count Ludwig of Hanau-Lichtenberg[109] and with the sixteen-year-old Count Philipp zu Solms-Lich,[110] who inherited title and lands upon the death of his brother Johann on the pilgrimage, are detailed. Breydenbach's close friendship with the new archbishop of Mainz, Berthold von Henneberg, and his position vis-à-vis the latter's program of reform for Mainz publishers are of particular interest,[111] as are Fuchs's extensive discussions of the Mainz herbals of 1484, 1485 and 1491, and the evidence for Breydenbach's authorship and Reuwich's role in the illustration of the 1485 *Gart der Gesundheit* [141].[112] Bernhard von Breydenbach's attendance at the election (Frankfurt) and at the coronation of Maximilian as King of the Romans in Aachen in 1491,[113] and his official position as canon in the church of St. Maria ad Gradus, the church for which the Housebook Master's *Marienleben* is believed to have been painted, must also be taken into consideration in regard to the possible identity of the Master with Erhard Reuwich.[114]

A PUDDING WITHOUT PROOF: THE STATE OF THE QUESTION, 1985

¶ An artist of such originality as the Housebook-Amsterdam Cabinet Master, in whom art histo-

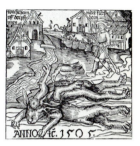

Fig. 42
Nikolaus Nievergalt of Worms, *Hasenmiszgeburt*. Woodcut, 1505. Worms, Stadtarchiv.

rians of an earlier day found a precursor of the 'modern' art of Chodowiecki, Böcklin and Hans Thoma,[115] seemed once to present the ideal test case for proving the superiority of each evolving art-historical method over the previous ones. So worldly an artist must surely have left tangible evidence of his existence. After nearly two centuries of detective work, and more than a dozen hypothetical identities, several missing persons of the fifteenth century have been located – Nikolaus Schit, Martin Caldenbach, Hans Hirtz and Nikolaus Nievergalt among them – but the creator of the Amsterdam prints remains nearly as enigmatic as ever.

THE PRINTMAKER

¶ Although the fragility of the drypoint technique and the limited number of surviving impressions suggest that the graphic work of the mysterious draftsman must have been available in the original to only a limited audience, yet he seems to have been a major force in shaping the taste of the late fifteenth century in an area extending from the Rhine valley to Nürnberg and beyond. His impact can be felt in such various media as painting, engraving, woodcut book illustration, manuscript illumination, embroidery and glass painting. The ideal of young manhood which he portrayed in the works of his 'court' style of the 1480s [see *Pair of lovers*, **75**] was still potent in Albrecht Dürer's youth, as the latter's self portraits of 1493 (Paris) and 1498 (Madrid) attest. How could so popular an artist have failed to leave identifying traces?

¶ A partial answer to this question lies in the fact that some of the artists whom he influenced most strongly – Israhel van Meckenem, Wenzel von Olmütz, Wilhelm Pleydenwurff and the youthful Dürer – were both prolific and highly visible themselves. In many cases the Master's influence must have been spread not by his own delicate example but by the faithful copies of his compositions engraved in longer-lasting copperplate by such 'reproductive' engravers as Israhel or Wenzel, or by the very similar style of the woodcut illustrations in such popular books as the *Schatzbehalter* or the *Nürnberg chronicle*.

¶ Many of the Master's plates, especially those dealing with the religious subjects, appear to have been executed in haste, and clearly were not intended for the open market. A number of the plates, which must have been made of a softer metal than copper – perhaps an alloy of lead, tin or zinc resembling pewter – were flawed with cracks, pits and scratches which show clearly in the surviving impressions. Misshapen haloes, uncorrected slips of the drypoint needle, impressions improperly inked or out of register, tiny flecks of color, pin pricks apparently made for purposes of transfer, linework damaged by excessive handling suggest that a number of them may have been intended from the beginning to serve as models for subsequent works of art, much in the manner of Gothic model books. The unique character of the Amsterdam collection, which resembles an artist's reference file or 'morgue,' would seem to support this conclusion. The secular works with courtly themes were consistently refined and polished, unlike the religious compositions, but these too were used as reference works by other artists [see **75**].

THE ILLUSTRATOR OF THE HOUSEBOOK

¶ The Wolfegg Housebook must have been exposed to an even more limited audience than the drypoints since, as a *Büchsenmeister*'s manual, it contains military information of the utmost sensitivity. The author of the technical text, clearly writing for the benefit of his successor – a trusted subordinate or perhaps a son – gives detailed and practical advice on a number of confidental matters, including the selection and management of personnel in such a way as to encourage loyalty and minimize opportunities for treason. Advising his pupil to 'keep God before your eyes' because of the constant danger involved in handling guns and powder, he advocates treating apprentices well and feeding them generously so that they will have no cause to develop a grudge against their master. He urges that the munitions officer should personally conduct any and all negotiations with the enemy, when besieged, and further offers practical advice for the deployment of both heavy artillery and archers, including the proper order of firing, both when on the attack and under siege. The medical portion of the manuscript, based on Avicenna, offers not only information on urology and hematology, but cautions the diagnostician not to reveal the results of his tests to the patient *in extremis*. The use of Hebrew letters for some of the key ingredients in the various medicines and household recipes, in the manner of a secret code; the exacting instructions for the minting of gold coins of various sizes; and, finally, the jubilant notation of a late sixteenth-century owner, Joachim Hof, that the manuscript is 'mine, all mine' vividly convey the impression that the codex was jealously guarded.

¶ The extent of the printmaker's responsibility for the illustrations in the various gatherings of the Housebook is an unresolved problem. Stylistic differences can indeed be seen, even within the two gatherings containing the best of the drawings: the small figures populating the scenes of tournament and hunt, bathhouse and pond house all bear a distinct family resemblance, unlike the

children of the planets, whose physiognomies are varied in accordance with the descriptions provided in the accompanying German verses. The flat, undivided floor surface used as a foil for the activities of Mercury's children reflects a prototype dating back to the beginning of the fifteenth century, as seen in a manuscript in Tübingen dating from 1405,[116] while the Saturn and Jupiter scenes are set in the formulaic landscapes of overlapping coulisses which typify the Berlin and Copenhagen blockbooks.[117] In *Mars*, *Sol* and *Luna*, the only three drawings universally accepted as the work of the printmaker, the landscape recedes more convincingly in a seamless transition from the foreground toward a lowered horizon. The beautiful water view in the Luna drawing, in fact, is so evocatively done that it has figured prominently in several of the attempts to identify the artist as a native of the area bordering the Bodensee (Lake Constance). In this regard, however, it should be noted that the presence of the obligatory watermill mentioned in the accompanying poem suggests that the body of water represented is not a lake but a river. In any case there is no reason to suppose that the landscape in this drawing need be related to the scenery of the artist's birthplace. As Curt Glaser convincingly demonstrated many years ago, the Master's earliest graphic works are precisely those in which landscape and architecture are almost entirely lacking.[118] The printmaker seems not to have employed landscape settings – with or without river views – until his middle and later years. One of the loveliest, *The Holy Family by the rosebush* [28], has been shown to consist entirely of elements representing Marian symbols from medieval hymns and litanies, in the manner of Jan van Eyck's Rolin Madonna.[119]

THE ORIGINS OF THE PRINTMAKER AS MINIATURIST

¶ The Master's major interest was the depiction of people. His sensitivity to individual differences is one of his most notable characteristics, and his lively sense of humor is another. The adjective most often used to describe him has been 'genial,' a quality formerly thought to have been unique to him in the art of his time. It is certainly true that his humor is more subtle and, to the modern mind, more genuinely funny than that of the Master E.S. or of Hieronymus Bosch, for whom humor and indecent exposure were frequently synonymous. However, now that more is known about fifteenth-century manuscript illumination and book production, and about carved misericordes and other so-called 'minor' arts, his humor proves to have had ample precedent. Examples which come to mind, in addition to the Tübingen *Planetenkinder*, are the miniatures and bas-de-page designs in the Hours of Catherine of Cleves (see *figs. 3, 4, 44*), notable for their atmosphere of gentle domesticity. More humorous yet – and stylistically even more similar – are the comic facial expressions and posturings in the richly illuminated manuscript of Frater Nicolas von Rohrbach's *Belial*, dated 1461, from Burg Trifels in the diocese of Speyer (*fig. 43*).[120]

¶ Theoretical grounding for the master's interest in human individuality is found in the north German rhymes which accompany the *Planetenkinder* in the Wolfegg Housebook and its blockbook predecessors. The texts of the poems describe the physiognomy appropriate to the 'children' of each planet, on the basis of the four 'elements' (earth, air, water, fire) governed by the planets. The descriptions cover not only complexion and temperament, but extend to the shape of face and body as well. Just as Chaucer characterized certain individuals as 'martian' or 'venereal,' the Housebook Master distinguished between the 'saturnine' and the 'jovial.' He did this not only in the planet drawings but also in such independent works as the Berlin silverpoint [121], showing a well-dressed young couple with the round and rosy faces associated with the fortunate children of Jupiter.

¶ The Berlin silverpoint represents a theoretical characterization. The Master found in the person of the Count Palatine, Philip the Sincere, a living embodiment of his ideal. Beginning in 1480 with the frontispiece for Johann von Soest's translation of *Die Kinder von Limburg* [118], he refined his image of fortunate youth still further. The Heidelberg manuscript provides a tangible and dated link with the art in which the Master was probably trained – the illumination of manuscripts. The exquisite Gospel book in the Cleveland Museum [119], which has a Coblenz provenance, attests that this was a profession which he continued to follow until his style had fully matured.

¶ It is possible that the Master's pioneering work in the drypoint technique, using innovative procedures and substandard printing equipment, may have been undertaken in the late 1460s and early 1470s as one of the many contemporary experiments directed toward the development of methods for 'customizing' books printed in moveable type. Reserved spaces in German incunabula were sometimes provided with handpainted miniatures and ornamental margins, evidently done to the customer's order.[121] As Ursula Petersen has shown,[122] such engravers as Master A G (probably identifiable as Anton Gerbel of Pforzheim) and his associate, Master W H, created canon pages and other material in copperplate, sometimes printed on parchment, for inclusion in the missals issued by the bishops of

Fig. 43
Belial, Speyer 1461, fol. Ib,
title page, and fol. 12a.
Munich, Bayerische
Staatsbibliothek, ms. cgm
48.

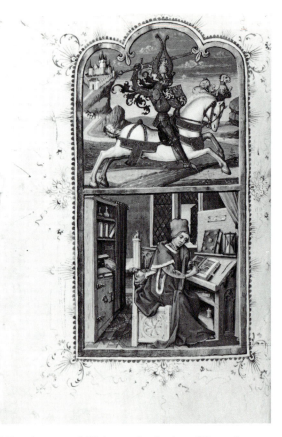

Fig. 43
Belial, Speyer 1461, fol. Ib,
title page, and fol. 12a.
Munich, Bayerische
Staatsbibliothek, ms. cgm
48.

Würzburg and Eichstätt in the late fifteenth century. The apogee of the customized printed book, of course, was to be reached in the early sixteenth century with the hand-ornamented prayerbook of Maximilian.

THE PAINTER

¶ Infrared reflectography, the latest technique brought to bear on the *Hausbuchmeisterfrage*, has now made it possible to reveal in part the under-drawing of a selection of the panel paintings which have been attributed to the printmaker by Friedländer and others. The results, presented for the first time in this exhibition, establish beyond a doubt the fact that the printmaker was active as a painter of panels as well as of miniatures. The surviving panels of his altar of the Passion have underdrawing in the printmaker's

characteristically vigorous hand, as do the *Nativity*, *Adoration of the Magi*, *Christ Among the Doctors* and portions of the *Pentecost* from the Mainz *Life of Mary* series [132]. This underdrawing goes far beyond the normal requirement for laying out a painting, and in certain areas, particularly in the depiction of faces and hands, it remains visible through the transparent glaze work as modeling shadow.

TIME AND AREA OF THE MASTER'S ACTIVITIES

¶ The Passion altar has a Speyer provenance, while the *Life of Mary* is thought to have been painted for the church of St. Maria ad Gradus in Mainz. This fourteenth-century parish church was used until its destruction during the French occupation at the turn of the nineteenth century as a ceremonial entrance to the cathedral, to which it

Fig. 44
The Hours of Catherine of Cleves, Utrecht, ca. 1440-45, fol. 32, margin illustration, two playing children: John the Baptist and Christ. New York, Pierpont Morgan Library.

had once been connected by an atrium in imitation of the corresponding structure at Old St. Peter's in Rome.[123] The painter-printmaker thus can be shown to have connections with Heidelberg, Speyer, Mainz and Coblenz. It is possible that he also visited Baden-Baden, for his depictions of the crucified Christ [14, 15] owe a debt to the sculpture of Nicolas Gerhardt. His own influence extends to Frankfurt as well, through the work of Master b x g [111].

The Master's panel paintings show strong Netherlandish influence of a type traceable to Cologne. The *Resurrection* and *Christ before Caiaphas* from the Speyer Altar are much influenced by two paintings from the Bouts workshop (*Resurrection, Arrest of Christ*, Munich, Alte Pinakothek) which in the late fifteenth century were in the church of St. Lorenz in Cologne. The Mainz series presupposes knowledge of the Columba Altar of Rogier van der Weyden, then in the Wasservass family chapel in St. Columba's in Cologne, as well as of the Boutsian work of the Lyversberg Passion Master and Master of the Life of Mary. These connections illustrate the comparative ease with which both artists and influences were transported from one city to another along the principal waterways of the Rhine, Main and Neckar in the fifteenth and early sixteenth centuries. Something of the richness of this cultural exchange is documented in the church of the Dominicans in Frankfurt, where, later, works by such prominent non-residents as Albrecht Dürer, Matthias Grünewald, Jörg Ratgeb and the elder Holbein were to be found. If Gertrud Rudloff-Hille's identification of the Gotha *Lovers* [133] is correct,[124] the Master also worked at least temporarily in Hanau for the young Graf Philipp of Hanau-Münzenberg (1449-1500).

Mainz and Reuwich

The Master's activity, then, is traceable today in the area of western Germany bordering on France, country which has repeatedly been devastated and plundered in time of war. The archiepiscopal city of Mainz, seat of the Primate of the Reich and once famed for its goldsmiths and jewellers, as well as for its three altars by Matthias Grünewald, was sacked by the Swedish army in the Thirty Years' War, and much of the booty lost in a shipwreck in the Baltic. Speyer and Heidelberg were devastated by the French first under Louis XIV, when the contents of the famous Palatine Library were removed, and later by the revolutionary forces. Further destruction in Mainz came about in Napoleonic times when the city was bombarded by German artillery in the attempt to recapture it from the French. The most serious damage of all was incurred in World War II. Thus, what has survived of our Master's work on panel almost surely represents only a portion of his total production.

It appears that the Mainz *Life of Mary*, planned and partially carried out by the Master, was not complete until 1505. That date is inscribed on the *Annunciation* panel, one of the compositions based on a drypoint [8] by the Master but painted by another hand. The series is thus later in date than the documented work of Erhard Reuwich, whose woodcut illustrations for Bernhard von Breydenbach's *Peregrinatio* and glass paintings for the *Amtskellerei* in Amorbach were completed in 1486.

A reconstruction of Reuwich's activities between 1483 and 1486 has been made by Fuchs. He regards it as nearly certain that Reuwich was the painter sent by Breydenbach to the residence of the young Count Johann zu Solms-Lich,[125] and he accepts the undocumented but stylistically secure identification of Reuwich as the illustrator of Breydenbach's *Gart der Gesundheit* (Mainz 1485), the first herbal to be published in the German language. Fuchs assumes that Reuwich lived in Mainz for several years prior to his documented involvement with Breydenbach on the grounds that Breydenbach and Count Solms would not have taken a complete stranger along on their tour of the Holy Land, whatever his talents. By virtue of his involvement with Breydenbach, who was a canon of St. Maria ad Gradus from at least 1486 until his death in 1497, Reuwich carries important credentials as a nominee for the Housebook/Amsterdam Cabinet Master. Moreover, we know from their art that both Reuwich and the anonymous Master were interested in exotic peoples, as well as in animal studies more or less after nature.

A grave difficulty is presented, however, by the fact that Reuwich's most striking characteristic as an artist is his consummate skill in the use of linear perspective, seen in the architectural views of the *Peregrinationes* – a skill which is never demonstrated in the drypoints nor in the panel paintings attributed to the printmaker. Furthermore, Reuwich's customary representation of groves of trees as rounded, shrublike, overlapping shapes, as seen in the panoramic view of Venice, has little in common with any of the tree work in the drypoints or in the Wolfegg Housebook. For the anonymous draftsman, trees like people came in all shapes and sizes. So far as he had a favorite form, it was one derived from Franco-Flemish manuscript illumination and used occasionally by Master E S (L. 155, 156) – a long, slender trunk with a crotch near the top, supporting a mass of leaves which are individually drawn and somewhat too large [see *Aristotle and Phyllis*, 54].

Reuwich's rhythmically spaced, elliptical trees are a direct prefiguration of the style of Albrecht Dürer, as seen both in his early woodcut work and in the backgrounds of such paintings of the 1490s as the *Portrait of Elspeth Tucher*. The same device is encountered in the famous *Swiss war* panorama of 1499, engraved by Master PW of Cologne (Nürnberg, Kupferstichkabinett).

DÜRER AND THE MASTER

¶ Evidence of Albrecht Dürer's acquaintance with the drypoints begins around 1490 in drawings like the *Holy Family* (Erlangen) and the Coburg *Elevation of St. Mary Magdalene* [50b], such early engravings as the *Offer of love* (M 77), the *Ravisher* [58e] the *Holy Family with a butterfly* [28a] and the early self portraits in Madrid and Paris. Even later works such as the *St. Eustace*, the famous watercolor of the *Wild hare* and the drypoint *Holy Family* of 1512 owe something to the precedent of the anonymous printmaker's pioneering interests in nature study, in humanity, and in technical experimentation. Dürer, however, quickly developed additional interests through his own travels in Italy as well as through his humanist friends in the Pirckheimer circle in Nürnberg, several of whom were productive scholars with Italian university degrees. With his knowledge of classical and modern Italian literature, and of the superior social status of Italian artists as revealed in his letters from Venice, Dürer acquired a Renaissance desire for worldly recognition which manifested itself in scrupulously signed and dated works, some of which he also inscribed with the name of his native city.

¶ The Master of the Housebook, of the Amsterdam prints and of the Passion Altar and Life of Mary paintings had been active in at least two university cities, Heidelberg and Mainz, and had evidently visited Cologne as well. As his portrait drawing of the Palatine court poet Johann von Soest attests [118], he too counted at least one humanist among his patrons. His predilection for themes of love, as well as his growing interest in river landscape settings have their literary parallels in the poetry of an even more important writer, Conrad Celtes, who visited Heidelberg in 1484 and 1490, and Mainz in 1491. Celtes, Poet Laureate to Kaiser Friedrich III (1487), was the founder of the *Sodalitas literaria Rhenana*, and the author of numerous works celebrating his own love affairs, the beauties of the river Rhine, and the city of Mainz as the birthplace of printing. Johannes Trithemius, author of an important treatise on St. Anne which is of interest in connection with the 'enlightened' view of the Holy Family espoused by the printmaker, was a member of Celtes' Rhenish literary solidality, as was Johann

von Dalberg, chancellor of Heidelberg University.[126]

¶ The printmaker's choice of the themes of *Solomon's idolatry* [7] and *Aristotle and Phyllis* [54] as pendants from among the many subjects catalogued by medieval writers and artists as illustrative of the power of women seems to betray knowledge not only of the contemporary south German carnival play *Ain spil von Maister Aristotiles*,[127] but of the current philosophical controversy between the so-called *via moderna* and the reactionary and neo-Thomist *via antiqua*, led by the Basel scholastic Johann Heynlin vom Stein, which had formed in resistance to it. At the university of Heidelberg, where several prominent Modernists, including the great Frisian humanist and critic of the *via antiqua*, Rudolf Agricola, served on the faculty (1483-85), the students were divided into two opposing factions which actually engaged in armed combat in the streets and taverns,[128] while theses were submitted on such topics as 'Whether a Thomist is the stupidest person in the world,' and 'Whether there is any difference between a realist and a chimera.'[129] During the fourteenth and fifteenth centuries St. Thomas Aquinas's theory of knowledge, which regarded man as a rational being in a world that can be understood by reason, had been successfully challenged in northern Europe by the opposing theory of the international Occamist movement (*via moderna*), which held that the way in which man knows the world (i.e. through experience) is not the way in which the world actually exists. The Master's pair of prints ridiculing two men revered in antiquity for their wisdom – the biblical philosopher-king Solomon and the Greek philosopher Aristotle, whose logic formed the theoretical basis for Thomas Aquinas's philosophical system, would have held particular appeal for a member of Agricola's circle at Heidelberg, for they vividly illustrate both the power of love and the dangers of uncritically following the examples of the ancients.

¶ The Master's religious work, prints as well as paintings, shows the influence of another type of opposition to Thomism, namely that of the *Devotio Moderna*, the movement begun in the Netherlands in the late fourteenth century and championed in the fifteenth century by Thomas à Kempis (d. 1471), author of the popular book *The Imitation of Christ*. Such prints as the *Bearing of the Cross* [13] and such paintings as the *Resurrection from the sealed tomb* and *Washing of the feet* [131d, e] illustrate themes from popular woodcuts and devotional books associated with this movement.[130] Rudolf Agricola was a follower of the Modern Devotion, as was Adolf of Nassau, the Archbishop of Mainz whose arms appear in the

Wolfegg Housebook (fol. 53 a-b).

¶ It is thus highly probable that the anonymous Master's access to and knowledge of a number of the leading humanists of Heidelberg and Mainz was an important factor in the development of his art. At the same time, however, it is evident from the assured way in which he depicted the pursuits of the nobility and ridiculed the social pretensions of the bourgeoisie that he worked in close association with one or more noble patrons, as well as for the highest ecclesiastical authorities in the case of the Mainz series. Such patronage could be expected to provide an artist with a still medieval form of security which made it unnecessary for him to advertise his name – a luxury which Albrecht Dürer never knew – but it meant that the name itself was lost at the death of the last of his patrons.

1. Renouvier mistook the inscription 'O vere tu...' on the pedestal beneath Solomon's idol on the print *Solomon's idolatry* [**7**] for a cryptic signature and proposed an identity for the printmaker with the goldsmith Gilliken van Overheet, whose name appears in a Burgundian register (Jules Renouvier, *Histoire de l'origine et des progrès de la gravure dans les Pays-Bas jusqu'à la fin du 15e siècle*, Brussels 1860, pp. 171-77).

2. On the Wolfegg Housebook, see Bossert and Storck 1912 and Waldburg-Wolfegg 1957. Ralf von Retberg's identification of the arms as those of the Goldast family of Konstanz has been discredited. (See Waldburg-Wolfegg 1957, pp. 39-40.) More recently Maria Lanckorońska has proposed an identification with the family of Siegmund von Ast, *Burgvogt* of the Schalksburg in Württemberg (Maria Lanckorońska, *Das mittelalterliche Hausbuch der fürstlich Waldburgschen Sammlung*, Darmstadt 1975).

3. See Filedt Kok 1983, p. 427 and J.W. Niemeijer, 'Baron van Leyden, founder of the Amsterdam print collection,' *Apollo* 117 (1983), pp. 461-68, especially p. 461.

4. C.H. von Heinecken, *Neue Nachrichten von Künstlern und Kunstsachen*, vol. 1, Dresden/Leipzig 1786, nrs. 24, 37, 289, 325; pp. 168, 362. On Heinecken, see further Christian Dittrich, 'Heinecken und Mariette,' *Jahrbuch der Staatlichen Kunstsammlungen Dresden* (1981), pp. 43-46.

5. C.H. von Heinecken, 'Beschreibung einer Reise nach Niedersachsen, Westphalen und Holland,' in *Nachrichten von Künstlern und Kunstsachen*, vol. 2, Leipzig 1769, p. 60. Niemeijer, op.cit. (note 3) p. 467, note 14.

6. As Niemeijer, ibid., note 15, has shown, there is reason to believe that the eighty prints and some other fifteenth-century engravings had been acquired *en bloc* by the baron, probably in the form of an album.

7. Adam Bartsch, *Le peintre-graveur*, 21 vols., vol. 6, Vienna 1803, p. 307; nr. 168 [**72**], and copies of [**75**] by Wenzel von Olmütz, Israhel van Meckenem and Master b x g; a sixteenth-century copy of [**13**] (Bartsch, vol. 6, p. 178, nr. 14; Bartsch, vol. 10, p. 4, nr. 8); a copy of [**89**] by Israhel.

8. Jean Duchesne aîné, *Voyage d'un iconophile*, Paris 1834, pp. 189, 241. See also pp. 77, 110, 222, 346, 363, 376.

9. Johann David Passavant, 'Zur Kunde der ältesten Kupferstecher und ihrer Werke,' *Deutsches Kunstblatt* 1 (1850), nr. 23, p. 181.

10. Johann David Passavant, *Le peintre-graveur*, 6 vols., vol. 2, Leipzig 1860, pp. 254-64.

11. H.A. Klinkhamer, 'Les estampes indécrites du Musée d'Amsterdam. Supplément au 10e vol. de Bartsch,' *Revue Universelle des Arts* 4 (1856), pp. 406-20.

12. G.F. Waagen, *Treasures of art in Great Britain*, 3 vols., London 1854, vol. 1, p. 291. In the *Solomon's idolatry* [**7**], however, he recognized a certain resemblance to the style of Martin Schongauer in the form of the hands, although the print itself was, 'in my opinion, of Netherlandish origin and about the year 1470.' The coats of arms he also thought to be Netherlandish, and about the year 1480, judging from the costume of the *Lady with owl and A.N in her escutcheon* [**86**].

13. G.F. Waagen, *Die vornehmste Kunstdenkmale in Wien*, vol. 2, Vienna 1867, pp. 258-59.

14. G.F. Waagen, *Über Hubert und Jan van Eyck*, Breslau 1822. On the cult of Jan van Eyck see also Friedrich Schlegel, 'Gemäldebeschreibungen aus Paris und den Niederlanden in den Jahren 1802 bis 1804,' in *Europa, eine Zeitschrift*, Frankfurt am Main 1803 (1805); Johanna Schopenhauer, *Johann van Eyck und seine Nachfolger*, 2 vols., Frankfurt 1822. (Hans-Wolfgang von Lohneysen, *Die ältere niederländische Malerei: Künstler und Kritiker*, Eisenach and Kassel 1956, pp. 189-254. Waagen's belief that Margaret, the sister of Jan and Hubert van Eyck, had been active as a miniaturist (cf. Waagen 1822), and that a third brother, Lambert, known only from documents, had taken an active role in the workshop (cf. Elizabeth Dhanens, *Hubert en Jan van Eyck*, Antwerp 1980, pp. 32, 36) made the possibilities for enrollment in the 'school' of van Eyck rather larger than are currently thought to have been the case.

15. C.D. Hassler, 'Bericht über eine Reise nach Wolfegg, 8. Juli 1854,' *Bericht über die Verhandlungen des Vereins für Kunst und Alterthum in Ulm und Oberschwaben*, Ulm 1855, p. 22.

16. Heinrich Heine, *Ludwig Börne: eine Denkschrift (1840)*, Düsseldorfer Ausgabe, vol. 11, Hamburg 1978, pp. 92, 568. ('Seit Jahren gelüstete mich mit eigenen Augen die theuern Blätter zu sehen, die uns [...] die Gedichte Walters von der Vogelweide, des grössten deutschen Lyrikers, aufbewahrt haben.' For this reference, and for much information regarding early nineteenth-century research utilizing German manuscripts, I am grateful to my colleague, Jost Hermand, Vilas Professor of German, University of Wisconsin-Madison). The *Manessische Handschrift* was to remain in Paris until 1888, when a Strasbourg book dealer obtained it in exchange for twenty-three Carolingian manuscripts (some of which, apparently, were stolen), and sold it to the Wilhelminian government for 400,000 marks as a four-hundredth anniversary gift for the university of Heidelberg. (Cf. *Brockhaus*, 'Manessische Handschrift.')

17. *Hausbuch*, fol. 31b: 'Pulchrum faciem;' 'Ein confect, ut mulier petat coitum;' 'Aliud pro viro et muliere;' 'Quod mulier sic probatur,' et al. Ingredients range from cooked egg yolks, nutmeg oil and chicken fat, to cloths soaked in menstrual blood and earth mixed with excrement, depending whether the mixture is to be taken internally, used as a poultice, or buried by the roadside at a place where a man has been murdered.

18. See further Waldburg-Wolfegg 1957, pp. 6 ff. and **117**. This type of manual originated in the fifteenth century, and normally contained information on such topics as fireworks, artillery, armored vehicles, heated bath-houses, wells, dredges and quartermaster supplies. The Wolfegg manuscript is unique in its combination of additional information on metallurgy, coinage and medical and domestic recipes.

19. Hassler, op.cit. (note 15).

20. For Hassler's biography, see *Allgemeine deutsche Biographie*, 'Konrad [sic] Dietrich Hassler.'

21. Ernst Foerster, *Denkmale deutscher Baukunst, Bilderei und Malerei*, 12 vols., vol. 3, Leipzig 1857, part 3, p. 14.

22. Ibid.

23. Ernst Georg Harzen, 'Über Bartholomaeus Zeitblom, Maler von Ulm, als Kupferstecher,' *Naumanns Archiv für die zeichnende Künste* 6 (1860), pp. 1-30, 97-124.

24. Wolf Stubbe, *Hundert Meisterzeichnungen aus der Hamburger Kunsthalle, 1500-1800*, Hamburg 1967, pp. 3-7. Harzen owned the best known impression of the *Tournament of wild men* [**53**], which he purchased in London in 1837 for £2.2s, as well as

the *Christ carrying the Cross* by Master b x g (L.3). See Lehrs, vol. 8 (1932).

25. Harzen, op.cit. (note 23), p. 14, note.

26. G.F. Waagen, *Handbuch der deutschen und niederländischen Malerschulen*, 2 vols., vol. 1, Stuttgart 1862, p. 184.

27. Ralf von Retberg, *Kulturgeschichtliche Briefe über ein mittelalterliches Hausbuch des 15. Jahrhunderts aus der fürstlich Waldburg-Wolfeggischen Sammlung*, Leipzig 1865, vol. 8, p. 53.

28. Karl Schnaase, *Geschichte der bildenden Künste*, 10 vols., vol. 8, Stuttgart 1879, pp. 423-24.

29. Moriz Thausing, *Dürer, Geschichte seines Lebens und seiner Kunst*, 2nd ed., 2 vols., Leipzig 1884 (1st ed. in English, 1882). See also J.W. Kaiser, *Curiosités du Musée d'Amsterdam*, vol. 1, *Facsimilés d'estampes de maîtres inconnus du 15e siècle*, Utrecht etc. 1856; G. Duplessis, *Histoire de la gravure en Italie, en Espagne, en Allemagne, dans les Pays-Bas, en Angleterre et en France*, Paris 1880, pp. 157-58; W.H. Willshire, *A descriptive catalogue of early prints in the British Museum*, 2 vols., vol. 2, London 1883, pp. 291-99; Eugène Dutuit, *Manuel de l'amateur d'estampes*, 5 vols., vol. 3, Paris 1882, pp. 132-34.

30. Alfred Woltmann and Karl Woermann, *Geschichte der Malerei*, 4 vols., vol. 3, Leipzig 1882, pp. 102ff.

31. Retberg, op.cit. (note 27), pp. 280-93. For Retberg's biography, see *Allgemeine deutsche Biographie*.

32. *Ein mittelalterliches Hausbuch: Bilderhandschrift des 15. Jahrhunderts mit vollständigem Text und faksimilierten Abbildungen*, herausgegeben vom Germanischen Museum, Leipzig 1866; second edition, with introduction by A. Essenwein, Frankfurt am Main 1887.

33. See Udo Kultermann, *Geschichte der Kunstgeschichte*, Vienna and Düsseldorf 1966, chap. 13, 'Der Dresdner Holbeinstreit,' pp. 251-62, with complete bibliography of the Holbein controversy, pp. 455-56, note 1.

34. Wilhelm Lübke, *Altes und Neues: Studien und Kritiken*, 1891, pp. 136-53. See also Carl von Lützow, *Geschichte des deutschen Kupferstiches und Holzschnittes* (*Geschichte der deutschen Kunst*, vol. 4), Berlin 1891, pp. 26-27; Woltmann and Woermann (1882), op.cit. (note 30); Adolf Bayersdorfer, *Katalog der in der königliche Galerie zu Schleissheim ausgestellten Gemälde*, 1885, p. 15, nr. 165; Wilhelm von Bode, *Bilderlese aus kleinen Gemäldesammlungen: Die Grossherzogliche Gemälde-Galerie zu Oldenburg*, Vienna 1888, p. 79.

35. Friedrich Lippmann, 'Über einen deutschen Stecher des 15. Jahrhunderts, den sogenannten Meister des Amsterdamer Kabinetts,' *Kunstchronik* 5 (1891), pp. 292-94; and *Sitzungsberichte der Berliner Kunstgeschichtlichen Gesellschaft* (1884), p. 26.

36. Aby Warburg in *Gesammelte Schriften*, 2 vols., vol. 2, Leipzig and Berlin 1932, p. 179. See also Fritz Saxl, 'The literary sources of the Finiguerra planets,' *Journal of the Warburg Institute* 2 (1938-39), pp. 72-74.

37. 'Historicus,' 'Hans Holbein der Ältere und die "Meister des Amsterdamer Kabinetts,"' *Kunstchronik* 5 (1894), pp. 313-16.

38. Hans Wolfgang Singer, 'Rezension von Lippmann, *Der Kupferstich*,' *Repertorium für Kunstwissenschaft* 17 (1894), pp. 165-68, especially p. 166.

39. Moriz Thausing, *Dürer, Geschichte seines Lebens und seiner Kunst*, Leipzig 1876, p. 23.

40. Robert Vischer, 'Albrecht Dürer und die Grundlagen seiner Kunst,' *Studien zur Kunstgeschichte*, Stuttgart 1886, pp. 174,415.

41. Germanisches Nationalmuseum, *Quellen zur Geschichte der Feuerwaffen*, Nürnberg 1872, cf. plates 61-63.

42. F.A. von Lehner, *Verzeichnis des Gemälde des fürstlich Hohenzollernschen Museums zu Sigmaringen*, 2nd ed., 1883.

43. Bayersdorfer, op.cit. (note 34), p. 15, nr. 165; Ludwig Scheibler, 'Schongauer und der Meister des Bartholomäus,' *Repertorium für Kunstwissenschaft* 7 (1884), pp. 31-68, especially p. 49, note 15.

44. Friedrich Niedermayer, 'Matthias Grünewald,' *Repertorium für Kunstwissenschaft* 7 (1884), pp. 245-66, especially p. 265.

45. Max J. Friedländer, 'Zum Meister des Amsterdamer Cabinets,' *Repertorium für Kunstwissenschaft* 17 (1894), pp. 270-73.

46. Max Lehrs, *Katalog der im Germanischen Museum befindlichen deutschen Kupferstiche des XV. Jahrhunderts*, Nürnberg 1887; 'Der deutsche und niederländische Kupferstich des fünfzehnten Jahrhunderts in den kleineren Sammlungen: Schloss Wolf-

egg,' *Repertorium für Kunstwissenschaft* 11 (1888), pp. 47-65, especially pp. 49-54; 'Amsterdam,' ibid. 15 (1892), pp. 110 ff.

47. Lehrs (1887) and (1888), loc.cit. (note 46).

48. Max Lehrs, *Der Meister des Amsterdamer Kabinetts*, Berlin (Internationale Chalkographische Gesellschaft) 1893, 1894 (cited as Lehrs 1893).

49. See Werner Schmidt, 'The prints and drawings cabinet,' in exhib. cat. *Splendor of Dresden*, New York 1978, p. 245, for Lehr's acquisitions of Toulouse-Lautrec.

50. Carl Hachmeister, *Der Meister des Amsterdamer Kabinetts und sein Verhältnis zu Albrecht Dürer* (Heidelberg dissertation), Berlin 1897, passim. (Future doctoral dissertations were to include those of Curt von Faber du Faur, Giessen 1921; Johannes Dürkopp, Halle 1931; Jane Campbell Hutchison, Wisconsin 1964 and Ulrike Frommberger-Weber, Heidelberg 1971, all of whom refrained from inaugurating new identities, preferring to gather evidence for or against candidates already placed in nomination by senior scholars, or to examine specialized aspects of the Master's oeuvre).

51. Henri Thode, *Die Malerschule von Nürnberg im 14. und 15. Jahrhundert in ihrer Entwicklung bis auf Dürer*, Frankfurt am Main 1891.

52. Hachmeister, op.cit. (note 50), pp. 38ff..

53. Max J. Friedländer, 'Rezension von Hachmeister, *Der Meister des Amsterdamer Kabinetts und sein Verhältnis zu Albrecht Dürer*,' *Zeitschrift für bildenden Kunst* N.F. 9 (1898), pp. 246-47.

54. Eduard Flechsig, 'Der Meister des Hausbuches als Maler,' *Zeitschrift für bildenden Kunst* 8 (1897), pp. 8-17, 66-73.

55. Max Lehrs, 'Bilder und Zeichnungen vom Meister des Hausbuches,' *Jahrbuch der königlich preussischen Kunstsammlungen* 20 (1899), pp. 173-82.

56. Henry Thode, 'Die Malerei am Mittelrhein im XV. Jahrhundert und der Meister der Darmstädter Passionsszenen,' *Jahrbuch der königlich preussischen Kunstsammlungen* 21 (1900), pp. 113-35.

57. Ibid., pp. 128-29 and passim.

58. See Kultermann, op.cit. (note 33), pp. 240-42, quoting Wickhoff's characterization of Thode as 'der priviligierte Entdecker, der die Welt seit langem mit falschen Dürers, Mantegnas, Correggios, etc. überschwemmt, [...] Der einen ganzen Band mit Bildern Dürers herausgegeben, von denen jedes von anderer Hand ist, von Rheinländern, Vlämen, Italienern. [...] Alle malenden Nationen sind dabei vertreten, nur ein Spanier und ein Chinese fehlen bis jetzt noch.' Wickhoff greeted one correct attribution of Thode's with the comment 'Beruhige dich, strenger Leser, zuweilen findet auch ein blindes Huhn ein Körnchen, tritt nur ein in den Chor vor Santo Spirito.' See also Max Liebermann, 'Der Fall Thode,' *Frankfurter Zeitung* (1905), reprinted in Max Liebermann, *Die Phantasie in der Malerei: Reden und Schriften*, Frankfurt am Main 1978 and Berlin (DDR) 1983, pp. 159-63.

59. Cf. Hans Rupprich, *Dürers schriftlicher Nachlass*, vol. 1, Berlin 1956, pp. 69, 73.

60. Eduard Flechsig, in *Die Baudenkmale in der Pfalz*, IIA, 1898, pp. 127-30. Nikolaus Schit was the painter of the Gelnhausen Altar (signed). See Stange, vol. 7, plates 266-67.

61. Baer 1903; Mela Escherich, 'Zur Martin-Hess-Frage,' *Repertorium für Kunstwissenschaft* 32 (1909), pp. 67-68; Carl Gebhardt, 'Martin Hess,' *Repertorium für Kunstwissenschaft* 31 (1908), pp. 437-45. On Martin Caldenbach (called Hess), see Thieme-Becker.

62. Leo Baer, 'Weitere Beiträge zur Chronologie und Lokalisierung der Werke des Hausbuchmeisters,' *Monatshefte für Kunstwissenschaft* 3 (1910), pp. 408-24.

63. (Eduard Flechsig), 'Eine Rundfrage: ex ungue leonem,' *Cicerone* 2 (1910), pp. 71-74, 190-94.

64. Glaser 1910, pp. 145-56. For Glaser's biography, see exhib. cat. *Max Beckmann (1884-1958), Gemälde, Zeichnungen, Graphik*, Berlin (DDR) 1984, p. 13. I am grateful to Glaubrecht Friedrich for his reference.

65. Solms-Laubach 1935-36, pp. 13-96.

66. Stange 1958.

67. Baer 1903, pp. 153 ff.

68. On Neumann see Jan Emmens, *Rembrandt en de regels van de kunst* (dissertation Utrecht 1964), Amsterdam 1979.

69. Cf. Kultermann, op.cit. (note 33), pp. 263 ff., chap. 14: 'Die Kunstanschauung des Impressionismus.'

90. Curt Glaser, *Die altdeutsche Malerei*, Munich 1924. In view of his concern for the Germanic purity of fifteenth-century art, it is sadly ironic that Glaser, who had served his country as a medical corpsman in World War I, was forced in 1933 to emigrate because of his Jewish ancestry. He died in New York in 1943 (see note 64 above).

91. See Gerhard Kratsch, *Kunstwart und Dürerbund: ein Beitrag zur Geschichte der Gebildeten im Zeitalter des Imperialismus*, Göttingen 1969, pp. 463-66. On *Heimatkunst* see Richard Hamann and Jost Hermand, *Stilkunst um 1900*, Berlin 1967, pp. 364-94.

92. Helmuth Bossert, 'Heinrich Lang und der Hausbuchmeister,' *Schau-ins-Land* 27 (1910), pp. 102-19.

93. Stange 1958, p. 7.

94. Johannes Dürkopp, 'Der Meister des Hausbuches,' *Oberrheinische Kunst* 4 (1932), pp. 83-159; Helmuth Bossert, 'Heinrich Lang und der Hausbuchmeister,' *Schau-ins-Land* 64 (1937).

95. Hans Weiszäcker, 'Die Heimat des Hausbuchmeisters,' *Jahrbuch der königlich preussischen Kunstsammlungen* 33 (1915), pp. 79-104; and 'Bodensee und Hausbuchmeister,' *Jahrbuch für Kunstwissenschaft* (1924-25), pp. 290-98.

96. Stange 1958; Stange, vol. 7.

97. A. Stange, 'Kunstwissenschaft,' in *Deutsche Wissenschaft, Arbeit und Aufgabe*, Leipzig 1939. See Kultermann, op.cit. (note 33), p. 372.

98. Lehrs, vol. 8.

99. I am grateful to Werner Schmidt of the Dresden Kupferstichkabinett for his information.

100. Lehrs, vol. 8, p. 70; he characterized the literature as 'das ohnehin fast bis zum Sinken überladene Hypothesenschifflein.'

101. Lehrs, vol. 8, p. 51.

102. Adrian Pit, 'La gravure dans les Pays-Bas au XVe siècle,' *Revue de l'art chrétien* 34 (1891), pp. 494, 497.

103. Solms-Laubach 1935-36.

104. Friedrich Uhlhorn, 'Zur Geschichte der Breydenbachsen Pilgerfahrt,' *Gutenberg-Jahrbuch* 1934, pp. 107-11.

105. Ernst Buchner, 'Studien zur mittelrheinischen Malerei und Graphik der Spätgotik,' *Münchner Jahrbuch* N.F. 4, (1927), pp. 284-313 (Meister der Coburger Rundblätter, Nikolaus Schit); Lilli Fischler, in *Oberrheinische Kunst* 4 (1933), pp. 41 ff.; Otto Fischer, 'Der Meister von Walderbach i.E.,' *Zeitschrift für Kunstgeschichte* 2 (1933), pp. 41 ff.; Lilli Fischler, *Die Karlsruher Passion und ihr Meister*, Karlsruhe 1952.

106. Rödelheimer Renterei Rechnung 1483-84. Graf zu Solms-Rödelheimisches Archiv, Assenheim.

107. Wilhelm Pinder, *Die Kunst der Dürerzeit*, Leipzig 1940, p. 144.

108. Bossert, op.cit. (note 74), pp. 10-11.

109. Johan Catherinus Justus Bierens de Haan, *De Meester van het Amsterdamsch Kabinet*, Amsterdam 1947. For a biography of Dr. Bierens de Haan, whose print collection was left to the Boymans Museum, see *Bulletin Museum Boymans* 3 (1952), nr. 2, July.

110. D.P.R.A. Bouvy, *Middeleeuwsche beeldhouwkunst in de Noordelijke Nederlanden*, Amsterdam 1947, pp. 76-80.

111. Dirk Bax, *De ontcijfering van Jeroen Bosch*, The Hague 1949, p. 251, note 157; pp. 239-43: 'Bosch en Erhard Reuwich.'

112. Karel G. Boon, 'Een Utrechtse schilder uit de 15e eeuw, de Meester van de Boom van Jesse in de Buurkerk,' *Oud-Holland* 76 (1961), pp. 51-60.

113. For information about Lehr's last year I am grateful to Werner Schmidt. Lehr's original notes are still preserved in the Dresden Kupferstichkabinett.

114. Ulrich Thieme and Felix Becker, *Allgemeines Lexikon der bildenden Künstler*, vol. 37 (1950), pp. 139-42.

115. Anzelewsky 1958, pp. 30-34 and Fedja Anzelewsky 'Der Hausbuchmeister,' *Zeitschrift für Kunstgeschichte* 24 (1961), pp. 86 ff.

116. Lottlisa Behling, 'Der Hausbuchmeister, Erhard Reuwich,' *Zeitschrift für Kunstwissenschaft* 5 (1951), pp. 179-90; *Die Pflanze in der mittelalterlichen Tafelmalerei*, Weimar 1957.

117. Volker Michael Strocka, 'Albrecht Dürer und Wolfgang Peurer,' in *Argo: Festschrift für Kurt Badt zu seinem 80. Geburtstag am 3. März 1970*, Martin Grosebruch and Lorenz Dittmann, eds., Cologne 1970, pp. 249-60.

118. Walter Strauss, verbally, February 1978.

119. For Master W B, see Alan Shestack, *Master LCz and Master W B*, New York 1971, especially pp. 72-80, 85.

100. Walter Hotz, 'Der 'Hausbuchmeister' Nikolaus Nievergalt und sein Kreis,' *Der Wormsgau* 3 (1953), pp. 97-125; and 6 (1956), pp. 306-16. Nievergalt's name had first entered the literature in 1916, in an article by W.K. Zulch on Martin (Caldenbach) Hess: W.K. Zulch, 'Martin Caldenbach gen. Hess, und Nikolaus Nyfergalt, zwei mittelrheinische Maler,' *Repertorium für Kunstwissenschaft* 38 (1916), p. 158. See further 'Nyfergalt' in Thieme-Becker (1931) and complete literature in Hotz, note 16.

101. Alfred Stange, for example, at first embraced Nievergalt with enthusiasm, as his congratulatory letter to Hotz shows. W. Hotz, 'Nikolaus Nievergalt von Worms in der spätgotischen Malerei: neue Beiträge zur Hausbuchmeisterfrage,' *Der Wormsgau* 6 (1956), pp. 306-16, p. 307, note 20. The letter is dated January 3, 1954: '[...] Ich glaube, man darf Ihnen gratulieren und den Namen Nievergalt zu mindesten als den wahrscheinlichsten akzeptieren.' A year later, in *Deutsche Malerei der Gotik*, vol. 8 (1955) he rejected the Nievergalt theory, as he also did in the 1958 monograph.

102. Hotz, op.cit. (noot 100), especially p. 118.

103. Ernstotto, Graf zu Solms-Laubach, 'Nachtrag zu Erhard Reuwich,' *Zeitschrift für Kunstwissenschaft* 10 (1956), pp. 187 ff.

104. Becksmann 1968, note 13.

105. Stange 1958, p. 59.

106. Fuchs 1958.

107. Ibid., p. 1177.

108. Ibid., p. 1165.

109. Ibid., p. 1168.

110. Ibid., p. 1169.

111. Ibid., pp. 1170-71.

112. Ibid., pp. 1199 ff. See further Behling 1951, op.cit. (note 96), pp. 179-90. The anonymous illustrator of the *Hortus sanitatis* is mentioned in the foreword as an artist who had gone on a pilgrimage to the Holy Sepulchre in the company of a dignitary from Mainz.

113. Ibid., p. 1171.

114. Ibid., p. 1163. State of question.

115. Bossert and Storck 1912, p. 38.

116. See Heinz Artur Strauss, *Der astrologische Gedanke in der deutschen Vergangenheit*, Oldenburg etc. 1926, fig. 26; Erwin Panofsky and Fritz Saxl, *Dürers Melencolia I: Eine Quellen- und Typengeschichtliche Untersuchung*, Leipzig 1923, Anhang V, pp. 121 ff.: 'Die Entwicklung der Planetenkinder Darstellung;' Guy de Tervarent, 'Astrological conceptions in Renaissance art,' *Gazette des Beaux-Arts* (1946), pp. 233-48.

117. On the block books see M.J. Schretlen, 'Blokbogen "De Syv Planeter,"' *Kunstmuseets Aarskrift* 16-18 (1929-31), pp. 1-15; see also [117]; E. Hoffmann-Krayer and Hans Bächtold-Stäubli, *Handwörterbuch des deutschen Aberglaubens*, Berlin and Leipzig 1935-36, vol. 7, pp. 278 ff.: 'Planeten.'

118. Glaser 1910, p. 146.

119. Hutchison 1976, pp. 109-10.

120. Munich, Bayerische Staatsbibliothek, ms. cgm 48.

121. The Rijksmuseum Meermanno-Westreenianum in The Hague owns a hand-illuminated copy of Peter Schöffer's 1468 edition of Justinian's *Institutiones cum glossa* (RMW 39 A 3) produced in Mainz, as well as a copy of Bernhard Richel's 1474-75 edition of Alphonsus de Spina's *Fortaliteum fidei* (RMW 1 A 11), which features both hand-illuminated initials and woodcut illustrations.

122. Ursula Petersen, *Meister A G* (dissertation Freiburg im Breisgau 1953).

123. See Rudolf Vierengel, 'Ad gradus Beatae Mariae Virginis,' *Mainzer Zeitschrift* 60-61 (1965-66), p. 89; Hutchison 1976, pp. 96-113.

124. Gertrud Rudloff-Hille, 'Das Doppelbildnis eines Liebespaares unter dem Hanauischen Wappen in Gotha,' *Bildende Kunst* (1968), pp. 19-23.

125. Fuchs 1958, p. 1165.

126. On the university of Heidelberg, and on Celtes's *Sodalitas Rhenana*, see Richard Benz, *Heidelberg: Schicksal und Geist*, Konstanz 1961, pp. 76-79; Gerhard Ritter, *Studien zur Spätscholastik*, vol. 2: *Via Antiqua und Via Moderna auf den deutschen Universitäten des XV. Jahrhunderts*, Heidelberg 1922; Karl Morneweg, *Johann von Dalberg, ein deutsche Humanist und Bischof*, Heidelberg 1887; Franz von Bezold, *Rudolf Agricola*, Munich 1884.

127. Hutchison 1966.
128. Willy Andreas, *Deutschland vor der Reformation*, Stuttgart and
 Berlin 1932, p. 51.
129. Ibid.

130. See *Geert Grote en de Moderne Devotie*, exhib. cat. Utrecht
 (Rijksmuseum Het Catharijneconvent) 1984, passim, and
 Cornelis Los, *Van Geert Grote tot Erasmus*, Zeist 1983, especially
 pp. 93-97, 'Rudolf Agricola.'

CHIVALRY AND
THE HOUSEBOOK MASTER
(MASTER OF THE AMSTERDAM CABINET)*

Keith P.F. Moxey

¶ As one of the most important artists to work in the medium of engraving before Albrecht Dürer, the Housebook Master or the Master of the Amsterdam Cabinet (hereafter referred to simply as the Master), has received considerable scholarly attention.[1] The literature to date, however, has concerned itself above all with the question of the artist's identity. Scholarly writing on this subject may fairly be described as having been obsessed with the need to find a historical personality with which to associate the surviving works of art – a distinctly modern concern, projecting into the past a view of the work of art as product of an intensely personal process of introspection. The consequence has been that the cultural and social significance of the Master's work has been largely ignored. While I agree that it is hardly possible to study a past culture without in some way projecting our own values into it, I feel that the awareness of this process can enable us to capture dimensions of the artistic significance of those works that have hitherto been ignored.[2]

¶ In view of the importance that has been ascribed to the problem of the Master's identity, it is perhaps inevitable that the character of his art should also have been described in terms of biographical metaphors. The artist has been above all characterized as an 'observer,' as an artistic personality dedicated to the study and representation of the real world. Such was his commitment to observation, the argument goes, that his art is marked by a naturalism that is radical in its intensity. This view is perhaps most forcefully stated in Alfred Stange's monograph of 1958: 'He must have looked about him with insatiable eyes. Far more than Schongauer, he regarded the first task of the artist to be the experience of life and the knowledge of humanity and he observed both life and things most freshly and naturally.'[3]

¶ According to Stange the Master was no ordinary observer but an artist who infused his observation with the power of his own emotions. This creative intensity is said to account for the unfinished quality of his work, in which the roughness of the preliminary sketch was preserved in the finished engraving: '...but when we see that he took pains to use two, three and even four strokes to capture a form – one stroke was not enough for him; he thought several were necessary to give form to the inexpressible – then he lets us look over his shoulder a little. We sense the beat of his pulse, the tension of his hand, we feel the waves of emotion that flowed through him in the course of his work and we can clearly trace how he fought his way through to completion.'[4]

¶ The Master thus emerges as an artist whose commitment to the process of observation was so intense that it permitted him to create dramatically naturalistic works that broke with the artistic conventions of his day. This essay will examine the aptness as well as the fullness of the picture just described. In a discussion of some of the Master's secular subjects, scenes representing courtly life as well as a series of heraldic shields, we will ask whether they offer us a vision of the world of nature and society or whether they represent new formulations of traditional or conventional artistic subjects. While sharing Stange's admiration for the remarkable qualities of the Master's pictorial vocabulary we will ask whether their power lies in the direct observation of the world or in an imaginative recasting of themes that were familiar to the society of which he was a part. Insofar as the Master's work can be shown to fall into pre-established iconographic categories we will attempt to understand their function within the cultural and social dynamics of his time. In other words, we will attempt to understand the significance of the Master's art within the context of the society of his day by showing the way in which its values intersected with those of the audience at which it was directed.

¶ The drypoint engraving known as *Pair of lovers* [75; *fig. 45*] is one of the most appealing compo-

sitions of fifteenth-century printmaking, one whose mood of tender feeling endows it with an intense charm. The young couple are apparently overcome by their emotion for one another, yet are shyly unsure of the way in which it should be expressed. The sensitivity with which their feelings have been characterized, the hesitancy of their actions and the mood of thoughtful reverie with which the artist has endowed them, move us and serve to account for the high aesthetic value this work has always been accorded. Yet, I suggest, it is the very immediacy with which we seem to grasp the print's subject, its apparent accessibility, that is responsible for our failure to come to terms with its significance for the period in which it was produced.

¶ Before attempting to suggest the pictorial conventions with which this image may be associated, it is necessary to review briefly previous suggestions of this kind. The carnations in the

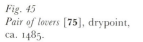

Fig. 45
Pair of lovers [**75**], drypoint, ca. 1485.

pot to the woman's left have been interpreted as a symbolic reference to the couple's engagement.[5] The use of the carnation among the varieties of flowers carried by engaged or married couples in German portraits of the fifteenth century, however, is insufficient to establish it as an unequivocal nuptial symbol. In fact, virtually any flower could symbolize marital intentions or the married state.[6] Moreover, because of its German name – *Nelke* or 'little nail' – the carnation was also used in portraits as a symbolic reference to the Passion, that is, to the nails that pierced Christ's hands and feet at the Crucifixion.[7] In such cases the flower served as a means whereby the sitters could affirm their concern for the life to come, their faith in Christ's sacrifice as the means of salvation, at the very moment when his or her worldly status and material circumstances were being recorded in paint. While the appropriateness of the carnation in portraiture is evident, the Master's print is not a portrait. As a consequence it is perhaps best not to ascribe specific meaning to the carnations in this composition. Like other elements in this work that are still to be discussed, the flowers may simply have been intended to refer to the world of nature as an appropriate setting for an amorous conversation.

¶ The jug of wine resting in the wine cooler, which is ignored by the couple, has also been viewed as a comment on the virtuous nature of their love.[8] It has been suggested that the lidded jug is a reference to unconsummated love and thus a symbol of the couple's chastity. Whether or not the closed jug has this meaning in this context, the presence of wine is a commonplace of the iconography of love. It is frequently included in representations of the love garden theme, as may be seen in *The large love garden* by the Master of the Love Gardens (*fig. 46*).[9] It is further possible that the trellis-like arch in which the lovers sit, with its improbable foliage, may be meant to suggest a garden setting for the scene.

¶ The small dog held in the woman's lap has been interpreted as a symbol of fidelity[10] emphasizing the mood of communion and trust that characterizes the attitude of the lovers. Dogs, to be sure, are frequently used as a symbol of fidelity in medieval portraiture. However, they are also frequent companions of the elegant couples that inhabit the world of love garden iconography, where they appear to possess no such significance. Since the Master's print has little to do with the visual traditions of portraiture but much to do with the expression of an ideal of love, it would seem unwarranted to assume that the dog in the print should be identified as a symbolic reference to the idea of fidelity.

¶ The seated or standing couple occurs on French

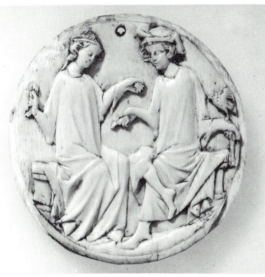

fourteenth-century ivory carving, as may be seen on a mirror back now in the British Museum (*fig. 47*).[11] The couple, who are seated on a bench, turn towards each other with hands raised in a gesture that implies communication if not conversation. More important than the compositional similarities with the Master's print, however, are the cultural values with which the ivory was associated. The seated lovers on the mirror back belong to a select group of themes that were repeatedly chosen for representation on objects of this type. Such themes include lovers meeting, exchanging garlands, hunting, playing chess and paying homage to the god of love. In addition we find tournament scenes, allegories such as the storming of the castle of love and occasionally illustrations of well-known scenes from chivalric romances. As Koechlin established, however, the vast majority of these subjects are not illustrations of specific texts but rather scenes that were meant to call to mind the general character of chivalric fiction

Fig. 46
Master of the Gardens of Love, *The large love garden*, engraving (L. 21), ca. 1450. Berlin-Dahlem, Staatliche Museen, Kupferstich-kabinett.

Fig. 47
Anonymous, French, ca. 1320, *Lovers conversing*, ivory mirror back. London, British Museum.

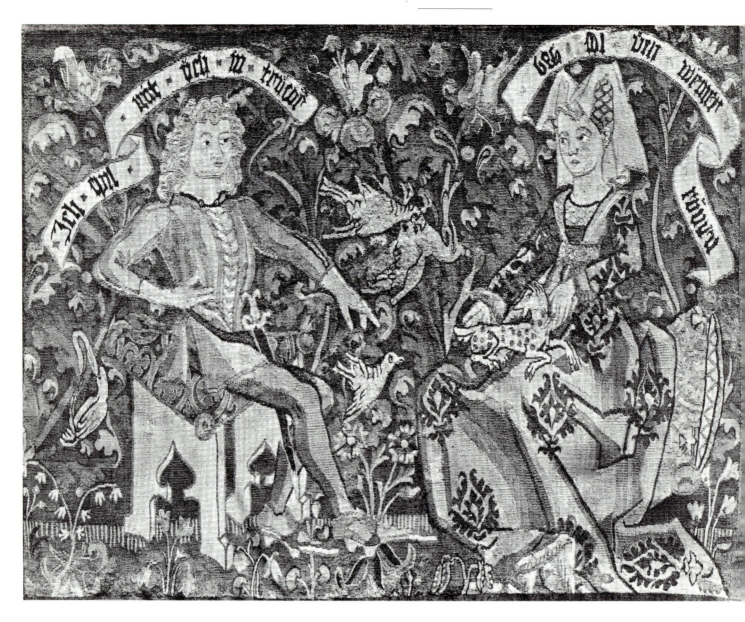

Fig. 48
Anonymous, Swiss, ca. 1480-90, *Allegory of fidelity*, tapestry. Formerly P.W. French and Co., New York.

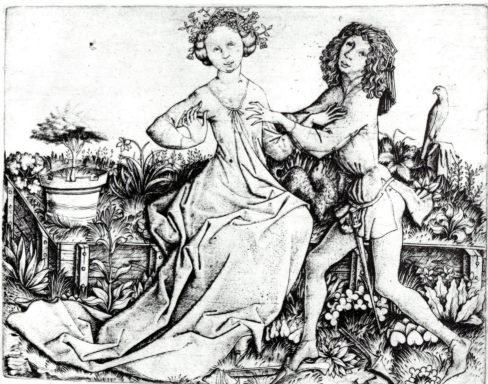

Fig. 49
Master E.S., *Pair of lovers* [**75**e], engraving (L. 211), ca. 1460. Vienna, Albertina.

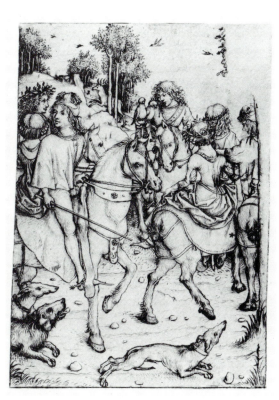

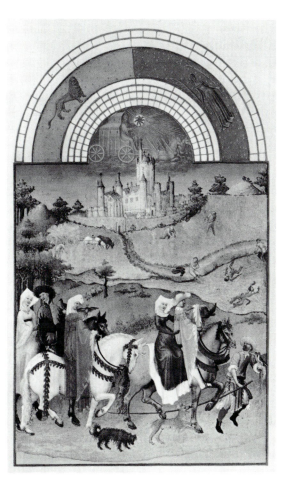

Fig. 50
Departure for the hunt [**72**],
drypoint, ca. 1485.

Fig. 51
Très Riches Heures, Limbourg
brothers, Paris, 1415-16, fol.
8v: *August*. Chantilly, Musée
Condé, ms. 65.

and which thus served to evoke the chivalric idea of love.[12] While the Master's print contains altogether too much narrative interest to serve only as a pictorial reference to a literary idea, it is possible that it may have served an analogous function. That is, far from representing an aspect of the Master's personal experience, *Pair of lovers* may constitute the visual affirmation of a cultural idea.

¶ The use of an amorous courtly couple as an image of chivalric romance is by no means restricted to French ivories. A number of Swiss tapestries produced at Basle in the second half of the fifteenth century made use of the same motif. A typical example is the tapestry, made about 1490 which was formerly in the possession of P.W. French & Co., New York, which is dated ca. 1490 (*fig. 48*).[13] Here a young couple are seated before a background of stylized plants suggesting a love garden. The banderole above the young man reads 'I will [love?] you faithfully,' while the woman replies, 'You will never regret it.' The values of constancy and fidelity expressed by these senti-

ments are among the most highly praised in chivalric literature. The sentiments expressed in the banderoles are visually supplemented by the miniature unicorn in the woman's lap, an undoubted reference to her chastity,[14] and by the falcon killing a heron at the center of the scene, a metaphor, like other hunting motifs, of love.[15] Although the Master's engraving does not have the allegorical structure of the tapestry, his image does share the cultural ideal it was meant to express. The tapestry formalizes the moral principles of the ideal of chivalric love in order to make a didactic statement, while the print attempts to conjure up the sensual lyricism of the same ideal. The former attempts to use a cultural ideal as a means of social instruction, the latter renders it as a charming and seductive vision intended for our pleasure and enjoyment.

¶ Comparison of the Master's print with its probable source, Master E.S.'s *Pair of lovers*, an engraving which is usually dated in the 1460s [**75**e; *fig. 49*], offers us a remarkable contrast. Despite the similarity of the compositions, the artists have

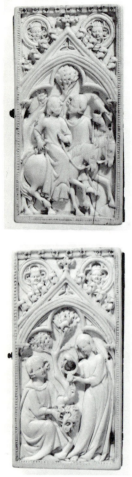

chosen to emphasize very different aspects of the relation between the sexes. Whereas the Master's offers us an admirable and inspiring vision of the chivalric ideal, Master E.S. defines the relation between the pair in terms of sexual attraction or lust. The male figure makes an overt sexual advance by placing his hand on his companion's breast. The woman appears to resist the action, if rather ineffectually, by pushing him away – a gesture which is comically echoed by her lap dog. The sense of emotional intimacy in our Master's print is absent from that by Master E.S. Rather than being concerned with their feelings for one another, the couple in the work by Master E.S. look out of the composition at the spectator as if aware of the moral opprobrium their actions were bound to incur. The differences between the prints reveal that the same theme has been used for the expression of radically different ideas. Whereas the former serves to enhance the value of the chivalric ideal, the latter subverts it by passing moral judgment upon it.[16]

¶ Like the *Pair of lovers*, the print known as the *Departure for the hunt* [72; *fig. 50*], is also characterized by a freshness of observation that has often led to its being regarded as a scene from everyday life. Not all commentators have followed this path, however. It has also been suggested that the engraving is related to representations of the months as they were developed in the calendars of illuminated manuscripts such as books of hours.[17] The month of August, for example, was often illustrated with a group of mounted nobles out hunting with falcons, as in the *Très Riches Heures of the Duke of Berry* (*fig. 51*).[18] Striking though the compositional parallels with the Master's print appear to be, the comparison raises the following issues. In the absence of any other illustrations of the months by the Master, we must assume that he borrowed this composition for a different purpose. Without a clarification of those intentions, the image loses its conventional status and becomes the product of the artist's fantasy. In its present form the suggestion reinforces the idea that the Master's art is the product of his untrammelled imagination.

¶ In attempting to uncover the cultural significance of the Master's image, it is important to note that whereas most of the activities chosen to illustrate the months of the year in the calendar illuminations were drawn from the life of the peasantry, those for January, April, May and August were sometimes drawn from the life of the nobility. Not only was the activity chosen to represent August a noble one, but it is one that is clearly associated with the idea of love. Hunting as a pastime of amorous couples is one of the pictorial traditions

of chivalric love. Not surprisingly, the *Departure for the hunt* is one of the themes that appear on four-teenth-century French ivories. An example is found on the back of a writing tablet in the British Museum (*figs. 52, 53*).[19] The use of the hunt as a pictorial 'emblem' of chivalric love depended on a rich literary tradition in which the hunt was used as a metaphor of the way in which a lover sought out and captured the object of his affection. Poems of this genre often took the form of allegories in which faithfulness and determination, the qualities exercised by the hunter in pursuit of his quarry, are likened to the virtues of the successful lover.[20] The pendant to this tablet shows a kneeling man about to be crowned by a woman – a scene which not only epitomizes the chivalric idea of love service and its reward, but recalls the garlands with which the riders in the Master's print are equipped. The ivory tablets with the *Departure for the hunt* and the *Crowning of the lover* thus serve to evoke the at once lyrical and erotic atmosphere of the world of romance.

¶ The hunt as an image of the values of chivalric love is also found in German tapestries of the Master's own day. In an Alsatian tapestry dating from the last quarter of the fifteenth century whose present whereabouts are unknown (*fig. 54*),[21] a couple chase a stag into a trap made of ropes strung between trees. According to the inscription on the banderole, the man says: 'I hunt for fidelity, I will never be happier than when I have found it.' The work is to be understood as an allegory of fidelity and thus as a moralized version of the chivalric love ideal. The Master's print shares neither the 'emblematic' quality of the image on the ivory nor the allegorical mode of the tapestry. Instead it clothes the ideal of love with the complexity of naturalistic observation and refuses to reduce its complex cultural implications to moral principles. By endow-

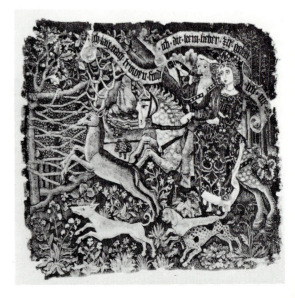

ing the cultural ideal with the illusionistic qualities of late fifteenth-century art, the Master endows it with fresh vitality and power.

¶ In the engraving known as the *Card players* [73] (*fig. 55*), the woman in the center of the composition seems just to have won a game of cards. The card in her lap, to which she points, has been identified as the ace of acorns (one of the suits of the German pack).[22] The image is intimately related to the iconographic tradition of the love garden, in which the game figured as one of the pastimes indulged in by amorous couples (see *fig. 46*).[23] Game playing between members of the opposite sex also occurs on fourteenth-century French ivories. The back of a mirror in the Louvre, for example (*fig. 56*),[24] shows a couple confronting each other across a chessboard. The woman seems to have just taken one of her opponent's pieces, a move to which the lady in waiting draws attention. Since the lady in waiting holds a garland in her other hand, it seems likely that the woman is the victor in this contest.[25] The fact that a woman is represented as the winner not only in this, but in all representations of the chess playing theme on ivories of this kind, makes it likely that the motif served to emphasize the importance of woman in the ideal of chivalric love.

¶ The use of the game-playing couple to express the values of chivalric love is also found in Swiss tapestries of the late fifteenth century. In the Meyer zum Pfeil tapestry in the Historisches Museum in Basle (*fig. 57*),[26] which is thought to have been executed in that city between 1471 and 1500, a card-playing couple is located in a tent at the center of the composition. The banderole above the man reads, 'You have carefully considered which card to play' and the woman answers, 'With it, I have won the game.' Placed within the context of two other loving couples

Fig. 55
Cardplayers [73], drypoint, ca. 1485.

who swear to be true to one another, the card-playing scene serves to exalt the role of woman within the chivalric love ideal. The location of the woman in the Master's print suggests that she plays the role of an arbiter within the company that surrounds her. The figure of the court fool placed behind the group, to the right, who is so frequently used in the imagery of this period as a way of referring to folly and sin, seems not to carry this significance in this composition. Far from commenting on the nature of the activity that preoccupies the group, the fool takes part in it.

¶ A print which bears certain compositional as well as thematic resemblances to the *Card players* is the engraving *Young man with two girls* [66]. The activity engaged in by this group is uncertain. They might on the one hand be singing (or about to sing), or they might be reading a letter.[27] Both activities find their counterparts in contemporary love garden iconography.[28] Unlike the other

Fig. 56
Anonymous, French, ca. 1340, *Couple playing chess*, ivory mirror back. Paris, Musée du Louvre.

Fig. 57
Anonymous, Swiss, ca. 1495, *Pair of lovers playing cards*, tapestry. Basel, Historisches Museum.

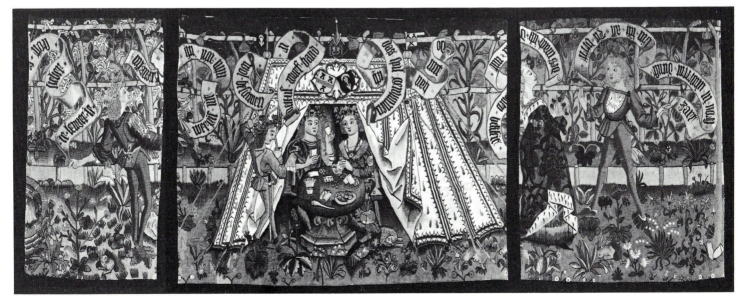

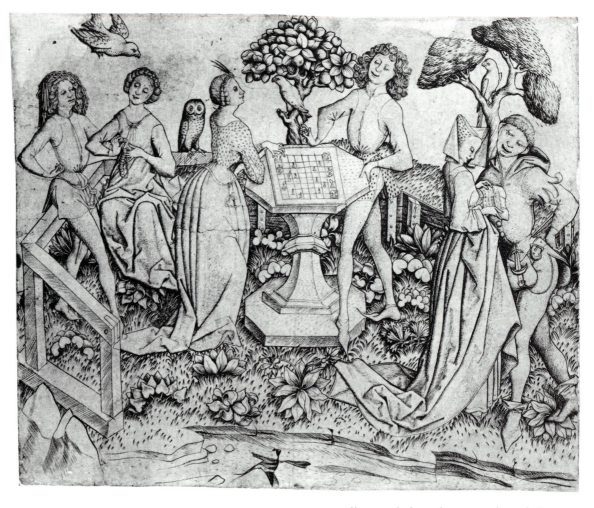

Fig. 58
Master E.S., *Love garden with chess players*, engraving (L. 214), ca. 1460. Berlin-Dahlem, Staatliche Museen, Kupferstichkabinett.

Fig. 59
Coat of arms with a peasant standing on his head [**89**], drypoint, ca. 1485.

scenes discussed there is, to my knowledge, no equivalent for this subject either among French ivories or among the tapestries of the Master's own day. Nevertheless, the subject would appear to function in a way that is similar to other courtly themes. Like them it invokes an ideal of intimacy, a world in which emotion is shared in an atmosphere of equality and respect.

¶ The prominence of women in card- and chess-playing scenes lent itself to satirization when the ideals of chivalry were called into question. This may be seen in an engraving by Master E.S. dating from the 1460s (*fig. 58*),[29] in which the chess game is used as a means of suggesting women's power to enslave men through the power of lust. The woman's role is invested with moral significance by the owl perched on the fence behind her. Symbolic of sin generally, the owl could also be used to refer specifically to lust.[30] Since the idea depended on the use of owls as decoys in fowling, the juxtaposition of woman and bird implies that she too acts as a lure and an enticement to men who are unaware that her charms will lead to their perdition. The presence of the court fool who makes amorous advances to the woman on the right of the composition serves to equate lust and folly. In emphasizing the sexual dimension of the relation between man and woman by placing his arm around his companion's waist, the fool con-

firms and dramatizes the dangers that lurk within the seemingly innocent game of chess.

¶ Confirmation of the Master's interest in chivalric values is found in his depiction of heraldic shields. That showing a peasant standing on his head [89; *fig. 59*] is dated about 1485 and is therefore considered contemporary with the illustrations of the chivalric ideal of love just discussed. The shield is surmounted by a helmet crowned in turn by the figure of a peasant who is being mounted by his wife. Adding insult to injury, he must hold her distaff while she continues to spin. The image of a man ridden by a woman is a direct reference to the iconography of Aristotle and Phyllis, a subject which the Master himself had depicted [54]. According to this tale Aristotle became so infatuated with Phyllis, the mistress of his pupil Alexander the Great, that he allowed her to treat him like a beast of burden in the hope of winning her favor. Rather than taking pleasure in his perverse 'love service,' however, the peasant in the Master's print cries out in pain. The visual connection between the couple above the helmet and the man standing on his head in the coat of arms serves to inform the viewer that the man's domination by his wife is an inversion of the 'natural' social order.[32] The image of a woman riding a man can be associated with several other iconographic themes popular in this period, satirical subjects such as the 'unruly wife' and the 'battle for the trousers,' which appear to have been directed at marriages in which the socially recognized sexual hierarchy had been overturned.[33]

¶ By the fifteenth century, the use of coats of arms was by no means restricted to members of the hereditary aristocracy. They had also been acquired by professionals, merchants, artisans and even wealthy peasants.[34] They were, however, still associated with aristocratic prestige for they referred to the ideal of military prowess, the traditional justification of social status and political power of those who bore hereditary titles. This prowess had been given ritual expression in carefully controlled martial spectacles, the tournaments, which reached the height of their popularity in the late Middle Ages.[35] The coat of arms was invested with new meaning as a result of its function in these pageants, where it served to identify the contestants as colorfully as possible. In Germany, the helmets surmounting coats of arms were taken from the tournament context and consisted mainly in the *Stechhelm* (or helmet used for jousting with lances) and the *Kolbenhelm* (or helmet used when fighting with clubs). Since the *Kolbenhelm* (which was only introduced in the fifteenth century) was originally associated with aristocratic arms, the fact that it should be the *Stechhelm* that appears on most (though not

all) of the satirical coats of arms of the Master, has been taken as an indication that the satire was directed at members of the professional and middle classes. In other words that the humor was aimed at those whose right to bear arms might have been considered questionable.[36] There are, however, a number of considerations that indicate that this humor was directed at a social class other than the bourgeoisie. Not only are most of the figures on the coats of arms peasants, but they are often supported by other peasants, while the objects that sometimes fill the shields are implements drawn from a peasant milieu. It is significant for example that the marital satire in the *Coat of arms with a peasant standing on his head* should refer to a peasant context. The same social setting was used in engravings of similar themes executed by his pupil the Master b x g [95, 102, 103]. One of these [95; *fig. 60*] depicts a man being beaten by his wife to assist her with her spinning.[37] It seems no accident that themes dealing with the need for marital discipline should have been cast in a peasant context. The disobedience and rebellion they exhibit would have been understood as a metaphor of the potential for disorder and revolution that always existed among the ranks of the lowest social class in the eyes of those who were more fortunately situated.

¶ The Master also executed blank shields supported by peasants whose suggestive gestures,

Fig. 60
Master b x g, *Henpecked husband* [95], engraving, ca. 1480.

squat proportions and caricatural expressions serve to inform the viewer that they belong to a social class renowned for its physical as well as moral ugliness and deformity.[38] A pair of pendant prints by Master b x g which are sometimes thought to be after lost works by our Master himself [110][39] represents a peasant couple who have

sat down to eat and drink. The man, who wears a wry expression on his face, has one hand tucked into his jerkin, a pose that has been recognized in other works of this period as signifying sloth.[40] The woman, who wears a lascivious grin on her aging features, lifts her skirts as she offers her companion a drink. While the first action seems suggestive enough, the second, the offer of drink, is frequently used as a visual metaphor of sexual invitation in both art and literature.[41] The woman's expression as well as her action indicate that this scene from peasant life contains a suggestive reference to sexuality.

¶ Satires of a somewhat different nature are those in which objects associated with the life of the peasantry are represented in the shields. In the *Peasant woman with sickle shield* [81], the traditional symbol of aristocratic pride is defiled by the incongruous appearance of a peasant implement. In a location inextricably bound up with the myth of martial prowess and heroic action, a tool used in manual labor by the humblest of social classes makes an unexpected and startling appearance. Bossert and Storck have already suggested that the insertion of the sickle into the coat of arms finds a parallel in literary works in which peasant satire was used as a means of mocking the institutions of chivalric society. In Heinrich Wittenwiler's poem *Der Ring*, composed about 1400, the peasants who engage in a tournament bear shields decorated with two pitchforks on a dung heap, a dead hare in a meadow, three flies in a glass, and so forth.[42] While the peasant woman supporting the shield does not seem to have been caricatured, Hutchison has suggested that the basket on her head may have been intended as a play on its German name *Korb*, which could also mean 'belly.' If this were the case, then the woman would have been characterized as gluttonous or greedy.[43]

¶ The Master also engraved a pair of pendant shields bearing a *Lady with radishes in her escutcheon* and a *Youth with garlic in his escutcheon* [84, 85]. In this case the shields are filled with items drawn from peasant diet yet they are supported by elegantly dressed figures belonging to the aristocracy or the bourgeoisie. What is the meaning of this curious juxtaposition of elements drawn from disparate social contexts? Like the other satirical coats of arms, these prints have been regarded as a mockery of bourgeois pretentions. According to this view, the social origins of the young couple would presumably be betrayed by their shields, despite their attempt to adopt the dress of the aristocracy. However, since the articles of food on the shield specifically refer to a peasant milieu it seems more likely that these images were meant to ridicule peasants. Moralizing criticism of peas-

ants who broke the rigid medieval dress codes by adopting styles that were above their social station is found, for example, in Sebastian Brant's *Ship of fools*, which was first published at Basle in 1494. Chapter 82, 'Of peasants squandering,' contains the following lines:

'They want no jackets cheap and plain
From Leyden, Mechlin they export
Clothes cutaway and slit and short,
With colors weird and quite absurd
Upon the sleeve a cuckoo bird.'[44]

¶ This analysis of some of the Master's secular subjects reveals that in many cases his work can be associated with pre-established pictorial traditions. These traditions indicate that far from being the products of random observation, the Master's prints are actually visual expressions of cultural values. Before we can understand the significance of the assertion of these values for the society in which the prints circulated, we must attempt to establish the type of audience to which they were intended to appeal. The technique chosen by the Master for the representation of his secular scenes was drypoint engraving. Drypoints are a particularly fragile medium, depending for their full aesthetic effect on the metal burr thrown up on the surface of the metal plate when scratched by a needle. The burr is rapidly worn down in the printing process so that fewer satisfactory impressions can be pulled than is the case with ordinary engravings. The rarity of the surviving impressions of the Master's work appears to corroborate the conclusion that the original editions were small. The 123 surviving impressions represent 91 different subjects, including no less than 70 that are known only in a single impression.[45] Since what little is known of the cost of early engravings indicates that they were relatively expensive, it has always been assumed that they were acquired and collected by those sectors of society that were at least comfortably off.[46] Such a consideration would tend to reinforce the conclusion that the Master's work was produced for a restricted circle of discriminating patrons belonging to the highest ranks of society. Further support for this point of view is found in the fact that the secular subjects of the Master find their closest parallels in ivory carvings and in tapestries. Both of these were expensive media traditionally associated with the patronage of the aristocracy and the urban bourgeoisie.[47] Finally it must be observed that in representing the chivalric ideal on the one hand and engaging in peasant satire on the other, the Master was producing visual equivalents of themes that had been traditional favorites of aristocratic literature. The patronage of both chivalric romances as well as of works that made use of peasant satire to mock the

chivalric ideal was to be found in the highest social classes.[48] The importance of the peasant class in the humor of the Middle Ages seems to have depended at least in part in its lying outside the scope of chivalric culture. As outsiders on whose incomprehension of courtly values the exclusivity of the chivalric myth depended, they lent themselves particularly well to a form of visual entertainment aimed at an aristocratic and wealthy bourgeois audience.[49]

¶ If we are correct in interpreting several of the Master's engravings as giving pictorial form to chivalric ideals first formulated in the literature of the high Middle Ages, it is important to consider the role these manifestations of chivalric culture played in the context of the society that collected and appreciated them. There has, for some time, been a movement away from the view that the fourteenth and fifteenth centuries saw a decline in the power and influence of the chivalric myth.[50] Historians have recently pointed to evidence that the appeal of the chivalric code was stronger in this period than in any other time. They cite the revived interest in chivalric literature, the increased willingness of the nobility to act out ritual behavior described in chivalric romances, and the ever-increasing popularity of the tournament.[51] The lively and creative quality of the idea of chivalry in fifteenth-century culture is particularly well documented in Germany. At the Munich court of Albrecht IV of Bavaria, for example, the poet and painter Ulrich Fütrer was commissioned to assemble an encyclopedic collection of Arthurian tales. This work, which is known as the *Buch der Abenteuer*, was completed between 1473 and 1478.[52] It seems likely that a similar interest in the revival of 'classical' chivalric literature lay behind the commission of Philip the Sincere of Heidelberg to Johann van Soest for a German translation of the fourteenth-century Dutch romance *Die Kinder von Limburg*.[53] The frontispiece to this work, which is dated 1480 and which represents the kneeling poet handing his work to the count, was executed by our Master [118].[54]

¶ What was the social significance of the revived interest in chivalric literature and how does it enable us to understand the imagery of our Master? One of the remarkable features of Philip the Sincere's patronage of chivalric romance is that it was accompanied by an interest in the work of the early German humanists. Philip was not only the patron of Johann van Soest but the maecenas of Rudolf Agricola and Johannes Reuchlin.[55] Kurt Nyholm has suggested that both these dimensions of courtly patronage should be understood as manifestations of a growing historical awareness. Both chivalric romance and Graeco-Roman literature were regarded as sources of historical knowledge.[56] This thesis has been developed by Jan-Dirk Müller, who interpreted the *Buch der Abenteuer* as a means by which Albrecht IV's prestige as ruler of Bavaria could be legitimated and enhanced. Müller argues that since the chivalric tales were understood as history, Fütrer's concern to show that Albrecht was genealogically related to the knights of the Round Table cannot be viewed as an extravagant piece of courtly flattery but must be regarded as a statement of historical truth.[57] In the case of Philip the Sincere, his enthusiasm for the ideal of chivalry was not restricted to his taste in literature. He is also an example of a late mediaeval prince anxious to equal if not surpass the legendary feats recorded in chivalric literature. In 1481 he organized a tournament at Heidelberg between the knights of the Rhine and those belonging to the Swabian League. The tournament lasted a week and Philip himself took part, jousting against Duke George of Bavaria. A total of five princes, twenty counts, four barons, sixty-nine knights and three hundred and fifty members of the lesser nobility took part. The Countess Mathilda observed this spectacle in the company of a hundred and fourteen noble ladies. The jousting was followed by a banquet, the distribution of prizes and a ball.[58]

¶ If we consider the Master's prints in the light of the role played by chivalric literature at the Heidelberg court at the time he is thought to have been associated with it, we are afforded new insight into their cultural and social significance. Far from offering us a vision of his personal experience, the Master's work appears to represent a sensitive and novel response to the importance accorded to the chivalric myth by the courtly circles with which he was associated. In an engraving such as the *Pair of lovers*, the Master offers us a visual interpretation of the literary ideal of chivalric love as a noble and inspiring relationship. The protagonists are represented as young and beautiful as well as exquisitely dressed. Their features are composed and their bearing is restrained, even formal, as well as graceful. The couple is presented not only as admirable but virtuous. In the works known as *Departure for the hunt* and *Young man and two girls*, there is an analogous concentration on the physical beauty of the protagonists as well as on the joyous intimacy of their association. They offer us an ideal society characterized by ease and leisure in which amorous couples can entertain themselves with lighthearted pastimes far from the cares and responsibilities of the everyday world. One is struck by the sensitivity that distinguishes the mood of these lovers. In *Departure for the hunt* a man turns

back to look at the woman who rides behind him in order to share the joy of the moment. Similarly the ease with which the sexes interact in *Card players* and *the Young man and two girls* serves to emphasize the privileged position of women within the chivalric myth.

¶ As with the illustrations of the chivalric ideal, we must also ask what the heraldic shields signified in the social context in which they were created. It is striking that the Master should have elaborated a visual equivalent for the literary tradition of peasant satire at a time when the peasant class was seething with discontent. The late fifteenth century saw the emergence of a number of peasant movements that threatened to destroy the very fabric of German society.[59] Complex though the reasons for this discontent were, recent scholarship has emphasized two major developments which combined to exacerbate the social tensions existing between the aristocracy and the peasantry. The great landowners, the nobility and the monasteries made attempts to bind 'their' peasants more closely to them while at the same time demanding greater economic tribute from them.[60] Such exactions were the product of the population losses brought about by the Black Death as well as by the flight from the land occasioned by the economic vitality of the expanding cities. Towards the end of the fifteenth century a population explosion which more than offset the losses of the previous century began to affect the economic position of the peasantry.[61] A period of high peasant earnings brought about by a labor shortage gave way to a period of hardship and want.

¶ In considering the Master's satirical coats of arms, with their mockery of the peasant class, in the light of the social circumstances sketched above, it is possible to draw the following conclusions. The satires make their point principally by means of sexual inversion and caricature. Neither of these could have been regarded as particularly novel by a society in which literary satires of peasants were an established institution. On the other hand, however much the Master's satires may correspond with pre-existent and socially sanctioned forms of humor, they did serve to provide them with a new and striking visual dimension. In the context of social unrest it would seem not unlikely that the inversion of the sexual hierarchy represented in the *Coat of arms with a peasant standing on his head* would have suggested the threat of social inversion. By these means the class that was unable to maintain sexual order is characterized as being incapable of maintaining social order.

¶ The peasant satires represent the other side of the coin of the works that appear to assert the value of the chivalric ideal. In providing a visual expression of the myths on which the social hierarchy depended – the spiritual nobility of chivalry on the one hand and the moral depravity of the peasantry on the other – the secular imagery of the Master served to confirm the class attitudes of the audience for which his prints were intended. The fresh naturalism borrowed from contemporary religious art was used on the one hand to clothe a reinvigorated vision of the chivalric ideal of love and on the other to add zest to a humorous but humiliating vision of the peasantry.

¶ An understanding of the ideological assumptions underlying some of the secular themes of the Master not only affords us with better insight into the way in which his art was appreciated in the fifteenth century but contributes to our aesthetic appreciation of his art today. An acknowledgement of the historical status of the Master's work serves to enhance and enrich its aesthetic power. Stange's sensitive response to the naturalistic achievements of the Master can be fused with our understanding of the cultural and social reverberations his subject matter possessed for his contemporaries. Stange's description of the Master's phenomenological involvement with his craft need not be rejected but merely reinterpreted. Rather than acts of pure observation, the products of an existential awareness of the world around him, the Master's creations must now be regarded as purposive. In other words, the Master used his powers of observation not to record nature and society for whatever interest they might have afforded in their own right, but to render traditional cultural values in a visual vocabulary that was as remarkable as it was new.

* This essay is an expanded version of a lecture delivered at a conference entitled 'Harvest of the middle ages: chivalry in late medieval and Renaissance literature and the arts,' sponsored by the Newberry Library and Northwestern University and held in Chicago in March 1984. I am grateful to Larry Silver for the opportunity to formulate my ideas on this subject for that meeting and to Sandra Hindman for her comments. The text was completed at the Zentralinstitut für Kunstgeschichte in Munich, with the support of a fellowship from the Humboldt Foundation. I am grateful to Professor Willibald Sauerländer for his sponsorship and to Dr. Thomas Berberich of the Humboldt Foundation for his unfailing helpfulness.

My interest in the work of the Master derives from a graduate seminar held at the University of Virginia in 1981 and particularly from an excellent research paper by Judith Thomas. The greatest debt, however, is to William McDonald, whose knowledge of late medieval German literature has been most

helpful to me. Finally, I should like to thank Jan Piet Filedt Kok for a careful reading of the text.

1. For a survey of the scholarship to date see pp. 41-64.

2. The method of approach suggested here depends upon a respect for the historical 'horizon' in which the work was produced as distinct from that in which the interpreter is situated. The interpretation resulting from this recognition is viewed as a 'fusion' of these separate historical moments. For a discussion of the theory on which such an attitude is based see Hans Robert Jauss, *Towards an aesthetic of reception,* trans. Timothy Baht, Minneapolis 1982. Jauss's theory is in turn based on the hermeneutical analysis of Hans-Georg Gadamer, *Truth and method,* ed. Garrett Barden and John Cumming, New York 1975.

3. Stange 1958, p. 12: 'mit unersättlichen Augen muss er um sich geschaut haben. Das Leben zu erfahren und den Menschen zu erkennen, ist ihm viel mehr als Schongauer erst Aufgabe des Künstlers gewesen, und er hat das Leben und die Dinge sehr frisch und natürlich geschaut.' This and the following translations are my own.

4. Ibid., p. 11: '...aber wenn wir sehen wie er mit zwei, drei, gar vier Strichen eine Form zu erfassen sich bemühte, wie ihm nicht ein Strich genügt hat, sondern mehrere ihm notwendig schienen, nur das Unsagbare, dem er Gestalt geben wollte, anschaulich zu machen, da lässt er uns wohl ein wenig über die Schulter schauen, spüren wir den Schlag seines Pulses, die Spannung seiner Hand, ahnen wir die Gefühlswellen die sein Ich bei dieser Arbeit durchliefen, können wir andeutend verfolgen, wie er sich durchgekämpft hat.'

5. A.P. de Mirimonde, 'Jan Massys dans les musées de province français,' *Gazette des Beaux-Arts* 60 (1961), pp. 543-64, p. 560, note 42. Mirimonde based himself on an article by Fernand Mercier, 'La valeur symbolique de l'oeuillet dans la peinture du moyen-âge,' *La Revue de l'Art* 41 (1937), pp. 233-36. For a similar point of view see Elisabeth Wolffhardt, 'Beiträge zur Pflanzensymbolik: über die Pflanzen des Frankfurter Paradiesgärtleins,' *Zeitschrift für Kunstwissenschaft* 8 (1954), pp. 177-96.

6. See for example Ernst Buchner, *Das deutsche Bildnis der Spätgotik und der frühen Dürerzeit,* Berlin 1933, passim.

7. Ingvar Bergström, *Den symboliska nejlikan,* Malmö 1958, pp. 26-29. See also the review of this book by C.G. Stridbeck, 'Den gätfulla nejlikan,' *Konsthistorisk Tidskrift* 29 (1960), pp. 81-87.

8. The claim was made by Mirimonde (see note 5). For the broken jug as a symbol of the loss of chastity see P.J. Vinken, 'Some observations on the symbolism of the broken pot in art and literature,' *The American Imago* (1958), pp. 149-74.

9. Lehrs, vol. 4, cat.nr. 21. The print is dated ca. 1440 by Roberta Favis, 'The garden of love in fifteenth-century Netherlandish and German engravings,' unpublished Ph.D. dissertation, University of Pennsylvania, 1974. For other examples of the presence of wine of love garden scenes, see the engravings by Master E.S. (Lehrs, vol. 2, cat.nrs. 203, 207 and 215).

10. Mirimonde, op.cit. (note 5).

11. Raymond Koechlin, *Les ivoires gothiques français,* 3 vols., Paris 1968 (1st ed., 1914), vol. 2, p. 365, cat.nr. 991; vol. 3, plate 175. See also Julius von Schlosser, 'Elfenbeinsättel des ausgehenden Mittelalters,' *Jahrbuch der Kunsthistorischen Sammlungen des Allerhöchsten Kaiserhauses, Wien* 15 (1894), pp. 260-94.

12. Koechlin, op.cit. (note 11), vol. 1, p. 374.

13. Heinrich Göbel, *Wandteppiche,* 3 vols., Leipzig and Berlin 1923-24, part 3, vol. 1, p. 51, plate 30. The inscriptions read: 'Ich soil mit uch in truwe'; 'Des sol uch niemer ruwen.' For other examples see Betty Kurth, *Die deutschen Bildteppiche des Mittelalters,* 3 vols., Vienna 1926, vol. 1, p. 213 and vol. 2, plate 32; vol. 1, p. 222, and vol. 2, plate 71a.

14. See *Reallexikon zur deutschen Kunstgeschichte,* vol. 4, ed. E. Gall and L.H. Heydenreich, Stuttgart 1958, cols. 1504-44, esp. 1528 and Margaret Freeman, *The Unicorn tapestries,* New York 1956, pp. 42-56.

15. See Mira M. Friedman, 'Hunting scenes in the art of the Middle Ages and Renaissance,' 2 vols., unpublished Ph.D. dissertation, Tel Aviv University 1978, esp. vol. 2, pp. 21-25 and 49-56 (I am grateful to William McDonald for making his copy of the English summary available to me).

16. For Master E.S.'s satires of chivalric love see Keith Moxey, 'Master E.S. and the folly of love,' *Simiolus* 11 (1980), pp. 125-48.

17. Hutchison 1972, p. 61.

18. The manuscript was probably illuminated in Paris by the Limbourg brothers between 1413 and 1416.

19. Koechlin, op.cit. (note 11), vol. 2, p. 417, cat.nrs. 1165 and 1166; vol. 3, plate 196.

20. See Marcelle Thiebaux, *The stag of love: the chase in medieval literature,* Ithaca and London 1974. For German examples see the literature cited by David Dalby, *Lexikon of the medieval German hunt,* Berlin 1965.

21. Kurth, op.cit. (note 13), vol. 1, pp. 131, 238; vol. 3, plate 140, 141a. The tapestry was formerly in the possession of P.W. French & Co., New York. The banderole reads 'Ich. iag. nach. truwen. find. ich. die. kein. lieber. zit. gelebt. ich. nie.' It may be identical with a very similar work now in the Burrell collection, Glasgow Art Gallery. For examples of the use of the hunt as an allegory of chivalric love on wooden caskets produced in Switzerland and on the upper and middle Rhine in the fifteenth century, see Heinrich Kohlhaussen, *Minnekästchen im Mittelalter,* Berlin 1928, cat.nr. 79, plate 57 and cat.nr. 42, plate 53. See also Heinrich Kohlhaussen, 'Eine höfische Minnekästchen Werkstatt zwischen Maas und Niederrhein von 1430,' *Anzeiger des Germanischen Nationalmuseum* (1963), pp. 55-61. The authenticity of some of the boxes included in Kohlhaussen's publications has recently been questioned by Horst Appuhn, 'Die schönste Minnekästchen aus Basel: Fälschungen aus der Zeit der Romantik,' *Zeitschrift für Schweizerische Archäologie und Kunstgeschichte* 41 (1984), pp. 149-59 (I am grateful to Peter Diemer for drawing my attention to this article).

22. Hutchison 1972, p. 62.

23. See also the 'love garden' tapestry in the Historisches Museum, Basle, which was probably produced in that city ca. 1460-80 (Kurth, op.cit. [note 13], vol. 1, p. 223; vol. 3, plates 75-76).

24. Koechlin, op.cit. (note 11), vol. 2, cat.nr. 1053; vol. 3, plate 180. See also the mirror back in the Galleria Nazionale, Perugia, where the chess game is combined with a *Departure for the hunt* (ibid., vol. 2, cat.nr. 1056; vol. 3, plate 180).

25. Contrary to Koechlin's claim that the men seem to win most of the games in treatments of this theme (op.cit. [note 11], pp. 387-88), just the opposite appears to be the case. In most instances the woman's triumph is indicated either through gestures or by the fact that she is shown holding more captured pieces than her opponent.

26. Kurth, op.cit. (note 13), vol. 1, p. 224; vol. 3, plates 78-79. The inscriptions above the card players read, 'den. us. wurf. hand. ir. wol. besunnen.' and 'domit. han. ich. das. spil. gewunnen.' Those above the couple on the left (which are partly destroyed) read: 'ie. lenger. ie. lieber. stott.' ...and 'wergis. nit. min. wil. ich. ...krentzlin.' The texts above the couple on the right read: 'zart. frou. in. uweren. dienst. bin. ich. all. zit. berit.' and 'des. mach. ich. dich. ...mit. (ro)ssen. bekleit.' The coats of arms on the work permit its identification as a tapestry commissioned to commemorate the marriage of the Basle city secretary, Meyer zum Pfeil, to Barbara zum Luft.

27. For the romantic connotations of the receipt of a letter in later art see E. de Jongh, *Zinne- en minnebeelden in de schilderkunst van de zeventiende eeuw,* Amsterdam and Antwerp 1967, pp. 50-52; idem, *Tot lering en vermaak,* exhib.cat. Amsterdam (Rijksmuseum) 1976, cat.nrs. 25, 39 and 71; Albert Blankert, *Johannes Vermeer van Delft, 1632-1675,* Utrecht and Antwerp 1975, pp. 78, 82 and cat.nr. 22.

28. See figs. 46 and 57.

29. Lehrs, vol. 2, cat.nr. 214.

30. See Moxey, op.cit. (note 16), pp. 132-37. The Housebook Master made similar use of the symbolism of the owl in his heraldic shield known as the *Lady with the helmet and the A.N. shield* (see **86**). The owl perched on the helmet suggests that the attractive young lady who dominates the scene is a seductress. The presence of an unfilled banderole confirms this reading, since they are rarely found in the Master's prints that are devoid of moralizing significance.

31. Hutchison 1966, pp. 73-78.

32. See David Kunzle, 'The world upside down: the iconography

of a European broadsheet type,' in *The reversible world: symbolic inversion in art and society*, ed. Barbara Babcock, Ithaca 1978, pp. 39-84. The inversion of the sexual hierarchy in marriage was a feature of 'world upside down' prints which were introduced in the late sixteenth century. The Housebook Master's use of a man standing on his head as a means of expressing this idea is the earliest example know to me. (For another see Caspar Utenhoven, *A la Modo Monsiers. die neue umgekehrte Welt*, engraved broadsheet, 1619 (Wolfenbuttel, Herzog August Bibliothek, Flugschriften, Ethica, Nr. I E 150).

33. For the 'unruly wife' see for example Israhel van Meckenem's engravings (Lehrs, vol. 9, cat.nrs. 473 and 504). For the 'battle for the trousers,' see the engraving by the Master of the Banderoles (Lehrs, vol. 4, cat.nr. 89). The cultural significance of such themes has been little studied but see Lené Dresen-Coenders, 'De strijd om de broek: de verhouding man/vrouw in het begin van de moderne tijd (1450-1630),' *De Revisor* 4 (1977), pp. 29-37, 77.

34. See Walter Leonhard, *Das grosse Buch der Wappenkunst: Entwicklung, Elemente, Bildmotive, Gestaltung*, Munich 1978, pp. 21-24, 31-32.

35. See Arthur B. Ferguson, *The Indian summer of English chivalry*, Durham (North Carolina) 1960, pp. 13-15; Larry D. Benson, *Malory's Morte d'Arthur*, Cambridge (Massachusetts) 1976.

36. Bossert and Storck 1912, p. 20; Hutchison 1972, p. 68. The suggestion that the Master's satirical coats of arms should have been directed at the bourgeoisie because of their illegitimate aspirations to participate in aristocratic culture depends in part on a misunderstanding of late medieval class structure. Recent historical studies have confirmed that far from subscribing to different value systems, the nobility and the urban bourgeoisie shared a common cultural identity. Not only did wealthy bourgeois own large landholdings, including castles, but their habits and dress coincided with those of the hereditary nobility. Like the latter they could inherit, earn and buy titles without impediment. See Otto Brunner, 'Zwei Studien zum Verhältnis von Bürgertum und Adel,' in his *Neue Wege der Verfassungs- und Sozialgeschichte*, Göttingen 1968, pp. 242-80. For a discussion of the similarities in the literary taste of the nobility and the urban bourgeoisie see Jan-Dirk Müller, 'Melusine in Bern: zum Problem der 'Verbürgerlichung' höfischer Epik im 15. Jahrhundert,' in *Literatur, Publikum, Historischer Kontext*, ed. Joachim Bumke et al., Bern 1977, pp. 29-77. This is not to suggest that social climbing was not perceived and criticized (see Hutchison 1972, p. 66), but rather that its criticism did not depend on class antagonism.

37. It is possible that the *Coat of arms with a woman winding yarn* [87] should be viewed as a satire of dominant women. The characterization of the old peasant woman in this image as emaciated and possessed of sharp, shrewish features is less than sympathetic. Her association with a fantastic screeching bird in the field of the coat of arms calls to mind Sebastian Brant's comparison of an evil woman with a magpie that chatters day and night (*Ship of fools*, ed. Edwin Zeydel, New York 1944, p. 213).

38. For a discussion of literary satires of peasant appearance, see Paul Vandenbroeck, 'Verbeeck's peasant weddings: a study of iconography and social function,' *Simiolus* 14 (1984), pp. 79-124, esp. 93-95.

39. See also **79, 80,** for two similar roundels in which the satire is restricted to caricature.

40. Susan Koslow, 'Frans Hals's fisherboys: exemplars of idleness,' *Art Bulletin* 57 (1975), pp. 418-32.

41. See Moxey, op.cit. (note 16), pp. 138-41.

42. Bossert and Storck 1912, p. 20, note 1.

43. Hutchison 1972, p. 68.

44. Brant, op.cit. (note 37), pp. 268-70.

45. Filedt Kok 1983, esp. p. 427.

46. For an estimate of the cost of early engravings see Charles Talbot et al., *Dürer in America: his graphic work*, exhib. cat. Washington (National Gallery of Art) 1971, pp. 14-15. For assessments of the social composition of the market see Alan

Shestack, exhib. cat. *Master E.S.: five-hundredth anniversary exhibition*, Philadelphia (Museum of Art) 1967, Introduction, and Erwin Panofsky, *Albrecht Dürer*, 2 vols., Princeton 1949, vol. 1, pp. 49-50 and 68-69.

47. For the cost of the ivories see Koechlin, op.cit. (note 11), vol. 1, p. 370. Many of the tapestries bear the coats of arms of the patrician families who commissioned them. See Kurth, op.cit. (note 13), pp. 71-72.

48. See Werner Fechter, *Das Publikum der mittelhochdeutschen Dichtung*, Frankfurt 1935 and idem, 'Der Kundenkreis des Diebold Lauber,' *Zentralblatt für Bibliothekswesen* 55 (1938), pp. 121-46.

49. See Fritz Martini, *Die Bauerntum in deutschen Schrifttum*, Halle 1944; Erhard Jöst, *Bauernfeindlichkeit: die Historien des Ritters Neithart Fuchs*, Göppingen 1976. The use of the peasant as a comic figure in the context of chivalric literature was taken over by fifteenth-century urban drama where it was used to contrast the moral laxity of peasant life in the surrounding countryside to the strictly controlled social life of the city. The criticism of the peasantry thus became an opportunity for the assertion of urban values. See Johannes Janota, 'Städter und Bauern in literarischen Quellen des Spätmittelalters,' *Die alte Stadt* 6 (1979), pp. 225-42.

50. This view is forever linked with Johan Huizinga's famous work, *The waning of the Middle Ages*, New York 1954 (1st ed. 1924). This thesis has been accepted by many subsequent writers, such as R.L. Kilgour, *The decline of chivalry*, Cambridge (Massachusetts) 1937; Gustave Cohen, *Histoire de la chevalerie en France au moyen-âge*, Paris 1949; Richard Baker, *The knight and chivalry*, London 1970.

51. See for example Ferguson, op.cit. (note 35), Maurice Keen, 'Huizinga, Kilgour and the decline of chivalry,' *Medievalia et Humanistica* 8 (1977), pp. 1-20; idem, *Chivalry*, New York 1984. For the development of this thesis in literary studies see Martin de Riquer, *Cavalleria fra realtà e letteratura nel Quattrocento*, Bari 1970; Benson, op.cit. (note 35); idem, 'The tournament in the romances of Chrétien de Troyes 'L'Histoire de Guillaume le Maréchal,'' in *Chivalric literature: essays on relations between literature and life in the late Middle Ages*, Kalamazoo 1980, pp. 1-24.

52. See Kurt Nyholm, 'Das höfische Epos im Zeitalter des Humanismus,' *Neuphilologische Mitteilungen* 66 (1965), pp. 297-313; Klaus Grubmüller, 'Das Hof als städtisches Literaturzentrum', in *Befund und Deutung: zum Verhältnis von Empirie und Interpretation in Sprach- und Literaturwissenschaft*, ed. Klaus Grubmüller et al., Tübingen 1979, pp. 414-21; Hellmut Rosenfeld, 'Der Münchner Maler und Dichter Ulrich Füetrer (1420-1496) in seiner Zeit und sein Name (eigentlich Furtter),' *Oberbayerische Archiv* 90 (1968), pp. 128-40.

53. Wolfgang Stammler, ed., *Die deutsche Literatur des Spätmittelalters: Verfasserlexikon*, vol. 2, Berlin and Leipzig 1938, cols. 629-34; Hans Rupprich, *Die deutschen Literatur von späten Mittelalter bis zum Barock*, part 1, Munich 1970, pp. 62-63.

54. For a discussion of this miniature, see Valentiner 1903.

55. Eckhard Bernstein, *Die Literatur des deutschen Frühhumanismus*, Stuttgart 1978, pp. 18-20; Wolfgang Stammler, *Von der Mystik zum Barock*, Stuttgart 1950, pp. 63-65.

56. Nyholm, op.cit. (note 52).

57. Jan-Dirk Müller, *Gedechtnus-Literatur und Hofgesellschaft um Maximilian I*, Munich 1982, p. 192. See also Christelrose Rischer, *Literarische Rezeption und kulturelles Selbstverständnis in der deutschen Literatur der 'Ritterrenaissance' der 15. Jahrhunderts*, Stuttgart 1973, who also interprets Füetrer's book as an attempt to endow the court of Albrecht IV with the brilliance and splendor of the Arthurian court (p. 22).

58. Elizabeth Godfrey (pseud. Jessee Bedford), *Heidelberg, its princes and its palaces*, London 1906, p. 102.

59. Gunther Franz, *Der deutsche Bauernkrieg*, 2 vols., Munich and Berlin 1932, vol. 1, parts B, C.

60. Peter Blickle, *Die Revolution von 1525*, Munich 1975, pp. 39-45.

61. Ibid, pp. 120-21.

THE MIDDLE RHINE AND THE FRANCONIAN UPPER RHINE IN THE LATE FIFTEENTH CENTURY

Peter Moraw

The Master of the Housebook flourished in the last quarter or the last third of the fifteenth century. Though every age may be called an age of change and transition, older German history, at least, reflects considerable differences in the scope and speed of such transformations. The late fifteenth century was undoubtedly an age of rapid and fundamental change. Though the Reformation, and Martin Luther in particular, had retained a good many medieval attitudes, the transition from the Middle Ages to the modern period had occurred well before 1500 and had been virtually completed by the last generation of the fifteenth century.

The period during which the Housebook Master was active represented an historical watershed and his geographical location was no less a meeting point of several regions – as far as we can tell his sphere of activity was largely confined to the middle Rhine and the Franconian upper Rhine. He may also have been familiar with the Alemannic upper Rhine, and with Alsace in particular, and even with Swabia as far as Augsburg, and with both banks of the lower Rhine, but there is no reliable evidence of his presence in any but the two great middle Rhenish political centers, namely Mainz and Heidelberg. From there, he must however have been in contact with the neighboring bishoprics of Worms and Speyer and with Frankfurt-on-Main, then the economic metropolis. The whole region constitutes a fairly uniform geographical entity. It runs beside the Rhine from the confluence of the Moselle and the Lahn in the north to the Lauter in the south and includes the mountain forests on either bank, especially the Odenwald, the Hunsrück and the Taunus. By German standards, it might be described as a natural economic and political whole.

Their geographical situation afforded and continues to afford the upper and middle Rhineland favored conditions of climate and commercial communications in central Europe, the latter at least on the north-south axis. As in so many other parts of the world, the major centers of activity were not uniformly distributed here. The great historical events with all their promise and danger took place mainly in the lowlands; it took time to open up the wooded mountain slopes and their inhabitants made a less important historical impact. The controlling factor, in any case, was the course of the Rhine, which was far more navigable north of the Lauter than it was in the Alemannic reaches; only between Bingen and St. Goar were there any serious obstacles to shipping. Frankfurt-on-Main lay at the junction of some of the most important routes linking the Rhineland to central Germany, to the north and the northeast and to upper Germany in the south. The central and upper Rhineland were therefore great thoroughfares but also regions with a considerable importance of their own and so diverse that only a few of their main characteristics can be set out here.

¶ The whole region holds a unique position in German history. Broadly speaking, it was hardly ever pre-eminent in any single respect, yet because it came second in a multitude of fields it achieved considerable prominence. Thus the leading centers of modernization in late medieval Europe had developed in upper Italy on the one hand, and on the Rhine estuary with Cologne and Aachen and also with Flanders, northeast France and southeast England on the other. The middle and upper Rhineland lagged behind, but not too far: they were comparatively 'modern' regions, moreover, and lay on the important route linking the two major centers of accelerating development. The Rhine was Europe's chief inland passage, and it was in the middle and lower Rhineland, the main area of Frankish settlement, that German history began. Indelible traces of these early beginnings continued to cling to the middle and upper Rhineland during the late Middle

Ages – we need only mention the region's polymorphous character and its highly developed political structure, two certain pointers to a long history. These developments were associated with the high rank of the leading political figures in the region, equally based on an ancient tradition, but no longer reflecting any great political potential, which had largely passed to other, 'younger' regions. The German constitution, too, reflected the past, the time when the Rhine had been the hub of political activity. Thus the emperor continued to be elected in the sacristy of St. Bartholomew's 'Cathedral' in Frankfurt, and crowned in the Minster in Aachen, even though he now had to travel a long way. Conflict between a glorious past and a problematic present – that phrase best describes the situation of the Rhineland during the waning of the Middle Ages and the dawn of the modern period. From the fifteenth to the seventeenth century, this conflict repeatedly gave rise to abortive attempts to reconcile grandiose claims based on history with contemporary reality. It was the inevitable result of the ultimately beneficial process of balancing the claims of west and east which may be said to have created German history in the broader sense. That process had made considerable strides by the fourteenth century, not least as a result of the consolidation of power by the great dynasties, which could make itself felt in the east but no longer in the west: most surprisingly, the first university in the empire was opened not on the Rhine, but in the Luxemburg and Hapsburg centers of Prague (1348) and Vienna (1365 or 1384); Rhenish Heidelberg did not follow suit until 1386. Even Erfurt, the Thuringian daughter of St. Boniface's Mainz, boasted a high school (1392) well ahead of the cathedral city on the Rhine (1477). This balancing act was paralleled by a similar development in Europe at large, as a result of which the south and west of the continent, which had been leaders for centuries, were confronted with new and stronger centers in the north and the east.

¶ However, the middle and upper Rhineland continued to bustle in non-political spheres, and especially in the intellectual, the artistic and the technological. Thus printing from movable type, probably the most important technical invention of the late Middle Ages, which transformed the world as few others did, saw the light of day in Mainz in 1450. It was the Housebook Master's generation which witnessed the development of that invention into the first of what became known much later as the mass media. Moreover it became a rallying point of an emerging national consciousness, comparable to the prevailing enthusiasm for empire and emperor.

¶ To the generation of the Housebook Master, the king and empire were Hapsburg and Austrian – and this state of affairs more or less continued from 1438 until the early nineteenth century. Despite relatively brief crises, and often also despite the 'technical' restrictions of an older age which worked against government from afar and in favor of particularist government, the imperial house continued to be the foremost political force in the empire. It was the sole, unquestioned source of legitimization of princes and governments. Historians now tend to take a kindlier view of Emperor Frederick III (1440-93) than they did a few decades ago. They no longer blame him for external difficulties that no contemporary could have surmounted: it was simply not within his power to concentrate, accumulate and maintain the financial and political resources needed to run so vast an empire. A fair judge must also remember that in Frederick's day it took approximately one month for people and news to travel from one end of the northern part of the empire to the other. However, in this field, too, the last medieval generation witnessed extraordinary changes. When Maximilian, the emperor's son (elected emperor in 1486; reigned 1493-1519), had added the Burgundian Netherlands (1477) as well as the Tyrol (1490) to the empire, the need for strong government in the hereditary lands became a spur to the creation of the first modern postal network. This resulted in Innsbruck becoming linked to Brussels via the middle Rhineland by postal dispatch riders who took five or six days to relay postbags across a series of constantly manned stations.

¶ In the Housebook Master's day, the empire witnessed one of the most remarkable transformations in its long history. From the 'open constitution' following the Staufer catastrophe (ca. 1250) and continuing to make its influence felt for centuries, the empire stepped into the age of 'consolidation' in about 1470. That move spelled the end of a period in which only a handful of princes had felt responsible for the empire and when the majority of them had steered a purely inward-looking political course, recognizing few if any external duties.

¶ The new consolidation as well as a strengthened sense of national cohesion were encouraged first of all by long-term intellectual, social, economic and technical processes that were hardly influenced by dynastic or political forces. The long years of crisis were followed in about 1450-70 by a population increase partly due to the opening up of new agricultural areas. Even earlier, the number of university students had greatly increased; at the end of the fifteenth century, some two hundred thousand students were en-

rolled in fourteen universities. In the cities, literacy grew apace: up to thirty percent of all citizens learned to read and write. Having lagged behind for some time, the territorial states, too, began to make greater progress once again. At about the same time, an economic revival put an end to decades of stagnation. Closely connected with that development went a more intense accumulation of capital; a more rapid flow of goods from town to town; increased production based on better methods; greater rationality of economic life and new techniques in mining and metallurgy, not merely in printing.

Equally important was the unifying effect of threats from external sources. There were the Turks; there was the duke of Burgundy, of whom no one would have guessed that he would become the unwitting instrument of a great invigoration of the house of Hapsburg; and at the end of the century there was the nascent 'imperialism' of the French monarchy. The king-emperor at the head of his hereditary territories braved these threats and soon afterwards launched a patriotic appeal to the Diet.

Essential elements of these developments took place in the Rhineland. These territories felt threatened by the expansion of Burgundy and clung to the emperor; only the electorate of the Palatinate sided with the duke. From 1444 to 1471 Frederick had never once set foot in the interior of his empire. But now he came to enlist help on the Rhine against the Turks who were advancing from the southeast; in addition, the European interests of the Hapsburg dynasty demanded a united stand on the Burgundian question. In 1473, at a sensational meeting in Trier, the emperor came face to face with Charles the Bold (1467-77), who was obviously hoping for a regional crown, like the Bohemian. In exchange he apparently offered the hand of Mary, the Burgundian heiress, to Maximilian, the emperor's son. No agreement was reached. Soon afterwards, Charles intervened in a conflict between the archbishop of Cologne and his cathedral chapter and laid siege to Neuss (1474). This advance on the Rhine not only called forth the usual antihegemonial resistance of the territories, but also indicated clearly that the consolidation of the empire had made considerable headway. For the response to Charles the Bold's action seemed to be the mobilization of a far larger number of soldiery than had ever been brought out before in a similar feud. Another new development was that the emperor's forces fought in the name of something that had been unheard of until then: imperial patriotism. And when the emperor appeared at the head of an imperial army, the duke retired without a struggle. The imperial camp, perhaps before Neuss or possibly further south along the approaches to the Rhine, has been captured in one of the Housebook Master's drawings [**117**, fol. 53a and 53a₁]. Charles gave Mary away, even without having been granted a royal crown, shortly before he fell in battle at Nancy (1477) against his fellow-princes, the Alsatians and Lotharingians. Once the historic marriage between Maximilian and Mary of Burgundy had been solemnized, the emperor hastened to enfeoff his son; as guardian of his wife he was also ruler over what had been French Flanders and he defended the latter at Guinegate (1479). The richest territories in Europe north of the Alps were now in Hapsburg hands, albeit in the then customary form of weak rule over powerful estates. When the citizens of Flemish Bruges, encouraged by France, took Maximilian prisoner and refused to let him go except on very humiliating terms, the old emperor was once again forced to draw up an imperial army. The Housebook Master made sketches of what were probably two episodes in the Bruges negotiations [**124**]. It was not until the signing of the Peace of Senlis (1493) that the Burgundian inheritance was finally made secure.

¶ These events show that political problems were much more complex in Maximilian's age than they had been at any earlier period of the late Middle Ages. Above all, the question of an all-imperial constitution, which had been put off under Frederick III, now became pressing. The middle Rhineland was once again the main arena, because the leading champions of political dualism – the electorates of Mainz and of the Palatinate – were situated there and also because all other potential players of the political game had to make their moves in this old geographical center of the empire. Thus the first of the town diets (Städtetage) held since 1471, at which the free and the imperial cities rubbed shoulders, was held in Frankfurt. First and foremost, however, the middle Rhineland provided a platform for constitutional change, for what went under the name of 'imperial reform': Worms lay halfway between Mainz and Heidelberg. At the Imperial Diet held there in 1495, Maximilian, pressed hard by the Turks and the French, tried to reach broad agreement with the leading estates. The use of mercenary armies had vastly increased the cost of military campaigns, so that the king was badly in need of financial assistance. At Worms, a detailed compromise was reached, but one that both sides tried to turn to their own advantage. It was only in retrospect that 1495 was seen, not as a particularly eventful year, but as a perfectly normal one. The main spokesman of the 'constitutional' party – by the side of supporters among the estates of political dualism – was the archbishop of Mainz,

Berthold von Henneberg (1484-1504). No modern political ideas were voiced; all that happened was that in return for financial assistance some of the royal prerogatives were tempered in favor of the strongest estates. The main achievements of Worms were the Perpetual Peace, that is, the imperial ban on feuds which was finally implemented after a generation had passed, thus confirming or rather creating the empire as a law-giving institution; reorganization of the royal supreme court in which the estates gained greater say; and the imposition of a general imperial tax (at first for four years) as well as the creation of a central, corporative tax authority controlled by seven imperial treasurers in Frankfurt-on-Main. Even more important, however, was an unexpected side result: the *de facto* legitimization of the Diet as the organ of maturing institutionalized political dualism. By the side of the extended imperial court, the Diet became the second most important political forum in the empire, and hence the largest and foremost assembly of estates in all Europe. Institutionalized dualism eventually became the basis of German government.

¶ Though many of these developments had foreign parallels, in Germany alone were they grounded in a consensus impaired very little by the Reformation or even by growing confessionalism. Because neither side was strong enough to subdue the other, the weaker princes were not crushed by a central, hereditary dynasty, as happened elsewhere. Admittedly the process was laborious, slow and incomplete. However, the German consensus had a spatial dimension and a material complexity without equal in Europe, and was, moreover, a consensus of nobles not yet accustomed to long-term commitments or to written agreements, and lacking in the appropriate financial skills. The understandable desire of the estates to have as much say as possible while also expecting the king to shoulder most of the financial burden soon proved illusory.

¶ Even while the empire was laboring hard to extend its political influence, the modern state kept maturing in the constituent lands. The concentration of feudal rights, which differed from place to place, gradually led to the emergence of a form of territorial sovereignty. This process was not a purely legal one, however, but also involved violence and chance. Many of the smaller princes fell by the wayside or lost out to their stronger rivals. The vanquished then banded together with prelates and towns and organized themselves into estates. The two-dimensional nature of the historical map tends to exaggerate the cohesion of the Rhenish territories. Conditions could differ from one village to the next. The ultimate object of the sovereign state, namely the assimilation of all its subjects, had in many cases to wait for the modern age: by the side of apparently rectilinear 'modern' develpments, accidental and incalculable factors continued to hold sway.

¶ Nevertheless, modernization led to an increase in public duties that were increasingly concentrated in the hands of the territorial administration. The traditional fragmentation of public authority was reduced by the princely state, the prince extending his ancient privilege of dispensing justice and preserving the peace, to embrace many other spheres of life for the common good, as he saw it. The constitution became the instrument of the overlord, helping him to hold back and humble the minor nobles. The princes were the great political champions even in the age of the Reformation.

¶ These developments had external repercussions and led to the creation and defense of hegemonial spheres of influence. As a result, the traditional political plurality was reduced in practice until only a few hegemonial powers enjoyed any real freedom of manoeuvre in the empire. In this process, the Rhenish territories clearly lost out to the territories in the east. This change was preceded by a shift of influence from the spiritual to the temporal princes.

¶ The middle Rhineland, including Hesse which does not concern us here, was one of the empire's fourteen political entities, each with its own interplay of forces. Political life in the empire was still based on strong regional structures that needed major challenges before they became polarized or even organized for however short a period. To the north lay the lower Rhenish political system, followed in a clockwise direction by Wettin-middle Elbe, Franconia, Swabia-Alsace and Lothringia-Trier. The middle Rhenish system had a bipolar organization, the two main forces in it being the electorate of Mainz and the electorate of the Palatinate, two of the most renowned electorates. The contrast between them was a century-old and widely acknowledged feature of imperial history. Each of the two constituted an independent hegemonial sphere. The Palatinate included the bishoprics of Worms and Speyer and the free cities by the same name, the margravate of Baden, a number of counties and seignories (demesnes) as well as ecclesiastical territories, other towns and a widely scattered lower nobility.

¶ By virtue of their venerable history, their diffuse powers and their involvement in the affairs of Pope and king, the archbishops of Mainz, who as metropolitans of the largest German ecclesiastical province were also the most distinguished of imperial princes, had failed despite great exer-

tions to gain control over a compact territory in the middle Rhineland. They were left with relatively small districts, especially in the Rhinegau and also on the Main round Aschaffenburg. Even Mainz itself eluded their grasp until 1462. Beyond that they were involved in a number of more or less protracted conflicts with various rivals. Besides the count Palatine, their most dangerous enemy in the middle Rhineland was the landgrave of Hesse. In the early fifteenth century, its defeat by Hesse had forced the electorate of Mainz into second place in the race for political power. Hardly less crucial was the effect of the four Mainz cathedral feuds between the simultaneously elevated and more or less equally qualified claimants to the archbishop-elector's throne, which ate away the substance of the archiepiscopal see. Lastly, Mainz's championship of the house of Nassau also had a most adverse effect. In the end, Archbishop Adolph II of Nassau (1463-75), who had emerged as the victor of the last great episcopal feud (1461-63), was forced to take service as the emperor's chancellor to relieve the financial distress of his archbishopric. His escutcheon may have been included in the Housebook (fol. 1). In 1460, his rival and later successor Dieter II of Isenburg (1475-82) had been defeated by the elector of the Palatinate, with consequent losses of territory and even greater losses of money, plunging him into debt. Archbishop Berthold of Henneberg (1484-1504) once again went to the brink of war with the Palatinate. He tried to save the almost bankrupt electoral archbishopric by advocating imperial reforms of a 'constitutional' type. In about 1495 his attempts were crowned with success, albeit for a short time only. The rival in the south, the electorate of the Palatinate, next to Bohemia the highest-ranking secular princedom in the empire, had been in the hands of the Wittelsbach dynasty since 1214. They had not forgotten the royal status they had enjoyed under Louis of Bavaria (1314-47) and under Ruprecht (1400-10). After the extinction of the Luxemburg line in 1437, the Wittelsbachs, who also ruled over the Bavarian duchies, were second in renown and influence only to the imperial house. Beyond that, they held various 'super-princely' positions under the imperial constitution, amongst them the imperial vicariate, that is, they represented the emperor in the west of the empire. Frederick the Victorious, count Palatine (1449-76), aimed at maximum political influence over the territory, especially from 1463 to 1475 when one of his relations was archbishop of Cologne. His ruthless pursuit of power politics culminated in the subjection of all neighboring princes; Frederick did not even flinch from violent clashes with the emperor. In

1462, he humiliated his opponents at Seckenheim. In his day, the political map of the region – the middle Rhineland, the Franconian upper Rhineland and Hesse – more than ever resembled that of a Palatine hegemonial system. It is generally agreed that the electorate of the Palatinate more or less doubled its size in the fifteenth century. If the Housebook Master, as seems likely, worked for a time at the Palatine court, he was, in fact, serving the mightiest dynasty in the region. Even so, the Palatinate was vulnerable: its power base did not fully warrant the pretensions of its ruler. In other words, its power politics did not have adequate foundations unless, as with the electorate of Mainz, ancient sovereign rights were taken into consideration. The actual territory was not particularly large and was, moreover, highly fragmented; hence what was needed was the feudal, 'social' or hegemonial adherence of a large number of 'satellites.' In the same region, however, Frederick's expansionist drive had helped to create a circle of potential enemies who could only be subdued temporarily. Frederick's legal status, too, was uncertain. He declared himself guardian of the legitimate heir, his young nephew, and arrogated to himself the dignity of prince-elector under Roman law. The emperor voiced his disapproval and in 1474 pronounced the imperial ban which he was, however, unable to enforce because the Palatinate was too powerful. Frederick's successor, Philip the Handsome (1476-1508), also clashed with the emperor when he signed a treaty with the French king in 1492 and, moreover, did his utmost to obstruct the imperial reforms in the Diet. However, when it came to the Bavarian (Landshut) succession, the Palatinate really did overreach itself. The result was a crushing defeat at the hands of a coalition which the emperor himself eventually joined. The neighbors now extorted payment for their long years of subjection. With the collapse of the last of the great powers in the Rhineland, the center of gravity of German politics shifted eastwards for centuries to come.

¶ In the middle and upper Rhineland, the Housebook Master may also have come into contact with the smaller, politically dependent territories: the archbishoprics of Worms and Speyer, whose rulers were in almost continuous conflict with the free cities by the same names; with the many ducal houses which, after the death of the count of Katzenelnbogen (1479), were led by Nassau; or perhaps with the counts of Hanau and Epstein, whose escutcheons may have been preserved in the Housebook, and finally, in the Odenwald, with the Cupbearers of Erbach. The king had protected the weak against the strong for

so long that along the Rhine an unusually large number of minor nobles had been able to preserve at least some of their privileges. In the sixteenth century, some of them would become Knights of the Holy Roman Empire. At the time, few could have realized what historians know today, namely that their decline and growing political dependence were inevitable. The nobility at large still seemed a political force to be reckoned with and so was the restlessness of the 'common man.' The tense atmosphere partly reflected the hostility of the lower nobility to the princes and the cities. Only the Perpetual Peace of 1495 was to put a stop to impetuous recourse to the sword. The chivalrous orders had still wielded considerable power under Emperor Sigismund (1410-37), Frederick III's predecessor. Theirs was an old tradition; the Order of the Ass had been founded as early as 1387 not far from the Palatinate. Many, but by no means all members of these orders lived in straitened circumstances; in fact, the lower nobility ranged from paupers to men of great wealth. In that respect, the differences between them were no smaller than those between citizens or peasants. Beyond that, the 'indispensability of the nobility as an estate' (V. Press) was a characteristic of the age. No territory could dispense with their collaboration.

¶ The Housebook Master paid particular attention to the court, that social structure fostered by the emperor and the high nobility and frequented by the lower nobility, by patricians, jurists, humanists and administrators. The court was, in fact, the 'show window' of princely life, as well as the workshop of the nascent state. The Palatine court in Heidelberg seems to have been particularly attractive to artists, but so also was the emperor's temporary residence on the Rhine and in the Netherlands. It would be wrong to look upon the court as an old-fashioned or outdated institution or to consider it an irrelevance. Its assimilation of the nobility met an essential political need, especially in the Palatinate. Festivals, tournaments, hunts, banquets and dances, as depicted in the drawings of the Housebook Master, were not only expressions of courtly entertainment, but reflected the power and centripetal pull of the prince just as surely as did castles and offices. Here and there, the territorial state began to take faltering steps into the modern age. For any innovations to be effective, they had first to be accepted by the prince's entourage – the administration of the territory was still inseparable from the court. Political life in the territories and in the empire was essentially vested in the nobility, sometimes enlarged with new elements under their sway. Although the creation of new official posts at the end of the Middle Ages opened the door to ambitious outsiders, the potentially explosive effects of money and technical knowledge were neutralized by the social predominance of the court. State officials of bourgeois origin, some of whom may perhaps be recognized in the Housebook, cultivated noble manners or even vied with the nobility. At the Heidelberg court, in particular, a small caste of bourgeois, legally trained officials close to the nobility and enjoying the prince's favor first appeared in the late fifteenth century. Humanism, too, gained admission in about 1470. Under the patronage of Johann Kammerer of Dalberg (chancellor from 1478), who was to become bishop of Worms four years later (died 1503), the Netherlander Rudolf Agricola (1483), followed by Konrad Celtis, the 'arch-humanist' (1484-85 and 1490-91) and by Johannes Reuchlin (1496-99), all flocked to the court. The Sodalitas Litteraria Rhenana, founded in Mainz in 1491, provided them with a welcome forum. It may well be that some feature in the work of the Housebook Master which seems less 'medieval' than the rest, for instance his accurate observation of nature and his naturalistic representation of men, was a graphic expression of such 'modern' views.

¶ At the end of this survey, the historian must confess that he would have liked to be able to establish closer links between the artist's life and work, even though many details in his drawings and panel paintings seem to lack the individual, personal stamp. This applies above all to scenes of clerical, urban and rural life.

¶ There seems to have been an odd contradiction in the attitude of his generation to matters spiritual or clerical on the one hand and to profane affairs on the other, and this was not reflected in his work alone. While medieval piety was never more multi-faceted and intense than it was immediately before the Reformation, it seemed to go hand in hand with the emergence of powerful and successful worldly elements. It is not difficult to imagine the resulting tensions as the new contributions of a very richly endowed and yet unpredictable generation took their place beside the old – there was room enough for both. This juxtaposition was reflected in the action of the princes, and not least of the count Palatine who, long before the Reformation, felt no less responsible for church life in his territories than he might have felt for an established church in the sixteenth century. Decline and renewal, too, often went hand in hand – much as they did in the chivalrous orders of the age. If we remember the considerable loss of church privileges (tithes, jurisprudence) and of traditional preserves (reading and writing), we appreciate that many further changes must have been expected. However, fun-

damental reforms foundered on the absence of adequate analytic tools – they would have been an anachronism – and also on the inherent nature of what was evidently an immutable overall structure. For the church was simply a mirror image of society at large; the clergy, for instance, consisting of rich prependaries at one extreme and paupers at the other, the two having opposing interests. The questions of whether the reforms were successful or not, and of who were the victors and who the vanquished, could not be answered until the sixteenth century. The previous age – the world of the Housebook Master – was one of new initiatives and ferment, but also the age of a generation that had not yet made up its mind.

¶ Urban life seems to have taken second place in the work of our artist, notwithstanding his remarkably 'realistic' approach, unless, of course, the technical drawings and sketches in the Housebook were by his hand as well. If so, he must have been keenly interested in mining, probably the most advanced technical field at the time. The so-called Planet pictures in the Housebook also depict various, often highly skilled, craftsmen (goldsmiths, clockmakers, wood-carvers, organ-builders).

¶ Despite their diminishing political weight, the towns played an increasingly important economic role. This was particulary true of the larger amongst them, in which the accumulation of capital was reflected in quick economic and technical progress. At the same time, there also emerged the first German generation to look upon this transformation as a problem. The land-owning aristocracy had been trying for some time to keep the urban patricians at bay, while the princes found the services of wealthy and well-educated townsmen as indispensable as ever. The year 1470, as we said earlier, brought a prolonged economic revival, the causes of which have not yet been fully understood. The leading commercial center was Frankfurt; even the Heidelberg court did its marketing there. Its two annual fairs caused a considerable twice-yearly influx and outflow of resources. The main products of the middle and upper Rhineland were wine, grain and timber. In addition, they supplied the middle-Rhenish and Hessian clothmakers with wool and dyestuffs. Speyer and above all Frankfurt were important money markets – after Augsburg and Nürnberg, Frankfurt was, in fact, the third greatest link in the chain of money, technology and labor from which upper German commercial capitalism was to develop into an international force in the sixteenth century. The growing dynamism of this process was already perceptible to the last fifteenth-century generation. It went

with an acceleration of the educational process, marked first of all by the emergence of urban schools. The increase in the number of university students no doubt gave rise to a greatly increased number of job-hunters, a development that must have worried churches, rulers and municipal authorities alike. The new urban intelligentsia – lawyers, doctors, clerks and 'engineers' – also included the leading artists. At the same time, the price of economic progress became apparent: the gulf between rich and poor seems to have widened, the broad masses being forced to do unskilled, badly paid and precarious labor and depending increasingly on the goodwill of their employers.

¶ The economic and social structure of the late Middle Ages, still a predominantly agricultural one – some eighty percent of the population was engaged on the land – is reflected no more than marginally in the work of the Housebook Master. Peasants to him were objects of ridicule or amusement or victims of circumstance; in any case their reactions were passive.

¶ Middle and upper Rhenish agriculture was fairly well developed; it was based on the cultivation of the vine, vegetables and various industrial plants, depending on natural circumstances and market forces. It also produced wheat of course, the staple diet. The smaller towns had particularly close links with the country. Historians are not agreed on the alleged increase in the rural population of the middle Rhineland and the Franconian upper Rhineland towards the end of the fifteenth century. Such an increase was indeed recorded in the lower Rhineland and in Swabia, but is disputed in the case of Alsace. If it did occur then, the fairly static demand for agricultural labor would have brought about an increase in the land-hungry or landless rural masses and with it a growth in social tensions. In general, wheat prices began to rise in about 1470, after a long depression; in the sixteenth century they rose faster than the price of industrial products. In this respect, too, an older trend was reversed. The new agricultural boom had a rather uneven effect. In the more highly developed villages, the typical peasant worked independently and marketed his own produce; his property rights were close to hereditaments. He too, of course, suffered periodic crop failures and hard times; these do not seem to have become rarer after 1470. This fact, the possible increase in population with all its consequences, and the expansion of territorial sovereignty to which we referred earlier, must have been so many growing burdens for the peasantry. Traditional property relations continued unchanged; princes, overlords, tithe lords, lords of the manor and what have you, continued

to press old or even new claims, especially when they themselves were hard up. In Alsace, the peasants rose up in 1493; this was followed in 1502 by the 'Bundschuh,' an attempt at a general peasants' revolt led by Joss Fritz from Untergrombach near Bruchsal. Neither the economic situation on the land nor a trans-regional, long-term 'revolutionary' tradition can be blamed for these risings. Every case must thus be judged on its own merit – often with very little documentation. Before the unrest could spread there had first to be a fresh upsurge of religious fervor.

¶ The Housebook Master's observations of rural life may well have been typical: he lived in a stimulating and exciting age, as well as a complex and tense one, now and then beset with crises. However, the situation was not yet explosive. Moments of great excitement might become moments of artistic stimulation and innovation, but equally they could encourge the more accurate representation of a past that continued to make its presence felt. We would like to be more certain about it all but as long as our artist cannot be identified and given a name of his own, we must content ourselves with fixing his position with the help of a general system of historical co-ordinates.

Important literature

Abel, Wilhelm, *Agrarkrisen und Agrarkonjunktur*, part 3: *Hamburg*, Berlin 1978.

Alter, Willi, 'Das Hochstift Speyer links des Rheins um 1500,' *Bulletin für pfälzische Kirchengeschichte und religiöse Volkskunde* 46 (1979), pp. 9-37.

Andermann, Kurt, *Studien zur Geschichte des pfälzischen Niederadels im späten Mittelalter*, Speyer 1982.

Beck, Hans-Georg et al., *Die mittelalterliche Kirche*, vol. 2 (*Handbuch der Kirchengeschichte*, ed. Hubert Jedin, III, 2), Freiburg etc. 1968.

Blickle, Peter, 'Bäuerliche Erhebungen im spätmittelalterlichen deutschen Reich,' *Zeitschrift für Agrargeschichte und Agrarsoziologie* 27 (1979), pp. 208-31.

Brockmann, Hartmut, 'Zu den geistigen und religiösen Voraussetzungen des Bauernkrieges,' in *Bauernkriegs-Studien* (Schriften des Vereins für Reformationsgeschichte, 189), ed. Bernd Moeller, Gütersloh 1975, pp. 9-27.

Cohn, Henry J., *The government of the Rhine Palatinate in the fifteenth century*, Oxford 1965.

Der deutsche Bauernkrieg, ed. Horst Buszello, Peter Blickle and Rudolf Endres, Paderborn etc. 1984.

Deutsche Verwaltungsgeschichte, vol. 1, Stuttgart 1983.

Drollinger, Kuno, *Kleine Städte Südwestdeutschlands* (Veröffentlichungen der Kommission für geschichtliche Landeskunde in Baden-Württemberg, 48), Stuttgart 1968.

Ennen, Edith and Walter Janssen, *Deutsche Agrargeschichte* (Wissenschaftliche Paperbacks, 12), Wiesbaden 1979.

Ernst, Fritz, 'Kurfürst Friedrich I., der Siegreiche von der Pfalz, 1425-1476,' *Saarpfälzische Lebensbilder* 1 (1938), pp. 45-59.

Eulenburg, Franz, 'Zur Bevölkerungs- und Vermögensstatistik des 15. Jahrhunderts,' *Vierteljahrsschrift für Sozial- und Wirtschaftsgeschichte* 3 (1895), pp. 424-67.

Geschichte der deutschen Länder, vol. 1, *Territorien-Ploetz*, ed. Georg Wilhelm Sante and A.G. Ploetz-Verlag, Würzburg 1964.

Handbuch der historischen Stätten Deutschlands, vol. 4, *Hessen*, ed. Georg Wilhelm Sante, Stuttgart 1975-76; vol. 3, *Rheinland-Pfalz und Saarland*, ed. Ludwig Petry, Stuttgart 1976; vol. 6, *Baden-Württemberg*, ed. Max Miller, Stuttgart 1980.

Karst, Theodor, *Das kurpfälzische Oberamt Neustadt an der Haardt*, Speyer 1960.

Luther und die politische Welt (Akademie der Wissenschaften und der Literatur, Mainz, *Historische Forschungen*, 9), ed. Erwin Iserloh and Gerhard Müller, Wiesbaden and Stuttgart 1984.

Lutz, Heinrich, *Das Ringen um deutsche Einheit und kirchliche Erneuerung* (Propyläen Geschichte Deutschlands, 4), Berlin 1983.

Martin Luther und die Reformation in Deutschland, Frankfurt am Main 1983.

Meuthen, Erich, *Das fünfzehnte Jahrhundert* (Oldenbourgs Grundriss der Geschichte, 9), Munich and Vienna 1980.

Moraw, Peter, 'Die kurfürstliche Politik der Pfalzgrafschaft im Spätmittelalter, vornehmlich im späten 14. und im frühen 15. Jahrhundert,' *Jahrbuch für westdeutsche Landesgeschichte* 9 (1983), pp. 45-97.

—, *Offene Verfassung und Verdichtung: das Reich im späten Mittelalter, 1250-1490* (Propyläen Geschichte Deutschlands, 3), Berlin 1985.

—, *Wahlreich und Territorien: Deutschland 1273-1500* (Neue Deutsche Geschichte, 3), Munich 1985.

Pabst, Hans, *Die ökonomische Landschaft am Mittelrhein vom Elsass bis zur Mosel im Mittelalter*, Frankfurt am Main 1930.

Pitz, Ernst, *Wirtschafts- und Sozialgeschichte Deutschlands im Mittelalter* (Wissenschaftliche Paperbacks, 15), Wiesbaden 1979.

Press, Volker, 'Der deutsche Bauernkrieg als Systemkrise,' *Giessener Universitätsbulletin* 11 (1978), part 2, pp. 114-35.

—, 'Führungsgruppen in der deutschen Gesellschaft im Übergang zur Neuzeit um 1500,' in *Deutsche Führungsgruppen in der Neuzeit: ein Zwischenbilanz*, ed. Hanns Hubert Hofmann and Günther Franz, Boppard 1980, pp. 29-77.

—, 'Soziale Folgen der Reformation in Deutschland,' in *Schichtung und Entwicklung der Gesellschaft in Polen und Deutschland im 16. und 17. Jahrhundert* (VSWG Beiheft 74), ed. Marian Biskup and Klaus Zernack, Wiesbaden 1983, pp. 196-243.

Die Protokolle des Mainzer Domkapitels, vol. 1, *1450-1484*, ed. Fritz Hermann and Hans Knies, Darmstadt 1976.

Rapp, Francis, 'Die soziale und wirtschaftliche Vorgeschichte des Bauernkrieges im Unterelsass,' in *Bauernkriegs-Studien* (Schriften des Vereins für Reformationsgeschichte, 189), ed. Bernd Moeller, Gütersloh 1975, pp. 29-45.

Rhein-Neckar Land, ed. Eugen Herwig, Mannheim 1968.

Schaab, Meinrad, 'Grundlagen und Grundzüge der pfälzischen Territorialentwicklung,' *Geschichtliche Landeskunde* 10 (1974), pp. 1-21.

—, 'Bergstrasse und Odenwald,' *Oberrheinische Studien* 3 (1975), pp. 237-65.

— and Peter Moraw, 'Territoriale Entwicklung der Kurpfalz (von 1156 bis 1792),' in *Pfalzatlas*, ed. Willi Alter, Speyer 1964, maps 50-53, text vol. 11, pp. 393-428.

Schindling, Anton, 'Kirchenfeindschaft, Reformation und Bauernkrieg,' *Zeitschrift für historische Forschung* 4 (1977), pp. 429-37.

Schröcker, Alfred, *Unio atque concordia*, diss. Würzburg 1970.

Schulze, Winfried, 'Aufruhr und Empörung?,' *Zeitschrift für historische Forschung* 9 (1982), pp. 63-72.

Spiess, Karl-Heinz, *Lehnsrecht, Lehnspolitik und Lehnsverwaltung der Pfalzgrafen bei Rhein im Spätmittelalter* (Geschichtliche Landeskunde, 18), Wiesbaden 1978.

Die Stadt am Ausgang des Mittelalters (Beiträge zur Geschichte der Städte Mitteleuropas, 3), ed. Wilhelm Rausch, Linz 1974.

Die Stadt an der Schwelle zur Neuzeit (Beiträge zur Geschichte der Städte Mitteleuropas, 4), ed. Wilhelm Rausch, Linz 1980.

Stromer von Reichenbach, Wolfgang Freiherr, 'Die oberdeutschen Geld- und Wechselmärkte,' *Scripta Mercaturae* 1 (1976), pp. 23-49.

1000 Jahre Mainzer Dom (975-1975): Werden und Wandel, ed.

Wilhelm Jung, Mainz 1975.

Vaughan, Richard, *Charles the Bold*, London 1963.

Volkert, Wilhelm, 'Pfälzische Zersplitterung,' *Handbuch der bayerischen Geschichte*, ed. Max Spindler, vol. 3, part 2, Munich 1971, pp. 1289-1349.

Wiesflecker, Hermann, *Kaiser Maximilian I.*, 4 vols., Munich 1971-81.

Zwischen Rhein und Mosel: der Kreis St. Goar, ed. Franz-Josef Heyen, Boppard 1966.

THE CATALOGUE

The catalogue includes all the works that can reasonably be assigned to the Master or his immediate circle. The list in the outer margins offers additional information concerning each entry.

Works exhibited in Amsterdam are marked with an asterisk, for example 7.1*.

The works are divided into the following categories:

PRINTS [1-116]

The prints are all reproduced in actual size; the illustrations of impressions in Amsterdam were made directly from the originals.

The titles of prints by the Master of the Amsterdam Cabinet (or the Housebook Master) and Master b x g are followed by references to the catalogues of their works compiled by Lehrs in 1893 and 1932. The former is cited as LI and the latter as LII. For the complete titles, see the 'Abbreviations of frequently cited literature' (p. 8).

In the outer margins is a list of all known impressions of the prints. When more than one impression has survived, the various examples are indicated with Arabic numerals following the catalogue number, for example 75.1, 75.2. The entries on prints by the Master [1-91] contain the most accurate available information on provenance, quality of the impression and condition of each print. See the 'Explanatory note on the drypoints,' pp. 91-93. The entries on prints by other engravers are less detailed.

The list in the outer margin also contains a brief mention of the known copies and works by other artists that can be linked to the print in question. These works are indicated with lower-case letters following the catalogue number, for example 7a, 7b, 51a.

MANUSCRIPTS [117-20]

The Housebook itself [117], which could not be studied by the author of the catalogue, is treated by Jane C. Hutchison. The black-and-white illustrations of drawings from the Housebook are taken from the 1912 facsimile edition by Bossert and Storck. In addition to the Housebook, three other manuscripts are also included, whose miniatures are attributed to the Master.

DRAWINGS [121-30]

¶ Of the large number of drawings that are attributed to the Master, the ten most important have been included. Nearly all of them are reproduced in actual size.

PAINTINGS [131-33]

¶ As in the case of the drawings, a sifting has taken place among the many paintings attributed to the Master. Included are those that the author finds the most convincing: the panels of the so-called *Speyer Altar* [131], those of the so-called *Mainz Life of the Virgin* [132] and the *Pair of lovers* [133] in Gotha.

¶ In the exhibition several panels from the altars are displayed [131d, 132d-e] alongside photographic documentation on the infrared reflectograms of the underdrawing of some of the paintings.

STAINED GLASS [134-39]

¶ None of the many attributions of stained-glass panels to the Master can be termed secure. The examples included in the exhibition and catalogue are related to the work of the Master in any of a number of ways.

BOOKS WITH WOODCUT ILLUSTRATIONS [140-42]

¶ Illustrations from dozens of German incunabula (books printed before 1500) have been discussed by scholars in connection with the work of the Master. Only a few of these attributions, which are on the whole unconvincing, are included. Among these are two books whose woodcuts were designed by Erhard Reuwich and which form the central evidence in the case for his identification with the Master.

DRYPOINTS

Explanatory note on the catalogue of drypoint prints

ORDER OF LISTING

Lehrs's oeuvre catalogue of 1893 (see p. 51), the first to reproduce all of the Master's prints, contained 89 entries. Lehrs's attributions have never been cast into serious doubt, and his numbering has been used in most subsequent literature. In the present catalogue, these numbers are abbreviated *LI*. Unfortunately, Lehrs himself, in 1932, introduced a second numbering, in the section of his *Geschichte und kritischer Katalog des deutschen, niederländischen und französischen Kupferstichs im XV. Jahrhundert* (vol. 8) devoted to the works of the Master. Those numbers are also included in the present catalogue, referred to as *LII*. One of Lehrs's reasons for the change was his inclusion of two new prints [**90, 91**], which, however, have never met with general acceptance. In other respects as well, the second numbering is less satisfactory than the first, so that few later specialists have adopted it. In the present catalogue, both numbers are given after the title, but the order of the 1893 listing is followed, with a few departures.

TITLES

The traditional titles, mainly derived from Lehrs, are used in all cases except where terminological consistency or iconographic accuracy dictated otherwise.

DATING

The chronology of the Master's prints is analyzed on pp. 29-34. None of the prints is dated securely, and only a few are known to have been made before a certain fixed date [**5a, 7a, 75a**]. The dates in the catalogue are therefore hypothetical, and should be seen in that spirit.

COLLECTIONS OF THE MASTER'S PRINTS

Of the 124 known impressions printed from the 91 plates assigned to the Master, no fewer than 80 are the property of the Rijksprentenkabinet. Of the remaining 43 impressions, 8 are in Vienna, 6 each in Coburg, Paris and London, 3 in Oxford, and the rest in collections that do not own more than one or two at the most.

¶ The provenance of most of the prints goes back to one of two eighteenth-century collections, those of Georg Friedrich Brandes (1719-91) and Pieter Cornelis, Baron van Leyden (1717-88).

¶ The collection of Hofrat Brandes of Hannover, which was auctioned by Weigel in Leipzig on 18 April 1795, contained at least ten prints by the Master, catalogued as Schongauers. At the sale, four were acquired by the Albertina in Vienna [**1**, **2**.1, **3**, **7**.2] and six by Veste Coburg [**13**.3, **54**.2, **73**.2, **74**.2, **75**.1, **89**.2].[1]

¶ The largest eighteenth-century collection of the drypoints was that of Pieter Cornelis, Baron van Leyden, who lived in Leiden and whose extensive print collection was acquired in 1807 by the Koninklijke Bibliotheek (Royal Library) in The Hague. We do not know where van Leyden bought the prints. He often purchased collections *en bloc*, and it is not unlikely that the drypoints came to him mounted in an album. The inventory of his collection, drawn up between 1760 and 1780, indicates that they were kept in portfolio 20, entitled 'Onbekende Meesters - Kopersnee' (Anonymous masters - engravings). Pencilled annotations in the inventory inform us that 84 of the prints in portfolio 20 were mounted on 25 sheets, probably of thick gray cartridge paper, called 'olifant' (elephant) in Dutch.[2] Of the 84, 82 are still in Amsterdam. Two are now assigned to other artists, although they are close in format and style to the Master's drypoints.[3] The missing two prints are now in the Bibliothèque Nationale in Paris. The reason for this lies in a forgotten incident of European history. Under Napoleon, the Netherlands were incorporated into France, and in 1812, as part of the policy of artistic centralization, the French transferred more than ten thousand prints from the van Leyden collection

EXAMPLE

7.1*
Amsterdam, Rijksprenten-
kabinet (van Leyden collec-
tion, port. 20, nr. 89, as
'David die den Afgod aanbid'
(David worshipping the
idol): sheet 25; Koninklijke
Bibliotheek, 1807; Paris,
1812-16, nr. 63; inv.nr.
OB:871): very good impres-
sion, diameter 155 mm.
(trimmed along and partly
through the outline; small
areas of damage along the
edge; restored tear along the
left edge, partly through
Solomon's billowing cape).

EXAMPLE EXPLAINED
number: **7**.1*
7: Catalogue number of the
plate **Solomon's idolatry**.
1: The first of three preserved
impressions.
*: Included in the exhibition.
collection: Amsterdam,
Rijksprentenkabinet
[printroom of the
Rijksmuseum, Amsterdam.]
provenance: Van Leyden
collection [according to
collector's inventory]
port[folio] [nr.] 20, [item] nr.
89, as 'David die den Afgod
aanbid,' [mounted on] sheet
[nr.] 25; [acquired by the]
Koninklijke Bibliotheek
[Royal Library in The Hague
in] 1807; [transferred to]
Paris, [where it remained in
the years] 1812-16, [as] nr. 63
[of the inventory of prints
from portfolio 20 that were
taken to Paris]; [present
inventory nr.] OB:871.
printing quality: very good
impression.
dimensions: diameter 155 mm.
condition of the impression:
trimmed along and partially
through the outline; small
damages along the edge;
restored tear along the left
edge, partly through
Solomon's billowing cape.

from the Koninklijke Bibliotheek to Paris. Among them were at least 65 of the Master's prints from portfolio 20. When the prints were examined in November 1816 in advance of their repatriation, the *Samson* [6] was found to be missing. Together with the *Pair of lovers* [75] and probably the *Virgin and child on the crescent moon, with book and starry crown* [25], which van Leyden attributed to Hopfer, it remained in Paris. The latter two are missing from the list of appropriated prints.[4] After being returned to the Netherlands, the van Leyden collection was brought to the Rijksmuseum in the Trippenhuis, where it formed the nucleus of the Rijksprentenkabinet, the National Printroom.

¶ In the present catalogue, the prints from the van Leyden collection are identified by inventory number in portfolio 20, the sheet on which the print was mounted and, where applicable, the number of the print on the list of items from portfolio 20 that were sent to Paris. The provenance of the other prints is also given as accu-

rately as possible. The date following the name of a collection indicates when the print was sold to a new owner.

DIMENSIONS

¶ In the case of prints that have been preserved in one impression only, the dimensions of that impression are given. For prints known in more than one impression, the dimensions of the most complete example are given after the title, and those of all the existing impressions in the marginal list. All dimensions are in millimeters. Very seldom is it possible to determine how large the printing plate was. Most impressions are trimmed within the platemark, many within the outlines of the print, and several to the image. In none of these cases is the platemark visible.

PRINTING QUALITY

¶ As discussed above (p. 34), the printing quality of the various drypoints shows considerable variation. Of outstanding quality are the prints with

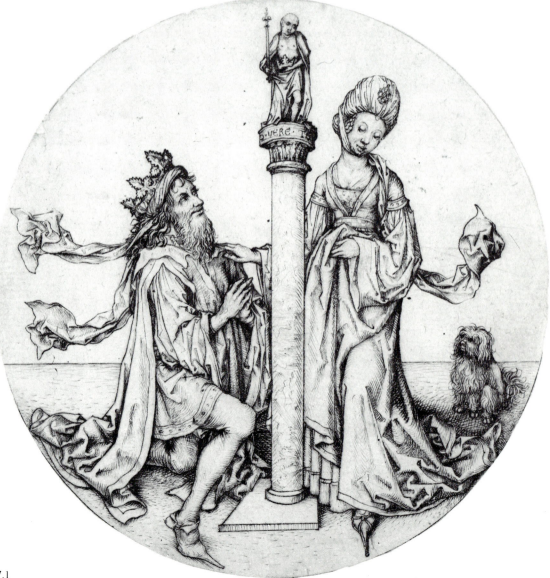

deep black drypoint passages, such as **30**, where the drawing cannot always be made out. Somewhat later but still good impressions show the drypoint lines without the heavy black areas. In several examples, such as **9**.2, **26**.3, **49**, **55** and **60**, only late, gray impressions have survived. Not only are the drypoint passages lost, but even some of the lines themselves. The printing, even of plates in good condition, is not always sharp, probably because the ink did not always sink deeply enough into the grooves. This is true of **22** and **28**. In one case [**45**] the plate seems to have slipped in the press. Some of the plates were marred by small pockmarks and pinpricks [**9, 50, 54, 75**], fine scratches [**16, 21, 77**] and even cracks [**45, 49**], which show up clearly in the printing.

ⷪONDITION

Aside from the close trimming and frayed edges of many of the prints, some also show paint stains [**5, 6, 38** and others] and a damaged surface. Several of the Amsterdam impressions have undergone rather heavy restoration, in the course of which stains were removed mechanically by

being scratched or burnished out. Uneven or damaged edges were sometimes filled out with pulp. The brush retouchings on several of the Amsterdam impressions were probably done at an early period. Some of them have been washed in the shadows by brush [**18, 19, 32**], and in others the drawing itself has been supplemented with brushwork [**66, 79, 85**]. In one case an impression is covered with body white, nearly as a miniature would be [**29**.1], and in another the contours have been pricked through [**45**].

WATERMARKS

¶ All of the few known watermarks are given in the catalogue. In APPENDIX I (pp. 285-88), the information on the watermarks is summed up.

LITERATURE

¶ In the notes, references to previous literature are largely limited to post-1972 publications and to the complete citations of earlier literature in Jane C. Hutchison, *The Master of the Housebook*, New York 1972 (cited as Hutchison 1972).

ⷧes

Hutchison 1972, p. 21.
Filedt Kok 1983, p. 427.
Ibid., p. 436, note 11. The prints are *Head of Christ with the crown of thorns*, Lehrs, vol. 4, p. 232, nr. 24, as by anonymous

artist from the school of Schongauer, and the *Head of an old man* by Wenzel von Olmütz, Lehrs, vol. 6, p. 238, nr. 57.
4. Filedt Kok 1983, p. 436, notes 10, 12.

1*
Vienna, Albertina (Brandes
coll., 1796; inv.nr. 309/1928):
very good impression,
129 x 53 mm. (with
platemark).
2.1*
Vienna, Albertina (Brandes
coll., 1796; inv.nr. 310/1928):
very good impression,
131 x 56 mm. (with
platemark).
2.2*
Amsterdam, Rijksprenten-
kabinet (van Leyden coll.,
port. 20, nr. 49: sheet 10;
Koninklijke Bibliotheek,
1807; Paris, 1812-16, nr. 35;
inv.nr. OB:868): good im-
pression, 121 x 47 mm.
(trimmed to the image, with
traces of red paint spots).
3*
Vienna, Albertina (Brandes
coll., 1796; inv.nr. 311/1928):
good impression,
130 x 54 mm. (with
platemark).

1-4. Four prophets
(Lı and Lıı, 1-4), ca. 1475

1. First prophet
Drypoint, unique impression, 129 x 53 mm.

2. Second prophet
Drypoint, two known impressions, 131 x 56 mm.

3. Third prophet
Drypoint, unique impression, 130 x 54 mm.

4. Fourth prophet
Drypoint, unique impression, 120 x 41 mm.

¶ In the Middle Ages, many northern artists depicted prophets and sibyls as heralds of Christ's coming: in the form of statues in larger architectural settings or of grisaille figures in niches on fifteenth-century Flemish altar shutters. Though there were no comparable represen-

tations of prophets in niches in fifteenth-century graphic art, it is possible that the Master modelled his work on similar figures in fifteenth-century south Netherlandish *painting*.[1]

¶ A woodcut of the prophet accompanied by a sibyl [4a] was long considered a fifteenth-century Dutch work,[2] until a copy was found in a small book published in Nürnberg in 1482, which militates against its Dutch origins.[3] The sibyl in this woodcut, too, seems to be based on one of the Master's prints (cf. Mary in the *Escutcheon with the arma Christi* [22];[4] this suggests that the impressions in Amsterdam and Vienna must have been part of a larger series in which the figures of prophets and sibyls faced each other in pairs, as in the woodcut.[5]

¶ The *Four prophets* are generally placed at the end of the Master's early period: the varied system of hatchings ensures a convincing distribution of light and shade, as a result of which the figures have a pronounced plastic effect (*fig. 24*).

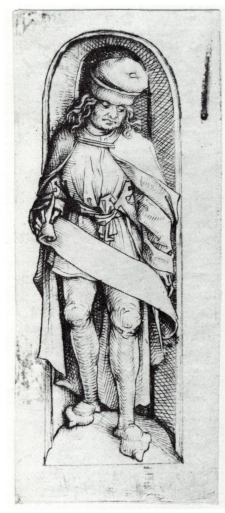

1

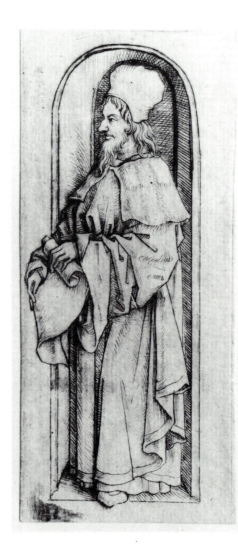

2.1

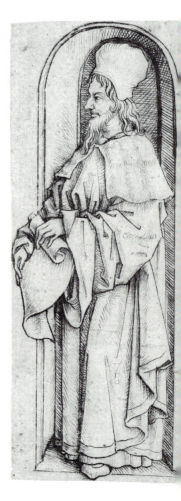

2.2

The three impressions in Vienna show most of the platemarks; the Amsterdam impressions, by contrast, have been trimmed to the picture.

Schneider 1915, p. 56; Solms-Laubach 1935-36, p. 30; many specialists have cited the Netherlandish origins of the prophet-in-a-niche motif as evidence that the artist was of Dutch origin or that he stayed in the Netherlands in about 1475.
Schneider 1915, pp. 57-59.
Fuchs 1958, p. 1199, note 697.
Hutchison 1972, p. 22.
Schneider 1915, p. 58.

4a

4*
Amsterdam, Rijksprentenkabinet (van Leyden coll., port. 20, nr. 52; Koninklijke Bibliotheek, 1807; Paris, 1812-16, nr. 38; inv.nr. OB:869): very good impression, 120 x 41 mm. (trimmed to the image).
4a
Woodcut copy of the fourth prophet, with the standing figure of a prophetess. Woodcut, 138 x 118 mm. Amsterdam, Rijksprentenkabinet (E. Bendeman coll., Zürich, 1921; inv.nr. 21:1199). The woodcuts were used to illustrate the 1482 edition of *Spruch von der Pestilenz* published by Hans Foltz in Nürnberg (H. 7220; Schramm, vol. 18, nrs. 364-65).

3 4

5*
Amsterdam, Rijksprenten-kabinet (van Leyden coll., port. 20, nr. 18: sheet 6; Koninklijke Bibliotheek, 1807; Paris, 1812-1816, nr. 13; inv.nr. OB:870): good impression, 92 x 83 mm. (probably somewhat trimmed [cf. **6**]; black inkspot upper left, Samson's neck and chin washed with the brush in gray paint; traces of green paint, mostly removed).

5a
Woodcut copy in reverse, used as illustration in *Spiegel menschlicher Behältnis* published by Peter Drach in Speyer in 1478-79 [see **140**].

6*
Paris, Bibliothèque Nationale (van Leyden coll., port. 20, nr. 17: sheet 6; Koninklijke Bibliotheek, 1807; Paris, 1812-16, nr. 12; could not be located in 1816 and was left behind; inv.nr. Ec.N. 427; Ea 41 rés): good impression, 95 x 84 mm. (trimmed along the platemark; folds; lower left corner missing; traces of red and black paint, mostly removed).

5a

5-6. The story of Samson
(L I and L II, 5-6), ca. 1470-75

5. Samson slaying the lion
Drypoint, unique impression, 92 x 83 mm.

6. Delilah cutting off Samson's hair
Drypoint, unique impression, 95 x 84 mm.

¶ Samson's strength was apparent even in his youth, when he killed a lion with his bare hands (Judges 14:5-6). Later, it helped him to foil all Philistine attempts to take him prisoner until his mistress, Delilah, in league with his enemies, wrested the secret of his strength from him. When he fell asleep on her knees, she cut off his hair, which no blade had ever touched, whereupon Samson's strength went from him and the Philistines were able to capture him (Judges 16:16-20). On the print we can see the enemy soldiers lying in wait.

¶ Both prints bring out the contrast between Samson's physical strength and his mental vulnerability.[1] In the fifteenth-century *Biblia pauperum*, a block book in which episodes from the Old and New Testaments were illustrated side by side, *Samson slaying the lion* (just like *David slaying Goliath*) was depicted as a prefiguration of *Christ's descent to hell*; in this context the hero invariably appears as the victor.[2]

¶ Although Samson's betrayal by Delilah can, similarly, be considered a prefiguration of Christ's suffering, in the Middle Ages it was seen above all as an example of the 'Wiles of Women': as one of many historical instances of men being ruined by women. The same theme also appears very explicitly in the Master's later *Aristotle and Phyllis* [**54**] and *Solomon's idolatry* [**7**].[3]

¶ The simple composition, the rather unsatisfactory treatment of space and the simple hatchings indicate that the Samson prints were among the Master's earlier works (*fig. 23*). The events are nevertheless depicted with astonishing directness and humor. The date of a book illustration (1478-79) [**5a**] largely based on the Master's *Samson slaying the lion* makes it clear that the print must, in any case, have been produced at an earlier date.[4]

1. For earlier graphic representations of the same theme in the work of Master E.S., see Lehrs, vol. 2, nrs. 2-5; ill. Lehrs (Dover), 193-94.
2. Hutchison 1972, p. 22.
3. Ibid., p. 23; see further [**7**] note 1.
4. See Naumann 1910, p. 21; the composition of this print is also reminiscent of an episode illustrated in the Dutch *Biblia pauperum*, ca. 1460, p. 28 of the fascimile edition by Adam Pilinski, Paris 1883.

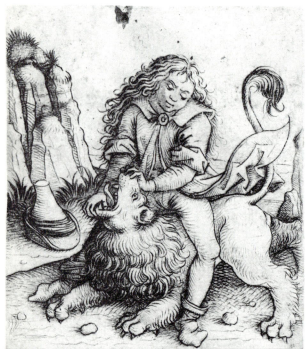

5

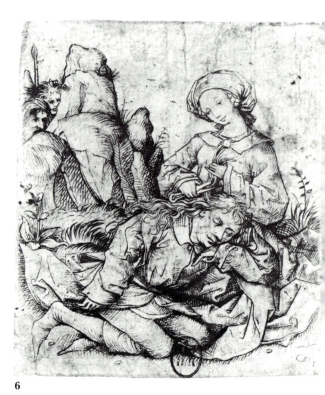

6

Solomon's idolatry (Li and Lii, 7), ca. 1485
rypoint, three known impressions, diam. 154 mm.
ompanion to Aristotle and Phyllis [54].

Solomon the Wise loved women from all corners
of the world, as well as his own wives. In his old
age these foreign concubines persuaded him to
worship the gods of their native lands and to dedi-
cate special shrines to them. His betrayal of God
led to a division of the people of Israel (1 Kings 11).
The print is a companion to *Aristotle and Phyllis*
[54]. In both cases, the subject matter is the depth
of folly to which men can be made to stoop by
women. This and comparable accounts of the
'Wiles of Women' [cf. 6] were often included in
late medieval texts as warnings against their
ubiquitous powers. Artists, too, made use of this
theme: as early as the thirteenth and fourteenth
centuries they depicted the 'Wiles of Women' on
ivory reliefs, small caskets, tapestries and the like.

In the early sixteenth century – when the popular-
ity of the subject was at its height – whole series of
prints were devoted to it, many of them based on
the Bible or classical history.[1]

¶ Unlike *Aristotle and Phyllis*, a subject depicted even
earlier on ivory lovers' caskets, this print is one of
the first representations of Solomon's idolatry. As
happened quite frequently with stories not previ-
ously illustrated, the posture of the figures was
influenced by a print of a fairly comparable sub-
ject, namely *Augustus and the Tiburtine Sybil* by Mas-
ter E.S. [7b].[2]

¶ Solomon's foolishness is underlined further by the
fact that the idol he worships is a mere prince; the
inscription beneath the idol – *O vere tu* – is presum-
ably the beginning of the prayer Solomon address-
es to him. The small dog beside the woman has a
double meaning: it is a symbol of conjugal devo-
tion – a form of devotion so strong that it brought
this wise ruler to worship other gods[3] – and it is

7.1*
Amsterdam, Rijksprenten-
kabinet (van Leyden coll.,
port. 20, nr. 89, as 'David
die den Afgod aanbid'
(David worshipping the
idol): sheet 25; Koninklijke
Bibliotheek, 1807; Paris,
1812-16, nr. 63; inv.nr.
OB:871): very good impres-
sion, diameter 155 mm.
(trimmed along and partly
through the outline; small
areas of damage along the
edge, restored tear along the
left edge, partly through
Solomon's billowing cape).
7.2
Vienna, Albertina (Brandes
coll., 1795; inv.nr. 312/1928):
very good impression,
diameter 160 mm. (with a
border around the outline;
ink stains left and right of
the main figures; partial
repair to lower part of Sol-
omon's foot; watermark:
small ox-head with horns
with single curve, bar and
star).

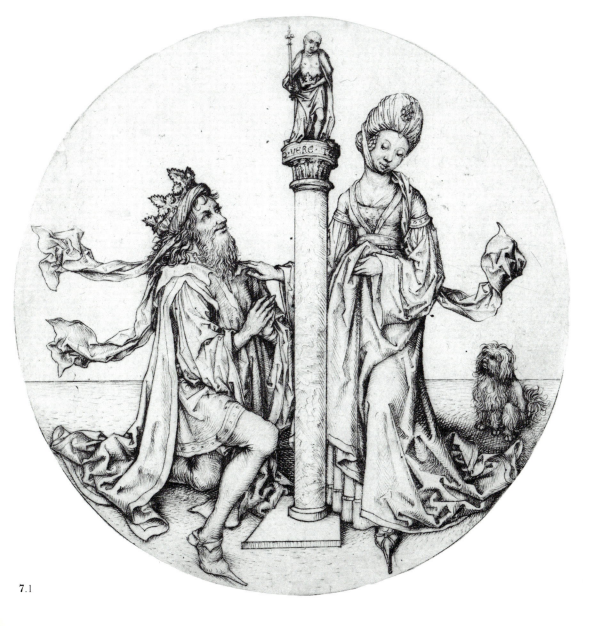

7.1

7.3
London, British Museum
(Hawkins coll., 1850; inv. nr.
1850-5-25-13): very good
impression, ca. 139 x 149
mm. (trimmed left, right and
bottom; inscribed in old
handwriting with a Latin
text that defaces the upper
part of the print in particu-
lar; several details retouched
with the pen).
7a
Free woodcut copy of
Solomon, as King
Andreas II of Hungary, used
as illustration in Johannes
Thurocz, *Chronica Hun-
garorum*, fol. 69v, published
by Erhard Ratdolt in
Augsburg in 1488 (H.C.
15518; Schramm, vol. 23,
291-339).
7b
Master E.S., *Emperor Augustus
and the Tiburtine sibyl*.
Engraving, 271 x 200 mm.
L.192. Vienna, Albertina.

7b

also a symbol of the profligacy and lechery that
helped to turn Solomon's head. The last meaning
links the print to *Young girl and old man* [**55**], which
mocks at the foolishness of an old man's courtship
of a young girl.

¶ With its pendant, *Aristotle and Phyllis*, this print is
one of the peaks of the Master's mature work. The
figures are drawn with great finesse and vitality,
and the costumes given a rich and elegant appear-
ance with the help of a varied system of cross-
hatchings in which the influence of Schongauer's
engravings is clearly reflected. The print must be
dated to shortly before 1488, in which year a wood-
cut copy of the figure of Solomon appeared as a
book illustration [**7**a].[4]

1. See exhib.cat. *Lucas van Leyden-grafiek*, Amsterdam 1978, pp.
 49-61; exhib.cat. *The prints of Lucas van Leyden and his contem-
 poraries*, Washington 1983, esp. pp. 102-06.
2. Hutchison 1966.
3. E. Panofsky, 'Jan van Eyck's Arnolfini Portrait,' *Burlington
 Magazine* 64 (1934), pp. 117-27; see also Stewart 1977, p. 57.
4. Baer 1902, p. 153.

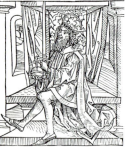

7a

7.3

8. The Annunciation

LI and LII, 8), ca. 1480
Drypoint, unique impression, 127 x 87 mm.

From the early Middle Ages, the Annunciation of the birth of Christ to the Virgin Mary by the angel Gabriel has been the subject of a host of representations. In the fifteenth century a new image of this theme appeared in Flanders: Mary is shown in a domestic setting while a devoutly kneeling angel disturbs her reading of a prayer book with his announcement. The Holy Ghost who dwells within her flies into the room in the form of a dove. The first words spoken by the angel, revealed as God's messenger by his sceptre – *Ave Maria gratia plena* ('Hail Mary full of grace') – are often inscribed on a banderole.

The print is without doubt based on Flemish models, some elements resembling those of the *Annunciation* by Roger van der Weyden; it is difficult to tell whether this was done directly or through copies or other versions of the compositions.

The composition of Roger's painting of the *Annunciation* in the Louvre [8a] served partly as a model for the print with this theme by the Flemish master FVB [8b], an engraving that is the qual-itative equal of the paintings of the Flemish primitives. Besides this print, our Master must also have been familiar with Roger van der Weyden's *Annunciation* in the Columba Altar then in Cologne (that altar also served as a model for the *Adoration of the Magi* [10]). The print uses various elements of the painting – the barrel-vaulted ceiling, for instance – and the closed door, an allusion to Mary's virginity.[1] Despite the similarity in certain details, however, our Master's print differs in character from the models we have mentioned, all of which breathe an air of solemnity. The Master's print, by contrast, dwells on the intimate nature of the events; in so doing it follows mystical currents that strove to render religious experience more personal and more closely tied to everyday events.[2]

¶ Unlike the angel of other models, that of the Master kneels before Mary.[3] This view is in accordance with the *Meditationes vitae Christi* by the Pseudo-Bonaventura.[4] The lily branch, which is seldom absent from any Annunciation and which symbolized Mary's purity, has been replaced with a burning candle, to be taken, perhaps, as an allusion to Christ as the Light of the World *(Lux Mundi)*.[5]

¶ The print must be assigned to the Master's

8*
Amsterdam, Rijksprenten-kabinet (van Leyden coll., port. 20, nr. 68: sheet 16; Koninklijke Bibliotheek, 1807; Paris, 1812-16, nr. 51; inv. nr. OB:872): very good impression, 127 x 87 mm. (with border around outline; traces of gray wash near the left window; black specks; lower left printed somewhat meagrely).

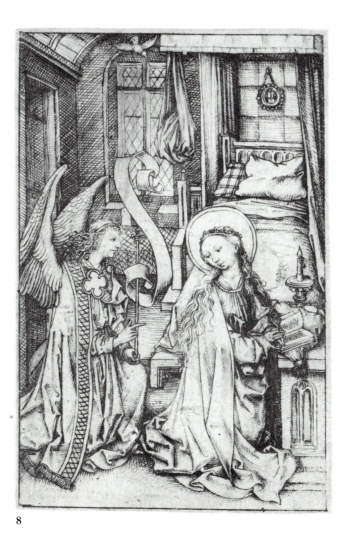

8

8a
Roger van der Weyden (or school?), *Annunciation*, ca. 1435-40. Panel, 86 x 93 cm. Paris, Musée du Louvre (inv. nr. 1982).
8b*
Master FVB, *Annunciation*, ca. 1480. Engraving, 202 x 157 mm. B.3. L.4. Düsseldorf, C.G. Boerner.
8c
Roger van der Weyden, *Annunciation*, left wing of the Columba Altar, ca. 1450-60. Panel, 138 x 70 cm. Munich, Alte Pinakothek (inv. nr.WAF 1190).

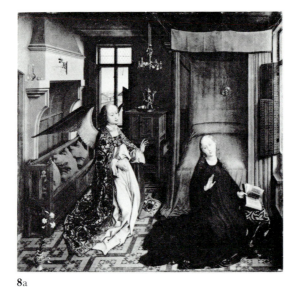

8a

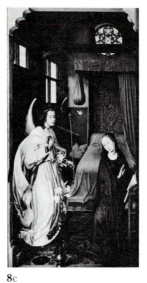

8c

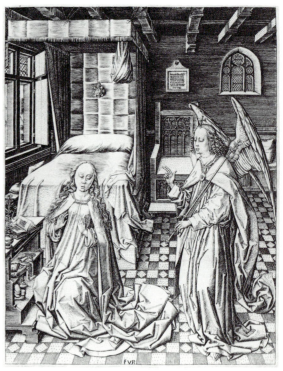

8b

mature period. Of probably much later origin is the *Annunciation* in the painted *Life of Mary* cycle in Mainz [**132**b], which was based on the print and is dated 1505. In that painting, probably executed by one of the Master's assistants after the latter's death, such traditional iconographic details as the lily branch have been restored.[6]

1. See Schneider 1915, p. 60; Hutchison 1972, pp. 24-25.
2. Jane Hutchison has suggested that the *modern devotion* may have had an important effect on this aspect of the Master's work (p. 61); this specifically Netherlandish movement was not, however, the only late-medieval current involved in the intensification of religious life. One of the most influential texts in this sphere was the late-medieval *Meditationes vitae Christi* by the Pseudo-Bonaventura; see *Meditations on the life of Christ, an illustrated manuscript of the fourteenth century*, translated by Isa Ragusa, Princeton 1961.
3. The kneeling angel also appears in the prints of Master E.S. (L.8-13) and Schongauer (B.3).
4. *Meditations*, op.cit. (note 2), pp. 16-18.
5. For the iconography of the *Annunciation*, see W. Braunfels, *Die Verkündigung*, Düsseldorf 1949; Kirschbaum, vol. 6, cols. 422-37; for the burning candle, see Hutchison 1964, p. 115 and Shestack 1966-67, nr. 41.
6. Hutchison 1964, pp. 112-21.

9. The Visitation

(L<small>I</small> and L<small>II</small>, 9), ca. 1480-85
Drypoint, two known impressions, 140 x 88 mm.

¶ After the Annunciation of the birth of Christ, Mary paid a visit to her cousin Elizabeth, who, having been barren until late in life, was now also with child – the later John the Baptist. From the early Middle Ages, the story of their meeting has been included in the *Life of Mary*. Until the fifteenth century, the two women were usually depicted alone and embracing each other; later the attendant maids and sometimes Joseph as well were added.[1] In the print, the Visitation, with Mary touching Elizabeth's stomach, took place in the presence of Elizabeth's aged husband, Zacharias, and of Joseph, who is shown trudging up to the gateway on the left. Although the presence of the two husbands is mentioned in the *Meditationes vitae Christi*, no direct visual model for this conception can be adduced.[2]

¶ An interesting detail above the group of trees behind the wall is the sketchily drawn owl, attacked and mocked by a flock of birds. The theme of an owl, a nocturnal bird and a symbol of darkness, being harassed by diurnal birds as harbingers of the light, was used frequently at the time and may be considered an allegorical reference to the struggle between good and evil. It remains an open question whether, in the context of the Visitation, this detail was meant to depict the sinful world before the coming of Christ; the same motif also occurs in the *Wild family* of Master b x g [93].[3]

¶ This print, too, served as a model for one of the panels of the *Life of Mary* in Mainz [132c], a work that must have been executed in our Master's workshop but is not by his own hand. The painting lacks such subtle details as Mary's touching of Elizabeth's stomach.[4]

¶ The *Visitation* is a splendid example of the Master's later work. The print was engraved with a very fine needle; the heavier drypoint areas are only used to represent deep shade. Both known impressions have small black spots probably caused by small pockmarks in the soft metal of the plate on which the print was incised. The Viennese print is a later impression; on it the drypoint areas as well as a number of fine, small lines have largely worn away and new lines have been added to Elizabeth's wimple.

1. Hutchison 1972, p. 25; Kirschbaum, vol. 2, cols. 229-35.
2. *Meditations*, op.cit. (**8**, note 2), p. 23-24.
3. See Jakob Rosenberg, 'On a meaning of a Bosch drawing,' *De artibus opuscula XL: essays in honor of Erwin Panofsky*, New York 1961, pp. 422-26. For prints with this theme by Master i.e. (Lehrs, vol. 6, p. 27, nr. 5) and Schongauer (B.108), Shestack 1967-68, nrs. 116 and 109 respectively. See also J.J.M. Timmers, *Christelijke symboliek en iconografie*, Haarlem 1978, nr. 299: the owl symbolizes the synagogue and Judaism.
4. Hutchison 1964, pp. 121-27.

9.2 (detail)

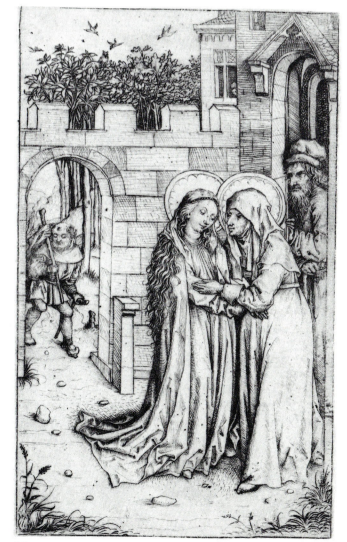

9.1

9.1*
Amsterdam, Rijksprentenkabinet (van Leyden coll., port. 20, nr. 55: sheet 11; Koninklijke Bibliotheek, 1807 (L. 240); Paris, 1812-16, nr. 41; inv. nr. OB:873): very good impression, 140 x 88 mm. (trimmed along outline; small repairs along the edges; watermark: small ox-head with horns with a single curve, bar and star).

9.2
Vienna, Albertina (Hofbibliothek; inv. nr. 313-1928): rather gray, meagre impression, 140 x 88 mm. (trimmed above and right just within outline; small repairs in lower half).

10. The Adoration of the Magi

(L I and L II, 10), ca. 1490
Drypoint, unique impression, 166 x 109 mm.

¶ After Christ's birth, the Magi, or kings from the East, led by a star, came to pay homage to the newly-born 'King of the Jews,' bringing him gifts and worshipping him (Matthew 2:11). This theme was most popular in late medieval art. The thirteenth-century *Legenda aurea* describes the event at length, and medieval artists followed this text fairly closely; the oldest of the Magi, Melchior, is usually depicted as an old man kneeling in worship before the child on Mary's lap, having first removed his crown; his present is gold. The other Magi hold their gifts in their hands: Bal-thazar has brought frankincense and the youngest, the black king Caspar, has brought an offering of myrrh.[1]

¶ The architectural setting is derived from the central panel of Roger van der Weyden's Columba Altar [10b]. So are the signs of a grotto in the foreground, the presence of which reflects the fourteenth-century legend that Christ was born in the cellar of the ruined house of David.[2]

¶ The dilapidated thatched building in Roman style alludes to the decline of the world at the time of Christ's birth, while the central column is an allusion to Christ's suffering at the whipping post.[3] A similar symmetrical structure can also be seen spanning the central panels, fashioned by the Master's own hand, of the Mainz *Life of Mary*

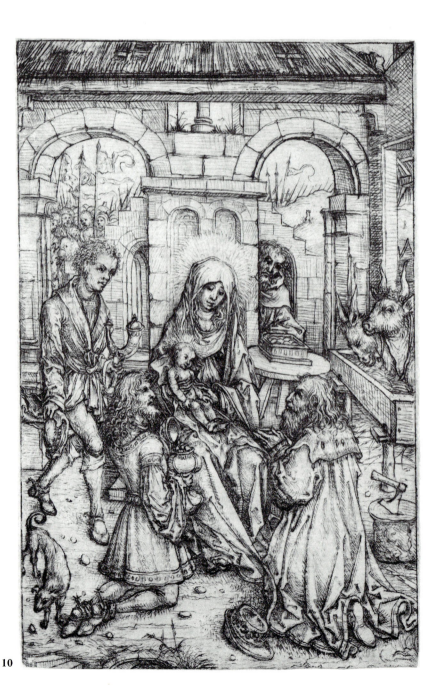

10

cycle: the *Nativity* and the *Adoration of the Magi* [**132**d and e].[4] The figures in the painting of the *Adoration*, too, are partly based on the print, which, in turn, is derived from Schongauer's engraving [**10**a], the figure of the kneeling Melchior quite especially so.

The print is typical of the Master's late work. The drawing is somewhat nervous and restless and many of the contours consist of several adjoining lines. The rather unsystematic hatchings help to model the volumes largely by gradations of tonal values.

1. *Legenda aurea*, pp. 103-09; see also Kirschbaum, vol. 1, cols. 539-49.
2. Panofsky 1953, p. 64, note 4; see also Hutchison 1964, p. 94.
3. Panofsky 1953, p. 277, note 3.
4. An unusual motif in the print is the hatchet embedded in a stump. It is a reference to John the Baptist's words to the Pharisees and Sadducees just before Christ's baptism: 'Even now the axe is laid to the root of the barren trees; every tree therefore that does not bear good fruit is cut down and thrown into the fire' (Matthew 3:10 and Luke 3:9). The use of a motif more commonly associated with Christ's baptism than with his birth can be explained by the coincidence in the liturgical year of his baptism with Epiphany, i.e. the manifestation of Christ to the Magi; see Hutchison 1972, p. 26 and particularly Hutchison 1976, p. 102.

10a*
Martin Schongauer, *Adoration of the Magi*, ca. 1470-75. Engraving, 259 x 170 mm. B.6. Rotterdam, Museum Boymans-van Beuningen (inv. nr. L. 1955-43).
10b
Roger van der Weyden, *Adoration of the Magi*, middle panel of the Columba Altar, ca. 1450-60. Panel, 138 x 153 cm. Munich, Alte Pinakothek.

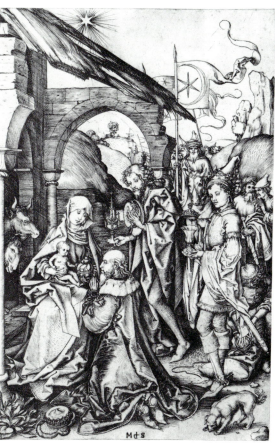

10a

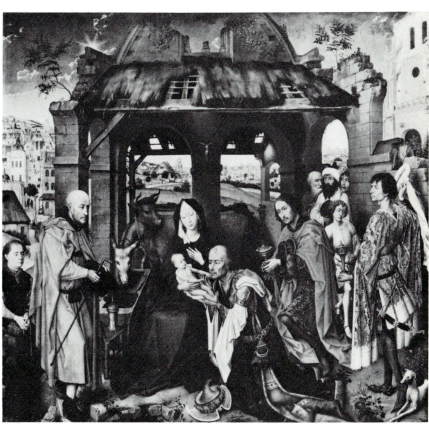

10b

11*
Amsterdam, Rijksprenten-
kabinet (van Leyden coll.,
port. 20, nr. 66: sheet 13;
Koninklijke Bibliotheek,
1807; Paris, 1812-16, nr. 50;
inv. nr. OB:875): good im-
pression, somewhat meagre
on the right, 168 x 122 mm.
(with thin border along the
outlines; surface damage to
eye of the left priest and face
of the Christ Child; small
piece missing below left; the
right half, which has lost
strength through rubbing,
was touched up with the pen;
this was largely removed in
an early restoration).

11. The Circumcision
(LI and LII, 11), ca. 1490
Drypoint, unique impression, 168 x 122 mm.

¶ On the eighth day after his birth, Christ was cir-
cumcised in accordance with Jewish law and
given the name of Jesus, as commanded by the
Archangel Gabriel (Luke 2:21).

¶ The blood Christ shed on that occasion was
thought to prefigure the Crucifixion, which ex-
plains why this motif used to be part of the *Life of
Mary* cycle, and later, in the fifteenth century, of
the Seven Sorrows of Mary.[1] It was rarely treated
as an independent theme and this print, together
with the *Adoration of the Magi* dating from about
the same time, may well have been the beginning
of an unfinished series depicting events in the life
of the Virgin, the Mary-cult being at its height in
the late fifteenth century.

¶ In a fairly complex composition, the Master tried
to depict the events as authentically as he could.
The Romanesque building with its wooden-
roofed structure symbolized the Old Covenant,
but is also an attempt to depict a synagogue as
faithfully as possible: an unadorned interior in
which the lectern bearing the scroll of the Law
stands under a baldachin surrounded by a pro-
tective grille. Oddly, this part of the building is
connected directly with the street through two
open side doors. The rather caricatural features
of most of the figures suggest that, like the Mainz
panel painting of *The twelve-year old Christ in the tem-
ple* [**132**g], they were meant to be Jews.[2]

¶ In style and technique, this print is related to the
Adoration of the Magi [**10**], with which it shares a
system of irregular hatchings. The only extant
impression has been printed rather unevenly;
although the drypoint areas on the left and in the
center are fairly strong, the right half is rather
thin and quite badly damaged.

1. *Reallexikon zur Deutschen Kunstgeschichte*, vol. 2, Stuttgart 1948,
cols. 327-31.
2. In the late fifteenth century, Jews were treated with a fair
amount of tolerance in the Rhineland, and in Mainz in par-
ticular; see Hutchison 1972, p. 26, and especially Hutchison
1976, pp. 102-06.

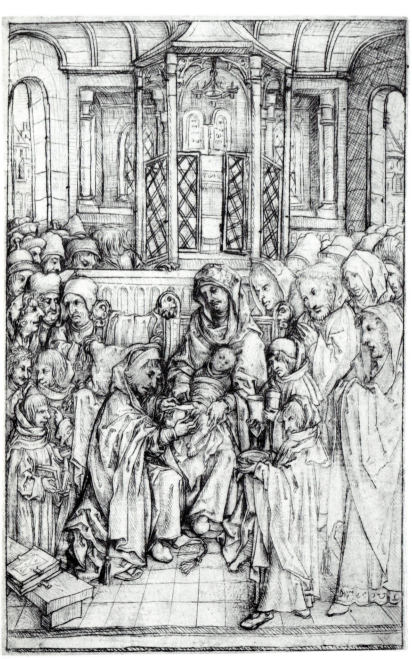

11

2. Christt betrayed
Li and Lii, 12), ca. 1470-75
rypoint, unique impression, 64 x 43 mm.

When Christ was about to be taken prisoner by the Romans and the Pharisees, his disciple Judas betrayed him with a kiss. On that occasion, Peter drew his sword and cut off the ear of one of the high priest's servants. According to legend, Christ then put the ear back on the servant's head.[1]

Traditionally, *Christ betrayed* was part of a Passion-cycle. As early as 1440-50, such cycles were being produced in very small format (maximum 100 x 80 mm., but also ca. 50 x 35 mm.) by northern printmakers, who probably intended them to

be pasted into prayer books.[2] It seems likely that this page, too, was made as part of such a series, the rest being lost or never completed.

¶ Although the composition is somewhat more convincing than that of an earlier version by Master E.S. [12a], it is nevertheless probable that our print was based on it or on a similar model.[3] Because of the still rather uncertain drypoint technique, it must be assigned to a fairly early period.

1. John 18: 1-11; Luke 22:47-53; Mark 14:43-52; Matthew 26:47-56.
2. For instance, Master E.S., Lehrs, vol. 2, nrs. 37-48; the Master of the Berlin Passion, Lehrs, vol. 3, nrs. 14-25, with a long digression on the Life of Christ cycle, pp. 53-76; illustrated in Lehrs (Dover), 142-53, 242-50.
3. Hutchison 1972, p. 27.

12*
Amsterdam, Rijksprenten-kabinet (van Leyden coll., port. 20, nr. 41: sheet 8; Koninklijke Bibliotheek, 1807; inv. nr. OB:876): good, rather heavy impression, 64 x 43 mm. (trimmed along the outlines; some pen lines in drapery on the left).
12a*
Master E.S., *The capture of Christ*, ca. 1450. Engraving, 93 x 75 mm. L. 38. Bremen, Kunsthalle (inv. nr. 89:39).

12

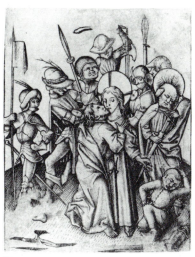

12a

13. The bearing of the Cross

(L1 and L11, 13), ca. 1480
Drypoint, three known impressions, 130 x 195 mm.

¶ In the early Middle Ages, the various elements of Christ's Passion used to be depicted as a series of successive motifs – from the entry into Jerusalem to the Resurrection – a series from which the Bearing of the Cross was never absent. John (19:17) is alone in stating that Christ bore the Cross himself; the other Evangelists tell us that Simon of Cyrene, a chance spectator, was compelled by the Roman soldiers to carry it. Late-medieval mystical texts combined both interpretations: when Christ fainted under the weight of the Cross, Simon of Cyrene was forced to share his burden.[1]

¶ In Schongauer's perhaps slightly earlier print, the *Bearing of the Cross* takes the form of a long, motley procession, Christ's dignified bearing being in striking contrast to that of the rough crew of soldiers and spectators on foot and of the mounted officials. Christ nearly breaks down under the weight of the Cross and rests on his

hands and knees [**13**b].

¶ In our Master's print, Christ's collapse[2] under the weight of the Cross is depicted most dramatically. Here the large contingent of soldiers is merely suggested by the tips of lances and spears protruding above the knolls in the background. The central motif is Christ's suffering and the cruelty of the three soldiers who force Christ and Simon of Cyrene to continue their ordeal. Christ makes what is obviously a tremendous physical effort to carry on. Pushed to one side, as it were, the grieving Mary, supported by John, stands on the left. Utterly indifferent to Christ's suffering, a soldier on the right – whose elegant bearing suggests that he must have been based on an Italianate model – has turned his back on the whole scene.

¶ The dramatic presentation of Christ's suffering on this print is in keeping with the detailed descriptions of Christ's Passion in late-medieval mystical writings intended to arouse compassion for his suffering.[3] The print is original not only in dramatic respects and in its composition, but also in its suggestion of volume and space, thanks

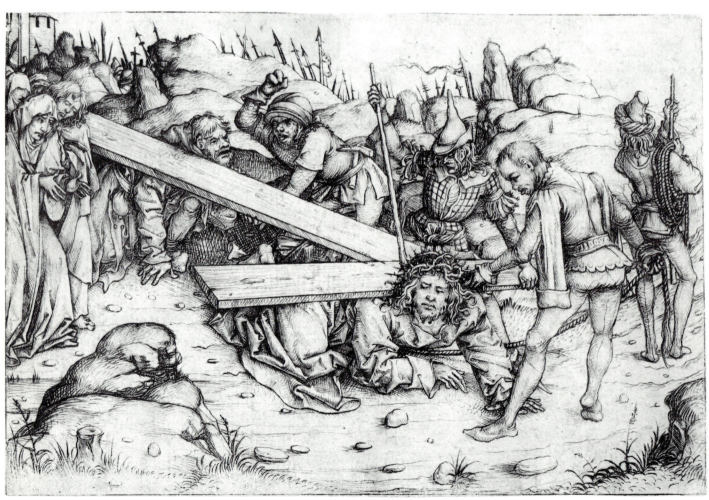

13.1

partly to the plastic modelling of the figures.
The differences in the systems of hatchings, some
strongly and some very delicately executed, com-
bined with the drypoint areas which introduce a
dark gray tone into the shaded areas, are charac-
teristic of the Master's mature work (ca. 1480; see
fig. 27). In the Coburg and Chicago impressions,
the velvety effect of the burr in the drypoint areas
is more pronounced than it is on the Amsterdam
impression which, however, is very sharp and
evenly printed.[4]

Hutchison 1972, p. 28; especially note 49.
Schneider 1915, p. 55 note 81: Christ adopts a similar posture
on a panel at Schaffhausen dated 1449; Hutchison 1972, p. 28,
note 48.
For instance in the *Meditations*, op.cit. (**8**, note 2), p. 332.
On the Coburg and Chicago impressions, the upper left
corner is blurred so that the gatehouse is not very clear;
moreover there is a large black spot under Christ's hands.

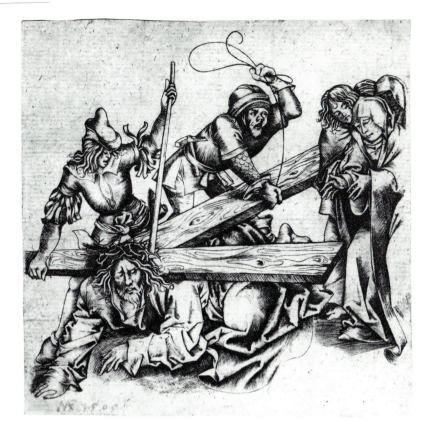

13a

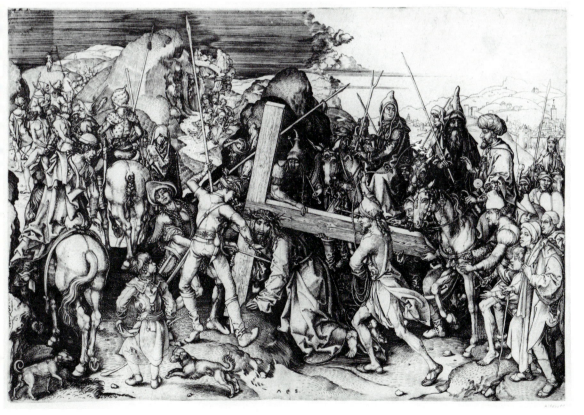

13b

13.3
Coburg, Veste Coburg
(Brandes coll., 1795; inv. nr.
II, D.1): very good
impression, 134 x 195 mm.
(dimensions of paper, with
margins: 157 x 214 mm.;
mounted on parchment;
folds through the middle,
both horizontal and vertical;
serious surface damage espe-
cially along the vertical fold).
13a
Copy in reverse, ca. 1500,
with seven rather than ten
main figures. Engraving,
120 x 116 mm. Lehrs, vol. 8,
p. 93. Dresden, Kup-
ferstichkabinett (inv. nr.
A.568).
13b*
Martin Schongauer, *The
'large' bearing of the Cross*, ca.
1480. Engraving, 286 x 430
mm. B.21, L.9. Amsterdam,
Rijksprentenkabinet (inv.
nr. OB:1015).

14. The Crucifixion

(LI and LII, 14), ca. 1485
Drypoint, unique impression, 124 x 76 mm.

15. The Crucifixion with Mary, St. John and two Holy Women

(LI and LII, 15), 1490
Drypoint, unique impression, 155 x 99 mm.

¶ Christ's Crucifixion, as the central event in his life, is probably the most frequently illustrated theme in Christian art.[1] In the late Middle Ages, the crucified Christ was depicted as dead and with closed eyes, often in a pitiful state. The theme was sometimes included in a larger altar-piece composition with the crucified thieves and a large number of spectators [131a], and some-times in smaller compositions for devotional use, generally with Mary and John alone.

¶ In fifteenth-century northern engraving, how-ever, the smaller composition was the general rule, Mary and John often being accompanied by a few soldiers or by the three holy women. The great demand for such prints is reflected in the fact that, in addition to the *Crucifixion* and his *Passion cycle*, Schongauer executed at least six separate and independent prints with this theme, each copied many times in turn.[2]

¶ There is little doubt but that our Master was acquainted with these prints, for though he did not copy them, he nevertheless took various elements from them.[3] His representation of Christ's body, however, is more reminiscent of the highly expressive style of such sculptors as Nicolaas Gerhaerdt[4] than of the serene character of Schon-gauer's prints. In the smaller, slightly earlier, print, the crucified Christ is shown all alone in a landscape that tends to accentuate his pitiful con-

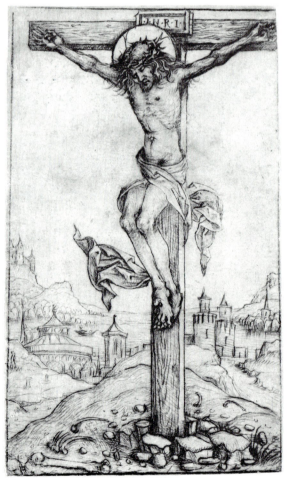

14

dition; in the larger, slightly later print, the expressive character of Christ's crucified body is enhanced by the rough-hewn Cross and his open eyes. An unusual iconographic feature is the presence, at the side of John and Mary, of only two of the three holy women.

The background of both prints shows Jerusalem, the round, central building probably being the Second Temple. Neither highly stereotyped townscapes bears much resemblance to the town profile Erhard Reuwich drew in 1483 and published in 1486 in woodcut form as an illustration for Breydenbach's *Peregrinationes* [142]; but this fact can hardly be used as evidence for the possible identification of our Master with Erhard Reuwich.[5]

Its style and the painterly use of the drypoint technique[6] suggest that the *Crucifixion with Mary, St. John and two Holy Women* must probably be assigned a later date (ca. 1490) than the other print.

1. Kirschbaum, vol. 2, cols. 606-42.
2. Lehrs, vol. 5, nrs. 10-14.
3. The planed Cross, the figures of Christ and the flowing loincloth, all of which go back to Rogier van der Weyden, also appear in Schongauer, L.11 and L.12 (B.23); the rough-hewn Cross appears in L.27 (B.17), and L.13 (B.24).
4. See Jane C. Hutchison, above, p. 59; cf. T. Müller, *Sculpture in the Netherlands, Germany, France and Spain*, Middlesex 1966, pl. 90B.
5. See Hutchison 1972, pp. 28-29, note 52; see also **142**.
6. The fine, unstructured hatching of **15** is reminiscent of that seen in the *Adoration of the Magi* [**10**].

14a*
Martin Schongauer,
The Crucifixion, ca. 1480.
Engraving, 286 x 430 mm.
L.11. Amsterdam,
Rijksprentenkabinet (inv.
nr. OB:1017).

14a

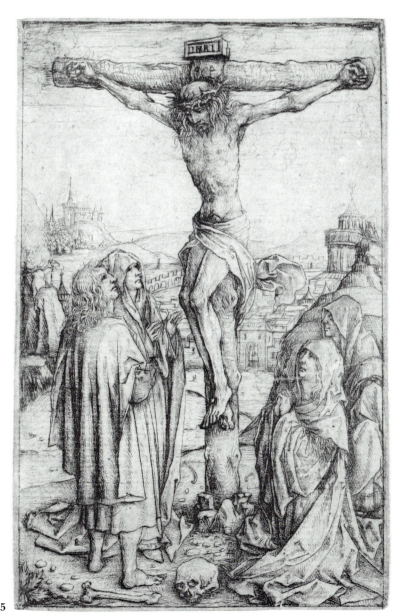

15

16. Heads of Christ and the Virgin

(L1 en L11, 16), ca. 1490
Drypoint, unique impression, 73 x 114 mm.

¶ The head of Christ bestowing a blessing, drawn in full face together with the turned head of the Virgin worshipping him, is found frequently in fifteenth-century south Netherlandish diptychs.[1]

¶ This print must have been based on the same devotional conception. For although Christ's hand raised in blessing and the Virgin's folded arms are missing, Christ has the stereotyped 'vera-icon' expression and the Virgin the typically downcast eyes of devotional pictures. Despite its sketchiness, the print can be assumed to have been intended as a model for an *Andachtsbild* of that kind.[2]

¶ Like the portrait studies [**76** and **77**], this print is usually considered to be a late work: the stylus is wielded with great finesse: the drypoint areas with their fresh burr melt into the fairly heavy gray tone produced by the plate. The many fine

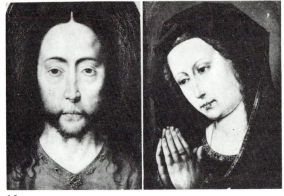

16a

vertical scratches in the plate, which suggest that it must have been used before and scraped clean, hardly matter and indeed contribute to the gray tone.

1. Schneider 1915, p. 62; see also Hutchison 1964, pp. 143-44 and Hutchison 1972, p. 30, note 59.
2. For the iconography and significance of such *Andachtsbilder*, see Panofsky 1953, p. 174, note 3 and p. 294, note 15, and Ringbom 1965, particularly p. 62.

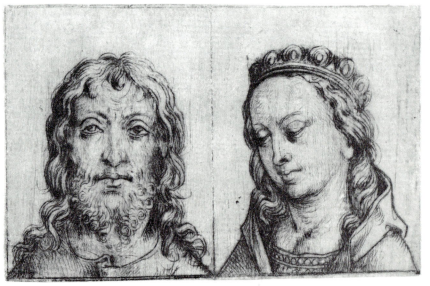

16

17. Christ as the Good Shepherd
(LI and LII, 18), ca. 1475
Drypoint, unique impression, 113 x 83 mm.

A beardless Christ carring a lamb on his shoulders was one of the earliest representations of the Savior in art, appearing in the third or fourth century. According to the Evangelists, Christ compared himself repeatedly to a good shepherd (John 10:11: 'I am the good shepherd: the good shepherd giveth his life for the sheep'). In the parable of the lost sheep (Luke 15:4), Christ speaks of the joy of the good shepherd as he lays the recovered sheep on his shoulders, and compares it to a sinner who has repented.

By the fifteenth century, representations of the Good Shepherd had become rarer.[1] A much larger Flemish woodcut [**17a**] with the same subject[2] probably served as model for this print. Christ's attitude and attire are the same; only the wounds in his hands and feet are missing from the print. The text on the woodcut related that his 'deep wounds' (his suffering on the Cross) enabled Christ to recover the lost sheep.[3] It seems likely that the empty banderole on the print was meant to carry a similar legend.

¶ This print is one of the earliest of the Master's works: the composition is simple and the drawing hesitant; the drypoint technique has not yet been fully mastered. Inside fairly heavy contours, the simple system of parallel and cross-hatchings lends the figure very little volume, so that the overall effect is rather flat (*fig. 22*).

1. Kirschbaum, vol. 2, cols. 289-99. A rare engraved prototype by Master E.S. is mentioned in Lehrs, vol. 2, 52. For the woodcuts, see Schreiber 838-40.
2. See Hutchison 1972, p. 30, notes 64 and 66.
3. Jane Hutchison has drawn my attention to the fact that this theme also appears on the frontispiece of Martin Luther's prayerbook (*Luther* exhibition, Wolfenbüttel) and that it is connected with the Modern Devotion movement.

17
Amsterdam, Rijksprentenkabinet (van Leyden coll., port. 20, nr. 57: sheet 18; Koninklijke Bibliotheek, 1807; Paris, 1812-16, nr. 43; inv. nr. OB:882): good impression, 113 x 83 mm. (trimmed along outlines; watermark: lower edge of Gothic P).

17a
Southern Netherlands, ca. 1470. *Christ as the Good Shepherd*. Woodcut, colored by hand, 373 x 247 mm. Breslau, Stadtbibliothek (laid down on the end paper of a missal).

17a

17

18. The Child-Savior bestowing a blessing
(Lɪ and Lɪɪ, 17), ca. 1490
Drypoint, unique impression, 164 x 33 mm.

19. Christ at the column
(Lɪ and Lɪɪ, 19), ca. 1490
Drypoint, unique impression, 165 x 33 mm.
Companion prints.

¶ The *Child-Savior* and *Christ at the column* were often portrayed by fifteenth-century sculptors and used to serve as *Andachtsbilder* for devotional use. They enhanced the emotional impact of the subject and were intended to elicit an intense religious response from the spectator. His positioning of the figures in a niche suggests that the Master must have had such sculptural *Andachtsbilder* in mind.

¶ Small statues of the naked Christ Child were very popular in the late Middle Ages; they would be dressed up on occasion and provided with a wardrobe for Sundays and holidays. Christ would be shown as a one-year-old boy, his right hand raised in blessing and his left holding an orb.[1] The Master had obviously failed to take the reversal of the printed image into account: on the print it is Christ's left hand which is raised in blessing. The letters INRI above the niche and the death's-head below it allude to Christ's death by crucifixion and link this print to its pendant, *Christ at the column.*

¶ In the latter, the emphasis is laid on Christ's suffering: naked except for a loincloth, he leans against the column while holding the instruments of his flagellation in his hands.[2] The words ECCE HOMO ('Behold the Man') refer to the moment after the flagellation when Christ, crowned with thorns, was shown to the populace.

18

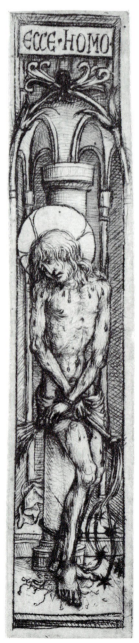

19

Christ at the column is reminiscent of the *Man of Sorrows*, in which the suffering Christ is portrayed after the Crucifixion with a crown of thorns and with wounds in his hands, feet and sides, another favorite devotional subject at the time [see **20**].[3] It is an open question to what extent these slender, small-sized prints were intended for insertion in the margins of prayerbooks, or as models for such marginal decorations. An example is the *Missal of Margaretha of Pfalz-Simmern*, which contains a comparable Christ Child surrounded by tendrils [**120**, fol. 15].

The extremely 'painterly' use of the drypoint technique suggests that this print must have been executed during a later period; the very fine and subtle modelling of the body goes hand in hand with the presence of heavy, velvety drypoint areas. The dark-gray washes at the back of the niche, which were added later, enhance the chiaroscuro effect.

Hans Wentzel, 'Christkind,' *Reallexikon zur deutschen Kunstgeschichte*, vol. 3, Stuttgart 1954, cols. 590-602; an early printed model by Master E.S., Lehrs, vol. 2, nr. 49, illustrated in Lehrs (Dover), 125, and perhaps based on it, Schongauer's B.67 (L.31).
Kirschbaum, vol. 2, cols. 126-27.
Traditionally but erroneously this print has been called the *Man of Sorrows*. I am indebted to Mrs. E. Verhaak for drawing my attention to this fact.

20. The body of Christ supported by two angels
(L1 and L11, 20), ca. 1475
Drypoint, unique impression, 100 x 71 mm.

¶ The body of the dead Christ is supported by two angels. The instruments of his suffering in the background – the Cross, the lance and the sponge – bear witness to his martyrdom. In contrast to the Pietà, which depicts the lifeless body of Christ on the Virgin's lap, this Italianate type of devotional representation of the 'Man of Sorrows' supported by two angels (the angelic Pietà or the 'Christ de Pietà') is rare in the north; in fifteenth-century French art Christ is usually supported by a single angel.[1]

¶ The heavy folds of the drapery, the rather untidy hatching and the angular proportions of the figures make this a relatively early work; the impression is slightly uneven, and not all the lines are cleanly printed.

1. Hutchison 1972, p. 31, note 70; Erwin Panofsky, 'Imago pietatis': ein Beitrag zur Typengeschichte des 'Schmerzensmanns' und der 'Maria Mediatrix,' *Festschrift für Max Friedländer*, Leipzig 1927, pp. 261-308, above all p. 282; see also R. Berliner, 'Bemerkungen zu einigen Darstellungen des Erlösers als Schmerzensmann,' *Münster* 9 (1956), pp. 97-117; Georg Swarzenski, 'Insinuationes divinae pietatis,' *Festschrift für Adolph Goldschmidt*, Leipzig 1923, pp. 65-74, especially pp. 66-68.

20*
Amsterdam, Rijksprentenkabinet (van Leyden coll., port. 20, nr. 40: sheet 8; Koninklijke Bibliotheek, 1807; Paris, 1812-16, nr. 26; inv. nr. OB:884): reasonable, somewhat gray impression, 100 x 71 mm. (trimmed along and through the outline, which is wholly visible only above; repairs in Christ's garment, both left and right of the knees).

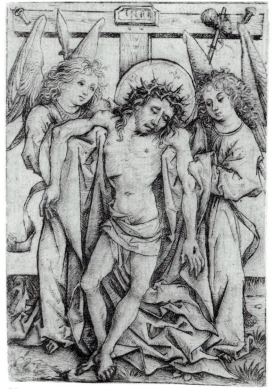

20

21*
Amsterdam, Rijksprenten-
kabinet (van Leyden coll.,
port. 20, nr. 62; sheet 14;
Koninklijke Bibliotheek,
1807; Paris, 1812-16, nr. 46;
inv. nr. OB:911): very good
impression, with horizontal
scratches in the plate,
127 x 92 mm.
21a
Master of Flémalle, *Holy
Trinity*. Panel, grisaille,
144 x 53 cm. Frankfurt am
Main, Städelsches Kunst-
institut (inv. nr. 939B).

21. The Adoration of the Trinity by the Virgin, St. John and angels

(LI, 21; LII, 50), ca. 1490
Drypoint, unique impression, 127 x 92 mm.

¶ The meaning of the term 'Holy Trinity' is that God manifests himself in three forms: as God the Father, as his son Jesus Christ and as the Holy Ghost. Traditionally the subject is represented by an enthroned God the Father pointing to a Crucifix, the Holy Ghost appearing as a dove (the so-called Throne of Grace). A new conception in which God the Father points to the body of the lifeless Christ appeared, probably on the model of the 'angelic Pietà' [20], in France in about 1400 and quickly spread across northern Europe.[1]

¶ An impressive example of this theme is a grisaille by the Master of Flémalle in Frankfurt [21a],[2] which in view of the rarity of the subject in German art may possibly have served as a prototype for the print. The conception of the Holy Trinity was converted into an *Andachtsbild* in painting, with God the Father taking pity on the lifeless Christ. In the print there were added further the kneeling Virgin and St. John who, with a host of angels in the background, adore the Holy Trinity.

¶ The ornamental use of floral motifs at the top of the print recurs several times in various forms in other late prints [27, 50, 75, 88], and suggests a painted or sculpted frame.

¶ Almost as fine as the horizontal scratches on the plate are the rather scratchy drypoint lines with which the figures have been constructed, strongly emphasizing the chiaroscuro effect. This drypoint technique and the somewhat elongated proportions of the figures suggest a fairly late date for the print.

1. Rudolf Berliner, 'Die Rechtfertigung der Menschen,' *Münster* 20 (1967), pp. 227-38; Panofsky 1927, op.cit. [20, note 1], pp. 284-92; see also Hutchison 1972, p. 32, note 74 and Ringbom 1965, pp. 117-18.
2. In the work of the Master of Flémalle the theme occurs several times (see Friedländer, vol. 2, figs. 65, 71); the Frankfurt version is, however, the most closely related to the print.

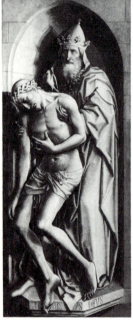

21a

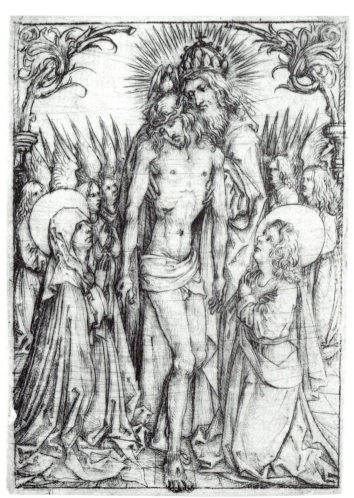

21

22. Escutcheon with the Arma Christi, with the Virgin and St. John

(L1, 22 and L11, 51), ca. 1475-80
Drypoint, unique impression, 121 x 103 mm.

¶ The instruments of Christ's suffering have here been wrought into a strange heraldic composition – the *Arma Christi* – in which the escutcheon crowned with Christ's face is flanked by a grieving Virgin and John. As well as the empty grave and the Cross with the scourge and flail, Mount Tabor and the Mount of Olives are depicted on the escutcheon.

¶ The description of Christ as a knight fighting for human salvation through his suffering recurs in late medieval literature. An early illustration of the escutcheon with the instruments of Christ's humiliation appears in the *Passionale* of Abbess Kunegunde (ca. 1320), in which the Passion is described as the fight fought by Christ the Knight for the salvation of the human soul. In Netherlandish manuscripts no less than in book covers it served as a much-used emblem.[1] Later in the fourteenth century Christ's escutcheon was depicted in accordance with the heraldic rules, with the instruments of his humiliation on the shield and a helmet from which the hand of God protrudes in blessing.[2]

¶ This theme had been used on a frequently copied engraving by Master E.S. [22a], in which the escutcheon was moreover flanked by the Virgin and by Christ as the Man of Sorrows and surrounded by the four Evangelists. This representation was probably the starting point for our Master's drypoint: John has taken the place of Christ beside the escutcheon, and his head crowned with thorns has replaced the helmet, lending the print a strangely illusionist character.

¶ In view of the careful hatching, the varied brightness of the folds and the rather stocky figures of Mary and John this print must probably be dated to the end of the early period.

1. Rudolf Berliner, 'Arma Christi,' *Münchner Jahrbuch*, third series, vol. 6 (1955), pp. 35-152; Hutchison 1972, p. 32; Kirschbaum, vol. 1, cols. 183-87.
2. Berliner, p. 62.

22*
Amsterdam, Rijksprentenkabinet (van Leyden coll., port. 20, nr. 30: sheet 8; Koninklijke Bibliotheek, 1807; Paris, 1812-16, nr. 20; inv. nr OB:912): good impression (ink has not taken completely in the upper left and right center), 121 x 103 mm. (outlines visible above, right and left; somewhat splotchy on the right).
22a
Master E.S., *Arms of the Passion*, ca. 1450-60. Engraving, 144 x 102 mm. B.89, L.188. Vienna, Albertina (inv. nr. 1926-776).

22

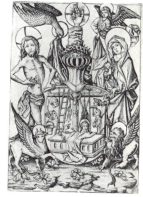

22a

27. The Virgin enthroned, adored by angels

(LI, 25 ; LII, 23), ca. 1490
Drypoint, unique impression, 129 x 77 mm.

¶ The conception of the Virgin suckling the Christ Child (*Madonna lactans*) embodies the most intimate moment of motherhood. The late medieval view of the Virgin was not just that of a nurse of Christ but also of all mankind (*nutrix omnium*). In Italian art she is often shown in that role while seated on the ground, as the *Madonna of Humility*.[1] An enthroned *Madonna lactans* appears in van Eyck's *Lucca Madonna* in Frankfurt and in Rogier van der Weyden's small *Virgin enthroned* in Lugano.[2] The Master's print is perhaps based on such a painting.

¶ The presence of adoring angels indicates that the print was intended as an *Andachtsbild* comparable to the *Trinity* [21], to which it also bears a stylistic resemblance.

¶ The decorative foliage framing the top of the print, which is also found in the *Trinity* [21] and in the *Elevation of St. Mary Magdalen* [50], is repeated in three-dimensional form in the surrounds of middle-Rhenish altarpieces.[3]

¶ The tiled floor at the bottom of the print has been trimmed and a heavy irregular line in Mary's cloak, caused by a flaw in the plate, has been retouched with white pigment.

1. See Millard Meiss, *Painting in Florence and Siena after the Black Death*, Princeton 1951, pp. 132-56.
2. Panofsky 1953, pl. 252 en pl. 306.
3. Stange, vol. 7, figs. 184, 214, 257, 265.

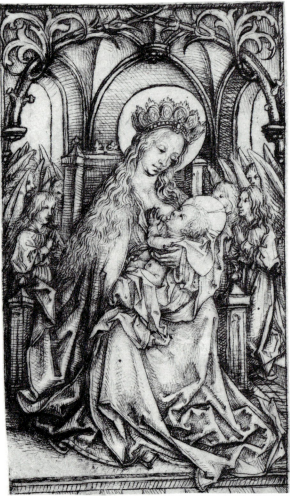

27

8. The Holy Family by the rosebush

LI, 28 ; LII, 27), ca. 1490
rypoint, unique impression, 142 x 115 mm.

In a strikingly original composition, the Virgin, the Christ Child and his foster father Joseph are depicted in the intimacy of an enclosed garden. Fifteenth-century Rhenish artists often presented the Virgin and Child in this kind of *hortus conclusus*, a symbol of the virginity of Mary, frequently adding a rosebush, another Marian symbol.[1] In the print, these symbols do not appear alone; indeed, nearly every element of the landscape can be interpreted as the kind of Marian symbol described in late medieval hymns to the Virgin: the church in the background represents Mary's embodiment of the mother church (*Maria ecclesia*); the fortified tower is the tower of David

(*turris David*); the gate on the extreme left is the gate of heaven (*porta coeli*); the river and harbor in the background are references to Mary as the safe harbor (*portus naufragantium*); and the apple tree near the rosebush is an allusion to original sin and the redeeming role of Mary as the new Eve and of Christ as the new Adam.[2]

¶ The role assigned to Joseph, half-hidden behind the seat, is surprising: he amuses and mollifies the Child by playing with two apples. Now in the late fifteenth century Joseph, who until then had often been presented as an old buffoon,[3] began to be revered by the church. Even earlier, in the late fourteenth century, a reference to Joseph's amusing the Christ Child by playing with two apples was made in the Pseudo-Bonaventua's *Meditationes vitae Christi*.[4]

¶ In Dürer's engraving [28a], which was closely

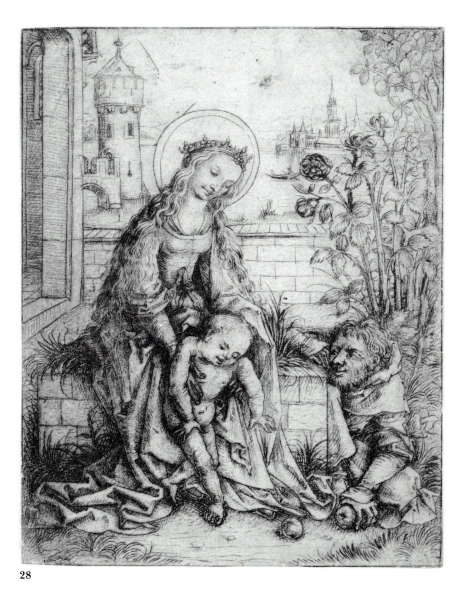

28

28a*
Albrecht Dürer, *Holy family
with a butterfly*, ca. 1495.
Engraving, 236 x 187 mm.
B.44, M. 42. Amsterdam,
Rijksprentenkabinet (inv.
nr. OB:1204).

28b
Albrecht Dürer, *Holy family
with St. John the Babtist, Mary
Magdalene and Nicodemus*,
1512. Drypoint, 216 x 190
mm. B.43, M.44.
Amsterdam, Rijksprenten-
kabinet (inv. nr. OB:1202).

based on the Master's, and in Dürer's prelimi-
nary sketches for it, Joseph is also assigned an
important role; in the print he is shown asleep,
probably an allusion to the dream in which he
was urged to flee to Egypt.[5]

¶ Dürer's print – one of his earliest engravings – is
more precisely constructed and more monumen-
tal but lacks the intimacy of the drypoint, which
belongs to the Master's late period. In Dürer's
prints, the very subtle lighting in the sfumato-like

drypoint areas has made way for a strong
interplay of light and shadow.

¶ Although the slightly gray impression of the
drypoint is fair, it is not evenly printed (*fig. 32*)
and is marred by the rubbing of the surface.

1. Ewald M. Vetter, *Maria im Rosenhaag*, Düsseldorf 1956.
2. Hutchison 1972, p. 36, notes 98 and 100.
3. Hutchison 1972, p. 36, notes 101 and 102; Kirschbaum, vol. 2,
 cols. 4-7.
4. Ringbom 1965, pp. 94-95; *Meditations*, op.cit. [**8**, note 2] p. 55.
5. Exhib. cat. *Albrecht Dürer*, Nürnberg 1971, nr. 144.

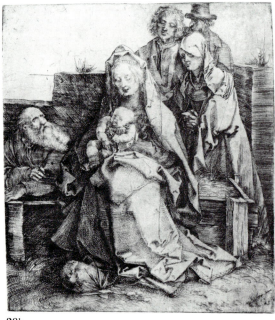

28b

28a

9. The Holy Family in a vaulted hall

LI, 29 ; LII, 28), ca. 1490
rypoint, two known impressions, 154 x 100 mm.

The Virgin, the Christ Child and his grand-mother, St. Anne, form the central group of this print; behind them stand Joseph and Joachim, the respective husbands of Mary and Anne. The dove representing the Holy Ghost probably alludes to the Immaculate Conception; the bud-ding tree stump outside the open window may be an allusion to the Cross on which Christ was to die.

¶ The central group – known as 'Anna Selbdritt,' a popular theme with fifteenth-century northern painters and sculptors – also became associated during the late Middle Ages with the Immaculate Conception; it served as a reminder that Jesus was born of Mary and Mary of Anne. As a result there was a tremendous upsurge in the adulation

29.1*
Amsterdam, Rijksprenten-kabinet (van Leyden coll., port. 20, nr. 67: sheet 17; Koninklijke Bibliotheek, 1807; inv. nr. OB:890): good impression, 148 x 95 mm. (trimmed along the plate mark, strip missing along lower edge; figures and architecture colored with yellow-brown water color and white highlights, partly oxidized).

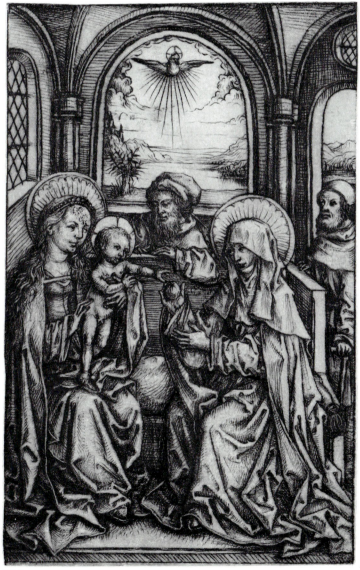

29.1

29.2*
Hamburg, Kunsthalle
(Lloyd coll., 1820; Wood-
burn; inv. nr. 3712): good
impression, 154 x 100 mm.
(border around outline;
small stains and repairs;
watermark: fragment of
bottom of Gothic P).
29a
Circle of the Master, *Virgin
and Child with St. Anne.* Panel,
136 x 105 cm. Oldenburg,
Landesmuseum.

of St. Anne. It is possible that, by confining the
Holy Family to the persons shown in the print,
the Master implicitly rejected the legend of the
two later marriages of St. Anne.[1]

¶ Joseph and Joachim are absent from a painting
in Oldenburg [**29**a], which was probably exe-
cuted in the Master's immediate environment
and was largely based on the print. For the rest,
Mary, the Child and St. Anne perform the same
actions, the handing over of the apple symboliz-
ing the surmounting of original sin. Like the other
Life of Mary representations [**10, 11**], this print
must be considered one of the Master's later
works.

¶ The Amsterdam impression has a narrow strip
missing at the bottom; moreover, like a minia-
ture, it has been retouched with yellow-brown
and white body color. Though the Hamburg
impression has weaker drypoint areas, it is
brighter and sharper than the heavily retouched
Amsterdam version.

1. According to this legend, Anne married Cleophas after
Joachim's death and Solomas after the death of Cleophas. She
bore each of her husbands a daughter, and the daughters had
children in their turn. This legend was the basis of the late
medieval conception of the Holy Kinship: Anne surrounded
by husbands, children and relatives, as depicted on the paint-
ing by Geertgen tot St. Jans in the Rijksmuseum. See Hutch-
ison 1972, p. 37, notes 110-13.

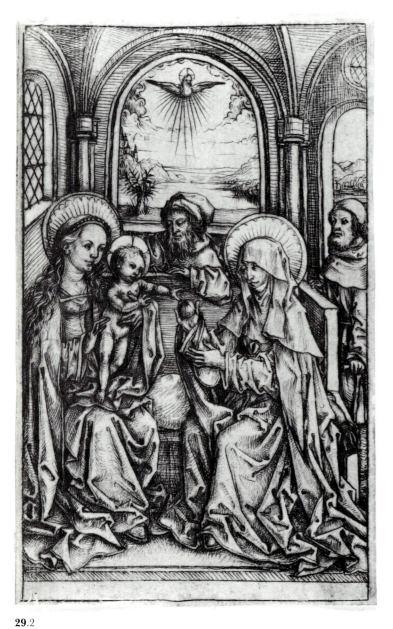

29.2

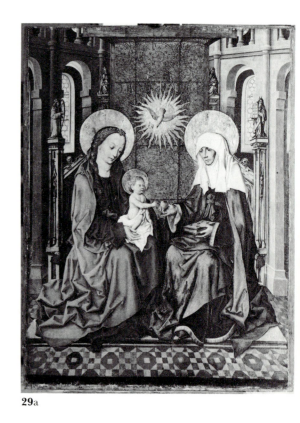

29a

0. The Virgin and Child with St. Anne ('Anna Selbdritt')

_I, 30 ; L_II, 29), ca. 1490
rypoint, unique impression, 85 x 76 mm.

The *Virgin and Child with St. Anne* was the subject not only of many paintings but also, and more particularly so, of a host of *Andachtsbilder* carved in wood, on which Mary was shown sitting on Anne's lap while holding the Christ Child.
Although, in the print, Mary is seated not on Anne's lap but on the step of her throne, the composition is directly linked to the carvings. The conception of 'Anna Selbdritt' is, as we said earlier [see under **29**], associated with the Immaculate Conception: Anne gave birth to Mary, and Mary to Christ, which is indicated in the print by the presence of the enclosed garden, the *hortus conclusus*, another symbol of the virginity of Mary, behind the throne. As Mother of Mercy, Anne embraces Mary suckling her child as the 'mother and nurse of all mankind' – the *Mater et nutrix omnium*.[1]

¶ The print is generally assigned to a late period. The deep black drypoint areas are so heavy and hence so undifferentiated in this unique impression that it cannot be called very successful. The sketchy technique and the experimental character of the impression indicate that the print was designed as a model and was not intended for wider distribution.

1. Hutchison 1964, pp. 142-44; Hutchison 1972, p. 38, notes 114-16.

30*
Amsterdam, Rijksprentenkabinet (van Leyden coll., port. 20, nr. 44: sheet 9; Koninklijke Bibliotheek, 1807; Paris, 1812-16, nr. 30; inv. nr. OB:891): good, very heavy impression, 85 x 76 mm. (trimmed left and above along the outline, presumably within the outline on the other sides; black and red paintspots).

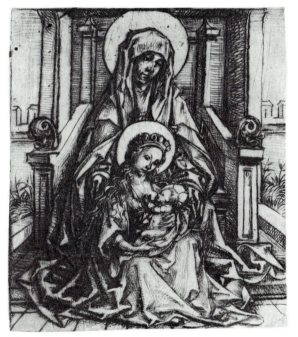

30

31-32. St. Christopher

31. St. Christopher ('large version')
(LI, 32 ; LII, 33), ca. 1480-85
Drypoint, unique impression, 166 x 105 mm.

32. St. Christopher ('small version')
(LI, 31 ; LII, 32), ca. 1490
Drypoint, unique impression, 123 x 72 mm.

¶ As patron saint of pilgrims and travellers and as
guardian against a 'sudden death,' St. Chris-
topher was one of the most popular saints of all.
The *Legenda aurea* tells us that this giant of a man
yearned to serve the most powerful master on
earth. After serveral setbacks – he successively

served a king and the Devil himself – he was
advised by a hermit to serve Christ by ferrying
passengers across a swift river on his back. One
night, a child appeared asking to be carried to the
other side of the river. Guided by the light of a her-
mit's lantern, the giant found the passage exceed-
ingly arduous, for the child who was 'carrying the
burden of the world's sorrow' became heavier
with every step. It was not until the next day that
St. Christopher realized who his passenger had
been: the staff which he had planted in the ground
at the child's request blossomed into a date palm
as a clear sign that he had spoken with God.[1]
¶ In a fourteenth-century German rhymed version
of the life of St. Christopher, the green leaves were
said to have sprouted from his staff even during

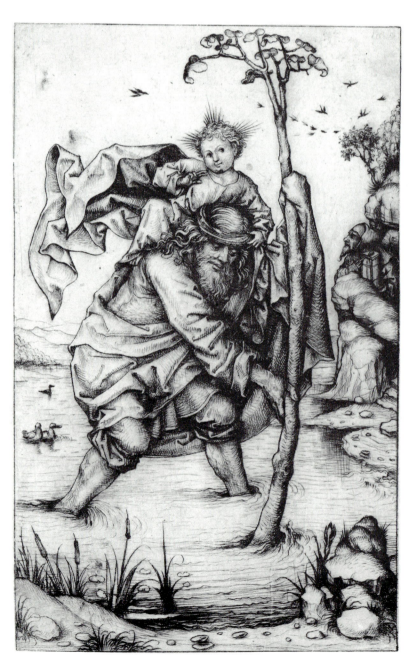

31a

31

the crossing,[2] a conception artists were quick to adopt. The sprouting staff was used by our Master in both versions of the theme he engraved. The first of these [31], a splendid example of his more mature style, has come down to us in a unique impression with fresh, powerful drypoint areas. The composition is probably based on Schongauer's early print of the same subject [31b].[3] In the drypoint print the weight of the child is distributed much more convincingly over the giant's legs and staff than it is in Schongauer's version. How hard St. Christopher finds it to stand up under the child's weight is indicated by a strange detail: he was wrapped his hand in the rough material of his coat to stop the staff cutting into his flesh.

The irises (or sword-lilies), symbols of Christ's suffering, which we can see in the foreground of Schongauer's print [31b], only appear in flowering form on the second drypoint representation

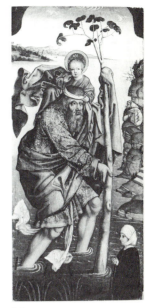

31c

of the subject [32]. Here, the Master follows the legend more closely: the burden of the world Christ carries is symbolized by the orb; the church on the right expresses St. Christopher's service to Christ; the giant himself is dressed as a pilgrim carrying a large purse.[4]

¶ The regular hatchings of the first print, in which Schongauer's influence is still plain, have made way on the second print for a livelier and more painterly treatment of light and shadow, rather spoiled by the heavy dark gray washes brushed on at some later date. The manner in which movement in the water is depicted in both prints is remarkable.

1. Kirschbaum, vol. 5, cols. 496-508. Hutchison 1972, p. 38, note 118; Ernst-Konrad Stahl, *Die Legende des Hl. Riesen Christophorus in der Graphik des 15. und 16. Jahrhunderts*, Munich 1920.
2. Hutchison 1972, p. 38, note 119.
3. Shestack 1967-68, nr. 81.
4. Hutchison 1972, p. 39.

31b*
Martin Schongauer,
St. Christopher, ca. 1475.
Engraving, 160 x 112 mm.
B.48, L.56. Amsterdam,
Rijksprentenkabinet (inv.
nr. 1039).

31c
Anonymous middle Rhenish
master, ca. 1500, *St. Christopher*. Panel, 101 x 46 cm.
Frankfurt am Main,
Historisches Museum
(inv. nr. B.307).

32*
Amsterdam, Rijksprentenkabinet (van Leyden coll.,
port. 20, nr. 58: sheet 11;
Koninklijke Bibliotheek,
1807; Paris, 1812-16, nr. 44;
inv. nr. OB:894): very good
black impression, 123 x 72
mm. (trimmed closely along
outlines, right upper corner
reattached, small repairs
along edge; retouched in the
shadows with gray-black
wash, in brush).

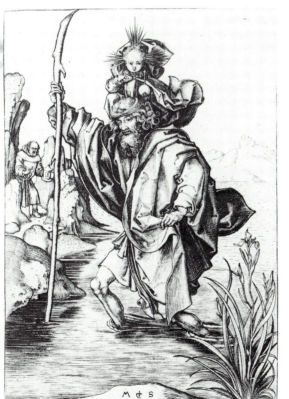

31b

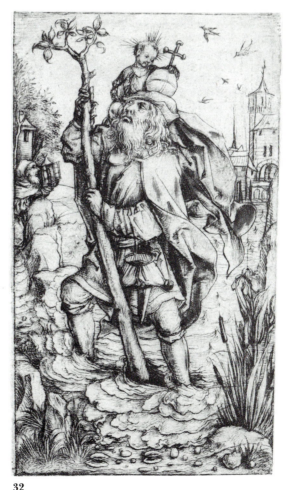

32

33-34. St. George

33. St. George mounted
(LI, 34 ; LII, 35), ca. 1475
Drypoint, unique impression, 145 x 105 mm.

34. St. George on foot
(LI, 33 ; LII, 34), ca. 1490
Drypoint, two known impressions, 141 x 114 mm.

¶ St. George was a Roman tribune from Cappado-
cia born to Christian parents. The town of Silene
in the neighboring province of Libya was being
terrorized at the time by a dragon who had to be
pacified by a daily sacrifice of two sheep. Even-
tually, sheep became scarce and a child chosen by
lot was substituted for one of the two sheep. One
day the lot fell on the king's daughter, Princess
Cleodelinde who, after much wavering, was
abandoned by the king in the marshes where the

dragon roamed. St. George appeared on the scene
in the nick of time, made the sign of the cross,
defeated the dragon in battle, and rescued the
princess.[1]

¶ This legend, an allegorical reference to the battle
of good and evil, which was not incorporated in
the life of the saint until the eleventh century, was
very popular in the late Middle Ages. As the pa-
tron saint of knights, St. George is usually shown
in full armor and mounted on a charger as he kills
the dragon with his lance or sword.[2]

¶ That is also how he appears on the first of the dry-
point prints [33]: as he slays the dragon,[3] Princess
Cleodelinde looks on in the background accom-
panied by the sheep.

¶ The print is an example of the Master's early
work, even though the fine, very effectively
applied cross-hatching indicates that it is not to
be counted among his very earliest. Despite the
confined space, the thick-set figures and the

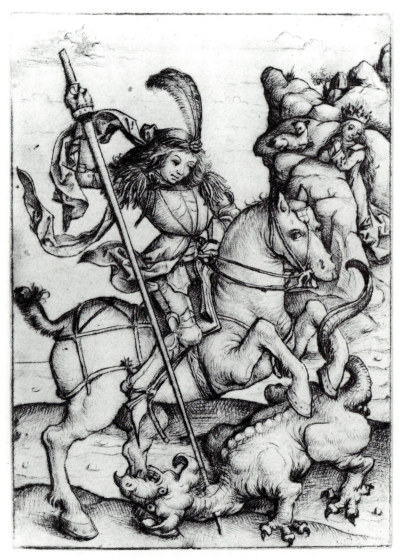

33

rather impersonal features, St. George and the horse are drawn very naturally, vividly and powerfully.

¶ In the later *St. George on foot* [34], greater prominence is given to the landscape, the lake in which the dragon dwelled, according to the *Legenda aurea*, and the royal castle. In other respects, the print is rather unusual: while the tall, graceful princess holds the armored knight's horse, St. George seizes the dragon by its ears and delivers the coup de grace with his sword.[4]

¶ This method of slaying the dragon, which is not mentioned in the legend, reflects medieval hunting practice: the stag, having been cornered, was thrown onto its back by one of the horsemen who dismounted to slit its neck with a knife or a sword. This unusual representation of St. George on foot thus shows that the Master must have been familiar with aristocratic hunting habits, which can only mean – as his profane prints indicate as well

– that he must have moved in aristocratic circles.

¶ The print is a characteristic example of the Master's late style. The spatial effect has been augmented, the figures are tall and supple. The drypoint technique has been applied in a highly refined and almost painterly manner: with the help of very fine, curly lines and some layers of superposed and varied hatchings, the Master has manage to achieve a subtle chiaroscuro effect.

1. *Legenda aurea*, pp. 300-06; Kirschbaum, vol. 6, cols. 366-90.
2. *Inter alia* on prints by Martin Schongauer (L.58) and of Master FVB (L.42); both depicted in Shestack 1967-68, nrs. 43,128.
3. Comparable with the monsters of the Master of St. Sebastian (L.6), illustrated in Lehrs (Dover), 349.
4. Hutchison 1972, p. 40. Note 123 refers the reader to Marcelle Thiebaux, 'The mediaeval chase,' *Speculum* 42 (1967), p. 271.

34.1*
Amsterdam, Rijksprentenkabinet (van Leyden coll., port. 20, nr. 82: sheet 20; Koninklijke Bibliotheek, 1807; Paris, 1812-16, nr. 61; inv. nr. OB:896): good impression (somewhat more uneven condition than **34**.2), 141 X 114 mm. (trimmed along and partly through the outlines).

34.2
Paris, Bibliothèque Nationale (inv. Ec. N. 429; Ea 41 rés.): very good impression, with light plate tone, 141 X 114 mm. (trimmed along outlines).

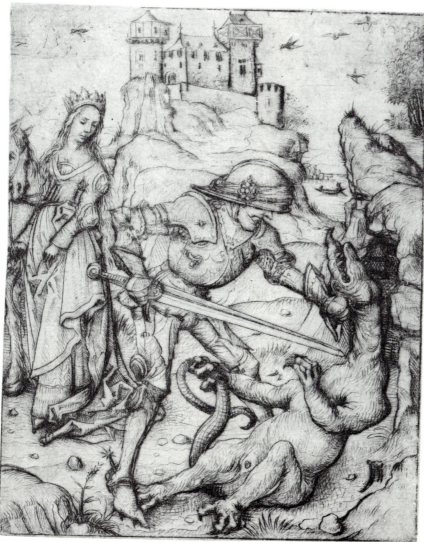

34

45. St. Barbara (large version)

(L1, 46 ; L11, 45), ca. 1470-75
Drypoint, unique impression, 125 x 82 mm.

¶ According to the legend, Barbara lived in the third century, the beautiful daughter of a rich pagan who locked her up in a tower to protect her from evil influences. Barbara nevertheless received regular visits from a follower of Christ and eventually became converted to Christianity herself. Her father realized what had happened when she asked that the tower be embellished with three windows in honor of the Holy Trinity. Furious at the obstinacy of a daughter who refused to foreswear her faith, he unsheathed his sword and beheaded her.[1]

¶ St. Barbara is usually depicted holding the martyr's palm and standing beside a tower with three windows. The drypoint is one of the Master's earliest works;[2] the composition is uncomplicated, St. Barbara's features are simple, and her robe lacking in volume. A technical flaw is the dark line across the drapery, caused by a broad crack in the plate. The contours of the print have been pricked for transfer but it is not known for what precise purpose – embroidery may have been one possibility. In any case, the pricking is evidence that some prints were used as models.

1. Kirschbaum, vol. 5, cols. 306-11. S. Peine, *St. Barbara und ihre Darstellung in der Kunst*, Leipzig 1896.
2. The print may have been influenced by a lost model by Master E.S. known from copies by the Master of the Banderoles (L.72; illustrated in Lehrs (Dover), 337) and by the Master of the Martyrdom of the Ten Thousand (L.80; depicted in Hollstein, vol. 12, p. 55).

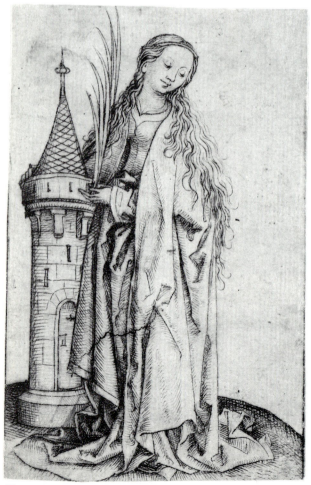

45

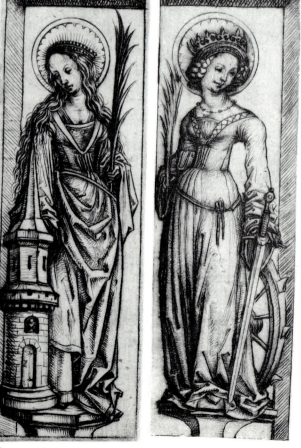

-47. St. Barbara and St. Catherine

. St. Barbara (small version)
I, 45 ; LII, 44), ca. 1485-90
rypoint, unique impression, 120 x 40 mm.

'. St. Catherine (in a niche)
I and LII, 47), ca. 1485-90
rypoint, unique impression, 119 x 38 mm.
ompanion prints.

The two figures of female saints who are shown standing with their attributes on consoles in a niche were undoubtedly intended as pendants, even though the consoles are viewed from different angles. St. Barbara is often coupled with St. Catherine, the first representing the active and the second the contemplative life.[1]
According to tradition, St. Catherine lived in Alexandria at the beginning of the fourth century. She was a pagan princess but became converted to Christianity and then devoted her life to preaching the Gospel. The *Legenda aurea* tells us that Emperor Maxentius assembled fifty of the most eminent scholars to refute Catherine's beliefs, but she put up so brilliant a defense that she converted them as well. The emperor then sentenced the scholars to death at the stake and Catherine to death on a wheel armed with knives and teeth. An angel came down and prevented her execution by destroying the wheel, and the saint was then ordered to be beheaded. She is usually pictured with the attribute of martyrdom, the palm branch, the sword with which she was beheaded and the wheel.[2]
Above the door of St. Barbara's tower there appears another attribute as a small detail, namely the chalice with the host: Barbara was one of the saints invoked against sudden death, that is, death without the sacraments.
Both impressions are exceptionally fine and have deep black drypoint areas. On stylistic grounds, both must be assigned to a late phase in the Master's mature period (the so-called court period).

Legenda aurea, pp. 917-27; Kirschbaum, vol. 7, cols. 289-96.
Similar pendants were executed even earlier, for instance by Master E.S. (L 160, 165) and Schongauer (B.63 en B.64; L.68 and L.69).
E. Klostermann and E. Seeberg, *Die Apologie der H. Katharina*, 1924.

48. St. Dorothy
(LI, 48 ; LII, 46), ca. 1485-90
Drypoint, unique impression, 98 x 48 mm.

¶ According to the *Legenda aurea*, when Dorothy, who lived during the persecution of the Christians under Emperor Diocletian, was condemned to be beheaded and on the way to her execution, a young lawyer named Theophilus mockingly asked her to send him a basket of fruit and flowers from Paradise. Dorothy agreed to do so. As she knelt on the scaffold to say her last prayer, a small boy appeared by her side and presented her with a basket of fruit and roses in bloom, despite the fact that it was mid-winter. Dorothy asked that they be handed to Theophilus who, after her execution, became a Christian and later a martyr himself.[1] From the fourteenth to the sixteenth century, Dorothy was widely revered, especially in Germany.

¶ Traditionally, *St. Dorothy* is depicted as a martyr holding a palm branch, her hair wreathed in blossoms, as she accepts a basket of flowers and apples from a small child. Like the pendant of female saints [46-47] described above, *St. Dorothy*, who is portrayed in a highly refined and subtle manner, must be assigned to the Master's later period.[2]

1. *Legenda aurea*, in *Der heiligen Leben und Leiden*, 2 vols., Leipzig 1913, vol. 1, p. 365; Kirschbaum, vol. 6, cols. 89-92.
2. Hutchison 1972, p. 47, observes that the child's hair was represented by the same method as that used for the *Child-Savior* [18]: by punching a series of small holes in the plate and then incising the curls around them.

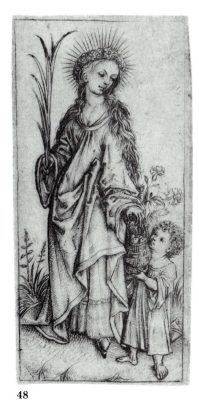

48

49*
Amsterdam, Rijksprenten-kabinet (van Leyden coll., port. 20, nr. 70: sheet 14; Koninklijke Bibliotheek, 1807; Paris, 1812-16, nr. 53; inv. nr. OB:910): meagre impression, 194 x 135 mm. (crack in the plate reaching to the lower right angel; no outlines; the impression has been damaged along a horizontal fold and through rubbing of the surface, among other causes; water-mark: Gothic P with flower).
49a
Master E.S., *The elevation of Mary Magdalene*. Engraving, 165 x 127 mm. L.169. Berlin-Dahlem, Staatliche Museen Preussischer Kulturbesitz.

49-50. The elevation of St. Mary Magdalene

49. The elevation of St. Mary Magdalene by five angels
(LI, 50 ; LII, 49), ca. 1480
Drypoint, unique impression, 194 x 135 mm.

50. The elevation of St. Mary Magdalene by four angels
(LI, 49 ; LII, 48), ca. 1490
Drypoint, unique impression, 123 x 89 mm.

¶ According to the *Legenda aurea*, Mary Magdalene who, after an initially sinful life, became convert-ed to Christianity, retired to a wilderness, living in a cave and renouncing all worldly needs such as clothing and food. Her body was clad in nothing but her own long, luxuriant hair, and for an hour each day she was lifted up into heaven by angels and nourished by heavenly music.[1]
¶ This elevation of St. Mary Magdalene was the subject of a great many late medieval German works of art. In the fifteenth century, these

49a

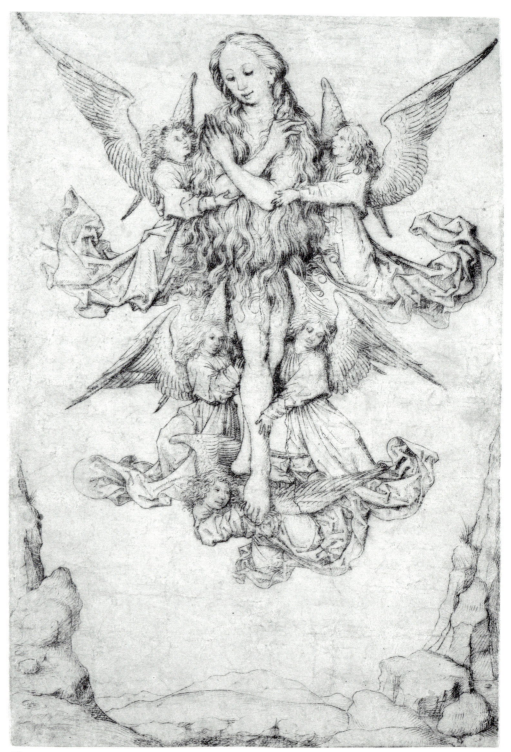

49

showed her covered in body hair like the 'wild woman' [see **51-52**], and that is also how she appears on the print by Master E.S. [**49**a], on which the first large version of our Master was probably based.[2] The drypoint print, however, has merely adopted the group of figures and has replaced the fertile craggy landscape of Master E.S. [**49**] with bare and inhospitable mountains, which are more in keeping with the story of Mary Magdalene's life.

The Master's print is one of his largest. Unfortunately the only extant impression comes from a fairly worn plate; moreover it has been torn and wrinkled and has been restored throughout. In other respects, too, the print is far from perfect, for it was taken from a plate with two heavy cracks down the center. The poor state of the

impression suggests that it must have served as a model.[3]

¶ Much finer is the later print [**50**] in which the saint, her arms folded, is carried heavenwards by four angels. The ornamental surround [as in **21, 27, 75**], the sketchy draftsmanship and the strong drypoint areas, all indicate that this work must be assigned to a late period. This print probably served as a model for Dürer's drawing of St. Mary Magdalene in Coburg; Dürer, however, did not cover the saint's body with hair [**49**b].[4]

1. *Legenda aurea*, pp. 470-82; Kirschbaum, vol. 7, cols. 516-44; Husband 1980-81, pp. 100-11; Hutchison 1972, p. 48, notes 162-63.
2. Bernheimer 1952, p. 199, note 29.
3. Hutchison 1972, pp. 48-49.
4. Exhib. cat. *Albrecht Dürer*, Nürnberg 1971, nr. 139.

49b
Albrecht Dürer, *The elevation of Mary Magdalene*. Pen, 243 x 178 mm. Winkler 38. Coburg, Veste Coburg (inv. nr. 2.97).
50*
Amsterdam, Rijksprenten-kabinet (van Leyden coll., port. 20, nr. 70: sheet 14; Koninklijke Bibliotheek, 1807; Paris, 1812-16, nr. 53; inv. nr. OB:909): good impression, not altogether sharp, with tiny inkspots, 123 x 89 mm. (trimmed along outlines).

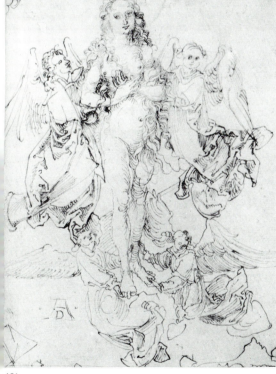

49b

50

51
Amsterdam, Rijksprenten-kabinet (van Leyden coll., port. 20, nr. 15: sheet 3; Koninklijke Bibliotheek, 1807; Paris, 1812-16, nr. 10; inv. nr. OB:914): good impression (somewhat splotchy), 106 x 78 mm. (probably trimmed somewhat on the left).

52*
Amsterdam, Rijksprenten-kabinet (van Leyden coll., port. 20, nr. 16: sheet 3; Koninklijke Bibliotheek, 1807; Paris, 1812-16, nr. 11; inv. nr. OB:915): very good impression (fine black spots in the plate), 92 x 84 mm. (probably trimmed a bit on all sides).

51. Wild woman and her children on a stag
(LI, 51 ; LII, 54), ca. 1475
Drypoint, unique impression, 106 x 78 mm.

52. Wild man on a unicorn
(LI, 52 ; LII, 55), ca. 1475
Drypoint, unique impression, 92 x 84 mm.
Companion prints.

¶ The imaginary being known as the wild man is a typical creation of the late Middle Ages. In many different contexts we encounter humans with bodies covered by hair or leaves, living in the wild, guided by instinct alone. Primitive, violent and sexually insatiable, the wild man personified sin, but he also represented mankind in a state of freedom and happiness, living in harmony with nature and unconstrained by civilization. He inspired fear, but his untrammeled life also kindled a certain jealousy among city folk.[1]

¶ The interpretation of late medieval depictions of wild men, some of which are based on known myths, is complicated by this ambivalent attitude. One has the impression that in the late fifteenth century the positive features of the wild man gained the upper hand.

¶ In the *Wild family* [93] by Master b x g, a positive interpretation seems called for.[2] In the companion prints by the Master, too, we are struck by the easygoing harmony between the wild people and their mounts.[3] Wild men are also found frequently in fifteenth-century decks of cards such as those by the Master of the Playing Cards and Master E.S. In one deck by the former, the various suits are indicated by wild flowers, birds, stags, lions and wild men of two varieties, one covered with hair, the other with leaves. The artist ranked the wild men among the denizens of the forest rather than among the human hierarchy of the face cards.

¶ The wild men in the cards of Master E.S. are higher in rank. On the minor jack of birds, which

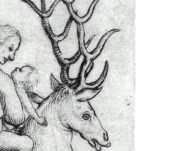

51

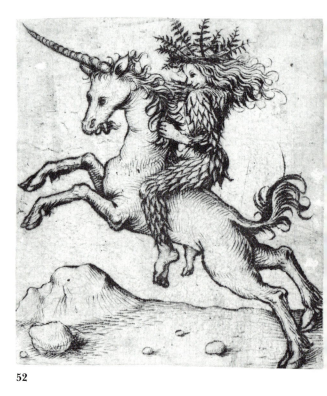

52

was probably the model for **52**, we see a wild man riding a unicorn which he holds by the tail and mane [**52**a].[4] His body is covered with leaves and he has a wreath of twigs on his head like those worn by young men and women in various prints by the Master [**67, 70, 72**].

The Master's wild men are conspicuously at home in the animal world. Even without saddles or reins, they have no trouble riding their mounts. The wild woman and her children ride a stag, symbol of faithfulness and honor; the man's unicorn is an old symbol of virginity but also of unchastity, repressed violence and female power.[5] According to legend, the unicorn can only be captured by a virgin – his prodigious strength ebbs away when his head is lain in the lap of a pure woman. Applied to the drypoint, this could mean that the wild man's unbridled erotic drive can be curbed, that he can be turned into a faithful lover.[6]

In general, the pair of prints is dated to the early period on the basis of their simple compositions and rudimentary modelling. The width of the contours is very irregular, which suggests that the engraver used the blade of a sharp knife rather than a needle.[7]

1. Bernheimer 1952 is a fundamental study that goes quite deeply into the literary background of the theme. For the wild man in art, see (Lise Lotte Möller), exhib.cat. *Die wilden Leute des Mittelalters*, Hamburg (Museum für Kunst und Gewerbe) 1963; (Timothy Husband with the assistance of Gloria Gilmore-House), exhib.cat. *The wild man: medieval myth and symbolism*, New York (The Metropolitan Museum of Art) 1980-81.
2. See Bernheimer 1952, p. 115; Husband 1980-81, pp. 13, nrs. 32-33.
3. See Bernheimer 1952, p. 6; Husband 1980-81, nr. 47, fig. 113.
4. See Hutchison 1972, p. 50; Husband 1980-81, nr. 47.
5. See Bernheimer 1952, p. 161; Husband 1980-81, nr. 28 and nr. 36; Hutchison 1972, p. 49. Hutchison sees the stag as a symbol of lust, thereby lending support to Kaiser's notion that the prints represent chastity (in the man) and unchastity (in the woman).
6. See Bernheimer 1952, p. 136; Husband 1980-81, nr. 15.
7. See Hutchison 1972, p. 49.

52a*
Master E.S., *Wild man on a unicorn with bird, Vogel unter*, ca. 1450, from the *Large deck of cards*. Engraving, 131 x 87 mm. L.269. Berlin-Dahlem, Kupferstichkabinett (inv. nr. 97:1891).

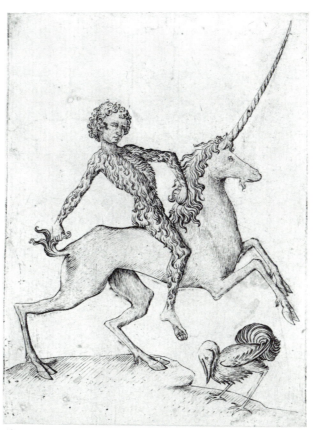

52a

53. Combat of two wild men on horseback
(LI, 53 ; LII, 56), ca. 1475-80
Drypoint, two known impressions, 125 x 92 mm.

¶ The two horsemen attacking each other with uprooted trees are shown as figures of fun. Their armor, like the cloths covering their steeds, consists of ornamental foliage that not only offers no protection but leaves the hands, arms and feet exposed. Equally curious are the helmets, which are crested not by heraldic insignia but by bunches of garlic and radish respectively. The same vegetables are found as crests for coats of arms in other prints by the Master from the same period, prints that were also probably intended as satires [84, 85].

¶ By all indications, the print must have been made as a parody of a knightly joust. Not only is the

armor exaggeratedly elaborate, it is also totally ineffective. The rider on the left is not even able to raise his treetrunk-lance to fighting level. The superfluous heraldic devices added to the armor and the vegetable crests, in combination with the standard attributes of the wild man, amount to a satire on the pretensions of knighthood.[1] Parodies of this kind, with wild men brought into the field as the opposite numbers of Christian knights, can be found in miniatures and tapestries as well.[2]

¶ The closest literary parallel to the print is found in the thirteenth-century stories of Hellekin and his horde of wild men, who were said to have ravaged the French countryside. We read there that they amused themselves by holding a joust with uprooted trees in the forest. However, this does not seem to be the source of the Master's subject. His wild men are not as horrendously

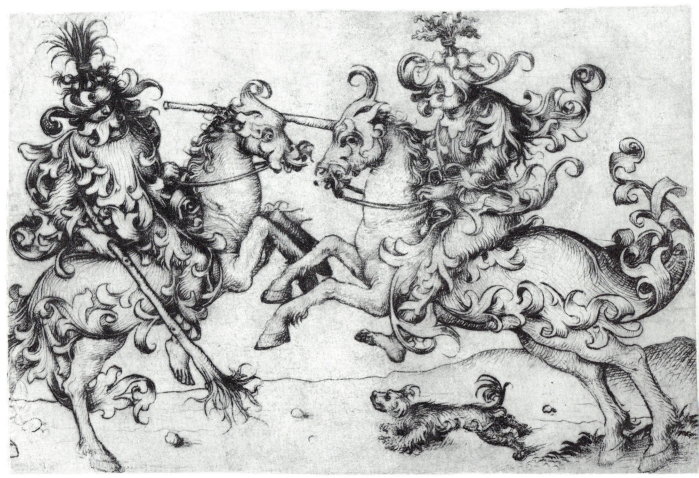

53.1

ugly as Hellekin and his crew, whose hairiness extends even to their faces.[3]

The print, which is usually dated to the middle period, is one of the first drypoints to outgrow the small format of the early work. The graceful ornamentation of the 'clothing' of the wild men and their horses is engraved successfully with the stylus. Even the dog's coat is daringly curled. Unfortunately, neither of the two impressions is preserved very well; that in Amsterdam is torn down the middle, damaged along the tear and heavily restored. The Hamburg impression [53.2], although dirty and rubbed, gives a better idea of the complete plate.

In Israhel van Meckenem's copy in reverse [53a], the dog is omitted and the ground is indicated with a few bare lines. The placing of the combatants in space, in the middle of the composition, is more balanced, and the cooler engraving style brings out the ornamental nature of the costumes even more strongly.[4]

1. Hutchison 1972, p. 50; Husband 1980-81, nr. 35; Bernheimer 1952, pp. 47-48.
2. Husband 1980-81, pp. 138-39.
3. Bernheimer 1952, pp. 65-66.
4. Husband 1980-81, p. 139.

53.2
Hamburg, Kunsthalle (Ottley coll., London, 1837; inv. nr. 3711): good, gray impression, 125 x 192 mm. (trimmed along platemark, small and large areas of damage, repairs and spots; watermark: small oxhead with bar and star).
53a*
Copy in reverse by Israhel van Meckenem, without the dog, ca. 1480. Engraving, 155 x 220 mm. B.200, L.491. Amsterdam, Rijksprentenkabinet (inv. nr. OB:1140).

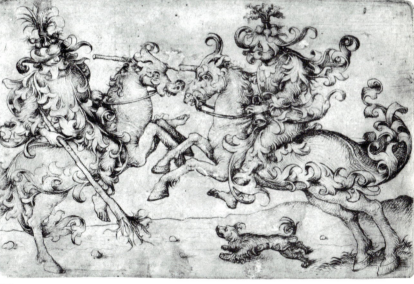

53.2

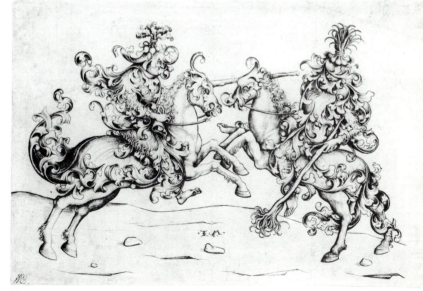

53a

54. Aristotle and Phyllis
(LI, 54 ; LII, 57), ca. 1485
Drypoint, four known impressions, diameter 155 mm.
Companion to *Solomon's idolatry* [**7**].

¶ Like its companion *Solomon's idolatry* [**7**], this image exemplifies the foolishness to which a wise man can be reduced by a woman. The tale of the great philosopher of antiquity going down on all fours to let the beautiful Phyllis ride on his back is not based on historical tradition. It was invented in the thirteenth century by the priest Jacques de Vitry, in an attempt to discredit classical philosophy. The story became very popular in the late Middle Ages, and we find it in many different variations.

¶ The two onlookers in the Master's version of the subject allow us to identify its source as the fifteenth-century German carnival play *Ain spil von Maister Aristoteles*. The characters in that work, a play of the kind traditionally staged on Shrove Tuesday, are Aristotle, an unnamed king and queen, and a clerk. After hearing the king praise Aristotle for his immunity to the charms of beautiful women, the queen decides to seduce him. The philosopher offers to become her tutor. When they are alone, she tells him she is less interested in learning than in riding around the garden on the back of someone as learned as he. The king, who has witnessed the entire scene with the clerk, chides the philosopher for allowing himself to be humiliated by a woman.[1]

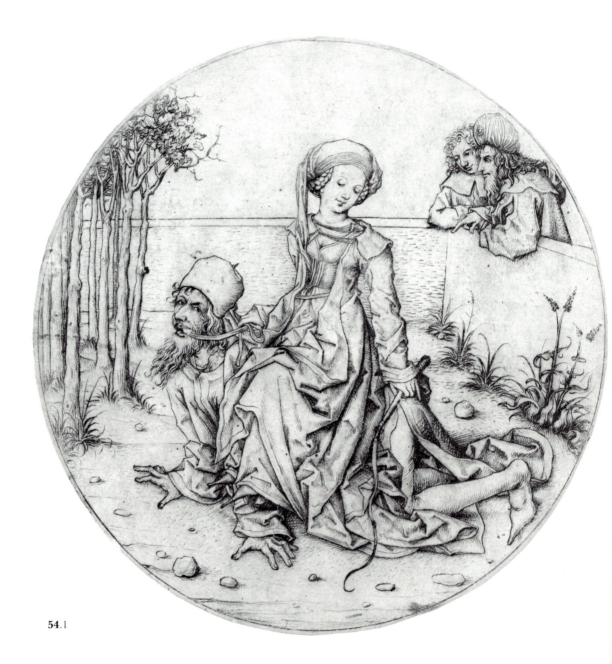

54.1

¶ The format of the print, like that of *Solomon's idolatry*, is round, probably indicating a derivation from roundels of stained glass such as **136** and **137**. The story is depicted in lively and witty fashion. In contrast to various other representations of the subject in early sixteenth-century prints, which show Phyllis as a shrew whipping the old man,[2] here she is a charming, playful young woman who makes Aristotle ridiculous without insulting him.

¶ The companion prints show two of the great heroes of medieval Europe – the wise king Solomon from the Bible and the pagan philosopher and scholar Aristotle – turning themselves into laughing-stocks through their weakness for women. The theory that such representations were intended as a criticism of the fifteenth-century followers of Thomas Aquinas, who were great admirers of Aristotle, is cited above, p. 60. Like *Solomon's idolatry*, this print is one of the high-points of the Master's mature style, and should probably be dated shortly before 1488.

1. Hutchison 1966; Hutchison 1972, pp. 51-52.
2. See exhib.cat. *Lucas van Leyden*, Amsterdam (Rijksprentenkabinet) 1978, pp. 56-57. The only one of the Master's contemporaries to depict the theme was Master BR. See Lehrs, vol. 6, p. 308, nr. 13, illustrated in Lehrs (Dover), 436.

54.2
Coburg, Veste Coburg, (Brandes coll., 1796; inv. K.530): very good impression, diameter 156 mm. (part of the image trimmed off left and right, also trimmed along the outline; with Schongauer's monogram M+S).

54.3
Oxford, Ashmolean Museum (Bodleian Library, Douce bequest, 1834; inv. S 24-2): good, somewhat uneven impression, blurred here and there, with strong, heavy drypoint passages, diameter 160 mm. (trimmed along platemark; the best-preserved of the extant impressions).

54.4
Vienna, Albertina (Hof-bibliotheek; inv. nr. 314/1928): good impression, diameter 153 mm. (trimmed just within the outline).

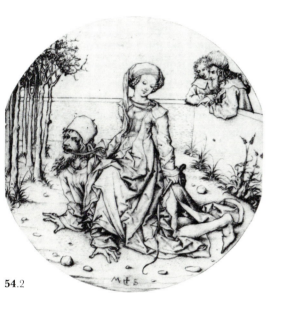

54.2

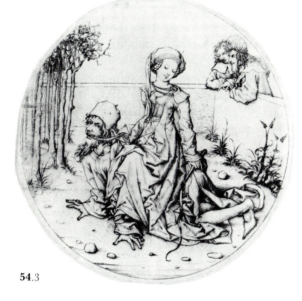

54.3

54.4

57. The three living and three dead kings

(LI, 57 ; LII, 52), ca. 1485-90
Drypoint, two known impressions, 124 x 185 mm.

¶ The story of the three living and three dead kings derives from French troubador poetry of the thirteenth century, and exists in several French, English and Italian variants. The central feature is the dialogue between the living and the dead. Three young noblemen were hunting in a lonely landscape when they passed an old cemetery. Suddenly three corpses appear, terrifying the young men with their putrified, wormeaten bodies. The corpses tell them about their own former lives, which were full of pride, vanity and luxury. They urge the young men to abandon their sinful ways, for which they will later be called to account. 'What you are now, we once were; what we are, you will become.' Their words are an admonition to think of death during life, to turn one's back on the vain pleasures of the world and to repent through love of God.[1]

¶ The story typifies late medieval attitudes towards life. Worldly and religious elements come together. The evanescence of earthly splendor and delight is contrasted to everlasting salvation through Christ.[2] In one of the earliest rhymed versions of the story, the appearance of the corpses is described as a mirror held up to the living men by God as a warning against living a vain and proud life.[3] The subject is found fairly frequently from the fourteenth century on, not only in miniatures, where it illustrates the prayers for the dead and dying in books of hours (*fig. 5*), but also, mainly in Italy, in cemetery wall paintings.

¶ Most of the earlier depictions are rather static. The corpses stand or lie in their coffins opposite the young noblemen, who are shown on foot or on horseback. The living trio sometimes seems to be shocked by the appearance of their dead counterparts, but seldom with the dramatic effect of the living figures in the Master's drypoint. The horses and dogs make it clear to the viewer that the confrontation takes place during the hunt. The bones on the ground near the corpses identify the locale as a cemetery. The corpses are shown not as skeletons but as decayed bodies. By their crowns, we recognize the living men as an emperor,[4] a king and a duke. The crowns of the dead may not be exactly the same, but it seems likely

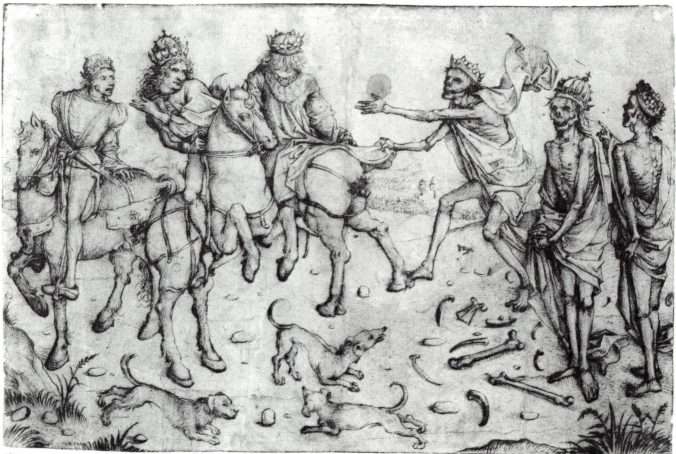

57.1

which the
pleasures

The two
black dry
success o
used for r
for a syste
low the f
21). The
Amsterda
copy afte
from the
The them
in two ea
nade: the
Death sta
lovers of
threatened
sure whe

that they too occupied the same elevated ranks in their life.

The meeting is depicted with uncommon dramatic power. The living men fly off in all directions as though struck by lightning. The emperor's horse rears, while the living king behind him attempts to flee, with his dead counterpart clutching him. The Master has succeeded to a surprising degree in distinguishing between various kinds of emotional reaction, which he characterizes by facial expression and gesture. One can point out weak passages in the drawing and composition of the print, such as the excessive foreshortening of the horse on the left, but it remains the most unusual and convincing depiction of the theme in graphic art.[5]

The plate was engraved with such a fine stylus that the ink could not penetrate very deeply, and all the surviving impressions are gray and somewhat blurred. The delicate, extremely subtle draftsmanship and modelling place the print in the Master's late period. Dürer's 1489 drawing of a group of horsemen [57a] is so similar to the print in structure and composition that we may assume that Dürer knew it.[6]

57a

57.2
Stuttgart, Graphische Sammlung (inv. nr. A 8700): good, gray impression, not sharp across the entire surface, 124 x 192 mm. (upper outline missing, platemark visible left and below right; scattered stains and areas of damage).

57a
Albrecht Dürer, *Company on horseback*, 1489. Drawing, 201 x 309 mm. W. 16. Formerly Bremen, Kunsthalle (lost in 1945).

1. The most recent discussion of the theme is W. Rotzler, *Die Begegnung der drei Lebenden und der drei Toten*, Winterthur, Switzerland 1961.
2. Johan Huizinga, *Herfsttij der Middeleeuwen*, Leiden 1919, chap. II.
3. See Rotzler, pp. 22-25.
4. The emblem on the flank of the emperor's rearing horse is in fact an imperial symbol, added for good measure.
5. Hutchison 1972, p. 54.
6. Erwin Panofsky, *Albrecht Dürer*, Princeton 1943, p. 20.

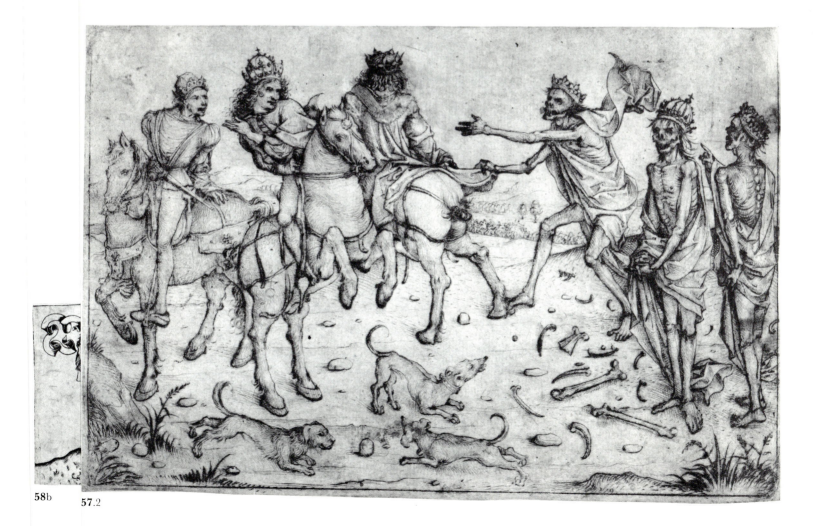

58b 57.2

58.1*
Amst[...]
kabin[...]
port. [...]
Konin[...]
1807; [...]
inv. n[...]
black [...]
mm. [...]
lines; [...]
traces [...]
58.2
Vienn[...]
(Hofb[...]
315-1[...]
sion, [...]
above [...]
pen i[...]
and a [...]
vertic[...]

5[...]
A[...]
a[...]
E[...]
E[...]
R[...]
n[...]

5[...]
A[...]
a[...]
E[...]
E[...]
R[...]
n[...]

59a
Book of hours of Duke Eberhard,
marginal illustration on fol.
42r. Stuttgart, Landes-
bibliothek, ms. brev. Q.I.
60a
Copy in reverse of **60** by
Master b x g. Engraving,
87 x 76 mm. *L.II (b x g), 11.*
Dresden, Kupferstich-
kabinett (inv. nr. A 444).
61a
Copy in reverse of **61** by
Master b x g. Engraving,
84 x 75 mm. *L.II (b x g), 13.*
61b
Master b x g, *Two infants
playing.* Engraving, 84 x 76
mm. *L.I, 95; L.II (b x g), 10.*
Dresden, Kupferstich-
kabinett (inv. nr. A 443).
61c.1
Master b x g, *Two infants
playing.* Engraving, 85 x 77
mm. *L.I, 96; L.II (b x g), 12.*
Dresden, Kupferstich-
kabinett (inv. nr. A 433).

infants in the margins of illuminated books of
hours (see *fig. 44*).[2] In at least one case, one of the
Master's infants was used, via a copy in reverse
by Master b x g, for such a marginal illustration
[**59**a].

¶ The three preserved prints were made in the Mas-
ter's early period. The drawing is simple and the
modelling of the bodies is limited to narrow bands
of hatching, while the eyes are indicated with a
simple dot.

¶ Two other prints of playing children by Israhel
van Meckenem [**61**h,i], in the past regarded as
copies after lost works by the Master, are now
thought to be inventions of van Meckenem in-

spired by the example of the Master. The figures
in the two prints are placed against a dark back-
ground of hatching, a device we know from van
Meckenem's late period. The children are some-
what older, and play with toys of all kinds. Here
too it is difficult to assign a specific meaning to the
representations, which may well be related to
allegories or proverbs.

1. Lehrs, vol. 8, pp. 139-41; Hutchison 1972, p. 56.
2. In the Hague book of hours attributed to the studio of the
Master of Catherine of Cleves (see p. 14), there is a reading
child in the margin of fol. 35v.

59a

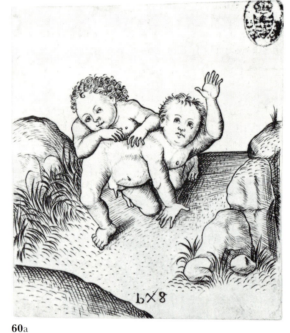

60a

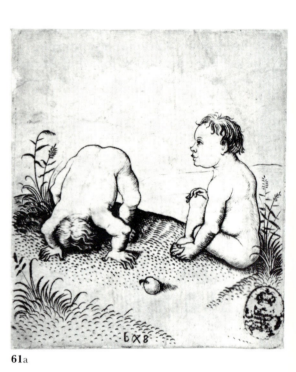

61a

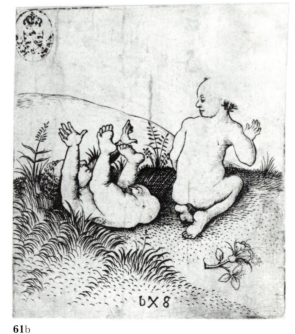

61b

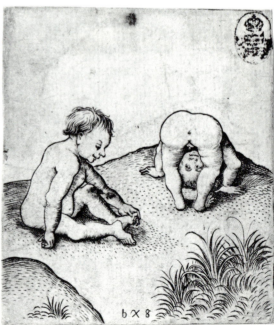

61c

1d

61e

51f

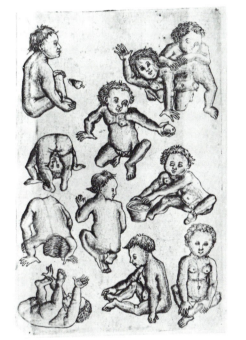

61g

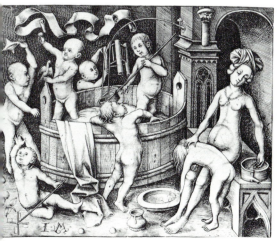

51h

61i

62. Bagpipe player

(L1, 62 ; L11, 65), ca. 1470-75
Drypoint, unique impression, 78 x 53 mm.

¶ A single figure clad in a long mantle sits on a rock
playing his instrument. His dress and bald head
put one in mind of a court jester, a figure we often
encounter in art as a bagpipe player.

¶ However, in the hands of a jester, the bagpipe
invariably has an obscene meaning,[1] and that
does not seem to be intended in the Master's
print. Alternatively, bagpipe players are also
found from the thirteenth to the fifteenth century
in less charged form in the marginal illuminations
of books of hours.[2] The rather schematic figure
does not give one the impression of being ob-
served from life, leading us to suspect that it is
derived from an example of that kind. It may have
been made in turn as a model for other illumina-
tions.

¶ The print is one of the Master's first: the hatching
is rather mechanical and does little to suggest
depth and space.

1. See Keith P.F. Moxey, 'Master E.S. and the folly of love,'
 Simiolus 11 (1980), pp. 125-48, especially 128-31.
2. Lilian M.C. Randall, *Images in the margins of Gothic manuscripts*,
 Berkeley and Los Angeles 1966, p. 174. A man playing the bag-
 pipes is also found in the margin of the Hague book of hours
 attributed to the studio of the Master of Catherine of Cleves,
 fol. 52v. Hutchison 1972, p. 57, note 213, cites examples of
 similar figures in carved choir stalls, where one frequently
 encounters the same themes as in the margins of manuscripts.

62

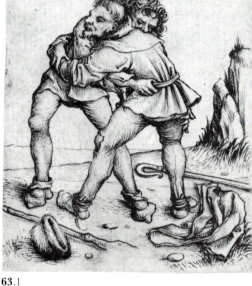

63.1

. Two peasants wrestling

1, 63 ; LII, 64), ca. 1475-80
rypoint, two known impressions, 76 x 69 mm.

Two peasants (or are they shepherds?) dressed in short tunics are engaged in a good-natured wrestling match. Their belongings – jackets, caps, a club and a crook – lie beside them on the ground. The apparent friendliness of the fight sets it off from the fighting peasants by Master FVB [63a], where the shabbily dressed combatants go at each other with a will. From the background of that print, we surmise that the two men were bowling and drinking before the fight broke out. The artist makes the men even more laughable by showing them with their pants falling down.

¶ The Master's print, which lacks these anecdotal details, seems more like a scene observed from life.[1] Yet the motif occurs frequently in marginalia.[2] In contrast to the *Bagpipe player* [62], this print seems too lifelike to have been based on a manuscript illumination. It may, however, have been made as a model for a miniaturist.

¶ The print can be dated in the Master's middle period. The unstudied drawing and varied hatching create a convincing suggestion of movement and space that comes across exceptionally well in the two deep black impressions.

1. Hutchison 1972, p. 57.
2. Randall 1966, op.cit. [62, note 2], p. 235.

63.1*
Amsterdam, Rijksprenten-kabinet (van Leyden coll., port. 20, nr. 24: sheet 7; Koninklijke Bibliotheek, 1807; inv. nr. OB:923): very good impression, 76 x 69 mm. (presumably trimmed along the platemark; traces of paint spots; large tear and hole in middle, repaired on the lower edge).
63.2
Washington, National Gallery of Art (Lloyd coll. [Wilson auction], London 1828; White, London 1830; Perry, Rumpf et al. auction, Stuttgart [Gutekunst], 1907; Gustav von Rath coll., Krefeld, 1929; Lessing J. Rosenwald coll., Jenkintown; inv. nr. B 11/144): very good impression, 72 x 66 mm. (trimmed somewhat closer to the image than 63.1, outline drawn with the pen; watermark: part of ox-head with bar and star).
63a*
Master FVB, *Two peasants fighting*. Engraving, 139 x 103 mm. L.51. Hamburg, Kunsthalle (inv. nr. 10448).

63.2

63a

64*
Amsterdam, Rijksprenten-
kabinet (van Leyden coll.,
port. 20, nr. 25: sheet 7;
Koninklijke Bibliotheek,
1807; inv. nr. OB: 925):
reasonable, somewhat gray
impression, 79 x 57 mm.
(trimmed along the
platemark; traced on the
back with the pen).

64a
Copy in reverse by Master
b x g. Engraving, 82 x 60
mm. *LII, 15*. Berlin-Dahlem,
Staatliche Museen Preus-
sischer Kulturbesitz,
Kupferstichkabinett (second
state with monogram).

64b
Copy in reverse by Wenzel
van Olmütz. Engraving,
77 x 57 mm. L.58.
Washington, D.C., National
Gallery of Art (Lessing J.
Rosenwald Collection).

64c
Martin Schongauer, *Peasant
family going to market.*
Engraving, 163 x 163 mm.
B.88; L. 90. Berlin-Dahlem,
Staatliche Museen
Preussischer Kulturbesitz,
Kupferstichkabinett.

64a

64b

64. Peasant couple
(LI, 64 ; LII, 66), ca. 1470-75
Drypoint, unique impression, 97 x 57 mm.

¶ A peasant couple, no longer young, appear to be on their way to the market with their wares, the woman with a goose under her arm and the man with a basket of eggs hanging from the club over his shoulder. They look poor and unprepossessing. The man has a big bump on his forehead and a growth under his chin, his jacket is unbuttoned and his pants torn. The laces of the couple's boots – the *Bundschuhe* of the poor – are unlaced. The woman holds the man's arm in a firm grasp and seems to be in charge of things.

¶ It has been suggested that the print is based on a farce or a play of some other kind, although no text can be pinpointed.[1] Considering the unflattering way in which the peasants are shown, it seems likely that the artist had a satire in mind.

¶ There are other prints of the late fifteenth and early sixteenth century that show an oldish peasant couple, the woman with a fowl or two and the man with a basket or sack of eggs. One of the earliest is by Schongauer [**64c**]: an older man with a sack (of eggs?) over his shoulder trudges along with a horse ridden by a witch of an old lady, carrying a withered branch, and a stunted child. The fowl too are in evidence. In a print by Master b x g [**109**] we see a grotesque, impoverished old couple on the road, the man with a basket of eggs in his hand, the woman with a basket of goslings, if that is what they are, on her head. In prints by Hans Sebald Beham and Dürer we also find peasant couples with the same wares.[2]

¶ The eggs and fowl may have an obscene meaning in such prints. Eggs often stand for male virility and (water) fowl for the sexual act. If so, one should read the print and that by Master b x g as a satire on the misplaced lust of the poor and foolish old couple.[3] An interpretation of this kind would certainly be called for if the representation were a Dutch genre painting of the seventeenth century, but whether it is also applicable in this case is uncertain. An equally likely reading is that the goose is a symbol of stupidity,[4] which also casts the couple in an unflattering light. The popularity of the subject is attested by the copies and variants after the print by Master b x g.

¶ The drypoint can probably be assigned to the Master's early period. The composition and hatching are simple, and the figures comparatively flat.

1. Hutchison 1972, p. 58.
2. Among others, see Ernst Ullmann, 'Die Gestalt des Bauern in der Kunst zur Zeit der frühbürgerlichen Revolution in Deutschland,' in exhib.cat. *Der Bauer und seine Befreiung*, Dresden 1975, pp. 26-31. See also exhib. cat. *Albrecht Dürer*, Nürnberg 1971, nr. 427 and Hans-Ernst Mittig, *Dürers Bauernsäule*, Frankfurt am Main 1984, pp. 32-47.
3. See Stewart 1977, pp. 53-54.
4. D. Bax, *Ontcijfering van Jeroen Bosch*, The Hague 1949, pp. 68, 185 (English translation, Rotterdam 1979, pp. 86, 88).

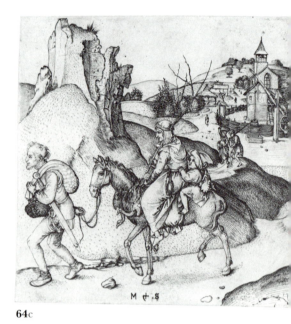
64c

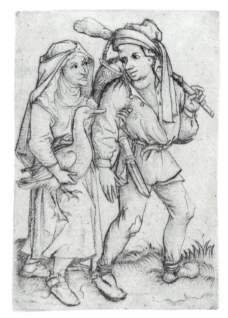
64

65. Family of gypsies

(L1, 65 ; L11, 67), ca. 1475-80
Drypoint, two known impressions, 82 x 61 mm.

In the past, this print was erroneously regarded as a companion piece to the *Old peasant couple* [64]. Aside, however, from the small differences in size, scale of the figures and style, the *Gypsies* lack the satirical touch of that print. The couple, dressed in oriental garb, is travelling with two small children. The man has a bow in his hand and the woman a sack over her shoulder. The former title – *Die Landstreicher*, The vagabonds[1] – was correct insofar as the couple are migrants or nomads, in the same category as pilgrims, beggars, gypsies, acrobats, musicians and others with no fixed residence, earning their living on the road.

The figures, like the man and woman supporting the coat of arms in drypoints **82** and **83**, are probably gypsies. Originally from northern India, this people came to Turkey via Persia in the eleventh century, only to be forced by the Turks in later centuries to move on to Europe. In the early fifteenth century, small groups of migrant gypsies began to show up in the Netherlands, Germany and France. At first they claimed to be pilgrims, and were received hospitably, but in the course of time they acquired a less flattering reputation as soothsayers, horse traders and petty thiefs. They began to be persecuted, to a particularly vicious degree in Germany.

¶ When they first came to Europe their clothing made a strong impression. The women wore a kind of turban fastened beneath the chin with a ribbon, and the men a broad-brimmed hat. In Flemish and German painting of the fifteenth century, dress of this kind – which was considered oriental – was often used for biblical figures.[2]

¶ In Dürer's early engraving of an *Oriental family* [65c], the dignity of the father and easternness of the family are emphasized, but in that print too it seems certain that the family are gypsies. The Master's print can be dated somewhat later than the *Old peasant couple* [64] on the basis of the hatching, which is delicate and sketchlike.

1. Lehrs, vol. 8, p. 143, nr. 67 and p. 160, note 1; Lehrs too was convinced at first that the figures were gypsies.
2. Hutchison 1972, pp. 58-59, note 221. See also Charles D. Cuttler, 'Exotics in fifteenth-century Netherlandish art: comments on oriental and gypsy costume,' *Liber amicorum Herman Liebaers* 1984, pp. 419-34.

65.1*
Amsterdam, Rijksprenten-kabinet (van Leyden coll., port. 20, nr. 26: sheet 7; Koninklijke Bibliotheek, 1807; inv. nr. OB:926): good, black, somewhat uneven impression, 82 x 61 mm. (trimmed along the platemark; spot on child's back removed, largely mechanically).
65.2
Paris, Bibliothèque Nationale (inv. nr. Ec.N. 431, Ea. 41 rés.): very good impression with light plate tone, 82 x 61 mm. (platemark visible below and above; small repairs).
65a
Copy in reverse of **65** by Master b x g. Engraving, 82 x 59 mm. *L.11, 15.* Paris, Musée du Louvre, E. de Rothschild coll. (from Bologna; inv. nr. 300 LR).
65b
Copy in reverse of **65** by Wenzel van Olmütz. Engraving, 80 x 60 mm. L.59. Vienna, Albertina (inv. nr. 1928/219).
65c*
Albrecht Dürer, *Oriental family*, ca. 1496. Engraving, 108 x 77 mm. B.85. M. 80. Amsterdam, Rijksprenten-kabinet (inv. nr. OB:1251). Not illustrated.

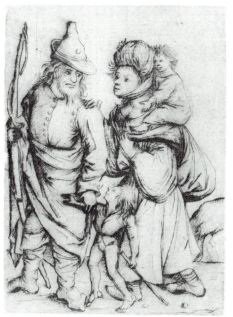

65.1

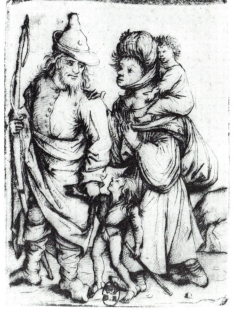

65.2

65a

65b

66. Young man and two girls
(Li, 66 ; Lii, 68), ca. 1480
Drypoint, unique impression, 93 x 83 mm.

¶ A fashionably dressed young man sits on a stool between two devoted young women. The girl to his right holds his hand, while he leans against the other girl, who holds a roll of paper with writing up for him. It is unclear whether they are reading a text or message together or perhaps singing a song.

¶ As observed elsewhere (p. 71), the print evokes an atmosphere of carefree intimacy and pleasure that we also find in depictions of the *Garden of love*.

¶ In that regard, the print is more likely to reflect an ideal view of how a knight spends his leisure time than a scene from daily life at court during the artist's lifetime. The specific anecdotal element in the composition leads us to suspect that some concrete meaning is intended.[1]

¶ The dating of the print is something of a problem. The dress, style and subject all concur with our image of the mature 'court period,' but the drapery and hatching lack the technical refinement of the other work from that time. This is undoubtedly due in part to the poor condition of the only preserved impression. Gray to begin with, the print has suffered from damage and abrasion. Probably at a later date, clouds were added above the figures and shadow behind the woman to the right.

1. Hutchison 1972, p. 53.

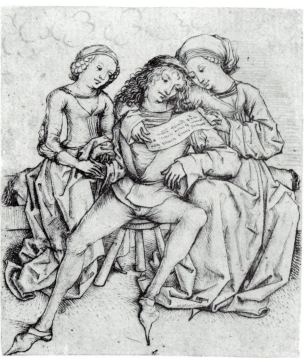

66

70. Falconer

Li, 70 ; Lii, 7
Drypoint, uniqu

¶ The hounds
ionably dre
something r
coner's han
slightly olde
et. The old
wears a sh
sleeves, tigl
dressed mo
and a jerki
jacket.¹ Th
right arm.

¶ His costun
long, curly

67. Stag hunt

(Li, 67 ; Lii, 69), ca. 1485-90
Drypoint, unique impression, 172 x 93 mm.

¶ This splendid landscape with hunters, hounds and fleeing game is probably the earliest and still one of the most captivating depictions of outdoor life in art. Of course there are earlier stag hunts in the margins of manuscripts (*fig. 3*), but in this print the theme is treated on a scale and with a truth to life that can only compared to the Months of the Limbourg brothers (*fig. 51*).

¶ The relation between light and shade plays an important role in the illusion of space in the print. Particularly the background view creates a convincing atmospheric perspective. The sounding of the horn by the foremost hunter identifies the moment as the beginning of the chase. A stag and a doe run off to the left, pursued by the hounds, their noses in the air, while a rabbit disappears to the right.

¶ Whereas the youthful courtiers of the *Departure for the hunt* [**72**] seem to be more interested in flirting than in hunting, this print shows a rougher crew of real hunters. Yet, it is not impossible that the wreath of leaves on the head of the rider is a sign of his engagement rather than a kind of camou-

flage. In that case, the scene may be an emblem of chivalric love (see pp. 69-70; **72**). Seemingly significant details are the dead tree with the bird's nest, the cross marking a grave, the chapel and the lonely traveller – is he a peddler? – although so far nothing more specific has been suggested concerning them than that they all presage death.¹

¶ Precisely captured are the hounds, which recur in very similar poses in a number of other prints by the Master [**57, 70-73**]. We recognize two types: a long-haired variety with long, floppy ears and one with a pointed nose and ears, resembling a greyhound. The first type hunts by scent, the second by sight.²

¶ The print is one of the late works of the Master, characterized by a freer and more pictorial style and a convincing evocation of space. An extremely fine stylus was used, which allowed for a great variety of textures, ranging from the hunters' clothing and the animals' coats to the landscape. The finer qualities of the print are brought out admirably in the well-preserved, deep black impression.

1. Hutchison 1972, p. 59.
2. P.M.C. Toepol, *Onze honden*, Amsterdam 1937, p. 183.

67*
Amsterdam, Rijksprentenkabinet (van Leyden coll., port. 20, nr. 86, sheet 23: Koninklijke Bibliotheek, 1807; Paris, 1812-16, nr. 62; inv. nr. OB:928): very good impression, 172 x 93 mm. (trimmed along outlines; despite a few small stains an exceptionally well preserved print; watermark: ox-head with bar and star).

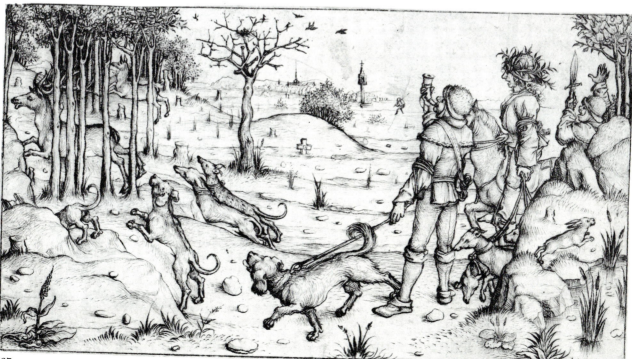

67

71*
Amsterdam, Rijksprenten-
kabinet (van Leyden coll.,
port. 20, nr. 80: sheet 22;
Koninklijke Bibliotheek,
1807; inv. nr. OB:935): very
good impression with light
plate tone, 128 x 92 mm.
(outlines visible above and
below, probably untrimmed
or barely trimmed; upper
left corner filled out).

71. Two hunters conversing
(LI, 71 ; LII, 76), ca. 1480
Drypoint, unique impression, 128 x 92 mm.

¶ The two men, one of whom holds a sniffing dog by the leash, can be seen as not too serious hunters. Although less fashionably dressed than the *Falconer* [70], their long swords, peacock feathers and pointed shoes do not seem very appropriate for the hunt. The poses of the two figures make them seem nearly mirror images of each other.[1] Yet there are small differences in their dress: the man facing us wears turned-down leggings, while the other one seems to have a folded scarf over his mouth, with the ends tossed over his shoulders.

Both men wear bearskin caps with ostrich feathers, short jackets with slashed sleeves, tight hose and long pointed shoes.

¶ The print has often been described as a companion to the *Falconer and his attendant* [70], but this does not seem likely, in view of the differences between them in scale, style and technique. Although the use of the drypoint is somewhat less refined than in the *Falconer*, the thematic links leave us little choice than to assume that these two prints as well as the *Stag hunt* [67] and the *Departure for the hunt* [72], were all made in the same period.

1. Hutchison 1972, p. 61.

68

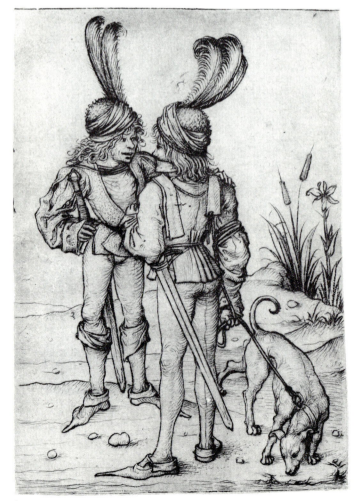

71

72. Departure for the hunt

(L1, 72 ; L11, 77), ca. 1485-90
Drypoint, two known impressions, 125 x 92 mm.

¶ A fashionably dressed company of aristocrats is on its way to the hunting grounds, as we see from the hounds, the hoodwinked falcons and the deer in the background. The presence of the ladies puts us more in mind of an outing than a heavy chase. The wreaths of leaves suggest that two of the participants are betrothed. The miniature of the month of August in the *Très Riches Heures* by the Limbourg brothers, of 1413-17, shows a similar aristocratic company going out on a falcon hunt *(fig. 51).*[1] A miniature like it may have influenced the Master's print, although the latter looks more like an incident of life at court than a serious hunting party. As explained elsewhere (pp. 70-71), the hunt was long associated with the notion of courtly love. In contemporaneous literature, the hunt is often compared with the conquest of a woman by her lover. Both call for faith-fulness and persistency. In this scene, seemingly no more than a vignet from life, various details allude to the symbolic significance of the hunt; the betrothal wreaths and the fancy clothing of the young folk are more fitting for a garden of love than for the hunt; hunting dogs can symbolize faith and persistency; the deer in the background, finally, can be an allusion to true love. In the Housebook we find a pair of lovers hunting with a falcon among the children of Jupiter [**117**, fol. 12a].

¶ This is one of the most refined of the Master's mature works. In small format, it evokes – or idealizes – life at court with striking effect. In the otherwise splendid Amsterdam impression [**72**.1], the treetop in the upper right is torn out; this detail, which serves as a repoussoir in the composition, can be seen in the much more poorly preserved impression in Berlin [**72**.2].

1. Hutchison 1972, p. 61.

72.1*
Amsterdam, Rijksprenten-kabinet (van Leyden coll., port. 20, nr. 85, sheet 22; Koninklijke Bibliotheek, 1807; inv. nr. OB:936): very good impression, 125 x 92 mm. (trimmed along outlines; in the right upper corner the treetop is missing and the paper is filled out with no image (cf.**72**.2); small spots of paint and surface damage).
72.2
Berlin, Staatliche Museen Preussischer Kulturbesitz, Kupferstichkabinett (Nagler coll.?; inv. nr. 328-1): mediocre, gray impression (printed after the drypoint passages had largely been worn away), 124 x 90 mm. (traces of red paint, other spots of paint and surface damage).

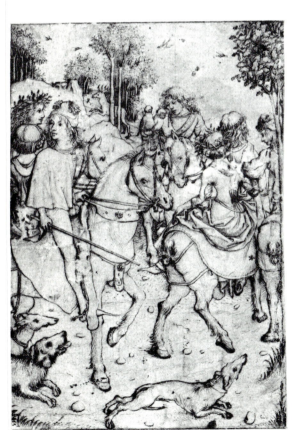

72.2

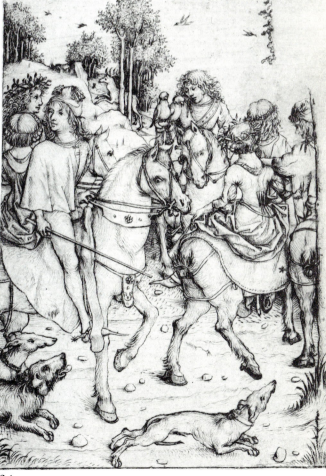

72.1

74.2
Coburg, Veste Coburg
(Brandes coll., 1796; inv. nr.
K 582): mediocre, blurred
impression with light gray
plate tone, 167 x 108 mm.
(some rubbing; press crease
in middle?; monogram M+S
added by hand).
74.3
London, British Museum
(Lloyd coll., 1820;
Woodburn coll.; inv. nr.
1845-8-9-134): good gray
impression, 159 x 104 mm.
(trimmed above and on the
left).
74.4
Vienna, Albertina
(Albertina, inv. nr. 316-108):
mediocre, gray, not
altogether sharp impression,
166 x 108 mm. (upper edge
slightly trimmed; water-
mark: small deer without
cross).

Venice, we must look elsewhere to account for his
knowledge of things Turkish. It has been ob-
served above (pp. 19-21) that the drypoint shows
a close similarity to the musicmaking Turkish
horsemen in Breydenbach's *Peregrinationes in Ter-
ram Sanctam* [**142**; *fig. 15*]. Since the illustrations
in the *Peregrinationes* were designed by Erhard
Reuwich after studies he made in the east, it
stands to reason that the Master's print is based
on a drawing by Reuwich. This hypothesis can be
accepted whether or not we identify Reuwich as
the Master. In any case, it tells us that the print
must have been made after 1484.

¶ This conclusion is supported by stylistic analysis.
The landscape shows an atmospheric perspective
that was to recur in the later works of Dürer. The
plate was engraved with an extremely fine stylus,

which in the shadows was plied in short strokes
to create a gentle sfumato. The understated
tonality of the surviving impressions is due not
only to this feature of the plate itself, but also to
the fact that the ink did not penetrate very deeply
into the fine grooves, with fairly gray results in the
printing.

1. See Julian Raby, *Venice, Dürer and the oriental mode*, London
 1982, especially pp. 19, 21.
2. In addition to B.88, Dürer also depicted Turkish turbans in
 engravings B.85 [65a] and M.91, *Enthroned oriental prince*; in
 woodcuts M.164, 175 and 177 from the *Apocalypse* and the
 early prints M.117-19 from the *Large Passion* there are also
 many Turkish figures. The orientals in drawings W.77-W.81
 are linked to his visit to Venice.
3. See Raby, op.cit. (note 1).

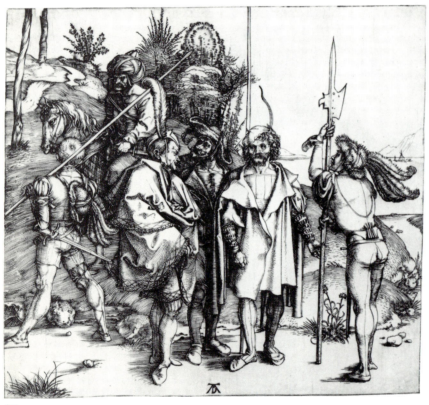

74a

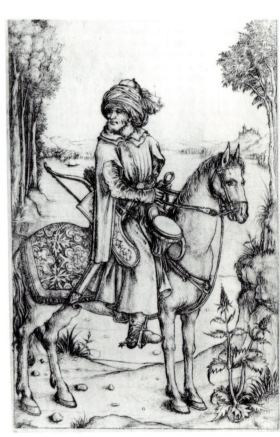

74.4

74a
Albrecht Dürer, *Five
lansquenets and an oriental on
horseback*, ca. 1495. Engrav-
ing, 132 x 147 mm. B. 88,
M. 81.

5. Pair of lovers

J, 75 ; LII, 80), ca. 1485
rypoint, two known impressions, 168 x 108 mm.

One of the Master's most captivating prints shows a pair of young lovers seated on a stone wall, with carnations in a flowerpot on the left and a jug of wine and a cup in a cooler on the ground to the right. They are enframed in a simple portal with two vines entwining in the arch. The tender feeling of the couple finds expression in the intimacy of the representation: the young woman has a lapdog, symbol of faithfulness, and gently covers the young man's hand on her knee with her own hand. The fashionably dressed young man puts his arm cautiously around her waist, a dreamy look in his eye. The pot with carnations – a flower that is frequently used in art as a token

of betrothal – places the scene out of doors, in a garden.

¶ In that regard, the image is linked to representations of the garden of love, as it occurs frequently in the prints and decorative arts of the late Middle Ages. As we have seen above (pp. 66-70), the composition is related to representations of young lovers engaged in conversation, music and playing chess and other games [see also **99-102**]. The wine in the cooler is another of the pleasures that we find in gardens of love.[1] The print evokes the ideals of courtly love, marked by faithfulness and mutual devotion.

¶ This distinguished the Master's print from the treatment of the same subject by Master E.S. [**75**e], in which the young man makes physical advances that are countered only in the vaguest way by the young lady. We are still in the garden

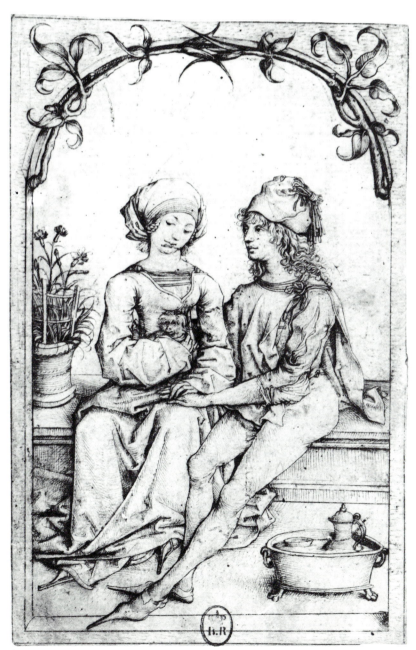

75.2

75a*
Copy in reverse of **75** by Master b x g. Engraving, 168 x 108 mm. *L.II, 32.* Frankfurt, Städelsches Kunstinstitut (inv. nr. 3368.7).
75b
Copy of **75** by Wenzel van Olmütz. Engraving, 168 x 110 mm. L.67. Vienna, Albertina.
75c
Copy of **75** in reverse by Israhel van Meckenem. Engraving, 167 x 134 mm. L.493, first state. Vienna, Albertina.
75d
Free copy of young woman alone, in a woodcut representing Queen Mary of Hungary, illustration in Johannes Thurocz *Chronica Hungarorum*, fol. 96b, published by Erhard Ratdolt, Augsburg 1488.
75e*
Master E.S., *Pair of lovers on a bench of grass*, ca. 1460. Engraving, 134 x 164 mm. L.211. Vienna, Albertina (inv. nr. 784/1926).

of love, but the relation between the sexes has turned erotic.[2] Despite the differences between them, the print by Master E.S. was probably one of the sources of the drypoint. The comparison demonstrates the development of the expressive means of graphic art in the intervening thirty years. While both plates are masterpieces of fifteenth-century printmaking, that by Master E.S. is stiff and stylized beside the work of the Housebook Master, and far less convincing in its creation of depth. The drypoint is more successful not only in those respects, but also shows a subtle approach to human feelings that is lacking in the earlier work.

¶ Questions of historical context to one side, the *Pair of lovers* is such a pure and sincere evocation of the ideals of love in all ages that it can still strike the viewer of today as true to life. There is no doubt that the print was very popular when it first appeared. At least three engraved copies of it were published [**75a-c**]. Notwithstanding a few small discrepancies that betray the personal engraving style of the copyists, all of them repro-

duced the Master's print quite accurately. As is often the case with Wenzel von Olmütz, his copy after the drypoint [**75b**] is in the same direction as the original. This could lead one to suspect that he worked after one of the two copies in mirror image [**75a, c**], but this was not the case. Wenzel's modelling is much subtler than that in the other copies, and closer to the drypoint.[3]

¶ The couple in an ornamental print by Israhel van Meckenem [**75f**] illustrates the influence of the Master. Surprisingly, the headwear of his couple is somewhat more old-fashioned than in the model. In van Meckenem's print, which dates from about 1490, the couple sits in a delightful ornamental framework composed of a blossoming vine inhabited by birds, dogs and wild men. A design of this kind could have served as the model for a marriage chest.[4]

¶ The young woman in the drypoint was copied in a woodcut printed in a book published in 1488 [**75d**]. This provides us with the latest possible date of the drypoint.

¶ The *Pair of lovers* is one of the highlights of the

75a

75b

75c

Master's so-called courtly style (see pp. 31-32). The prints from this period are drawn with such a fine stylus that they remind one of silverpoint drawings. In the *Pair of lovers* the lively modelling is built up of very fine, regular lines that create a subtle effect of light and shade. The lines were in fact so fine that the ink probably did not take well in the grooves, as we see in the somewhat vague and 'unfocussed' impression in Coburg [**75**.1]. That in Paris [**75**.2], while printed crisply, is somewhat irregular. The small inkspots on that impression indicate that the plate was disfigured by pockmarks.

See Douglas Percy Bliss, 'Love-Gardens in early German engravings and woodcuts,' *Print Collector's Quarterly* 15 (1928), pp. 90-109, and pp. 66-69, note 9; Thea Vignau Wilberg-Schuurman, *Hoofse minne en burgerlijke liefde in de prentkunst rond 1500*, Leiden 1983, pp. 7-11.
See (Alan Shestack), exhib.cat. *Master E.S.*, Philadelphia (Museum of Art) 1967, nr. 17.
For a niello copy and other works of art modelled after the print, see Lehrs, vol. 8, pp. 154-56.
Shestack 1967-68, nr. 245.

75f
Israhel van Meckenem, *Ornamental print with pair of lovers*, ca. 1490. Engraving, 162 x 240 mm. B.205; L.619. Amsterdam, Rijksprenten-kabinet (inv. nr. OB:1144).

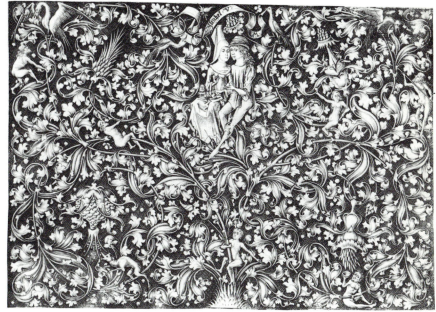

75f

75d

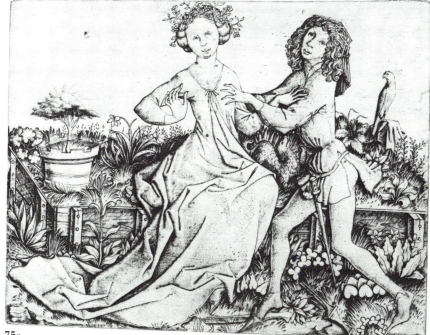

75e

76-77. Study heads

76. Head of an old man with beard

(LI, 76 ; LII, 59), ca. 1485-90
Drypoint, unique impression, 56 x 46 mm.

77. Study of two heads

(LI, 77 ; LII, 60), ca. 1485-90
Drypoint, unique impression, 84 x 29 mm.

¶ It is uncertain whether or not the three sketchy heads are portraits from life.[1] The similar form of nose, mouth and eyes would seem to point in the direction of facial types derived directly from the artist's imagination.[2]

¶ The prints remind one of late medieval model books (see pp. 24, 35), which also contain faces of the same sort. These heads represent three of the ages of man. We cannot know whether the Master made them as models or for his own pleasure.

¶ The two prints are closely related to the *Heads of Christ and the Virgin* [16], a print that is likely to have functioned as a model if only because it depicts an existing type of *Andachtsbild*. All three prints are drawn with a fine stylus and are strongly modelled. Like the *Heads of Christ and the Virgin*, the *Study of two heads* too displays a very fine pattern of scratches, leaving a light tone in the printed impression.

1. Ernstotto Graf zu Solms-Laubach, 'Nachtrag zu Erhard Reuwich,' *Beiträge für Georg Swarzenski*, Berlin 1951, pp. 111-13, identifies the two heads [77] as portraits of Count Philipp zu Solms Lich in his youth and his brother Count Johann zu Solms Lich. Documents referred to by Fuchs 1958, p. 1165, inform us that Erhard Reuwich was in Lich in 1483, shortly before his departure for the Holy Land with Breydenbach, in order to paint a portrait of Count Johann, who died during the pilgrimage [see 142].
2. Hutchison 1972, p. 65.

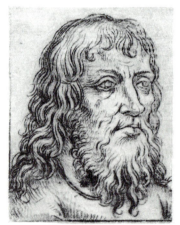

76

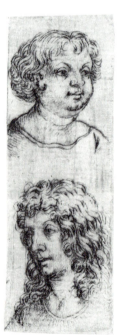

77

8. Dog scratching himself

I, 78 ; LII, 72), ca. 1475
rypoint, unique impression, 113 X 112 mm.

This study of a young hound [see **67**] is one of the Master's most imaginative and original prints. In the fifteenth century, other depictions of dogs in such poses, with this degree of accuracy and immediacy, can be found only in the margins of illuminated manuscripts.[1] As shown elsewhere (p. 16), the same motif recurs in a book of hours in The Hague attributed to the studio of the Master of Catharina of Cleves (*fig. 7*).

While the motif of the print may have been inspired by a marginal illustration of this kind, the Master's dog is so convincing in canine anatomy, coat and pose that it must be based on a study from life. The rather large format makes it unlikely that it was intended as a model for miniaturists. It is more likely to have been an independent study. After the Master, the first artist to depict animals with such intense concentration was Dürer. The small sixteenth-century bronzes of dogs attributed to Peter Visscher breathe the same spirit, but do not seem to be based directly on the Master's print.[2]

¶ The *Dog scratching himself* is usually assigned to the middle period. The forms are defined in broad contours, and the hatching is drawn with a rather large stylus in short, arched strokes that overlap each other in several layers in the dark areas. This technique allowed the Master to achieve a very convincing effect of roundness and depth (*fig. 25*).

¶ At a given moment, the figure of the dog was cut out of what was probably originally a square print and pasted onto a second sheet of paper. In a later restoration, the sheet on which the dog is printed was filled out again to a square.

1. Hutchison 1972, p. 65, note 262.
2. Lehrs, vol. 8, nr. 72, p. 147, note 2. Lehrs also points out that the drypoint must have been the model for the scratching dogs on two prints made in Antwerp in the late sixteenth century (Hutchison 1972, p. 66).

78*
Amsterdam, Rijksprenten-kabinet (van Leyden coll., port. 20, nr. 1: sheet 5; Koninklijke Bibliotheek, 1807; inv. nr. OB:931): very good impression, ca. 113 X 112 mm. (trimmed to image, filled out to square in a 1938 restoration, ca. 122 X 123 mm.; slight surface abrasion).

78 (before restoration)

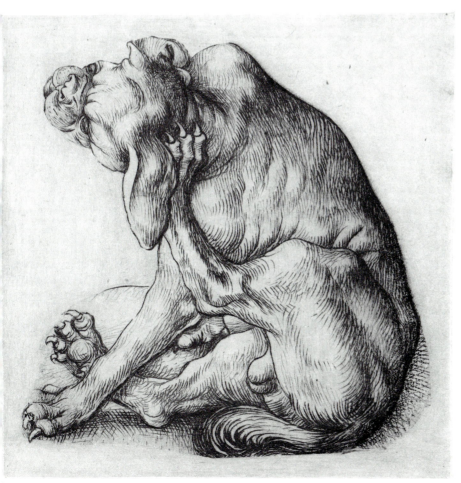

79. Peasant with blank shield
(LI, 79 ; LII, 81), ca. 1475-80
Drypoint, unique impression, diameter 78 mm.

80. Peasant woman spinning with blank shield
(LI, 80 ; LII, 82), ca. 1475-80
Drypoint, unique impression, diameter 79 mm.
Companion prints.

¶ The prints with coats of arms form a category of
their own in the oeuvre of the Master [**79-89**]. The
figures supporting the shields include peasants
and gypsies, and the shields themselves, if they
are not blank, have such bearings as a sickle,
onions or garlic. Neither aspect of the coats of
arms points in the direction of the aristocracy.

¶ By the fifteenth century the display of family coats
of arms was no longer exclusively reserved for the
aristocracy. Burghers began to adopt them as
well (see p. 73, note 34). There is a group of round
coats of arms by Schongauer [**80a-e**] that is as-
sumed to have been made for rich burghers who

wished to consolidate their new social promi-
nence in order to compete with the aristocracy.
The prints could have served as a kind of calling
card.[1] Depictions of coats of arms in the fifteenth
century usually show them being held by an angel
or a knight, but that function could also be filled
by wild men [see **51-53**], who protected the shield
with superhuman strength. Thanks to Schon-
gauer's engravings, we have several splendid
images of wild men, their carefree existence in the
wild pointed up by wreaths of flowers and
branches.[2]

¶ It is uncertain whether Schongauer made his
prints for specific families or as models for use by
goldsmiths and such, with replaceable bearings.
The angel and the wild man both fit into the
heraldic tradition, but it is certainly unconven-
tional to use a sleeping peasant [**80b**] as supporter
of a shield.

¶ The same applies to the peasants and gypsies who
appear as supporters in the Master's prints. It is
tempting to see them as a satire on the pretensions

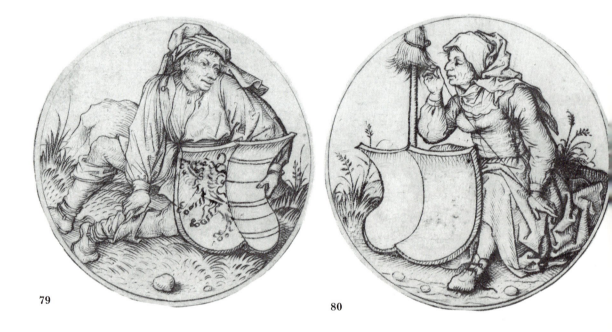

79 80

of status seekers who bore coats of arms to which their ancestry did not entitle them. In his *Ship of fools* of 1494, Sebastian Brandt pokes fun at the families that fostered such ambitions and describes the absurdity of their coats of arms.[3]

Four of the Master's prints have blank shields, leaving the user free to fill them in as he saw fit. On the one surviving impression of the *Peasant with coat of arms* [79], a heraldic lion has been drawn on the shield with the brush.

As we have seen, however (pp. 73-76), the satire in the prints is less likely to have been aimed at the bourgeoisie than at the peasants. In these prints, the typical peasant figures are captured with precision. The man, with his leggings falling down and his laces coming loose, makes a somewhat backward impression next to the industrious woman. In fact, all of the male and female peasants by the Master and his sidekick Master b x g show the woman as a more self-assured and active person than the man [**64, 97, 102, 103, 109, 110**].

¶ On stylistic grounds, one would be inclined to date the prints to the middle period, about 1475-80. However, Schongauer's round coats of arms [**80**a-e], which are usually dated after 1480, are so close to those by the Master that a date in the 1480s is more likely, unless one wants to assume that Schongauer modelled himself on the Master. The dimensions of the two groups of prints are virtually identical, and the outlines of both are formed by concentric circles. More important, the composition and the manner in which the figures are placed in the landscape are very similar.[4]

1. Shestack 1967-68, nrs. 90-97.
2. Bernheimer 1952, pp. 176-80; Husband 1980-81, pp. 185-89.
3. Hutchison 1972, p. 66.
4. Hutchison 1972, p. 67.

80a*
Martin Schongauer, *Coat of arms with lion's head, supported by a wild woman*, ca. 1480-90. Engraving, diameter 78 mm. B.100, L.99. Rotterdam, Museum Boymans-van Beuningen (inv. nr. 1933-44).
80b*
Martin Schongauer, *Coat of arms with wings, supported by a peasant*, ca. 1480-90. Engraving, diameter 77 mm. B.102, L.101. Amsterdam, Rijksprentenkabinet (inv. nr. OB:1072).
80c*
Martin Schongauer, *Coat of arms with greyhound, supported by a wild man*, ca. 1480-90. Engraving, diameter 78 mm. B.103, L.102. Amsterdam, Rijksprentenkabinet (inv. nr. 55:103).
80d*
Martin Schongauer, *Coat of arms with deer, supported by a wild man*, ca. 1480-90. Engraving, diameter 78 mm. B.104, L.103. Amsterdam, Rijksprentenkabinet (inv. nr. 52:573).
80e*
Martin Schongauer, *Coat of arms with moor's head and hare*, ca. 1480-90. Engraving, diameter 78 mm. B.105, L.104. Amsterdam, Rijksprentenkabinet (inv. nr. OB:1074).

80a

80b

80c 80d

80e

81. Peasant woman with sickle shield

(LI, 81 ; LII, 83), ca. 1475
Drypoint, unique impression, 81 x 82 mm.

¶ In accordance with heraldic usage, the sickle shield is topped with a helm and a crest, in this case a stylized decorative horse-cloth. The helmet is of the variety known as a *Stechhelm*, which was used only in tournaments, as protection against the lance. In heraldry, the *Stechhelm* is found particularly in the arms of burgher families, who had begun to organize their own tournaments by the mid-fifteenth century [see 135].[1] The print can therefore be read as a satire on a nouveau-riche burgher who cannot conceal her peasant ancestry. All of the attributes are connected with work in the fields: the sickle for mowing, the shoots and blades of grass sticking out of the helmet, and the woman's basket. If the latter, moreover, is intended as a symbol of greed [see also 102][2], we would be presented with a distinctly negative view of the subject. However, considering how good-natured the woman in the print seems to be, this interpretation does not seem very likely.

¶ Nonetheless, it remains possible that the above-named attributes were intended to ridicule the knightly ambitions of the lower estates. An early fifteenth-century epic poem satirizes a tournament of peasants, their shields adorned with pitchforks and such (see p. 74). One wonders whether there is an analogy with the *Combat of two wild men on horseback* [53], and if that print too does not make fun of knightly tournaments.

¶ The *Peasant woman* is one of the master's earliest prints, along with *Christ as the Good Shepherd* [17]. The composition is simple and the woman's body rather compact. The drypoint needle is used hesitantly and not very effectively. Because the ink was not taken up well in the grooves, the impression is somewhat uneven.

1. Hutchison 1972, p. 68.
2. Ibid.; see also above, p. 74.

81

2. Gypsy woman with two children and a blank shield

I, 82 ; LII, 84), ca. 1475-80
rypoint, unique impression, 92 x 72 mm.

3. Gypsy with blank shield

I, 83 ; LII, 85), ca. 1475-80
rypoint, five known impressions, 93 x 72 mm.
ompanion prints.

The gypsy couple that serve as companion shield-supporters are depicted with considerable liveliness. The orientalism of the costume is more emphatic than in the *Family of gypsies* [65], where we encounter the same or very similar figures. The woman wears a turban and a loose shirt with blousing sleeves, the man a broad-brimmed hat and jewelry. It is unclear what function is served by the long-handled hammer in the foreground.[1] The woman is as self-confident as the *Wild man's wife* in Schongauer's print [80a]. As 'vagabonds' [see **65**], the gypsies did not enjoy a positive reputation in the age of the Master, but this is not emphasized in the print any more than the negative side of the peasants in **79-80**.

¶ Surprisingly, the print of the man has survived in five impressions and that of the woman and children in one only. The print of the woman is part of a pair, with a provenance from the seventeenth-century Maltzan collection, and which is now in the Boston Museum of Fine Arts. Both impressions are well printed, with very wide margins.[2]

¶ The prints are among the Master's mature works. The lively and varied modelling, engraved with perfect self-assurance directly in the plate, gives the figures and their clothing a convincing sense of volume.

1. Lehrs, vol. 8, p. 159, note 1. See also Hutchison 1972, p. 69.
2. Most early prints, and many from the sixteenth and seventeenth century as well, were later trimmed to the platemark or the outline in order to be pasted into albums. Many of the prints from the Maltzan collection escaped this fate, leading one to suspect that the collection, which consists nearly exclusively of fifteenth- and early sixteenth-century prints, was formed very early. See Max Lehrs, 'Der deutsche und niederländische Kupferstich des fünfzehnten Jahrhunderts in den kleineren Sammlungen: Militsch (Graf Maltzan),' *Repertorium für Kunstwissenschaft* 16 (1893), pp. 328-30, and R.-M. Muthmann, *Von Israhel van Meckenem bis Albrecht Dürer: deutsche Graphik 1470-1530 aus Sammlung Graf Maltzan*, Düsseldorf (C.G. Boerner) 1983.

82*
Boston, Museum of Fine Arts (Maltzan coll., Militsch, Silesia; acquired in 1966 by the Katherine Eliot Bullard Fund; inv. nr. 1966:375): very good impression with plate tone, 92 x 72 mm. (with a very wide margin, paper measuring 180 x 129 mm.).
83.1*
Boston, Museum of Fine Arts (Maltzan coll., Militsch, Silesia; acquired in 1966 by the Katherine Eliot Bullard Fund; inv. nr. 1966:376): very good impression with light plate tone, 93 x 72 mm. (with a very wide margin, paper measuring 180 x 129 mm.; several holes repaired).

82

83.1

83.2*
Amsterdam, Rijksprenten-
kabinet (van Leyden coll.,
port. 20, nr. 28: sheet 7;
Koninklijke Bibliotheek,
1807; inv. nr. OB:942): very
good impression, 93 x 72
mm. (damaged and repaired
in the corners and along the
lower edge).
83.3
Berlin, Staatliche Museen
Preussicher Kulturbesitz,
Kupferstichkabinett (Nagler
coll.; inv. nr. 327-1): very
good impression, 93 x 72
mm. (with margins 108 x 93
mm.).
83.4
Stuttgart, Kunsthalle
(Klebeband Stimmer,
woodcuts; inv. nr. 8701):
somewhat meagre gray
impression, 88 x 71 mm.
(trimmed with stains).
83.5
Vienna, Albertina
(Hofbibliothek; inv. nr.
317-1928): good impression
in poor condition, 93 x 72
mm. (crumpled).
82a
Copy in reverse by Master
b x g. Engraving, 95 x 80
mm. *L.II, 38.* Paris, Musée
du Louvre, E. de Rothschild
coll.
83a
Copy in reverse by Master
b x g. Engraving, 94 x 77
mm. *L.II, 39.* Vienna,
Albertina.

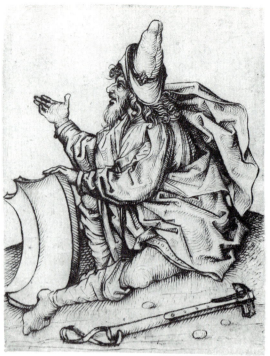

83.2

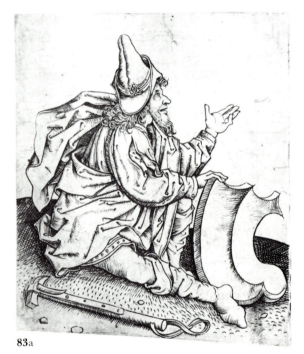

83a

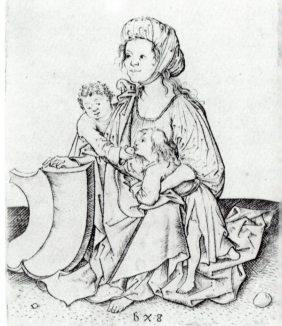

82a

4. Lady with radishes in her escutcheon

(Li, 84 ; Lii, 86), ca. 1475
Drypoint, unique impression, 96 x 78 mm.

5. Youth with garlic in his escutcheon

(Li, 85 ; Lii, 87), ca. 1475
Drypoint, unique impression, 121 x 85 mm.

The supporters in these prints are not peasants but fashionably dressed youngsters. In the escutcheon of the young man are bulbs of garlic, and the crest is a bunch of onions. The vegetable on the woman's shield is probably a radish, the same as on her helmet.[1]

The vegetables in the helmets recur in those of the *Combat of two wild men on horseback* [53], which is probably a parody on a knightly tournament. While the satirical intention here is unmistakeable, we are left in uncertainty whether the targets are rich burghers of modest descent[2] or peasants. As noted above (p. 74), it is most likely that the satire is aimed against peasants who

dress and behave above their station in life.

¶ Both prints can be dated on the early side. The contours are broad and the hatching simple; the artist had not yet mastered the technique of the drypoint to perfection. The thin lines are printed vaguely, and the thick ones have splotches. Added to this, neither of the two impressions is very well preserved. The unique impression of the *Lady* in Dresden [84] – the only print by the Master that could not be borrowed for the exhibition – is printed rather unclearly and has been subjected to a radical cleaning. The impression of the *Youth* in Amsterdam [85], also unique, is not only printed grayly but is also splotchy and worn. The ornaments in the corners were brushed in later.

1. See Lottlisa Behling, 'Der Hausbuchmeister - Erhard Reuwich,' *Zeitschrift für Kunstwissenschaft* 5 (1951), pp. 179-90, especially pp. 188-90, where the author demonstrates the close resemblance of the Master's onions (*allium cepa*), radishes or black radishes (*Rettich: raphanus sativus*) and beets (*brassica rapa*) to those in the *Gart der Gesuntheit*, Mainz 1485. See **141**.
2. Hutchison 1972, p. 70.

84
Dresden, Kupferstich-kabinett: good, but rather blurred impression, 96 x 78 mm. (no outlines).
85*
Amsterdam, Rijksprenten-kabinet (van Leyden coll., port. 20, nr. 5: sheet 1; Koninklijke Bibliotheek, 1807; Paris, 1812-16, nr. 4; inv. nr. OB:943): reasonably gray impression, 121 x 85 mm. (the ornamental corners are drawn with the brush in gray ink; the impression is very stained).

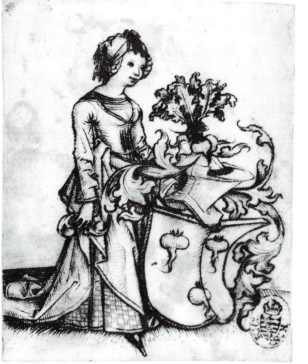

84

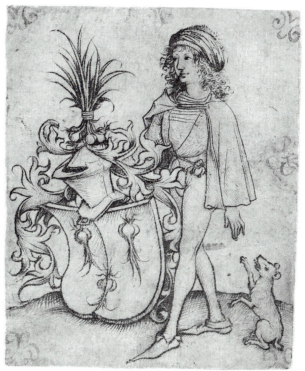

85

86. Lady with owl and AN in her escutcheon
(LI, 86 ; LII, 88), ca. 1485
Drypoint, three known impressions, 125 x 85 mm.

¶ In terms of style and technique this is one of the most refined of the prints with coats of arms. Its subject remains obscure. The elegant and charming young lady reminds us in her costume, coiffure and facial features of the women in the *Card players* [**73**] and the *Pair of lovers* [**75**] as well as of Phyllis mounted on Aristotle [**54**]. Her tasseled cap, however, is one that is otherwise worn mostly by young men.

¶ The meaning of the letters AN on the shield is not clear, nor can we say exactly what the owl is doing on the helmet. As observed elsewhere (p. 72), the owl is usually symbolic of sin, and in this context perhaps of lust. We would then have to see the young woman in the print as a temptress: just as the owl serves as a decoy in the hunt, the young woman seduces men to their destruction. The empty banderole could have been intended for a moral of this kind, although one is uncertain how this fits in with the woman's function as shield supporter.

¶ The helmet is a *Spangenhelm*, used for duels with the mace rather than the lance. In heraldry, it occurred only on the arms of aristocrats until the sixteenth century.[1] However, that does not necessarily allow us to relate the print to the Master's court period (see pp. 31-32), since a *Spangenhelm* is also found in the *Coat of arms with an old woman* [**87**], which was probably satirical.

¶ In terms of technique, the print is one of the Master's most refined and carefully executed works. The drapery folds are composed of fine, transparent hatching applied with utmost delicacy (*fig. 29*). As in the other prints from this group, a very fine stylus was used.

1. Hutchison 1972, p. 71.

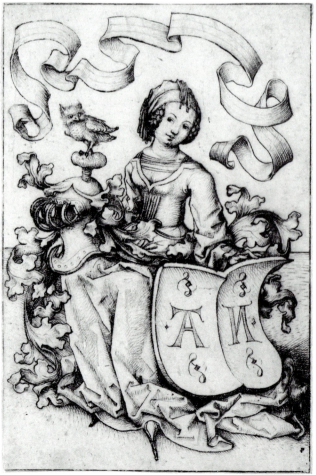

86

7. Coat of arms with an old woman winding yarn

I, 87 ; LII, 89), ca. 1490
rypoint, unique impression, 115 x 78 mm.

This and the following two prints depict heraldic shields propped up in the grass against a wooden helmet rack. There is no trace of supporters, as in the preceding plates. On top of the helmet, from which luxuriant ornamental foliage sprouts, stands a bird of an imaginary species. With its half-spread wings, its crest on edge and its sharp, open beak, the animal makes a distinctly aggressive impression.[1]

It is possible that the shrieking bird is intended to characterize the old woman as a bickering gossip and schemer (see p. 78, note 37). The emaciated old woman is not very attractive to look at, but her activity leaves no room for a negative interpretation: she is industriously spinning yarn. The wheel, a forerunner of the spinning wheel depicted in the Housebook [117, fol. 34a], is of a type that can be used for spinning as well as for wind-ing. The woman on the shield uses the wheel to help wind the spun wool from a pot on the ground onto a spindle, one end of which she holds between her toes. With one hand she leads the thread of yarn and with the other keeps the wheel turning.[2] Her complicated pose is captured with trenchancy and humor. It is unclear whether the objects in her lap are balls of yarn or, less likely, apples. In sum, the exact meaning of the shield, crowned by an aristocratic *Spangenhelm* [see 86], is obscure, although it too seems to be satirical in intent.

¶ The print is executed with a sharp needle and is one of the Master's later works. The impression is printed in a deep black that does justice to the drypoint effects, especially in the bird.

1. As was observed by Lehrs, vol. 8, p. 163, the imaginary bird is reminiscent of that on the prints by the Master of the Playing Cards (L.67 and L.68; cf. the illustrations in Lehrs (Dover), 15 and 17).
2. Hutchison 1972, p. 71.

87*
Amsterdam, Rijksprenten-kabinet (van Leyden coll., port. 20, nr. 9: sheet 2 [?]; Koninklijke Bibliotheek, 1807; Paris, 1812-16, nr. 8; inv. nr. OB:945): very good impression, 115 x 78 mm. (no outlines, no platemark).

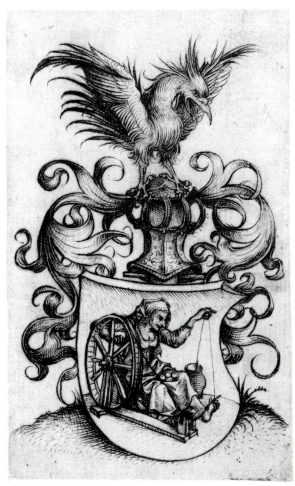

87

88. Coat of arms with jugglers

(L1, 88 ; L11, 90), ca. 1490
Drypoint, unique impression, 135 x 74 mm.

¶ This coat of arms is even more puzzling than the last one. The young man standing on his head, the crest of the arms, may, like the following print, represent the world upside-down. In the latter, the woman astride her husband is a clear demonstration of the natural order reversed. Another possibility is that the print is a satire on the popular amusement offered by itinerant jugglers. These predecessors of circus acrobats belonged to the class of vagabonds [see 65] that was so mistrusted by the burghers. Medieval moralists disapproved of them for distracting people from more elevated thoughts.[1]

¶ The fashionably dressed youths on the shields, who seem to be engaged in a friendly duel with daggers or short swords, remind one of the young wrestlers and swordfighters who figure as children of Sol in the Housebook [117, fol. 14a]. In both cases one is inclined to think of the athletic pastimes of young aristocrats.[2] On the other hand, the somersaulting youngsters in the foreground make it more likely that the swordfighters too are travelling acrobats. One wonders to what extent the print is a parody of the aristocratic pastime of the tournament. The lances in the foreground and the *Stechhelm* both point in that direction.

¶ The very lively print was probably made in the same period as the previous one. The weakness of the impression and the unsharp printing are due to faulty inking.

1. Hutchison 1972, p. 72.
2. With thanks to Keith Moxey for his help in interpreting the print. He referred me to Werner Danckert, *Unehrliche Leute,* Bern 1979, pp. 214-35.

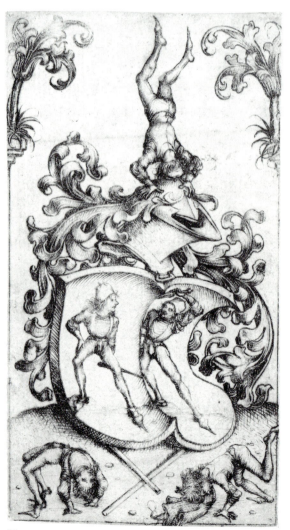

88

89. Coat of arms with a peasant standing on his head

(L I, 89 ; L II, 91), ca. 1485-90
Drypoint, three known impressions, 137 x 85 mm.

The shield is adorned with a peasant or farmboy standing on his head, supporting himself on two rocks. Cresting the *Stechhelm* is a peasant being ridden by his wife. Availing herself of the distaff he is holding for her, she spins yarn. Unlike Aristotle, who rides Phyllis around on his back in philosophical resignation [**54**], the peasant seems to be shouting in pain. The meaning of the representation is clear: just as the man standing on his head sees the world upside down, the peasant couple represent a reversal of the natural order of society, a reversal that is both ridiculous and reprehensible (see p. 73).[1] The hen-pecked husband who is threatenend into submission by the distaff is a theme that was also depicted by Master b x g [see **95**] and Israhel van Meckenem.[2]

The image of the topsy-turvy world as a figure standing on his head, which was probably used for the first time in this print, endured until deep into the nineteenth century. It was particularly popular in catchpenny prints.[3]

¶ As we have seen above (pp. 73-76), this print, along with other satirical prints by the Master and Master b x g, expresses an unashamedly negative view of the peasantry. This is not the only print in which peasants are humiliated and ridiculed. The reversal of social values, with the woman in charge, is exemplary for the moral backwardness of the peasant.

¶ The print is executed with a somewhat blunter stylus and on a larger scale than the previous one, but it too is one of the late works. Once more we notice how lively and well-observed the figures are. In the copy in reverse by Israhel van Meckenem [**89a**], the foliage has spread further to the sides, giving the print a wider format.

1. Hutchison 1972, p. 72.
2. Zie Lehrs, vol. 9, nr. 473, illustrated in Lehrs (Dover), 649; nr. 504 is illustrated in Shestack 1967-68, nr. 237.
3. See among others exhib.cat. *Centsprenten*, Amsterdam (Rijksprentenkabinet) 1976, pp. 115-16. See also p. 78, note 32.

89.1*
Amsterdam, Rijksprentenkabinet (van Leyden coll., port. 20, nr. 6: sheet 2; Koninklijke Bibliotheek, 1807; Paris, 1812-16, nr. 5; inv. nr. OB:947): very good impression, 137 x 84 mm. (trimmed along outlines, no outline above; somewhat smudged and stained; watermark: ox-head with star and bar).

89.2
Coburg, Veste Coburg (Brandes coll., 1795; inv. nr. K 534): very good impression, 135 x 84 mm. (trimmed along outline, above within the outline; minor areas of damage and repairs; watermark: ox-head with star and bar).

89.3
London, British Museum (inv. nr. E I-138): good impression in poor condition, 137 x 85 mm. (heavily filled out and repaired along the edges, surface badly abraded).

89a
Copy in reverse by Israhel van Meckenem. Engraving, 145 x 118 mm. L.521. Vienna, Albertina (inv. nr. 1926, 1291).

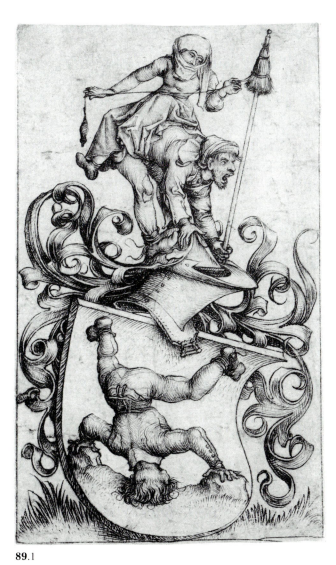

89.1

89a

*P*RINTS

WRONGLY ASCRIBED TO THE MASTER

90. Madonna with a rosary in a crescent moon, with two angels

(LII, 24), ca. 1485
Engraving, heavily worked over with pen and brush, unique impression, 158 x 117 mm.

¶ The Madonna on a crescent moon is depicted in three drypoints by the Master [23-25]. In this print we see her in half-length, encircled in a nearly round sickle moon, flanked by two angels. The probable source for the print is an engraving by Martin Schongauer [90a], in which the two angels crown the Virgin with a wreath of stars. In the print attributed to the Master there is a noticeable emphasis on rosary devotion: the Christ Child plays with a rosary, while the halo around the crescent moon is surrounded by a larger one.

¶ The attribution to the Master is based on superficial resemblances to the Madonnas and angels in several of his prints [25, 26, 49, 50],[1] not on considerations of technique. The latter is difficult to study because the print has been gone over so heavily with pen and brush. In fact, the only places where one can still see engraved lines are in the wreath of stars and the angel on the right.[2] There are several reasons for doubting that the impression was printed in the fifteenth century. For one thing, the sketching of the angels' wings below the outline seems to imply that the plate was never completed. The most likely possibility is that the impression was printed on old paper, probably in the nineteenth century, from an unfinished plate, and that the missing passages or those that could barely be seen were filled in by hand. The perpetrator must have had considerable knowledge of fifteenth-century engraving.

One of the first specialists in the field, T.O. Weigel, purchased the print and published it in 1866 as one of the earliest known engravings.[3] The glass panel with the same composition in the west window of the northern side-aisle of St. Leonard's in Frankfurt am Main, signed A. Linneman and dated (18)81, was probably based on the illustration in that publication or perhaps on that in the 1872 sale catalogue of Weigel's collection.[4]

¶ Weigel located the origins of the print in Cologne in the 1470s, but its next owner, Baron E. de Rothschild, listed it as 'Primitif français du XVe siècle.' Lehrs initially suspected a forgery, but in 1912 he accepted the print as the Master's work,[5] and thereafter does not seems to have entertained serious doubts on the matter.

¶ Solms-Laubach pointed out the compositional similarities between the print and the *Pilgrimage Madonna (fig. 39)* in the crossing of Mainz Cathedral, donated in 1484 by Breydenbach in thanks for his safe return from a pilgrimage to the Holy Land [see 142]. The print provides Solms-Laubach with an important argument for attributing the relief and other monumental sculpture to Erhard Reuwich, whom he identifies as the Master.[6]

¶ The composition provides ground for relating the print to middle Rhenish art of the period, but not for an attribution to the Master.

Lehrs, vol. 8, p. 102.
The curator of the E. de Rothschild collection in the Musée du Louvre, Paris, Mme. Pierrette Jean-Richard, was kind enough to allow me to conduct a thorough examination of the sheet.
T.O. Weigel and A. Zestermann, *Die Anfänge der Druckerkunst in Bild und Schrift: anderen frühesten Erzeugnissen in der Weigel'schen Sammlung erläutet*, 2 vols., Leipzig 1866, p. 355, pl. 424.
Husband 1985, note 66.
Max Lehrs, 'Neue Funde zum Werk des Meisters E.S.,' *Jahrbuch der königlich preussischen Kunstsammlungen* 33 (1912), pp. 275-83, especially p. 275.
Solms-Laubach 1935-36, p. 56.

90
Paris, Musée du Louvre, E. de Rothschild coll.(T.O. Weigel coll., Leipzig, 1872; inv. nr. 69 LR as 'Primitif français du XVe siècle'): Engraving (?), 158 x 117 mm. (heavily worked up in gray ink with pen and brush, so that little of anything is still visible of the printed lines).

90a
Martin Schongauer, *Madonna on a crescent moon*, ca. 1480. Engraving, 173 x 109 mm. B.31; L.40. Berlin, Staatliche Museen Preussischer Kulturbesitz (inv. nr. 33730).

90

90a

91. Boccaccio writing the story of Adam and Eve

(LII, 58), shortly before 1476
Engraving, fragment, unique impression, 128 x 138 mm.

¶ This fragmentarily preserved print shows Boccaccio engaged in writing the story of the Fall of Man. He is seated at a lectern, with Adam and Eve before him, and in the background the Creation, the Fall and the Expulsion from Paradise.

¶ A copy of the print [**91**b] is included with eight other Boccaccio illustrations in the first printed book to be illustrated with engravings: a French translation of Boccaccio's *De casibus illustrium virorum et mulierum*, published by Colard Mansion in Bruges in 1476 as *De la ruine des nobles hommes et femmes*. The four successive editions of the book show that the idea of an illustrated printing did not come all at once. The first edition had no engravings, and the second only an illustration in the prologue, while the third and fourth editions have eight and nine engravings respectively.[1]

¶ Only a few copies of the book with its pasted-in engravings have been preserved. The most complete is in Boston, a third edition with the eight engravings colored by hand.[2] All the plates were engraved by the same Master of the Boccaccio Illustrations who was also responsible for the copy after the Paris fragment [**91**].

¶ The composition is recorded in yet a third version: an engraving preserved in a unique impression in Vienna [**91**a]. It is larger than the other two, departs from them in numerous details and is executed in another style, visibly inspired by Hugo van der Goes.

¶ When Lehrs published the Paris fragment [**91**] and the version in Vienna [**91**a] in 1902, he suspected that the three prints came into being as the result of a competition arranged by the publisher, to find the best engraver for the projected illustrations. It did not take long before other scholars pointed out that the print by the Master of the Boccaccio Illustrations must have been modelled on the Paris fragment, and that it may well have been intended to illustrate a new edition of the prologue.[3] It was also observed that the version in Vienna was too large to fit into the book.

¶ Furthermore, it became apparent that neither the Paris nor Vienna plate was engraved by an experienced master, which is no doubt the reason why

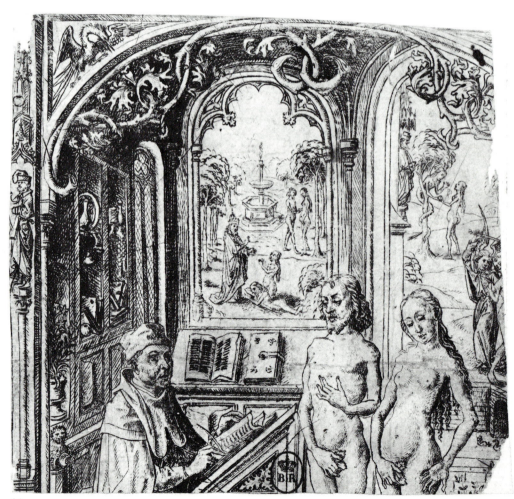

91

the commission went to a man with more routine at his command, the Master of the Boccaccio Illustrations.

Anzelewsky has observed that the print in Vienna shows a strong resemblance to miniatures by the Master of Mary of Burgundy, whom he identifies as Sanders Bening. His theory is that all three versions derive from a miniature that may have served as the dedication page to Mansion's first printed edition of Boccaccio. He sees the Vienna version [91a] as the most reliable copy of the miniature. For this reason Anzelewsky ascribes the definitive prints in Mansion's Boccaccio to another miniaturist, the Master of the Dresden Book of Hours.[4]

Neither Anzelewsky nor Boon questions the attribution of the Paris fragment to the Master, whom they identify as the Dutch-trained miniaturist Erhard Reuwich. In this regard, the Paris fragment is a key piece of evidence for the relation between the art of the Master and contemporaneous developments in Flanders.

As Glaser has already observed, there are considerable differences between the print and the Master's drypoints in terms of modelling, physiognomy, the creation of space and the style of ornamentation.[5] The engraving technique is hesitant and sketchy, but in fundamentally different ways than we encounter in the early drypoints by the Master (see pp. 29-31).

¶ It would therefore seem more reasonable to assign the print to a miniaturist from Bruges or Ghent, someone with as little experience in engraving as the maker of the plate in Vienna. Even if they have no relation to the work of the Master, these prints are of vital importance for the clues they provide concerning the close ties between Bruges manuscript illumination and early printed illustrations.

1. Max Lehrs, 'Der Meister der Boccaccio-Bilder', *Jahrbuch der königlich preussischen Kunstsammlungen* 23 (1902), pp. 124-41.
2. Henry P. Rossiter, 'Colard Mansion's Boccaccio of 1476', *Beiträge für Georg Swarzenski*, New York 1951, pp. 103-11.
3. Baer 1903, p. 137; Max Geisberg, 'Der Hausbuchmeister in den Niederlanden?', *Cicerone* 1 (1909), demonstrated that the figure of Eve in the Paris print is based on the so-called Courtrai Altar in the Prado, which must have been made in the atelier of Roger van der Weyden. Eve's strange pose is explained by the fact that in the altarpiece she is holding an apple. The anomaly was corrected in the print by the Master of the Boccaccio Illustrations.
4. Fedya Anzeleswky, 'Die drei Boccaccio-Stiche von 1476 und ihre Meister', *Festschrift für Friedrich Winkler*, Berlin 1959, pp. 114-25; K.G. Boon, 'Was Colard Mansion de illustrator van 'Le Livre de la Ruyne des nobles hommes et femmes'?', *Amor Librorum: a tribute to Abraham Horodisch*, Amsterdam 1958, pp. 85-88.
5. Glaser 1910, p. 154.

91a*
The same subject, by an anonymous master, ca. 1475. Engraving, unique impression, worked up by pen, 290 x 169 mm. Lehrs, vol. 4, p. 270, nr. 82. Vienna, Albertina (inv. nr. 1926:905).
91b*
The same subject, by the Master of the Boccaccio Illustrations, 1476. Engraving, 186 x 167 mm. Lehrs, vol. 4, p. 174, nr. 3. Paris, Bibliothèque Nationale (inv. nr. Ec.N. 795).

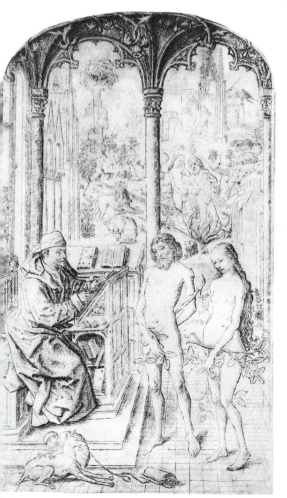

91a

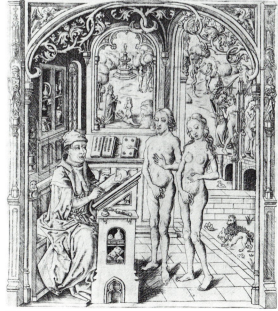

91b

PRINTS

BY MASTER b⍺8

The body of engravings with the monogram b x g has traditionally been linked with the Master's work. In the nineteenth century Harzen even thought that the engravings which bear this monogram and those with the letters W B (see p. 45) were by the same hand as the Master's drypoint prints. Since he read the last letter of the monogram b x g as an s, he identified the maker of this very varied oeuvre with Bartholomeus Zeitblom, a theory which has never found much of a following. That the last letter of the monogram is not an s but a g was proved at the beginning of this century by a comparison with letters in manuscripts and early printed books. The monogram had already been read wrongly in the seventeenth century, when it was identified as that of Barthel Schoen, who was supposed to be a brother of Martin Schongauer. Although the latter did indeed have four brothers, there was no Bartholomeus among them. All the same this fantastic identification survived into the present century.

With the discovery in 1856 of the copper plate of the print with the *Coats of arms of the Rohrbach and Holzhausen families* [111] it became clear that the monogrammist must have worked in Frankfurt am Main. Flechsig, who made quite a deep study of this artist in 1911, conjectured that he was a Frankfurt goldsmith and suggested the name of Bartholomeus Gobel, about whom nothing further is known.[1]

Lehrs attributed forty-four prints to Master b x g, most of which bear the monogram and five of which are copies after Schongauer. Although models in the form of drypoint prints by the Master can be posited for only seven of the other engravings, the majority of the prints by Master b x g have been linked with the Master's work. In his *catalogue raisonné* of 1893-94 Lehrs included a list of thirty prints by Master b x g as copies of lost drypoint prints by the Master.

Thematically this group is exceptionally interest-ing in that virtually all the prints have secular subjects. Whether all thirty of the prints mentioned really are based on models by the Master or whether the monogrammist may also be assumed to have possessed a certain originality are questions we do not propose to enter into in depth here. What does seem certain is that the engravings are very close to examples by the Master in both style and content, so that it makes sense to exhibit and describe them in the present context.

¶ It may be noted that the majority of the prints by Master b x g link up with our Master's earlier work of around 1475-80, his more mature work appearing to find an echo only in a few prints with courtly themes [98-101, 104-06] and in a copy of the *Pair of lovers* [75a]. Quite marked differences of quality can be detected between the prints with the monogram b x g: in the worst cases they are quite coarse; in the best [92, 93, 108] they are engraved in a fine, lively and varied manner. The style of the engraving has already given rise in the past to the suggestion that this Master was a goldsmith by profession.

¶ The prints by Master b x g are almost as rare as those by the Master. The largest assemblage of them, twenty sheets, is to be found in the E. de Rothschild Collection in the Louvre, Paris. Fourteen of these sheets came from the eighteenth-century collection of Prospero Lambertini (the later Pope Benedict XIV), which was in the university library in Bologna.[2] Since the Rothschild Collection is never lent out, a number of unique prints are missing from the exhibition. What is included is a print with a *Pair of lovers* which was discovered after the publication of Lehrs's catalogue in 1932 [106].

¶ In the catalogue descriptions of twenty-three prints by Master b x g [92-112], the order in Lehrs's catalogue of 1893-94 (referred to here as *L1*) has been kept to. In addition, five sheets with children (*L1, 92-96; L11, 7-12*) are described in

conjunction with the drypoint prints of the same subject by the Master. A few of the prints described by Lehrs (*L1, 109, 113; L11 (b x g), 26, 28, 31*) have so little in common with the Master's work that there did not seem much point in including them.

¶ Although Lehrs's 1932 catalogue of the prints by the Master b x g (referred to here as *L11 (b x g)*) gives careful descriptions of the prints and the various extant impressions, little has been done since then as regards the interpretation of their content. Thus the present writer is grateful to Keith Moxey for his numerous suggestions in this respect.[3]

1. Flechsig, see **111**, note 1; see further Lehrs, vol. 8, pp. 165-79.
2. Lehrs, vol. 8, p. 169, note 1.
3. I am indebted to him for the references in the following notes: **94**, note 1; **96**, note 1; **107**, note 2; **109**, note 2.

92. St. Anthony visiting St. Paul the Hermit
(L1, 90 ; L11 (b x g), 6), ca. 1475-80
Engraving, four known impressions, 159 x 107 mm.

¶ St. Paul of Thebes lived in the third century A.D. In order to escape the persecution of the Christians he retreated into the desert, where he lived for sixty years as a hermit. He dressed in palm leaves and every day a raven brought him a piece of bread. Shortly before his death he was visited by another hermit, St. Anthony Abbot, who had only found him after long wanderings. When it was time to eat, the raven flew in with a double portion of bread.[1]

¶ That is the moment that is shown here. The two aged hermits are seated by a spring engaged in pleasant conversation, St. Paul under a thatched awning in front of the cave in which he lives and St. Anthony under a tree. The event is rendered with such an obvious, rather naive sense of humor that there can be no doubt that it was based on a model by the Master, probably from his early period. Although the burin lacks the subtlety of the drypoint, a fine range of gradations has been achieved here, especially in the shadows.

1. *Legenda aurea*, pp. 111-12.

92.1*
Berlin, Staatliche Museen Preussischer Kulturbesitz, Kupferstichkabinett (Murray coll., 1888; inv.nr. 126.1891): very good impression, 157 x 106 mm. (trimmed around outline).
92.2
Dresden, Kupferstichkabinett: good impression, 158 x 106 mm. (with border around outline).
92.3
New York, Metropolitan Museum; very good black impression, 158 x 108 mm.
92.4
Private collection, United States (Frederick Augustus coll., Dresden, 1926; G. Ronald coll.): good impression with margin (watermark: wide Gothic P with cloverleaf).

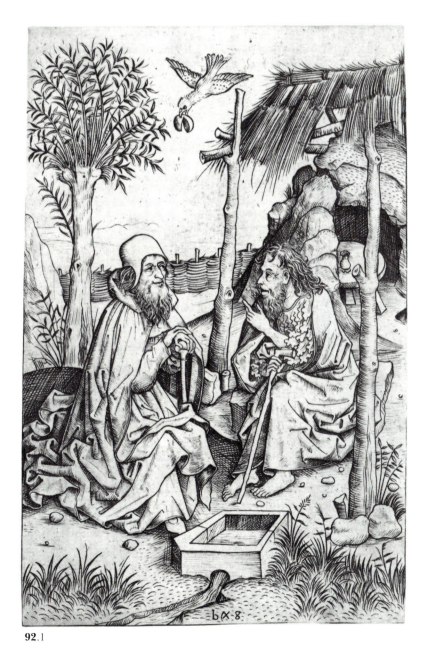

92.1

100
Paris, Bibliothèque
Nationale (inv.nr. Ec.N.
436): matt impression,
diameter 90 mm. (trimmed
around outline).
101.1*
Oxford, Ashmolean Museum
(Douce bequest; inv.nr.
S.20-15): very good impres-
sion, diameter 89 mm.
(trimmed around outline).
101.2
Formerly Graf York von
Wartenburg coll., Klein
Oels (von Praun coll.; Fries
coll.; Wilson coll.;
W. Esdaile coll.; Arozarena
coll., 1861).

young woman accompanies him on a type of zither, a stringed instrument played with two small hammers.

¶ All four prints picture a courtly ideal love such as we are also familiar with from the work of the Master (pp. 66-72). The dress of the lovers also indicates that they belong to the same privileged group as the young people in the Master's courtly prints. But that need not imply that these engravings are based on prints by the Master, for they are quite straightforward in composition and could perfectly well have been designed by the monogrammist himself.

¶ The same 'garden of love' motifs as those on these four prints are found in a number of quatrefoil stained-glass panels with secular subjects (see **139**),[3] which are often linked with the work of the Master. It remains an open question whether the prints were made as models for such panels.

1. See Moxey 1980, op.cit. (62, note 1), pp. 138-41.
2. See exhib.cat. *Lucas van Leyden*, Amsterdam 1978, p. 72.
3. Schmitz 1913, vol. 1, pp. 101-16; vol. 2, pl. 30-31.

100

101.1

102. Peasant pulling his wife along in a basket

(Lı, 105 ; Lıı (b x g), 24), ca. 1475-80
Engraving, unique impression, 84 x 126 mm.

103. Peasant pushing his wife in a wheelbarrow

(Lı, 106 ; Lıı (b x g), 25), ca. 1475-80
Engraving, four known impressions, 98 x 157 mm.

¶ In both prints an old woman is being transported by a peasant (?) in tattered clothing in a primitive vehicle. In the one [**102**] the woman sits scolding in a basket, which the man is pulling along on a rope. In the other [**103**] the old woman, with a straw hat on her head, a dead branch in one hand and a flask in the other, is seated in a wheelbarrow being pushed by a peasant. In both cases there is an obvious satirical content: the man is under the women's thumb and is thus a henpecked husband, who is forced to act like a slave.

¶ In the print with the old woman in the wheelbarrow it can be concluded from the wine flask in her hand that she is drunk. The dead branch, which we have also come across in the case of the old woman in Schongauer's print of *Peasants on the way to market* [**64**c], is an attribute of carnival revellers, but it can also be an attribute of folly.[1] There are various examples of a drunken man being transported by women in a wheelbarrow or on a sledge.[2] Admittedly the roles are reversed here, but the situation is just as humiliating.

¶ In this print too the peasants are depicted as ugly and stupid, all the details accentuating the grotesque and ridiculous nature of the event, which violates the 'natural' hierarchy of society.

102
Paris, Musée du Louvre,
E. de Rothschild coll. (from
Bologna; inv.nr. 303 LR):
very good impression,
84 x 126 mm. (with margins
95 x 131 mm.: watermark:
Gothic P with flower).

102

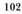

105
Paris, Musée du Louvre,
E. de Rothschild coll (from
Bologna; inv.nr. 298 LR):
very good impression,
155 x 137 mm.

105. Pair of lovers (half-length)

(L1, 108 ; L11 (b x g), 30), ca. 1480
Engraving, unique impression, 155 x 137 mm.

¶ This youthful pair of lovers equally fit in with the courtly tradition of chivalric ideals of love. The composition is reminiscent of the *Pair of lovers* at Gotha [133], who are likewise shown at half-length. The young woman is giving her lover, who has his arm round her waist, a sprig of flowers (and berries?) evidently of the same species as

that his betrothal wreath is made of. The giving of a flower to the beloved, probably a symbol of fidelity, often appears in betrothal and marriage portraits of the period [see 133]. Reference has been made elsewhere [55-56] to the possibility that a lost model by the Master for this pair of 'equal lovers' formed a counterpart to his 'unequal lovers' [55]. However, it is not certain that such a model ever existed, for the rather broad, coarse features of the lovers have little in common with similar figures in the Master's prints.

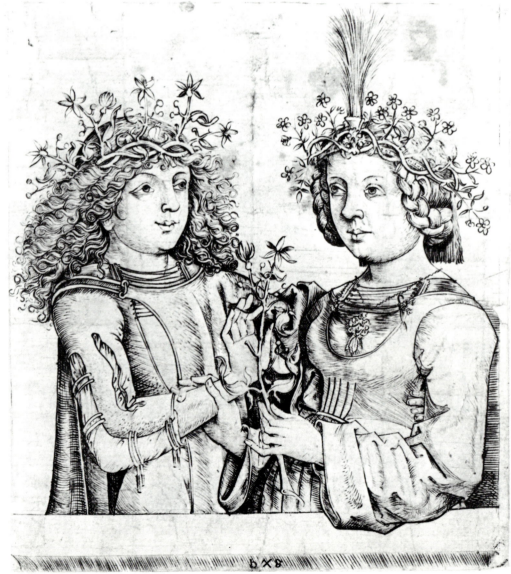

105

6. Pair of lovers (half-length)

ot in Lehrs), ca. 1480
graving, unique impression, 181 x 159 mm.

This engraving, of which only one impression survives, is one of the largest and most remarkable prints by Master b x g.[1] Although his monogram is missing, the style of engraving is so close to his monogrammed work that the attribution to him seems justified.

The dress of the lovers is rendered in a high degree of detail: the young woman with a cap over her carefully bound-up plaits and a full upper garment over a shift decorated with a brocade pattern; the young man with a tasselled cap on his head and a jerkin laced at the neck and with a slash in the upper part of the sleeves that can be fastened by round buttons.

¶ Although the rich and fashionable clothing seems to place these lovers in the courtly milieu, it is no noble ideal of love that is rendered here, as in the previous print. The young man is feeling for the breasts of the woman, who is scarcely attempting to fend him off, but looks at the spectator as at a sort of accomplice. It is obvious that the relationship between the couple is governed more by feelings of lust [75e] than by the chivalric ideal of love.

¶ Although the style of engraving is not particularly subtle, the composition does not lack a certain refinement, especially in the way it strays over the lines of the framework.

1. See Hutchison 1972, p. 80, illustrated on p. 185; the print was published by William Ivins Jr., 'Lovers by the Master b x g, an undescribed early German engraving,' *Metropolitan Museum Studies* 5 (1936), p. 234.

106*
New York, Metropolitan Museum (inv.nr. 34.38.6; Harris Brisbane Dick Fund 1934): good impression, 181 x 159 mm.

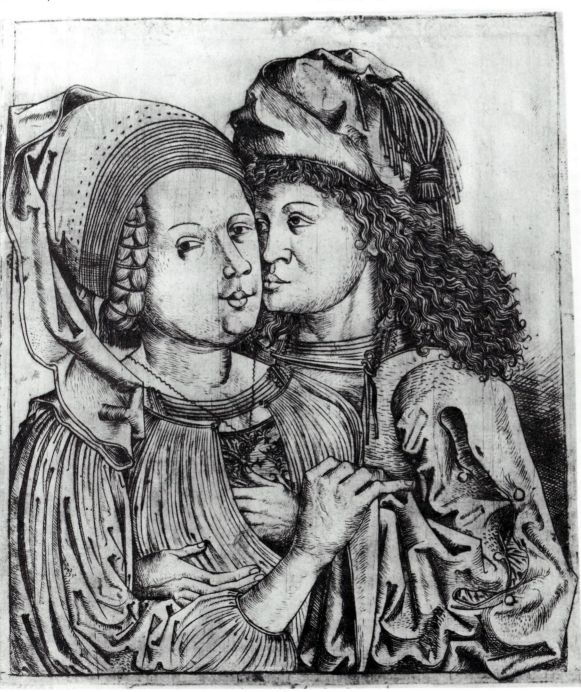

107.1*
Munich, Staatliche
Graphische Sammlung
(Maltzan coll., Militsch ;
inv.nr.1964:424): good
impression, 174 x 208 mm.
107.2
Paris, Musée du Louvre,
E. de Rothschild coll. (from
Bologna; inv.nr. 302 LR):
very good impression,
175 x 109 mm. (watermark:
Gothic P).
107a
Daniel Hopfer, *Marcolf and
Polikana*, ca. 1530. Etching,
244 x 227 mm., N.72.

107. Dancing fool and old woman

(L1, 110 ; L11 (b x g), 33), ca. 1480
Engraving, two known impressions, 175 x 209 mm.

¶ In this print, an unusually large one for the fif-
teenth century, we see an old woman with a stick
hobbling along hand in hand with a dancing fool.
His fool's costume and shoes are worn out, there
is a flute stuck in one of his sagging hose and at
his side hang a sword and a rush basket with a
goose (?). The ugly old woman has the same fea-
tures as other peasant women in prints by the

monogrammist [**94-95, 97, 102-03**], but the fool
looks a bit younger than the one on the next print.
¶ Nevertheless, although this has not been
suggested before, it seems acceptable that these
are the comical couple of fools, Marcolf and his
wife Polikana. At least this is what they are called
in Daniel Hopfer's etching made around 1530,
which also shows a dancing fool and an old
woman [**107a**]. In the caption to a later edition of
this print it is explained that if Marcolf and
Polikana had not been so foolish, they would long
have been forgotten.[1] Marcolf's renown is evident

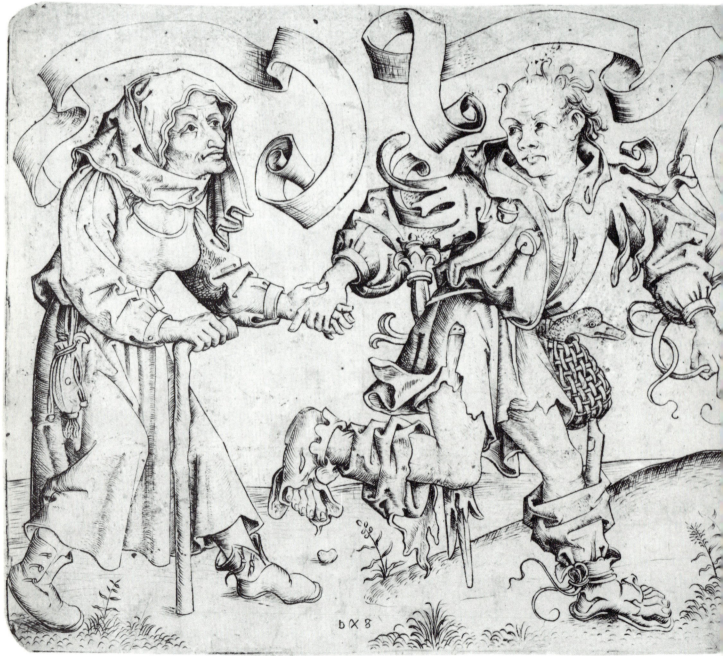

107.1

from, among other things, a famous fifteen-century text, *Dialogus Salomonis et Marcolfi*, of which dozens of versions, mostly in German, are preserved in manuscripts and printed books.[2] According to this story, the wise Solomon invited Marcolf, who was as quick at repartee as he was ugly, to a debate, which became a comical confrontation between Solomon's higher (Biblical) wisdom and Marcolf's earthy hard-headedness and practical knowledge of life.

It has not proved possible to establish whether the print pictures an actual episode in the fool's life, but it can be taken that the banderoles above the figures were meant for a moralizing or mocking commentary and that the goose in the basket also has a specific meaning.

Lehrs, vol. 8, p. 206.
In addition to editions of the text, there exists quite an extensive literature on this text, listed in a lexicographical article by Michael Curschmann, to which Keith Moxey drew my attention.

108. Old woman and fool at a window
(LI, 111 ; LII (b x g), 34), ca. 1480
Engraving, seven known impressions, 181 x 158 mm.

¶ Behind a stone sill to a window, of which the frame is decorated with foliate ornament, a couple sit eating: an old peasant woman and a balding fool with a lump and a pimple on his head. It was already remarked in the nineteenth century that this couple could be the fools Marcolf and Polikana [see **107**] and, as with the previous print, that identification seems quite acceptable.[1] In this print too the gestures of the woman's hands, the bowl, the bread, the jar and the ladle in the man's hands can scarcely be devoid of meaning. It is possible that the lustful natures of the elderly couple are being ridiculed [see also **64, 96, 97, 109**]. Both the bread and the jar could indicate this, while the ladle probably symbolizes folly. The caption to a free copy of the print of the late sixteenth century [**108**a] points out that the

108.1*
Oxford, Ashmolean Museum (Douce bequest): very good impression, 178 x 157 mm.
108.2
Paris, Musée du Louvre, E. de Rothschild coll.: uneven impression, 172 x 148 mm.
108.3
Paris, Musée du Louvre, E. de Rothschild coll.: very good impression, 166 x 144 mm. (colored in red and yellow).
108.4
Chicago, Art Institute (Frederick Augustus II of Saxony, Dresden; W. McCollin McKee Memorial Coll.): good impression, 180 x 158 mm.
108.5
Vienna, Graphische Sammlung Albertina (inv.nr. 1928/333): very good impression, 181 x 157 mm.
108.6
Formerly von Liechtenstein coll., Vienna.
108.7
Formerly Maltzan coll, Militsch.

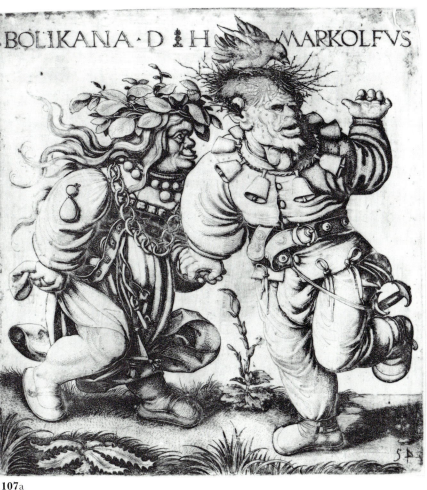

BOLIKANA · D ⚜ H MARKOLFVS

107a

108a
Copy in reverse by Nicolaas
de Bruyn, ca. 1590. Engrav-
ing, 113 x 145 mm. Holl. 200.

old couple certainly eat a lot, but they still remain
thin. Since the verb 'to eat' in the German of that
time could also have an obscene connotation, this
text could confirm the lustful character of the old
couple.[2]

¶ Qualitatively the print belongs among the finest
by the monogrammist b x g. It is engraved in a
powerful, yet also quite subtle way with a great
variety of hatchings, curved lines, dots and
suchlike. The detailed composition makes the
print a sort of counterpart of the courtly double
portraits [**75**, **113**]. For these reasons one is
inclined to think that it was based on a lost
drypoint print by the Master.

1. Lehrs, vol. 8, pp. 205-07, nr. 34.
2. Stewart 1977, pp. 51-52.

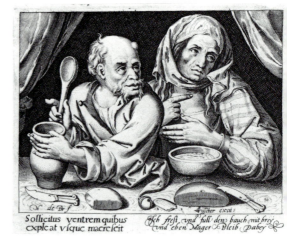

Sollicitus ventrem quibus
expleat vtque marcescit

108a

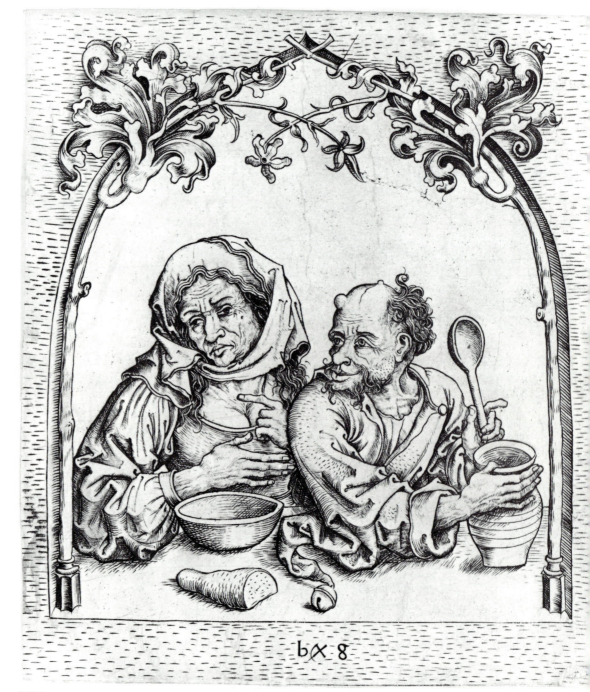

108.1

09. Peasant couple

I, 112 ; LII (b x g), 35), ca. 1475
ngraving, two known impressions, 186 x 116 mm.

This quite large print shows a peasant couple going along with their wares. The man's clothes and shoes and even the scabbard of his sword are worn out. He is wearing an old-fashioned cowl with a liripipe (which was in vogue in the first half of the fifteenth century)[1] and has a sack over his shoulder and a basket of eggs in his hand. The peasant woman, who looks rather less down-at-heel, is carrying a basket of ducklings (?) on her head and an earthenware jar in a hanger on her arm. The banderoles above the figures suggest a moralizing commentary.

As has been described in detail under the Master's *Old peasant couple* [64], the print forms part of a series of such scenes. As in the case of other prints by the monogrammist [94, 96, 97], this one can be taken to be a satire on the foolish lusts of the poor.

¶ The grotesque way in which the two partners in the print are depicted emphasizes here again the coarse stupidity and foolish sensuality of peasants. This picture agrees with the way in which peasants selling their wares at market were represented in the carnival plays of the time. They were seen as an unreliable lot, who cheated townsfolk by offering tainted goods as fresh.[2]

1. Paul Vandenbroeck, Antwerp, was kind enough to point this out to me. D. Bax, *Ontcijfering van Jeroen Bosch*, The Hague 1949, pp. 181-82.
2. H.A. von Keller, *Fastnachtspielen aus den fünfzehnten Jahrhundert*, 3 vols., Stuttgart 1853, vol. 2, nr. 113.

109.1
Paris, Musée du Louvre, E. de Rothschild coll. (from Bologna): very good impression, 184 x 115 mm. (watermark: large Gothic P with flower).
109.2*
Karlsruhe, Kunsthalle (inv.nr. 2326): reasonable, rather meagre impression, 186 x 115 mm.

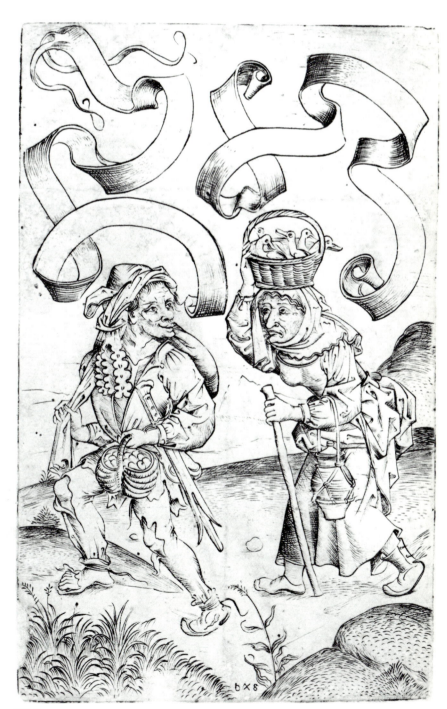

109.2

110a.1* and 110b.1*
Frankfurt am Main, Städelsches Kunstinstitut (inv.nr. 33688/89): very good impression, diameter 90 mm. (with margin).

110a.2
London, British Museum (Durazzo coll., 1873): very good impression, with margin, 91 x 94 mm.

110a.3
Paris, Musée du Louvre, E. de Rothschild coll. (from Bologna): good impression (trimmed around outline).

110a.4
Pavia, Museo Civico, Malaspina coll.: mediocre impression, with margins, 93 x 90 mm.

110a.5
Vienna, Albertina (inv.nr. 1928/330): mediocre impression, diameter 84 mm., (trimmed).

110a.6 and 110b.4
Sale Leipzig (Boerner), 14 May 1934, nrs. 394 and 395 (Wolfegg impressions?).

110b.1* See 110a.1.

110b.2
Berlin, Kupferstichkabinett: very good impression (trimmed).

110b.3
Paris, Musée du Louvre, E. de Rothschild coll. (from Bologna): good impression, diameter 91 mm. (trimmed around outline).

110b.4 See 110a.6

110a. Peasant with garlic and blank shield
(L1, 114 ; L11 (b x g), 36), ca. 1475-80
Engraving, six known impressions, diameter 90 mm.

110b. Peasant woman with a goblet and blank shield
(L1, 115 ; L11 (b x g), 37), ca. 1475-80
Engraving, four known impressions, diameter 90 mm.
Companion prints.

¶ The composition, format and figure types of these engravings are close to those of the two drypoint prints by the Master of a peasant and peasant woman with blank shields [79, 80], although the narrative character is more strongly accentuated here, through the poses and gestures of the figures, than in the prints by the Master. As is explained elsewhere (p. 74), the representations contain the indispensable allusions to sensual love. The peasant has his hand in his jacket, a gesture that can stand for laziness. The peasant woman, who is again quite old, is lifting up her skirts, while offering her companion a drink, both gestures suggesting sexual advances.

¶ On stylistic grounds one would be inclined to regard these prints as copies of lost drypoints by the Master, but it is striking that the satirical prints with peasants by Master b x g are of a much more vulgar character than those by the Master himself.

110a.1

110b.1

111. Coats of arms of the Rohrbach and Holzhausen families

L I, 116 ; L II (b x g), 40), ca. 1480
Engraving, six old impressions preserved, 96 x 93 mm.

This engraving belongs among the best documented fifteenth-century prints. Not only has the copper plate for it survived, but it is also possible to identify the arms shown. This time they are not fictitious, but the arms of Bernhard von Rohrbach and Adelgunde von Holzhausen, who were married on 19 September 1466. In the past it was assumed that this print was made on the occasion of their marriage, but that is impossible, since at that time there was as yet no crown on the helmet above their arms, this only being granted to the patrician von Rohrbach family by Emperor Frederick III in 1470.[1]

It can also be taken that the fashionably dressed young people in the print are not the young bride and groom, but merely heraldic supporters. In view of their dress it is probable that the print was first made in 1480, shortly before the death of Bernhard von Rohrbach [see also **135**] in December 1482. It proves to have been used as a book-plate in at least one book [see **111**.3], so that it can be supposed to have been made for that purpose.

The copper plate probably came into the patron's possession on the delivery of a number of impressions and after the Rohrbach family died out it remained in the possession of the Holzhausen family. In 1856, or shortly before, the very well-preserved copper plate was found in the Holzhausen family archives, wrapped in a piece of paper with the date 1467, and thirty modern impressions were made of it at that time. After having disappeared for a long time, it was acquired ten years ago for the printroom in Berlin.[2]

¶ In this case it is most unlikely that the engraving is based on a lost drypoint print by the Master. It confirms the fact that the monogrammist had a style of his own, albeit a rather stereotyped one. Thus it can also be taken that a number of the prints with his monogram were not based on models by others, but were designed by the artist himself.

1. Eduard Flechsig, 'Der Meister des Hausbuchs als Zeichner für den Holzschnitt,' *Monatshefte für Kunstgeschichte* 4 (1911), pp. 95-115, 162-75, especially pp. 164-67. See also Lehrs, vol. 8, pp. 212-17.
2. Peter Dreyer, 'Eine wiedergefundene Platte des Monogrammisten b x g,' *Jahrbuch der Berliner Museen*, NF 17 (1975), pp. 144-48.

111.1*
Munich, Staatliche Graphische Sammlung (from Reichlschen Klebeband, 1567; inv.nr. 171721): good impression with light tone, 96 x 93 mm.
111.2
Paris, Musée du Louvre, E. de Rothschild coll. (from Bologna).
111.3
Kassel, Landesbibliothek (as book-plate in manuscript of *Legenda aurea* (ms. theol. fol. 5).
111.4
Washington, National Gallery of Art (Maltzan coll., Militsch, 1952; J. Rosenwald coll., inv.nr. B20.215).
111.5
Berlin, Staatliche Museen Preussischer Kulturbesitz, Kupferstichkabinett (inv.nr. 671.1).
111.6
Hamburg, Kunsthalle.
111a*
Copper plate of the engraving, 98 x 93 mm. Berlin, Staatliche Museen Preussischer Kulturbesitz, Kupferstichkabinett (Holzhausen family archives, Frankfurt am Main, acquired in 1973). Thirty modern impressions were made in the nineteenth century, after the plate had been rediscovered around 1856 in the Holzhausen family archives.

111.1

111a

113-16. Portrait heads by Master W B

113. Old man
(L (W B), 1), ca. 1485-90
Engraving, unique impression, 137 x 90 mm.

114. Young woman
(L (W B), 2), ca. 1485-90
Engraving, unique impression, 116 x 87 mm.

115. Old man with turban
(L (W B), 3), ca. 1485
Engraving, three known impressions, 138 x 88 mm.

116. Young woman with jewel on her cap
(L (W B), 4), ca. 1485
Engraving, unique impression, 132 x 89 mm.

¶ The four prints form two pairs of busts in a niche behind a balustrade. In the first pair [113, 114] an interior is suggested behind the figures, two walls being indicated by dense hatching, against which the light faces stand out. In the second [115, 116]

the space around the figures is even more cramped, but a window in the side wall offers a view outside.

¶ Although the master was an outstanding portrait painter [116a-b] and the figures in his prints have quite distinctive facial features, it is questionable whether these are specific portraits. They seem to be character studies rather than individual likenesses. The two pairs of prints differ in conception from the famous engraved portrait by van Meckenem [116c] of himself and his wife Ida. The big difference in age between the (old) men and (young) women portrayed also makes it possible that these are pairs of 'unequal lovers' (see 55, 56), although there are no allusions whatever to any moralizing meaning.[1] The old man in the first pair [113], whose head is slightly inclined to the left, is the most distinctive character; with his wrinkled face and large mournful eyes he seems to have been drawn from life. The young woman [114], by contrast, has an unlined, but also somewhat expressionless face, despite her rather bulging eyes. In the second pair [115-16], the propor-

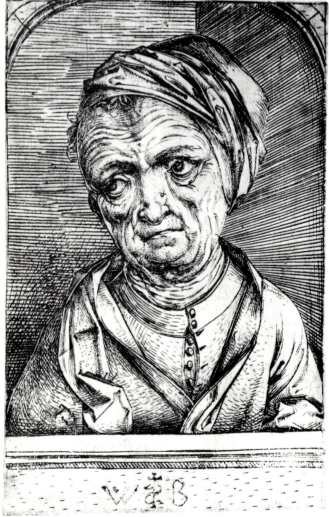

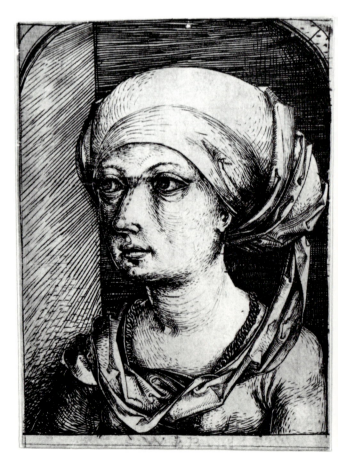

113 114

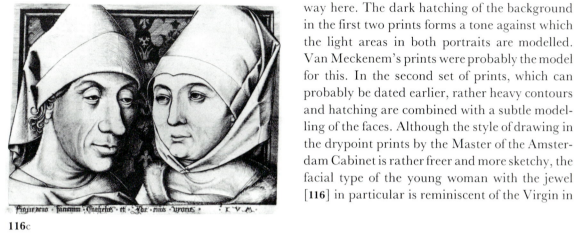

115.3

116c

tionally large heads of both partners seem to be clamped in the small space of the niche. Here too the man with the turban has more pronounced features than the woman with the jewel on her tasselled cap.

¶ The burin has been used in a very varied way here, with thin, fine lines in some places and heavy, powerful contours in others. Although Schongauer can be seen as a model for the types of hatching, the engraving technique is in general used much less regularly and in a very pictorial way here. The dark hatching of the background in the first two prints forms a tone against which the light areas in both portraits are modelled. Van Meckenem's prints were probably the model for this. In the second set of prints, which can probably be dated earlier, rather heavy contours and hatching are combined with a subtle model-ling of the faces. Although the style of drawing in the drypoint prints by the Master of the Amster-dam Cabinet is rather freer and more sketchy, the facial type of the young woman with the jewel [116] in particular is reminiscent of the Virgin in

115.1-2 *First state:*
115.1*
Paris, Bibliothèque Nationale (inv.nr. Ec.N. 432): good impression, 138 x 88 mm. (with fragment of watermark: cross of ox-head).
115.2
Paris, Musée du Louvre, E. de Rothschild coll. (Lloyd coll., 1825; Ottley; inv.nr. 71 LR): very good impression with platemark, with mar-gins 143 x 94 mm.
Second state:
115.3
Second state with retouching to nose and right shoulder: Basel, Kunstmuseum, Kupferstichkabinett (inv.nr. aus K. 6.16), 130 x 93 mm. (cut at bottom).
116*
Hamburg, Kunsthalle (Berkley coll., 1738; Lloyd coll., 1825; Cole & Wilson, 1828; Ottley coll., 1837; inv.nr. 3723): very good impression with platemark, printing blurred on right, 132 x 89 mm.

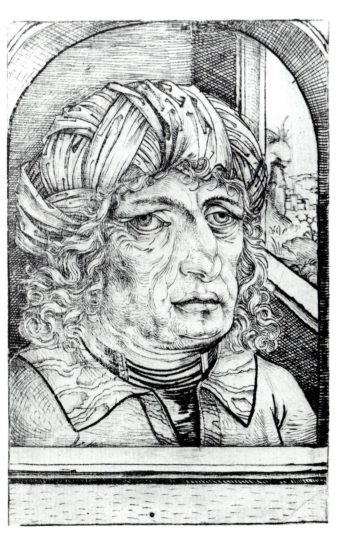

115.2

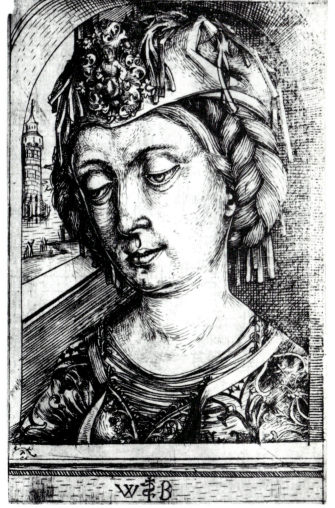

116

116a-b
Master WB, *Portrait of a man*
and *Portrait of a woman*, ca.
1484. Both panel, both
45 x 33 cm. Frankfurt am
Main, Städelsches
Kunstinstitut (inv.nrs. 334
and 335).
116c
Israhel von Meckenem,
*Double portrait of the artist and
his wife*, ca. 1490. Engraving,
129 x 174 mm. B.1 and L.1.
Vienna, Graphische
Sammlung Albertina.

the late sheet of studies with *Christ and the Virgin*
[16]. Because of this and the dates on the painted
portraits by Master W B, these surprising por-
trait prints can be dated between ca. 1485 and
1490.[2]

1. Buchner 1927, pp. 229-30; Shestack 1971, p. 54.
2. Buchner 1927, p. 235, dates the prints between 1480 and 1485.
 Shestack 1971, p. 59, dates them rather later in the light of the
 portrait of a man of 1487 in Lugano.

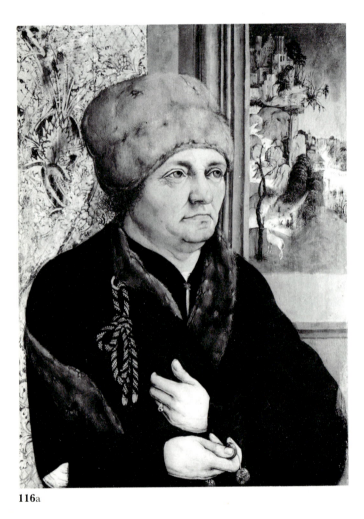

116a

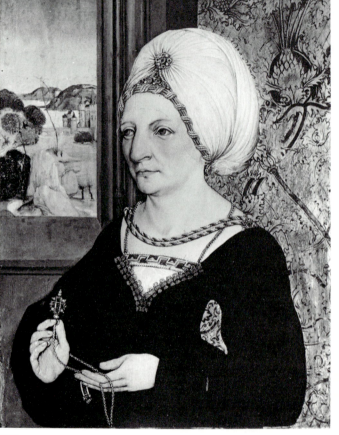

116b

*I*LLUMINATED

MANUSCRIPTS

Although it is assumed by the various authors in their introductions that the Master was trained as a miniaturist (pp. 15-17,57-58), only a limited number of illuminated manuscripts can be linked with him. Moreover, the illustrations in two of these can hardly be called miniatures. Admittedly, the Housebook [117] does contain a few illuminated pages, initials and foliate scrollwork, but it is precisely these parts of it that are seldom attributed to the Master, while of the remainder of the illustrations, all pen drawings, only a certain number are colored with watercolor and that rather sparingly. The dedication page of '*Die Kinder von Limburg,*' which is colored with body- and watercolor, cannot be called a miniature either, even though the color certainly plays a bigger part there [118]. It is, however, clear that the illustrations in both manuscripts occupy a central place in the Master's work, although opinions remain very divided as to the extent to which he worked on the drawings in the Housebook. The greatest purists think that only three of the planet sheets, *Mars, Sol* and *Luna* (fols. 13a, 14a and 17a) are by him, while others ascribe a large part of the illustrations to him. Although the opinions about this govern the attributions of the other drawings, the paintings and the stained-glass panels to a certain extent, this catalogue does not pretend to give a definitive judgment here. Only a better knowledge of the original manuscript can, in the long run, contribute to a clearer picture. Since it did not prove possible to study the manuscript during the preparations for the exhibition, the catalogue entry by Jane Hutchison is unavoidably rather summary in character.

¶ Curiously, relatively little has survived of what was undoubtedly a very rich store of illuminated manuscripts in the middle Rhine area[1] and there is only one manuscript of which the miniatures can be attributed to the Master with a fairly high degree of certainty, the *Gospels* in Cleveland [119]. The *Missal of Margaretha von Simmern* of 1481-82 [120], which unhappily cannot be shown for conservation reasons, is the most beautiful example of a small group of manuscripts in which the borders show the Master's influence.

1. For this see Frommberger-Weber 1973, pp. 37-42, and Anzelewsky 1958, p. 30.

117. The 'Medieval Housebook,' *ca. 1475-85.**

Limp leather binding with sixty-three pages of thin parchment with forty pen drawings in brown and black ink, partly, to a limited extent, colored with watercolor and with gold; with two miniatures and illuminated initials, ca. 290 x 186 mm.

¶ The principal manuscript attributed to the maker of the Amsterdam print is a small, untitled and unfinished volume of handwritten notes and pen drawings on fine parchment.[1] The name 'Medieval Housebook' given to it at the time of its discovery by mid-nineteenth-century scholars is misleading, for the manuscript bears little resemblance to the household almanacs of the day, and still less to the Lutheran *Hausvater-literatur* of the late sixteenth century, which normally featured household and farming information as well as advice on family management.[2] The only items of purely domestic interest in the Wolfegg manuscript are directions for purifying wine and removing stains, for making candles, toilet soap and dyes for textiles, a recipe for making hazelnut torte, and a drawing of a spinning wheel (fol. 34a), thought to be the earliest known example of a pedal-operated apparatus capable of filling bobbins simultaneously with the spinning of raw fibre into thread.[3] The majority of entries in the notebook deal with munitions and military tactics, medical and cosmetic treatments for humans and horses, metallurgy and minting of gold coins. The several recipes for aphrodisiacs (fol. 31b) and humorous drawings of a satirical castle of love inhabited by predatory women (fol. 23b-24a), a pornographic garden of love (fol. 24b-25a), based on an engraving by Master E.S. (L. 215), and a bathhouse containing nude bathers of both sexes (fol. 18b-19a) place this manuscript well outside the scope of family almanacs.

¶ As the late Johannes von Waldburg-Wolfegg noted,[4] the manuscript is not a housebook at all, but an extended war manual of the type initiated by Konrad Kyeser von Eichstätt's *Bellifortis* of 1402-04 (Göttingen, cod. ms. philos. 63), a Latin treatise dealing with explosives, fireworks and alchemy which, like the 'Housebook,' and like many other manuscripts dealing with technical subjects such as medicine or metallurgy, begins with a series of illustrations of the seven planets. Kyeser (1366-1405) was a Bavarian army doctor and self-made engineer who had served in the forces of Sigmund of Hungary, later switching his allegiance to the Holy Roman Emperor Wenzel of Bohemia. He wrote his manuscript, which is dedicated to Wenzel's successor Ruprecht, formerly Count Palatine of the Rhine (d. 1410), while under arrest after Wenzel's deposition in 1402.

His manuscript, illustrated by a Bohemian miniaturist, was soon copied, and its contents had become widely known by the mid-fifteenth century.[5]

DATING THE MANUSCRIPT

¶ The Wolfegg manuscript, which is in High German except for a brief passage in Latin dealing with mnemonics (fol. 4a-5b), was written approximately eighty years later than Keyser's war manual and covers a greater variety of subjects, the most important being medicine and metallurgy. Like the *Bellifortis*, the Housebook seems to have originated with the imperial circle, for it contains an accurate depiction of the encampment of Emperor Frederick III during the siege of Neuss in 1475 (53a-a$_1$). A notoriously reluctant warrior, Frederick rarely took the field at all, and this successful if belated manoeuvre to halt Charles the Bold's attempted conquest of the Rhine near Cologne is considered his crowning military achievement. Contemporary chronicles mention the trench which surrounded the circular camp of the imperial party, and the presence in the camp of Frederick's chancellor, Adolf II of Nassau, archbishop of Mainz (died September 6, 1475), whose banner is prominently displayed nearest the tent with the Hapsburg arms.[6] The heavily bearded man who stands before the imperial tent has been convincingly identified by Lanckorońska as Count Eberhard im Bart of Württemberg,[7] whom chroniclers mention as having been in constant attendance on the emperor.

¶ As Anni Warburg has shown, the siege of Neuss was an event of some importance for the graphic arts, since it was so protracted as to attract a large encampment of civilians selling provisions, armor, religious souvenirs, sexual favors and much else. The Burgundian court goldsmith-engraver, Master W with the Key, was present in the encampment of Charles the Bold, as his print of St. Quirinus of Neuss demonstrates, and it is presumed that his military engravings of army units date from this period as well. Warburg suggested that Israhel van Meckenem might also have been at Neuss with the forces of the bishop of Münster.[8] As Hotz has shown, a 'Clas Nyuergal von Spyr' was an infantryman in the Frankfurt contingent of the imperial army. This man, who may have been identical with the artist Nikolaus Nievergalt of Worms mentioned in later documents in the circle of Johan von Dalberg, was Hotz's candidate for the authorship of the Housebook drawings and Amsterdam prints (see pp. 53-54). The *Neusser Lager* drawing thus establishes the probability that either the writer of the militry text or its illustrator, or perhaps both,

117, fol. 2a

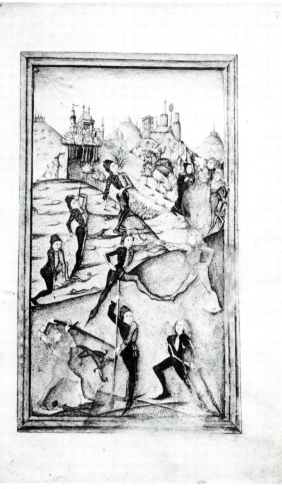

117, fol. 3a

were veterans of Frederick's campaign against Charles the Bold, and fixes 1475 as a *terminus post quem* for the drawing.

A *terminus ante* for a portion of the medical text ('Von der kreps,' fol. 29b) can be inferred from the fact that the treatment of the duke of Lorraine for cancer is described with the comment that it doesn't seem to be having any effect on the progress of the disease. René II of Lorraine (1467-1508) suffered from cancer in 1481, but made a complete and seemingly miraculous recovery from it late in 1482, a fact which the author surely would have mentioned if it had taken place by the time of his writing.[9]

The use of Hebrew letters to spell out German words for various ingredients in the medical and metallurgical sections of the manuscript offer a further indication that the author of these portions of the text had connections with the high nobility in the imperial circle. Frederick III is known to have employed a Jewish physician, Jacob ben Jehiël Loans (ca. 1450-ca. 1506), whom he knighted, and a Jewish surgeon as well.[10] The emperor's reliance on Jewish doctors was in violation of the ban imposed by the Coun-

cil of Basel (1434), forbidden the treatment of Christian patients by Jews. Frederick's own chancellor, Archbishop Adolf of Nassau, had expelled the entire Jewish community from the episcopal city of Mainz as recently as 1473, converting the former synagogue into a Christian chapel;[11] hence, a flirtation with the Hebrew alphabet, implying contact with a Jewish doctor or supplier of pharmaceuticals, would have been rather a daring enterprise in the early 1480s, and one which probably would not have been undertaken without knowledge of the emperor's own views on the subject.

Frederick III died in 1493 in the old fortress of Linz, where he had lived in semi-retirement since 1485. He was succeeded as Holy Roman Emperor by his son Maximilian, who took a far greater interest in warfare than his father, finding it necessary to invest heavily in new armaments and to hire additional munitions officers shortly after taking office. The relatively light artillery pieces portrayed in the Housebook, with their ingenious mountings, appear antiquated in comparison to the new, heavy-calibre cannons cast with Renaissance ornament and designed for use

with standardized shot made to Maximilian's order.[12]

¶ A further link with the old emperor is the depiction of his famous device AEIOU on a banner held by a mounted knight (fol. 52a₁). This rebus was supplied with many meanings at Frederick's court, all glorifying Austria: *Austria Erit In Orbe Ultima* (Austria will live forever); *Al Ere Ist Ob Uns* (We are the source of all honor); *Austriæ Est Imperium Orbis Universi* (Austria rules the entire world).[13] As Count Waldburg noted, Frederick's chivalric order of the Jar (a white stole with an embroidered golden vase of lilies) is worn by a young man appearing in several of the drawings (fol. 18b-24a). This order, of Aragonese origin, was awarded by Frederick to his favorites; Maximilian preferred to use the Burgundian order of the Golden Fleece for this purpose.

¶ These specific references to the regime of the old emperor, together with the consistent use of late fifteenth-century fashions, including *Schnabelschuhe*, would seem to indicate that the illustrations in the first two gatherings of the manuscript must have been essentially complete by the time of Frederick's death in 1493.

THE WRITERS

¶ Two different hands were involved in writing the text of the Housebook: one a professional scribe and the other an amateur. The first, who wrote in a flawless minuscule, was responsible only for the brief Latin passage dealing with mnemonics (fol. 4a-5b)[14] and for the High German poems accompanying the *Planetenkinder* drawings (fols. 10b-16b), which make up the first two gatherings of the manuscript. The remainder of the text, including all of the technical information, gives evidence of having been written in portions, over a long period of time and in differing solutions of ink, by an energetic and more individualized hand. The many corrections indicate that he wrote it for his own use. He knew Latin, as his liberal use of Latin medical terms and obscenities shows, and he was learning the Hebrew alphabet while the first portion of the manuscript was in progress, as may be seen from the way in which the first entries in Hebrew lettering have been set into reserved spaces in the German text, while subsequent ones were entered in the same ink mixture as the surrounding text. The Hebrew characters appear with some frequency throughout the medical and household sections, and figure prominently in the two pages of information detailing the separation of metals from their ores (fol. 40a-b). Not surprisingly, none appear in the sections on munitions and military tactics, for medieval Jews were forbidden to bear arms and could contribute no expertise in these areas.

¶ Like Konrad Kyeser, the author was evidently called upon to provide medical treatment as well as to perform feats of engineering. His most important source of medical information was Avicenna's *Canon medicinae* (acknowledged on fol. 27a: 'Kopff setzen'), but folk remedies were included as well. Topics covered include those of most interest to an army doctor (e.g., treatments for open wounds, broken limbs, dysentery, purgatives for horses etc.) as well as those of more general interest (blood and urine analysis, treatments for fever, kidney stones, constipation, impotence, obesity, gangrene, warts, the plague). Practical advice is also offered as to whether the patient should be informed of the extent of his illness.

¶ The military section of the manuscript begins with a frank discussion of the responsibilities and occupational hazards with which a munitions officer must deal ('Dis hort eim büchsenmeister zu,' fols. 57a ff.). Advice is given as to personnel selection and training, foods to avoid and measures to be taken to prevent treason. A checklist of essential supplies is given, as well as tactical advice on the defense of a castle under siege, and formulas for making gunpowder, stink bombs and fireworks of various sorts. Offensive weapons, including artillery field pieces with adjustable mounts for aiming, scaling ladders and climbing equipment, covered wagons for the transport of light cannons, and even a cannon mounting which could be moved by a team of six horses pushing from behind, all appear only in illustrations, and not in the text, as is also the case with the tactical drawings of the marching army (an ingenious 'fold-out,' fol. 51b-52a₁) and the *Neusser Lager*, the model encampment. The level of expertise displayed in both the text and pictures in this section strongly suggests that the first owner of the manuscript was both author and illustrator of this material, a man of mature years with considerable practical experience as a *Büchsenmeister*.[15] Lanckorońska has suggested that this man, though an expert in munitions, must have held a position of feudal responsibility as a castellan – a theory which has much to recommend it, since it would account for the inclusion of the material on medicine, metallurgy and household information within the same manuscript.[16]

¶ Lanckorońska's identification of the coat of arms forming the frontispiece to the manuscript as that of the castellan of the Schalksburg, a knight of the Ergenzingen family known as Ast (bough), seems convincing. This castle, an ancient Hohenzollern fortress, had come into the possession of the counts of Württemberg by the fifteenth century – a fact of interest in view of the depiction of Count

Eberhard im Bart at the siege of Neuss – and had been rebuilt in 1467. It had taxation privileges as well as hunting, fishing and wine-making rights, and its remote location at the highest peak of the Swabian Alps (near Ballingen) would account for the emphasis upon military science as well as for the lack of reference to agricultural estate management. This remoteness, however, would militate against an extended personal association between the *Büchsenmeister* and the maker of the drypoints, whose activities were centered in the Rhine valley far to the west.

The manuscript apparently remained in the possession of its author and his descendants until the early sixteenth century, at which time it was acquired by an owner named Ludwig Hof – perhaps during a trip to Innsbrück, as a notation in Hof's hand seems to indicate ('zog zu Innsbrugg'). Since Inssbrück was the artillery capital of Europe during the reign of Maximilian, it is possible that Hof was himself a munitions officer in the service of a member of the high nobility. The names of two further owners of the Hof family – Joachim and Leonhard – are recorded in the manuscript before its acquisition in the seventeenth century by the Reichserbtruchsess Maximilian von Waldburg, who is known to have combined a military career with interest in alchemy, medicine, rare books and works of art.[17] It remains in the possession of his descendants to the present day.

As we now know, but as was not yet fully understood in the nineteenth century at the time of the first publications devoted to the Housebook, the manuscript forms part of a rich and uninterrupted tradition of technological literature which included the thirteenth-century notebook of Villard d'Honnecourt and Leonardo da Vinci's Codex Atlantico (ca. 1490), as well as the work of Konrad Kyeser.

THE PLANETENKINDER (fols. 11a-17a)

In form and content, the Wolfegg manuscript is most closely related to such early fifteenth-century technical manuals as Konrad Kyeser's *Bellifortis* and its copies, and to the Tübingen manual on astrology and medicine (M.d.2) written in 1404 and bearing the Württemberg arms, all of which are profusely illustrated. Its set of High German verses recounting the characteristics of the 'children' of each of the seven planets is almost identical to that found in an astrological manuscript dated 1445 (Kassel, Landesbibliothek, ms. astron., fol. 1), illustrated with round pictures drawn in ink and lightly tinted with watercolor.

The Kyeser manuscripts include representations of the seven planets but not of their 'children,' and

have verses in corrupt Latin. The Tübingen manuscript, which resembles the Housebook in drawing on both Greco-Roman and Hebrew medical information, included depiction of the signs of the zodiac with German descriptions of the professions which they govern, and of the seven planets, with descriptions of the temperament and complexion associated with each. Humor is a notable feature of the illustrations, which strongly prefigure the compositions of the *Planetenkinder* blockbooks of the mid-1460s (Copenhagen, Berlin) and the Wolfegg Housebook.

¶ Unlike the Tübingen codex, the blockbooks and such related manuscripts as the so-called *Schermar manuscript* (a medical treatise dedicated to Frederick I, margrave of Brandenburg, dating from 1410-40: Ulm, libri med. nr. 8) and the Kassel astronomical manuscript of 1445 (Landesbibliothek, ms. astron. 1.2), all of which feature personifications of each planet as a standing figure inscribed in a circle, the Housebook planets are depicted as equestrian figures carrying lances with banners, in the tradition of manuscripts in Vienna (cod. vindob. lat. 3068, fols. 80 ff.) and Wolfenbüttel (ms. 29. 14 Aug. 4⁰. fol. 90v).[18]

¶ Stylistic differences between drawings in the Housebook were already noted in the nineteenth century (see p. 44). Various specialists regard only the best drawings among the *Children of the Planets*, Mars, Sol and Luna, as the work of the Master who made the drypoints. The stylistic differences that exist between those three sheets and those with Saturn, Jupiter and Mercury could be explained, according to Becksmann, by differences in their dates, the best sheets belonging to the mature, the others to the early work. In Husband's opinion at least three artists worked on the *Planets*, while the third hand will also have been responsible for the drawings of courtly scenes. Other specialists, particularly those who have been able to study the Housebook in the original, believe that a single artist is responsible for the drawings there in the main.[19]

SATURN (fol. 11a)

¶ The Housebook series of *Planetenkinder* begins with Saturn, the most distant of the planets in the Ptolemaic universe, an inauspicious planet whose influence is used to explain the existence of inequality and misfortune in the world. The most animated of the equestrian figures in the series, he rides a rearing horse caparisoned with bells, and carries a banner emblazoned with a dragon. His 'children,' described in the accompanying poem as pale, hard, cold, sad and old, include the cripple, the prisoner, the knacker and the farmer. His element is earth, and his symbolic animal the pig. This drawing, executed entirely in a black

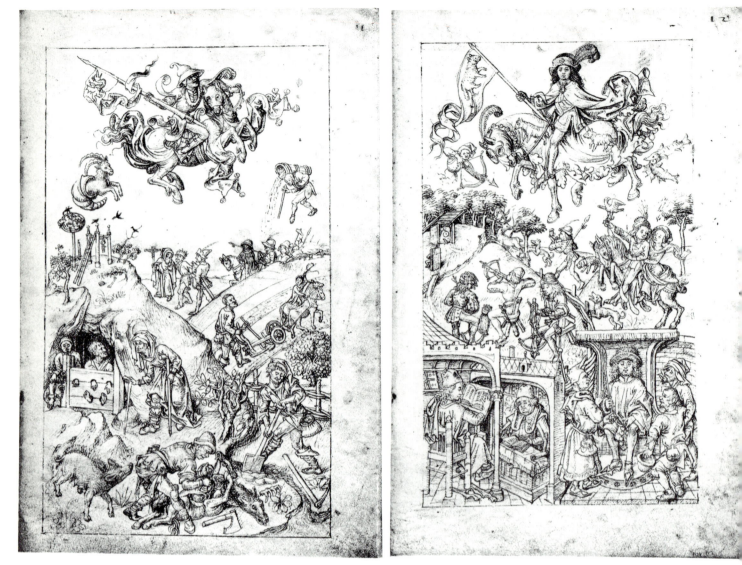

117, fol. 11a **117**, fol. 12a

ink, is more awkward than any of the others.

JUPITER (fol. 12a)

¶ Jupiter, the second of the planets, rides a pacing horse. His emblem, a lamb, is repeated on both his banner and on his horse's 'sack.' From his position in the heavens, between Sagittarius and Pisces, he governs archers, hunters, falconers, judges, lawyers and scholars. His nature is warm and his children are handsome, well-dressed, good-humored and ingenious.

MARS (fol. 13a)

¶ Mars, the ancient god of war, personifies the third planet. A mature, bearded man wearing a kingly crown and dressed in armor, he carries a banner decorated only with drops of blood and rides a galloping horse. The landscape below is seamless, receding gradually toward a horizon outlined by castles and trees, and given over entirely to violence – a village is put to the torch, its women attacked and its cattle stolen by marauding knights, while common highwaymen rob a

bank and murder a pilgrim in the foreground. An ironic touch is the stork's nest in the chimney of the bank, ordinarily a sign of good luck. The scale of figures in this drawing is well related to the landscape, and the figures themselves are slender and gracefully drawn and are readily identifiable as the work of the printmaker. The attempt to create the effect of smoke by means of a smudge, and the reworking of the original bistre drawing, still visible in the foreground, with a strong mixture of carbon black applied to Mars's horse and banner, seem in keeping with the experimental nature of much of the printmaker's work.

SOL (fol. 14a)

¶ The same black, oily ink was used for the entire composition devoted to Sol, except for the zodiac sign of Leo, the lion, the sun's face, and the two men duelling with staves. As in the Mars drawing, the spatial recession is smooth and the figures petite and well-integrated into it. The children of Sol are happy, noble and handsome, strong-bodied and musically gifted. Before noon, as the

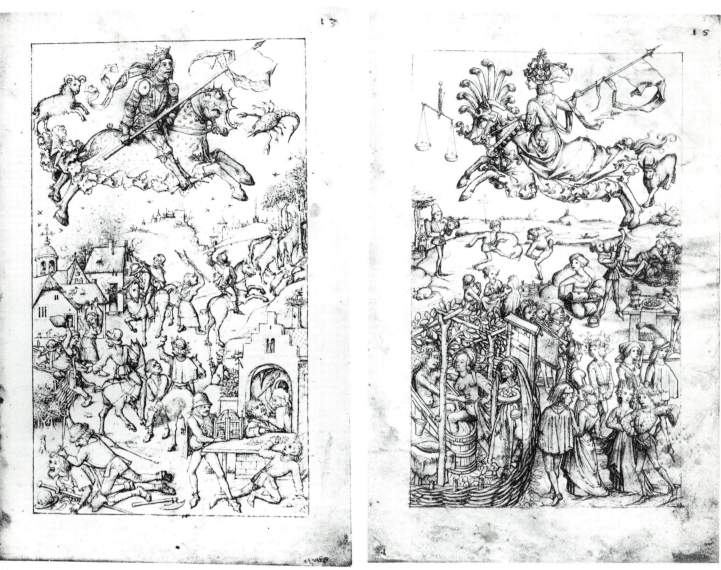

117, fol. 13a

117, fol. 15a

poem explains, they serve God, and thereafter may amuse themselves as they wish. In a small, open chapel at lower left, three children of Sol kneel before an altar to pray, while a fourth gives alms to the crippled beggar seated at the door. Outside, in a walled garden, young lovers are serenaded by musicians, while in the meadow beyond, eight young men participate in athletic contests of weight lifting, wrestling and parrying with staves. As in the Copenhagen blockbook, Sol is characterized as an elderly bearded man wearing the imperial crown and holding a sceptre; here, however, he is comfortably clothed in a mantle with an ermine collar, soft riding boots and spurs. Carrying a black banner, he rides a galloping horse crested with three ostrich plumes.

VENUS (fol. 15a)

The first of the two female planets, Venus is dressed as a youthful empress, who rides sidesaddle on an elaborately caparisoned galloping horse across a flattened landscape, flanked by the zodiac signs of Libra and Taurus. Her children,

as the poem explains, are happy here on earth, whether they are rich or poor. Like the children of Sol they enjoy musical diversions. Roundfaced and well built, they are inclined to be unchaste. In the blockbooks and Housebook, as on a drawing in the early fifteenth-century *Schermar manuscript*, unchastity is illustrated by nude couples caressing in bathtubs. The Housebook goes far beyond the previous examples in making clear the social distinctions between rich and poor, in accordance with the accompanying text. In the foreground, aristocratic couples dance decorously to the tune of a brass ensemble (trumpet and two cornets), while in the background a plebeian couple are unceremoniously fornicating in the shrubbery, accompanied by a hurdy-gurdy and a sackhorn. Still further to the rear, two boys dance the wild *Maruschka* to a drum and recorder. The distant horizon is rendered in bistre, while the bath-tower in the foreground is drawn in carbon black. A light wash has been used for shading certain of the figures, most notably the hurdy-gurdy player and her companion, and the danc-

117, fol. 14a (in color on p. 225, *plate Ia*).

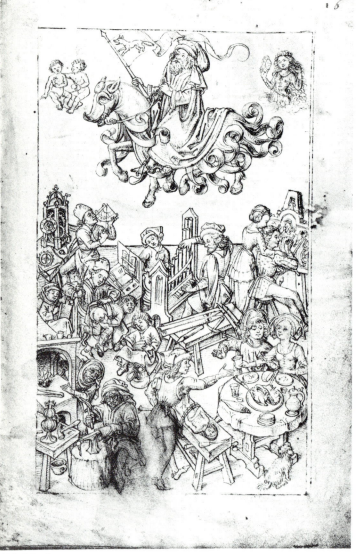

117, fol. 16a

117, fol. 17a (in color on p. 225, *plate Ib*).

ers at lower right. The drawing is flawed by the odd perspective of the bower and its gateway, and by differences in scale between the occupant of the bower and the adjacent dancers just outside.

MERCURY (fol. 16a)

¶ Mercury, who was considered the patron of the visual arts in the days before Albrecht Dürer's acceptance of Aristotelian melancholy as characteristic of artistic genius, is portrayed as an old man in bourgeois dress. Carrying a banner emblazoned with a wolf, he rides a pacing horse between Virgo, who admires herself in a hand mirror, and the Gemini, two naked infants. Mercury's children pursue their professions on a flat floor – a much more appropriate setting for the exclusively indoor activities of Mercury's children than the elaborate landscape used in the blockbooks. As the poem explains, they are round-faced, pale, and fond of beauty, but inclined to be selfish. Industrious, intelligent and well-educated, they are writers, goldsmiths, painters and sculptors, and makers of organs and

clocks. Iconographically this is one of the most original drawings in the series – note, for example, the painter, whose mistress embraces him while he paints an altarpiece featuring the Madonna and St. Catherine; the schoolmaster flogging the bare bottom of a pupil; the sculptor's journeyman who pauses to accept a cup of wine from his master's wife, over her husband's objections.

LUNA (fol. 17a)

¶ The most celebrated of the Wolfegg *Planetenkinder* is Luna, a sheet which together with the Sol and Mars, has unanimously been accepted as a work of autograph quality. Drawn almost entirely in black ink, except for the zodiac sign of Cancer, parts of the horse's neck and tail, and the light portions of Luna's garment, which are in pale bistre, the composition is set in a particularly beautiful landscape. Luna's children, as the poem notes, are unstable and capricious ('unstet und wunderlich'), as well as independent. Round-faced, thick-lipped and short of stature, they are susceptible to the sins of pride and idleness. Vagrants, magicians, hunters and fishermen, millers, sailors and swimmers ('pader')[20] are governed by this nearest and most fickle of planets, whose nature is cold and whose element is water.

SCENES OF COURTLY LIFE (fols. 18b-24a)

¶ The third gathering of the Housebook (which, as Bossert and Storck have shown, was originally the fifth, separated from the planet series by sixteen pages now missing) contains no text of its own, but precedes the section dealing with medicine, aphrodisiacs, and household recipes and procedures. The drawings of this group each extend over two pages. Unlike the planet series, they are lightly tinted in watercolor, sometimes with touches of gold or silver ornament. Although the subject matter of this section is often fascinating in its originality, the depiction of the human figure, as well as of animals, is less expertly done than was true of the *Planetenkinder* or of most of the drypoints. In part, the differences can be accounted for by the influence of the poetry accompanying the pictures of the planets, which dictates a variety of facial shapes, ages and physical types. If the same artist created both sets of drawings, they must have been widely separated in time, a theory difficult to sustain in view of the relative homogeneity of the costumes in both groups. Rüdiger Becksmann and others have assigned these drawings and certain of the *Planetenkinder* as well to a separate Master of the Tournaments, also attributing the glass painting of a patrician tournament [**135**] to his hand.[21]

PLATE I a-b / CAT. NR. 117 / THE HOUSEBOOK, FOLS. 14a, 17a 225

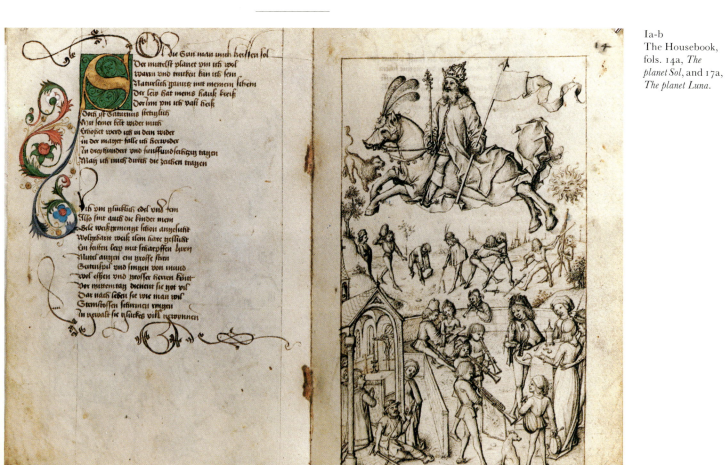

117, fol. 14a

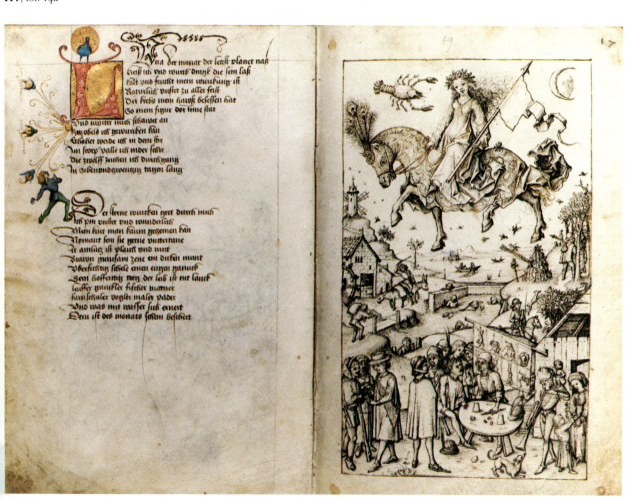

117, fol. 17a

Ia-b
The Housebook,
fols. 14a, *The
planet Sol*, and 17a,
The planet Luna.

IIa-b
The Housebook,
fols. 20b-21a,
Tournament:
Deutsches Stechen,
and 21b-22a,
Duel: Scharfrennen.

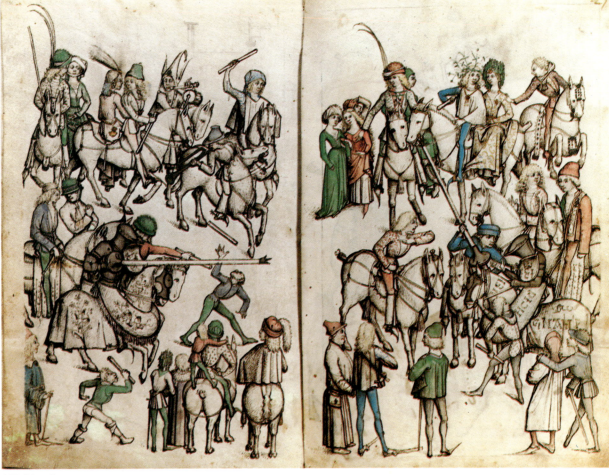

117, fol. 20b-21a

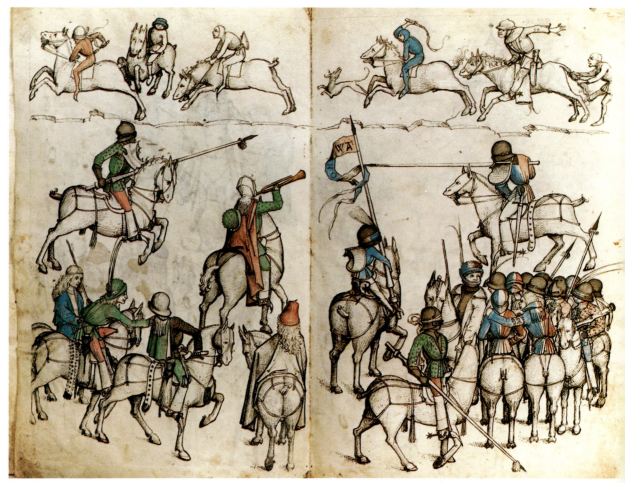

117, fol. 21b-22a

IIIa-b
The Housebook,
fols. 22b-23a, *Stag
hunt*, and 23b-24a,
*An ill-defended
castle of love.*

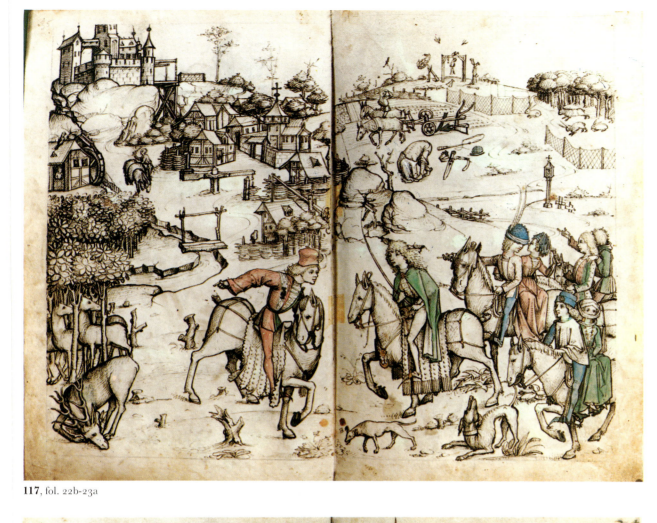

117, fol. 22b-23a

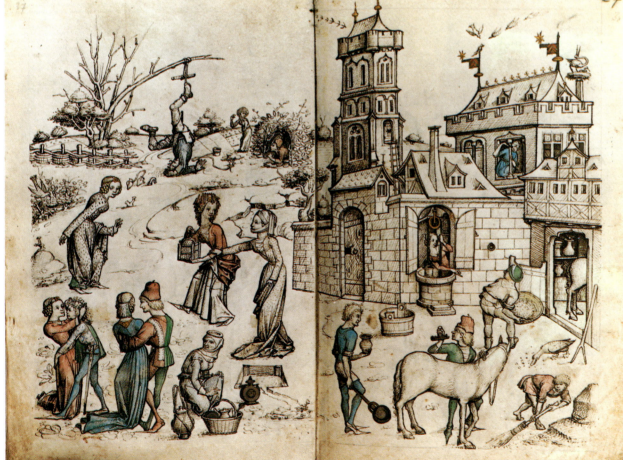

117, fol. 23b-24a

VIII
The Resurrection from the
so-called Speyer Altar,
Frankfurt am Main.

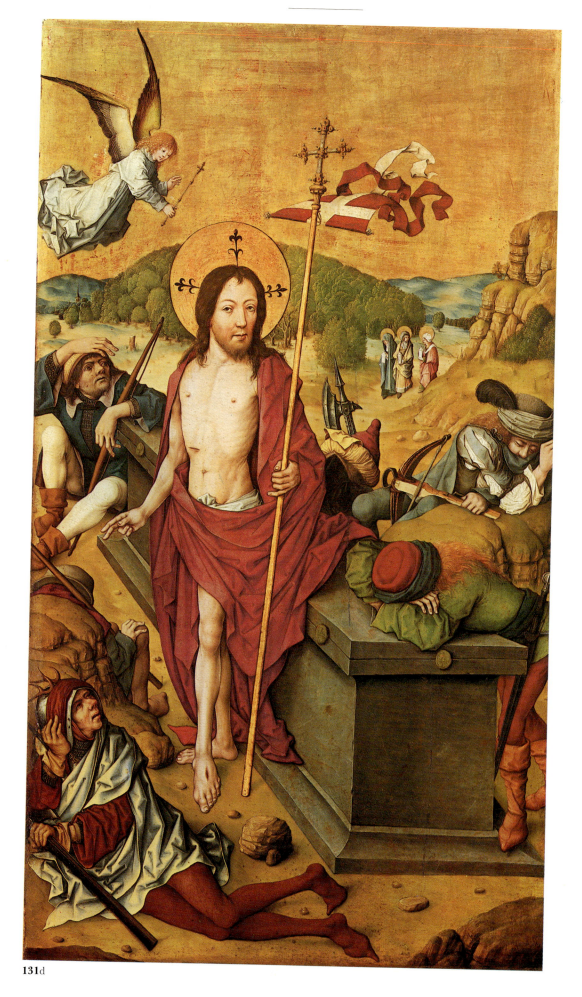

131d

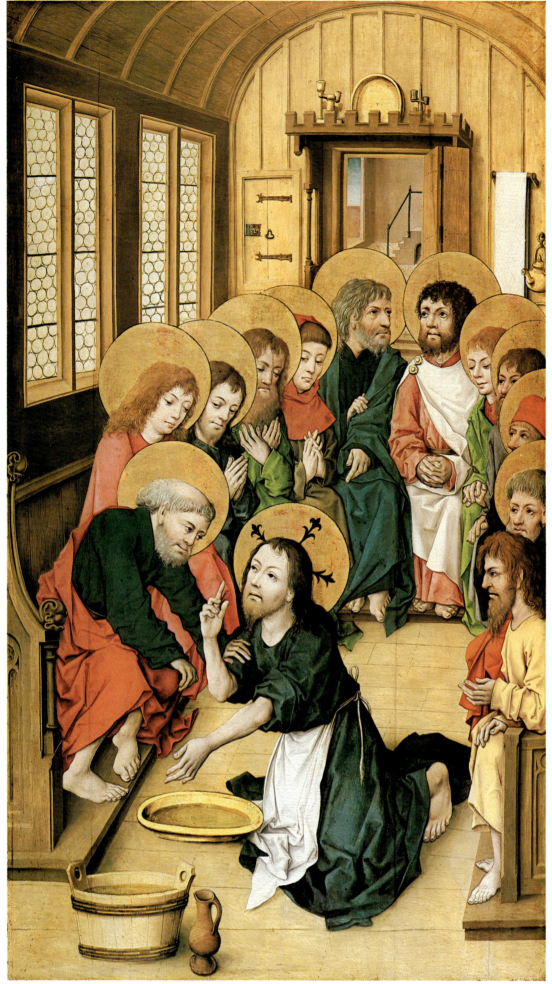

IX
Christ washing the disciples' feet,
from the so-called Speyer
Altar, Berlin.

131e

240

PLATE XVI / CAT. NR. 138 / PORTRAIT OF A DONOR (JOHANN VON DALBERG?)

XVI
Portrait of a donor (Johann von Dalberg?), Karlsruhe.

138

PLATE XVI / CAT. NR. 138 / PORTRAIT OF A DONOR (JOHANN VON DALBERG?)

117, fol. 18b-19a

117, fol. 19b-20a

The first of the double-page drawings represents a bathhouse surrounded by a high walled courtyard containing a fountain. A party of mixed bathers may be seen through the window of the 'hot tub' room, while the courtyard is staffed with young couples in the manner of a love garden. In view of the fact that fountains and hydraulics fell within the purview of the *Büchsenmeister*, the figures here would have been of secondary interest. One young man (left) wears the stole of Emperor Frederick III's order of the Jar. The fountain features a shield emblazoned with a Jerusalem Cross, emblem of the dukes of Lorraine.[22]

OND HOUSE (fols. 19b-20a)
In this drawing, as well as in the preceding one, it is the architecture rather than the human activities which forms the focus of attention. The drawbridge by which the small square building is approached was probably the most important element from the *Büchsenmeister*'s point of view. However, scholars have more often directed their attention to the iconography of the fishers and fowlers in the foreground.[23]

OURNAMENT: DEUTSCHES STECHEN (fols. 20b-21a)
One of the finest of the two-page drawings is that of the tournament with lances tipped with coronels ('Deutsches Stechen'), a joust performed only for sport, in which victory is awarded to the knight who unseats his opponent.[24] The festive atmosphere of this tournament, between a knight wearing as his device the five-petalled rose of Burgundy and an opponent whose second wears the imperial order of the Jar, suggests that it may recall the events staged in celebration of

Maximilian's engagement to Mary of Burgundy in 1473. The inscription on the German or Austrian knight's caparison, read variously as 'Heinrich Mang' or 'Lang,' once figured prominently in the search for the Hausbuchmeister's historical identity (see p. 50).[25]

DUEL: SCHARFRENNEN (fols. 21b-22a)
¶ Unlike the festive tournament with tipped lances, which is attended by women and children and fully staffed with referees carrying batons, the duel with sharpened lances can result in death or severe injury, and is witnessed only by men, a number of whom are armed. A single small boy on horseback is permitted to act as standard bearer, and the start of the combat is signalled by a bugler. The combatants ride unprotected horses, using low racing saddles, and wear battle helmets with chin pieces which provide more freedom of movement than the rigid tournament helmets used in the *Deutsches Stechen*. A horserace is seen at the top of the composition.[26]

STAG HUNT (fols. 22b-23a)
¶ Depictions of the hunt are much less common in fifteenth-century art than they were to become under the regime of the sports-minded emperor Maximilian in the sixteenth century. The present composition, however, features a young man wearing the chivalric order of the Jar, the decoration which Maximilian's father awarded to his favorites. As in the Venus page from the *Planetenkinder*, a deliberate contrast between aristocracy and peasantry has been drawn here: a set of rabbit snares in the background, and a gallows where dead men are themselves the food for birds of prey make a counterpoint to the festive hunting party of noble couples. The moment depicted is that of

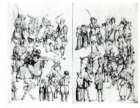

117, fol. 20b-21a
(in color on p. 226, *plate IIa*)

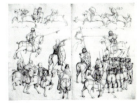

117, fol. 21b-22a
(in color on p. 226, *plate IIb*)

117, fol. 22b-23a
(in color on p. 227, *plate IIIa*)

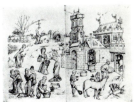

117, fol. 23b-24a
(in color on p. 227, *plate IIIb*)

117, fols. 51b, 51b₁, 52a, 52a₁

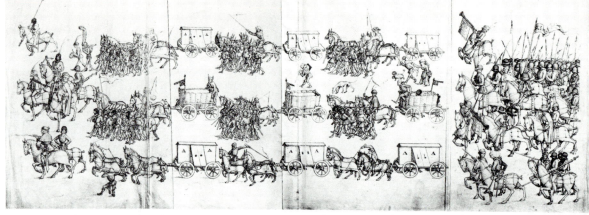

the *Halali* (view halloo), when the deer have been sighted. The 'kneeling' stag in the foreground recalls the designs from the Playing Card Master's suit of stags which were used as illuminator's models in Utrecht and Mainz,[27] while the village and trees in the rear seem to betray a knowledge of Martin Schongauer's early engraving, the *Peasant family going to market* [L.90; **64**c]. The printmaker's two drypoints dealing with comparable themes, the *Stag hunt* [**67**] and the *Departure for the chase* [**72**] are drawn with greater sensitivity to the contours, textures and proportions of horses and game animals, and show a superior knowledge of human anatomy. The detailed observation of the plow, turnstile and mill wheel, on the other hand, suggest an intimate connection with the interests of the *Büchsenmeister* or castellan.

MINNEBURG: AN ILL-DEFENDED CASTLE OF LOVE (fols. 23b-24a)

¶ In a travesty of the courtly allegory of love familiar from French ivories and from the fourteenth-century German poem *Die Minneburg*, among many other medieval poems,[28] the female

117, fol. 24b-25a

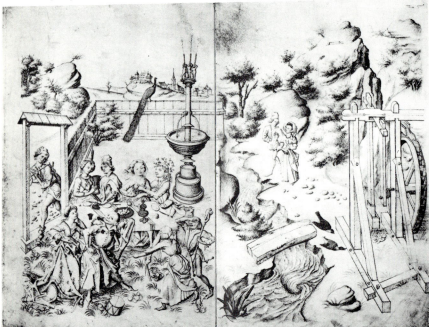

inhabitants of this ill-defended castle do not require their suitors to conquer the fortress of their hearts. On the contrary, they have boldly ventured into the courtyard to seduce and ensnare lovers from all classes of society: a young man wearing the stole of the order of the Jar embraces a girl, while in the background a peasant dangles helpless in an animal trap. One woman holds a bird cage – a familiar emblem of prostitution in later Netherlandish art, but perhaps used here as a more general reference to entrapment – while another beckons to a stable boy from her vantage point in the well housing. The roof of this disorderly establishment is ornamented by a stork's nest, and by two pennants showing red and silver chevrons, arms similar to those of the Gotha *Lovers*. This castle is approached not from the drawbridge but from the stableyard, and the representation of the currying and feeding of horses and cleaning of the stable area were probably the initial motivation for its inclusion, amplifying the veterinary information given in the text.

¶ The last of the series of double-page scenes of courtly life, the *Garden of Love* (fols. 24b-25a), is largely based on the engraving by Master E.S., the 'large' *Love garden* (L.215) as far as the left half is concerned. It is drawn in metalpoint, a technique which does not otherwise appear in the Housebook, and like the previous scenes is partly colored. This drawing is no more regarded by most specialists as the work of the Master than the earlier mentioned (p. 16) colored drawing *Mountain work*(fol. 35a; *fig. 9*). The same applies to the large group of technical drawings of cannon, machines, siege equipment and suchlike. Unfortunately there is no room to go into these interesting sheets in more detail here.

¶ The *Army on the march* (fol. 51b, 51b₁, 52a, 52a₁) and the *Army encampment at Neuss* (fols. 53a, 53a₁) are in general regarded as authentic drawings by the Master, however, and they are certainly by the same hand as the scenes from courtly life.

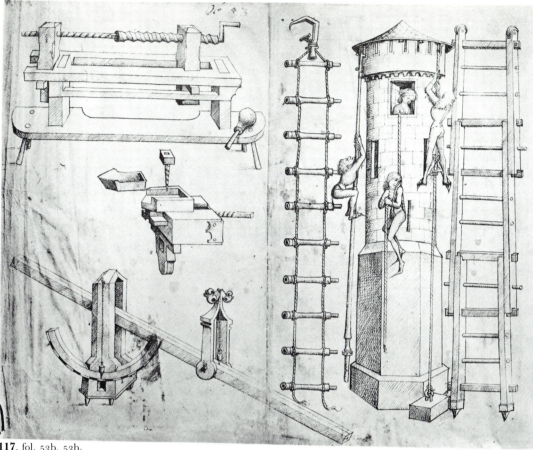

117, fol. 35a (see p. 15, *fig. 9*)

117, fol. 53a-53a₁
(in color on p. 228, *plate IVa*)

117, fol. 56b-57a
(in color on p. 228, *plate IV*)

117, fol. 53b, 53b₁

117, fol. 52b

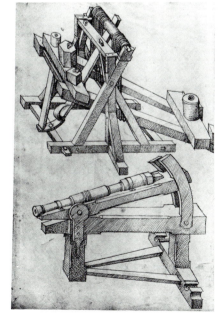

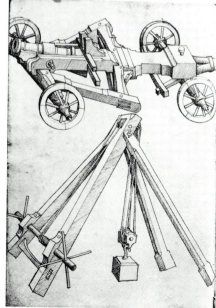

117, fol. 54b

117, fol. 55b

117, fol. 56b

1. For a full physical description of the Housebook and its pagination, and an annotated edition of the complete text, see Bossert and Storck 1912. For historical analysis, see Waldburg-Wolfegg 1957; Ralf von Retberg, *Kulturgeschichtliche Briefe über ein mittelalterliches Hausbuch des 15. Jahrhunderts aus der fürstlich Waldburg-Wolfeggischen Sammlung*, vol. 8, Leipzig 1865; Lehrs, vol. 8, pp. 36-40. See also M. Scheffold, 'Das mittelalterliche Hausbuch als Dokument für die Geschichte der Technik,' *Industrie-Jahrbuch des Vereins deutscher Ingenieure* 19 (1929), pp. 127ff.

2. For a useful brief history of such literature, see exhib.cat. *Kalender im Wandel der Zeiten*, Karlsruhe (Badische Landesbibliothek) 1982.

3. Wolfgang Born, 'Das Spinnrad mit Flügelspindel und Trittanbetrieb,' *CIBA Rundschau* 30 (1938), p. 1104; Walter Endrei, *l'Evolution des techniques du filage et du tissage du moyen-âge à la révolution industrielle*, The Hague 1968 (Ecole Pratique des Hautes Etudes, Sorbonne, 6th series: Sciences Economiques et Sociales), pp. 100ff., fig. 29.

4. Waldburg-Wolfegg 1957, pp. 6-7.

5. Cf. *Neue deutsche Biographie*, vol. 8, 'Kyeser'; Lynn White Jr., 'Kyeser's *Bellifortis*,' *Technology and Culture* 10 (1969), pp. 436-41.

6. Bossert and Storck 1912, p. 22.

7. Maria Lanckorońska, *Das Mittelalterliche Hausbuch der Fürstlich Waldburgschen Sammlung: Auftraggeber, Entstehungsgrund und Zeichner*, Darmstadt 1975.

8. Anni Warburg, *Israhel von Meckenem*, Bonn 1930, pp. 24ff. (based on Christian Wierstrait's *Chronik*). Wolfgang Boerner, *Der Meister W mit dem Schlüssel*, Leipzig 1927 (diss.), p. 53. For an opposing view of Israhel's involvement at Neuss, see Henry Meier, 'Some Israhel van Meckenem problems,' *The Print Collectors Quarterly* 27 (1940), pp. 41-67.

9. Eduard Flechsig, 'Der Meister des Hausbuchs als Zeichner für den Holzschnitt,' *Monatshefte für Kunstgeschichte* 4 (1911), pp. 172-73.

10. On Loans (Loanz), see *The Jewish Encyclopedia*, vol. 8, New York and London 1905, p. 417: 'Medicine.'

11. Valentin Ferdinand von Gudenus, *Codex diplomaticus anecdotum res Moguntinas, Francicas, Trevirenses, Hessiaces*, vol. 4, Frankfurt and Leipzig 1758, p. 412: 'Synagogam judaeorum.'

12. On Maximilian's artillery and *Büchsenmeister*, see Erich Egg and Wolfgang Pfaundler, *Maximilian I und Tirol*, Innsbruck and Vienna, n.d. (unpaginated).

13. Bossert and Storck 1912, p. 28, note *.

14. Ibid., p. 68. This passage is drawn from the *Liber secretorum ad Monteum*, ascribed to Galen, and from the *Rhetoricum ad C. Herennium libri IV* falsely attributed to Cicero.

15. Ibid., pl. 48-71. See also Waldburg-Wolfegg 1957, pp. 24ff.

16. Lanckorońska, op.cit. (note 7).

17. Matthäus von Pappenheim, *Chronik der Truchsessen von Waldburg, zweyter Theyl*, 1785, p. 440 (Bossert and Storck 1912, p. 17). The manuscript was first catalogued by Maximilian Franz von Waldburg (d. 1681), founder of the Wolfegg line, as 'Manuscriptum chimicum auff Pergamen der Saturnus etc., alt.' Between 1780 and 1800, it was recatalogued as 'Der Lauf der 7 Planeten in Gemälde auf Pergament vorgestellt.'

18. On the history of the *Planetenkinder* series, see Anton Hauber, *Planetenkinderbilder und Sternbilder: zur Geschichte des menschlichen Glaubens und Irrens*, Strasbourg 1916; Erwin Panofsky and Fritz Saxl, *Dürer's Melencolia I: eine Quellen und Typengeschichtliche Untersuchung*, Leipzig and Berlin 1923, pp. 121-36, 'Die Entwicklung der Planetenkinder Darstellung'; Raymond Klibansky, Erwin Panofsky and Fritz Saxl, *Saturn and melancholy: studies in the history of natural philosophy, religion and art*, New York 1964, pp. 191-93; Renate M. Radbruch, *Der deutsche Bauernstand zwischen Mittelalter und Neuzeit*, Göttingen 1961, pp. 37-47, 'Planetenkinder'; E. Hoffmann-Krayer and Hanns Bächtold-Stäubli, *Handwörterbuch des deutschen Aberglaubens*, vol. 7, Berlin and Leipzig 1935-36, pp. 278ff.; R. Kautzsch, 'Planetendarstellungen aus dem Jahre 1445,' *Repertorium für Kunstwissenschaft* 20 (1897), pp. 32-40; Ernst Zinner, *Geschichte und Bibliographie der astronomischen Literatur in Deutschland zur Zeit der Renaissance*, Leipzig 1941. (N.B. The well-known *Der sieben Planeten* by Friedrich Lippmann is unreliable in its historical information. See Aby Warburg, in *Gesammelte Schriften*, vol. 1, Berlin 1932, p. 179.)

19. See, for example, Hans Naumann, 'Das Hausbuch und der Meister des Amsterdamer Kabinetts,' *Repertorium für Kunstwissenschaft* 21 (1910), pp. 293-309; Willy F. Storck, 'Über das mittelalterliche Hausbuch,' *Monatshefte für Kunstwissenschaft* 3 (1910), pp. 285-87; Stange 1958, p. 28; Becksmann 1968 and Husband 1985. For the opposing view of scholars who attribute the majority of the drawings to the Master, see Lehrs, vol. 8, pp. 36-37; (Peter Halm), exhib.cat. *Deutsche Zeichnungen 1400-1900*, 1953, pp. 21-22, nr. 15; Waldburg-Wolfegg 1957 and Fedya Anzelewsky's review of Stange, in *Zeitschrift für Kunstgeschichte* 24 (1961), part 1, pp. 86ff.

20. The Kassel manuscript has a barber (*Bader*) and his customers, rather than bathers – one of the many indications that the imagery of the *Planetenkinder* arose from the German poems, rather than from Latin literary sources or from Italian visual models, as Lippmann had supposed. See Warburg, op.cit. (note 18) and Fritz Saxl, 'Literary sources for the 'Finiguerra Planets,' *Journal of the Warburg Institute* 2 (1938-39), pp. 72-74.

21. Becksmann 1968.

22. Waldburg-Wolfegg 1957, p. 39.

23. See in particular W. Hotz, 'Nikolaus Nievergalt van Worms in der spätgotischen Malerei: neue Beiträge zur Hausbuchmeisterfrage,' *Der Wormsgau* 6 (1956), pp. 312-13, in which a connection is drawn with the marriage of the poet Johann von Soest to Margaretha Hecht (her name means 'pike'), daughter of the Heidelberg mint-master, in 1494. Hotz interpreted the motif of the young man in the foreground who holds a fish in his hand as a reference to the poet's felicitous 'catch.' Von Soest's betrothal, it is interesting to note, was held in the bathhouse belonging to the bride's father.

24. Waldburg-Wolfegg 1957, pp. 22-23. Although this tournament game is known in Germany as 'Deutsches Stechen,' it was in fact known internationally and is depicted on fourteenth-century French ivories. See for example the lid of an early fourteenth-century French ivory casket in the Walters Art Gallery, Baltimore, nr. 71.264. On the saddles and armor used here, see Retberg, op.cit. (note 1), pp. 6ff.

25. Bossert and Storck 1912, pp. 31-34. For a complete bibliography of Henrich Mang/Heinrich Lang studies, see Hutchison 1972, p. 82.

26. Retberg, op.cit. (note 1), pp. 62-64; Waldburg-Wolfegg 1957, p. 23.

27. See Ann H. van Buren and Sheila Edmunds, 'Playing cards and manuscripts: some widely disseminated fifteenth-century model sheets,' *Art Bulletin* 56 (1974), pp. 12-29. See also Helmut Presser, *Gutenberg-Museum of the City of Mainz: World Museum of Printing*, p. 16, for a similar motif in a Bible manuscript dating from ca. 1450.

28. Cf. Raimond van Marle, *Iconographie de l'art profane au moyen-âge et à la Renaissance*, vol. 2, The Hague 1931-32, pp. 442ff., 'Château d'amour.' See also Retberg, op.cit. (note 1), p. 263. For the symbolism of the trap, see van Marle, p. 472 and Heinrich Kohlhausen, *Minnekästchen im Mittelalter*, Berlin 1928, nr. 47.

118. Dedication page of 'Die Kinder von Limburg': Johann von Soest presenting his manuscript to Philip the Sincere, 1480

Pen drawing, colored with body- and watercolor, on paper, pasted into the manuscript, 284 x 192 mm.

This colored pen drawing is pasted in at the beginning of the manuscript of the verse romance *The children of Limburg*, which was translated from Middle Dutch into German by Johann von Soest (1442-1501), court ministrel and poet to the Elector Palatine at Heidelberg. The romance tells the story of the children Otto, duke of Limburg, full of feats of arms and tales of love. The duke's son Heinrich has set off in search of his sister Margaretha, who has been carried off and held captive by the sultan. With the aid of the king's son, Echites, who is in love with Margaretha, Heinrich finally succeeds in rescuing her so that she can marry Echites. Among the 25,000 words of the manuscript are various personal comments by Johann von Soest, from which it emerges that he made this lengthy translation to the elector's commission.[1] He probably finished his work on Christmas Eve 1479, so that he was able to present the manuscript to the elector on New Year's Day 1480.[2]

This is the event shown in the drawing: on his knees Johann von Soest gives the book to the Elector Palatine, Philip the Sincere (1442-1508, elector since 1476). The lozenge pattern on the binding, in the Bavarian colors blue on white, was part of the arms of the Elector Palatine, and although this binding has been replaced, the blue and white lozenges can still be seen on the casing.[3] Philip the Sincere, who was then 32 years old and whom Johann von Soest called 'der hubschte Furst in al Tutschland' (the best-looking prince in all of Germany), is depicted as a handsome young man with long curly hair, which is kept in place by a metal headband with a diadem and feather. Over a shirt with horizontal lacing he wears a *Schaube*, a long gown with wide V-neck and wide sleeves, made of black brocade and with an edging and collar of fur. On his feet he wears shoes with long pointed toes ('poulaines') on wooden pattens (see p. 289). The court minstrel's long high-backed black garment also has a fur edging, but looks simpler.

It can still be seen in a few places that the drawing was first sketched in black chalk and then elaborated with the pen and brown ink, after which it was worked up with a fine brush in water- and bodycolor. The color scheme of the drawing, which is surrounded by a wide red border,[4] is a limited one: some pinkish red in the cheeks, blue in the lozenges on the bookbinding and the shoes, yellowish brown for the hair, the modelling of the scroll and the fur edges of the gowns; the brocade pattern on Philip's black gown is drawn with a brush in both black and white. Most of these details are lost in reproductions, which could be the reason why doubt has repeatedly been cast on the Master's authorship.[5] Nonetheless the pen drawing, partly covered by bodycolor, reveals its authenticity in many details.[6] The inscription on the scroll, which is in the same handwriting as the rest of the manuscript, was probably filled in by von Soest himself.

¶ The attribution of the sheet to the Master is central to the discussion of his personality. If it is correct, it proves that he was in contact with the court of Philip the Sincere at Heidelberg, one of the liveliest cultural centers of the day. Philip played an important role in his time as a promotor of the arts and sciences, so that his reign is known as the 'Palatine Renaissance' (see pp. 59-61). Whether the Master was ever in his service is questionable, but in his life style and his court, Philip the Sincere strove for the 'courtly' ideals of chivalry which we find reflected in the Master's work (see pp. 75-76).

1. Valentiner 1903, p. 293, note 3.
2. Ibid., p. 294, note 1.
3. Ibid., p. 293.
4. The drawing was probably cut out of this red border when it was restored in 1962; the red line on the right to be seen in the illustration in Valentiner 1903 is now missing.
5. First published by J. Springer in 1904 (see **125**, note 1); recently by Frommberger-Weber 1973, pp. 121-23. Becksmann 1968, p. 359, also attributes the drawing to the second draftsman of the Housebook. For the attribution see also Storck 1909, nr. 4; Lehrs, vol. 8, p. 78; Winkler 1932, nr. 14; Solms-Laubach 1935-36, pp. 47-48; Stange 1958, p. 28, nr. 102.
6. Valentiner 1903, pp. 291-92, describes the many stylistic similarities with other work by the Master; the style of drawing further offers a good comparison with the pen drawing *Three men in discussion* [**123**].

118*
Heidelberg, Universitäts-bibliothek (codex pal. germ. 87). With date 1480. On scroll:
Laborem hunc dux accipe
De musica discipulo
Sed plus affectum suscipe
Johannes de Suzato.

118 (in color on p. 229, *plate V*)

119. The Four Evangelists, *ca. 1475-80*

Manuscript, in original leather binding, 229 x 168 mm., with four full-page miniatures, water- and bodycolor on parchment, without border 149 x 97 mm., with border 156 x 120 mm.

¶ The *Gospels* of which these miniatures form part comprise the accounts of Christ's life and passion by Sts. Matthew, Mark, Luke and John. In addition to illuminated initials and borders in the text, the manuscript contains four full-page miniatures of each of the Evangelists, who are all shown writing at desks, with their names on scrolls held by their traditional symbols: the angel for St. Matthew, the lion for St. Mark, the bull for St. Luke and the eagle for St. John. The Evangelists are depicted, with humor and attention to specific details like ink pots, pens, a pair of scissors and the like, each absorbed in his own task. St. John is even engaged in scratching something out with a knife.[1] The bright, lively colors of the miniatures have remained fresh. Elements common to the color schemes of all of them are the gold border, the bright blue sky in which white clouds are indicated by brush lines, the yellow furniture and the tiled floor in gray with purple and green. The garments of the Evangelists, in strong red, turquoise-green, blue and purple, are equally bright in color. A notable feature is that in the garments, in particular, the hatching is drawn in different, often complementary colors. The shadows in the furniture and other details are also indicated by extensive hatching.

¶ Such a technique is not uncommon in miniature art, but what is exceptional is the expressive, draftsmanlike way in which it has been applied. It is this that links the miniatures with the work of the Master, in whose prints and in the underdrawing in the paintings (see Appendix III, pp. 295-302) comparable hatching is to be seen. The facial types with the heavy eyelids and the proportions and poses of the figures are also reminiscent of the prints of the middle period of his work.

¶ Also noteworthy are the strong similarities to the earlier-mentioned Belial manuscript (p. 58, *figs. 43a-b*), which was written in 1461 by Brother Nikolaus von Rohrbach, chaplain at Burg Trifels in the bishopric of Speyer.[2] Not only do the wide gold borders and the ornamental borders around them executed in pen afford a good comparison, but the color schemes and technique are also quite close. A fundamental difference is to be found in the strongly draftsmanlike treatment of the garments of the Evangelists in the Cleveland *Gospels*, which makes these figures more plastic and realistic than those in the Belial manuscript. However, the points of comparison with the latter do lend support to the hypothesis that the Master was trained as a miniaturist in the middle Rhine area.

1. The manuscript was first published after its acquisition by the Cleveland Museum of Art in 1953 by William M. Milliken, 'An illuminated manuscript by the Master of the Hausbuch,' *The Bulletin of the Cleveland Museum of Art* 40 (1953), pp. 121-23; see Stange, vol. 7, pp. 105, 120; Stange 1958, pp. 29-30 (ca. 1500); Frommberger-Weber 1973, pp. 96-97, thinks it is the work of the Master's school, under the influence of Netherlandish and Burgundian miniatures.
2. Munich, Staatsbibliothek, ms. CGM 48. See Frommberger-Weber 1973, pp. 86-97.

119 (the *Four Evangelists* are reproduced in color on p. 230, *plate VI*)

20. Missal of Margaretha von Simmern, Electress Palatine, *1481-82*

Manuscript, 191 pages on parchment in original leather binding with illuminated initials and borders and a miniature of the Crucifixion, now preserved separately, 233 x 172 cm.

¶ This is the most beautifully illuminated manuscript of a small group produced around 1480 in and around Mainz, the borders of which show the Master's influence.[1] It is dated both 1481 and 1482 and was made for Margaretha von Simmern, daughter of Arnold, duke of Guelders, who in 1454 married Frederick, Elector Palatine, who died in 1480. From 1459 onwards she bore the arms rendered on the first illuminated page of the manuscript (fol. 8a).[2]

¶ The decoration of the manuscript was probably confined to illuminated initials and borders, which consist of complex floral and foliate scrolls incorporating human and animal figures. The initials exhibit a different style from these and must have been done by another artist. The scrollwork and, above all, the figures in it are most reminiscent of the Master's work. In addition to some religious themes, one sees within the scrolls soldiers, nobles and peasants, who in some cases offer good comparisons with the Master's work: two figures wrestling [fol. 44b, cf. **63**], a young man and Death [fol. 160b, cf. **58**] and a standing Christ Child [fol. 14b, cf. **18**]. Anzelewsky, who argued for the attribution of the

120
Berlin, Staatliche Museen Preussischer Kulturbesitz, Kupferstichkabinett, ms. 78b.4. Missal with borders in pen and bodycolor, with gold.

120, fol. 160b

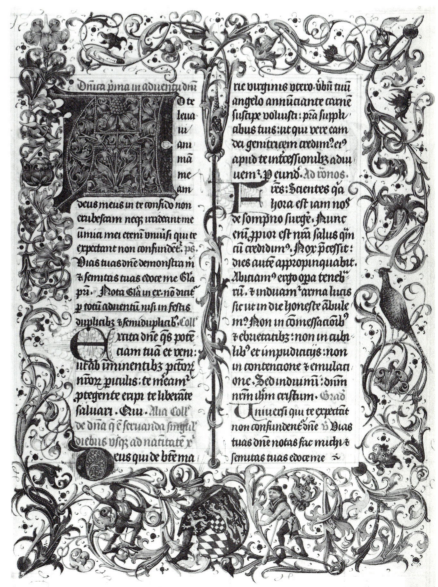

120, fol. 8a

120, fol. 14a (detail)

borders to the Master, considered the very fact that these subjects are not repetitions of the prints to be supporting evidence for his hypothesis.[3]

¶ The figures are drawn in a sharp and lively manner, first with the pen and then with bodycolor in a delicate range of color, in which various tones of green, blue, red and ochre predominate, with some gold. The borders have little in common with the Master's prints as regards the style of drawing and the figure types, but there is certainly a relationship with the double-page drawings of scenes of courtly life in the Housebook (fol. 18b-24a).

¶ As has been noted elsewhere, the figures inhabiting the scrolls are quite strongly reminiscent of Burgundian Netherlandish miniature art, particularly the work of van Lathem (*fig. 12*), which could indicate that the miniaturist of this missal was trained in that milieu.[4]

1. Paul Wescher, 'Zwei Rheinische Miniaturhandschriften in Berliner Kupferstichkabinett,' *Wallraf-Richartz-Jahrbuch* NF 1 (1930), pp. 118-22.
2. See ibid. and Anzelewsky 1958.
3. Anzelewsky 1958, pp. 33-34.
4. See pp. 16-17, note 21.

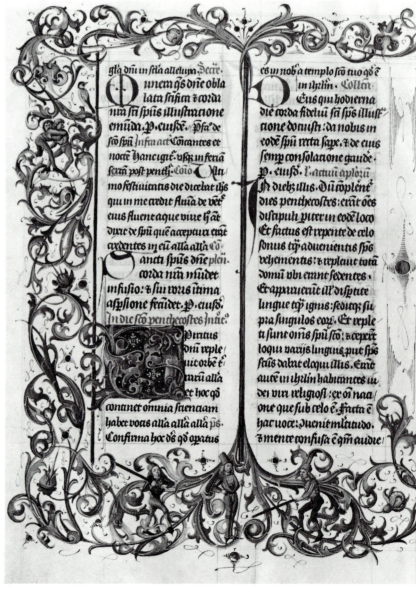

120, fol. 44b

Drawings

¶

¶ When Lehrs published his book on the prints in 1893-94, he wrote in the introduction that, apart from those in the Housebook, only one other drawing could be attributed to the Master for certain: the silverpoint drawing of the *Standing lovers* in Berlin [**121**]. A few years later, in 1899, he added to this the fragmentary design for a quatrefoil stained-glass panel with *Princess Cleodelinde* [**127**], which he had acquired shortly before for the Dresden printroom.[1] In the first decades of this century the Berlin printroom succeeded in acquiring three pen drawings [**123-25**] that exhibit a close relationship with the Master's work. All of them were published in the *Jahrbuch der königlich preussischen Kunstsammlungen*, as was the silverpoint drawing *Standing lovers seen from behind* [**122**], which came to light in Leipzig in 1913. The drawing of the *Crucifixion* in Paris [**128**] was also published at the beginning of this century. As in the case of the paintings and stained-glass panels, many other drawings were attributed to the Master in the years that followed, seldom very convincingly.[2] The most acceptable of these attributions is the small sheet with *Women peddlers fighting* in Frankfurt [**126**], which was published in 1956.

¶ The small group of drawings discussed here is linked with the Master's work in a variety of ways. Closest to the prints are the silverpoint drawings of lovers [**121, 122**], which are firmly linked to those of courtly themes both stylistically and technically. This also applies to the pen drawings *Three men in discussion* [**123**], although this is rather less detailed than the two silverpoint drawings. The drawing of *Maximilian I at a peace banquet* [**124**], which is related to this sheet in its style of drawing to a certain extent, is much sketchier in character. If the subject has been correctly identified, this probably represents an eyewitness record. The sheet with the *Women peddlers fighting* [**126**] is probably an example of the Master's earlier style of drawing. It links up both with the prints of the middle period and the drawings of the planets in the Housebook.

¶ It is more difficult to connect directly the other drawings with the prints; opinion as to their authenticity also differs more widely. Since it was not possible to study the Housebook in the original during the preparations for the exhibition, it could not be determined which of the drawings in it are by the Master's own hand. Consequently, there was no possibility of more closely studying the relationship between the drawings there and others attributed to the Master. It is hoped that the exhibition itself, in which so many of the drawings ascribed to him are brought together with the Housebook for the first time, will offer a good opportunity for testing the various attributions.

1. Lehrs 1899, pp. 180-81.
2. Storck 1909 compiled the first critical list of the drawings in which, apart from sheets discussed here [**118, 121, 127, 127**b, **128**], mention is also made of the drawing of the *Adoration of the Magi* in Coburg, which up to 1927 was generally regarded as the Master's work. Buchner 1927, pp. 284-300, attributed this drawing as part of a large group to the Master of the Coburg Roundels (see Christiane Anderson and Charles Talbot, exhib.cat. *From a mighty fortress*, Detroit 1983, pp. 108-45, 388-93). For critical comments on the many attributed drawings see Lehrs, vol. 8, pp. 41-45, Stange 1958, pp. 28-30, and the bibliography in Hutchison 1972, pp. 91-92.

124*
Berlin, Staatliche Museen
Preussischer Kulturbesitz,
Kupferstichkabinett (von
Lanna coll. (L. 2773), 1910;
inv.nr. K.K. 4442).

very lively, rather sketchy manner, with hatching, often in several layers, and contour lines strengthened with heavier brown lines. There is no lack of alterations and improvements. The way in which faces, hair and shoes are drawn is reminiscent of similar details in the dedication page of 1480 [118], suggesting that this sheet can be dated to the same period.

1. Published in 1905 by J.S(pringer), 'Eine neue Zeichnung vom Meister des Hausbuchs,' *Jahrbuch der königlich preussischen Kunstsammlungen* 26 (1905), p. 68; see further Storck 1909, p. 262, nr. 6; Winkler 1932, nr. 11; Solms-Laubach 1934-35, p. 90; Stange 1958, nr. 109; (F. Anzelewsky), exhib.cat. *Dürer en zijn tijd*, Amsterdam (Rijksmuseum), 1964-65, nr. 8.

124. Maximilian I at a peace banquet in Bruges, 16 May 1488, with on the verso Maximilian I at a peace mass

Pen and brown ink, 277 x 192 mm.

¶ It is highly likely that this sheet with sketches on both sides is an eye-witness record of an important historical event: the peace concluded between the burghers of Bruges (and other Flemish towns) and Maximilian, the then king of the Romans and later emperor, after he had been held prisoner in Bruges for several months.[1]

¶ Through Maximilian's marriage to Mary of Burgundy in 1477, Burgundy, to which Flanders

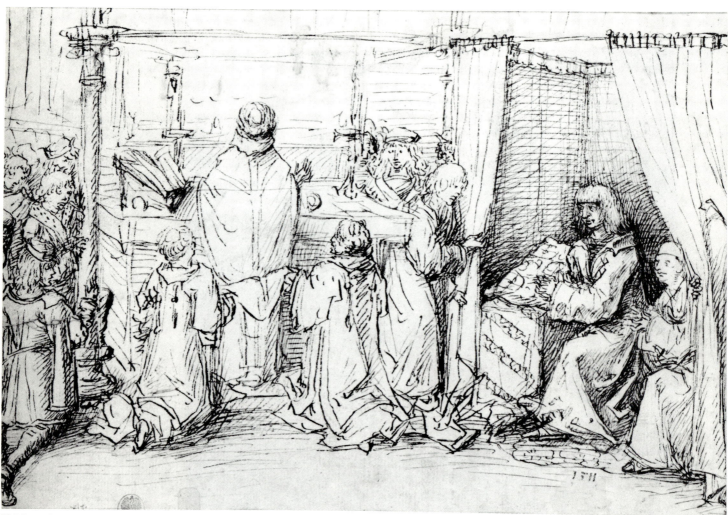

124 (verso)

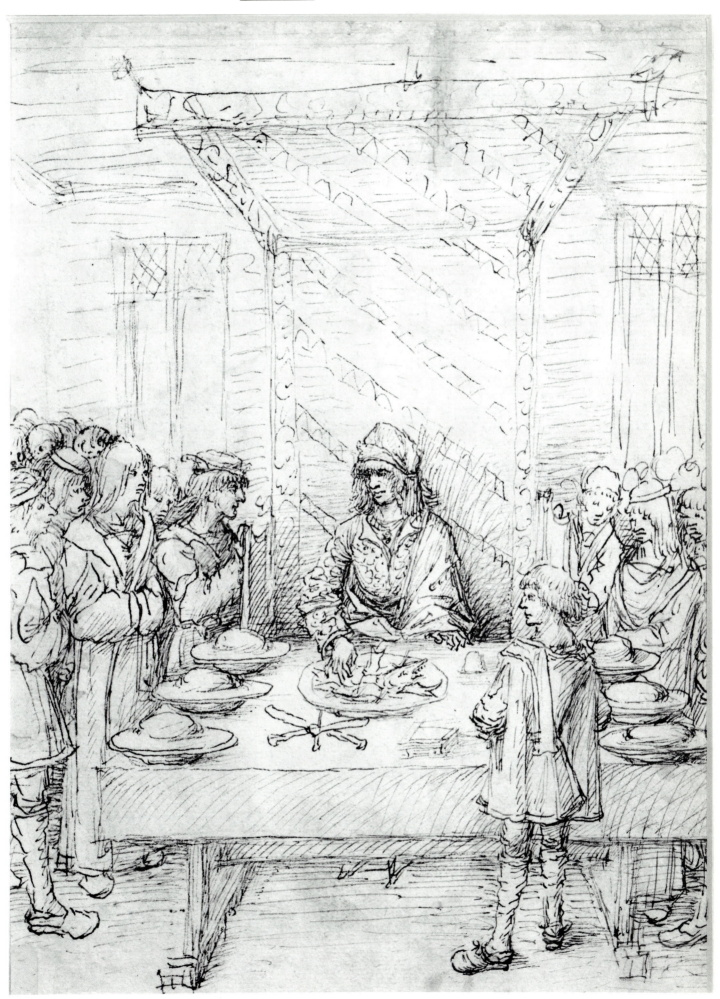

124

belonged, came under the rule of the Hapsburg Emperor Frederick III. The wealthy Flemish towns had little inclination to accept this, so on 5 February 1488, Maximilian was taken captive by the burghers of Bruges. Although the town was threatened by the approach of the army of his father, Frederick III, the burghers succeeded in wringing far-reaching concessions out of the 'pale and emaciated' prince ('fort amagry et palle') in exchange for freeing him after the public conclusion of a peace treaty (see p. 81). This ceremony took place on 16 May 1488 on the Grande Place in Bruges, where an altar was set up in the open air with the relics of the True Cross and St. Donatius placed upon it. During a solemn mass Maximilian swore, with his hand on the sacraments and relics, to meet the demands of the burghers of Bruges, promising, among other things, not to make his son Philip regent of the Netherlands, to withdraw the German occupation from the Flemish towns and to take no revenge on Bruges. Representatives of the nobles and burghers of Bruges then swore an oath of peace on the same altar. Immediately after this event a peace banquet was held for Maximilian at the house of Jan Canneel. The events of that day can be followed from the descriptions in Flemish chronicles.[2]

¶ The strong resemblance between the known portraits of Maximilian and the prince depicted on either side of this sheet, plus the circumstances in which he is shown, make it likely that these scenes record episodes in the ceremonies of 16 May 1488. The peace mass is depicted on the verso of the sheet. The area in which it is celebrated is schematically rendered, with no indication whatever of a church interior, since it took place on the Grand Place. Around the altar stand four columns, which appear to support a canopy, while the prince kneels directly beside it in a *chambre de tapisserie* and the burghers of Bruges are indicated in a very summary way behind it.

¶ At the peace banquet the prince is seated under a canopy. He is wearing on his head, so the chronicle tells us, a 'fine scarlet cap,' a cap with tied-up ear flaps and a tassel, such as we quite often see in the Master's work [see 73, 75, 123]. He alone wears shoes with long pointed toes ('poulaines'), while all the other men present wear the broadtoed footwear (*koemuilen* or clogs) current in Flan-

ders at that time. Since 16 May 1488 fell on a Friday, it can be taken that the platter of fish, probably pike, on the table in front of Maximilian was the main course. The man in front of the table with a cloth over his shoulder is probably his personal cook, while spectators and participants of the banquet are crowded together to the right and left of the table.

¶ Earlier compositions somewhat similar to these two scenes are to be found in miniatures,[3] but these do not constitute convincing arguments against Warburg's ingenious identification of them with the historical events described above. At most, such representations formed a compositional framework for these on-the-spot records. The sketchy style certainly suggests that the drawings were swiftly done in pen by a sure hand 'from life.' Not only is it difficult to compare this sketchy style of drawing with that in the prints, but also one seldom encounters such a convincing suggestion of spatial perspective there.[4] Although far less sketchy, the style of the *Three men in discussion* [123] exhibits numerous similarities, which makes it difficult to attribute these drawings to another hand. For example, one finds the same way of drawing the heads, the handling of the hair and the characteristic form of the hands, scribbled hatching and zigzag lines in all three drawings.

¶ If the attribution to the Master is correct, and it has in fact seldom seriously been doubted, then it is probable that the artist visited Bruges in 1488, perhaps in the entourage of one of the German noblemen who remained behind as hostages after the conclusion of the peace treaty. They included the count of Hanau, who might be portrayed in the *Pair of lovers* in Gotha [133].

1. The drawing was published in 1911 by A. Warburg (with a 'Vorbemerkung' by Max J. Friedländer), 'Zwei Szenen aus König Maximilians Brügger Gefangenschaft aus einem Skizzenblatt des sogenannten 'Hausbuchmeisters,'' *Jahrbuch der königlich preussischen Kunstsammlungen* 32 (1911), pp. 180-84. See further Winkler 1932, nr. 13; Stange 1958, nr. 108.
2. Warburg mentions extensive source material in his article (see note 1).
3. Solms-Laubach 1935-36, pp. 33-34, fig. 45; exhib.cat. *Dürer en zijn tijd*, op.cit. [123, note 1], nr. 7.
4. Beckscmann 1968, p. 359, attributes the drawing, like 123, to the second draftsman in the Housebook, among whose contributions are thought to be the tournament scenes. Jane Hutchison remarked in conversation that in her opinion the advanced perspective in the drawing in particular gives reason for doubting the attribution to the Master.

125. Man walking, *ca. 1490*
pen and black ink on reddish-brown tinted paper,
118 x 73 mm.

This sheet was discovered at the beginning of this century. It was pasted on the inside back cover of the binding of a French edition of the New Testament of 1558.[1] The inscription on the drawing, *David Heunzellius*, and the date 1560 probably refer to the former owner of the book and the year of its acquisition, but have nothing to do with the drawing itself.[2]

The man appears to be simply dressed in a long gown with wide sleeves, wrinkled hose and clogs (*koemuilen*), which came into fashion at the end of the 1480s and are also to be seen in the previous drawing.

¶ The drawing is done in a sharp and lively manner with pen and black ink. The double contour lines are also found in the two-sided sheet with Maximilian I [124]. Otherwise, however, the style of drawing bears little relation to that in the later prints, thereby making its attribution less certain.

1. The drawing was published in 1904 by J.S(pringer)., 'Notiz: eine Zeichnung vom Meister des Hausbuchs,' *Jahrbuch der königlich preussischen Kunstsammlungen* 25 (1904), p. 142; see further Storck 1909, nr. 5; Stange 1958, nr. 110.
2. According to Springer (see note 1), the book contained a second drawing, pasted on the inside of the front cover of the binding, with the inscription *1576 Benedictus Heincellius*. Unfortunately the present whereabouts are unknown of the book with the drawing of an escutcheon with a supporter, which was regarded by Springer as a copy of a drawing by the Master of the Housebook (information kindly supplied by Dr. H. Mielke).

125*
Berlin, Staatliche Museen Preussischer Kulturbesitz, Kupferstichkabinett (pasted into book *Il Nuovo testamento*, Lyon 1558; W. Bode, 1903; inv.nr. K.K. 4281). With inscription *David Heunzellius, 1560*; damaged and restored in various places.

125

126. Women peddlers fighting, *ca. 1475-80*

Pen and brown ink on yellowish paper, the background later heightened with white, 78 x 81 mm.

¶ Two peasant women are setting about one another in a fierce, aggressive manner. The seated younger woman has grabbed an earthenware jar out of her basket to hit with, while with her other hand she is pushing away the face of her older opponent, who has seized her by the hair. The clothes and shoes (*Bundschuhe*) are reminiscent of those of the peasant women on the escutcheons [**80, 81**]. The women are probably on their way to market to sell their wares: the sack leaning against the three-legged stool belongs to the older woman, while the younger one has a basket of earthenware with her. Whatever the precise meaning of the drawing may be, it can scarcely be denied that this unbridled explosion of fury presents a distinctly unelevating picture of the peasant class (cf. the print of the fighting peasants by Master FVB, **63**a).

¶ Reference has rightly been made to the similarities between this drawing and that of the planet Mars and his children in the Housebook [**117**, fol.

13a], in which peasant women are attacking looting soldiers in an equally ferocious manner. Despite its small size the drawing is a detailed one: fine hatching in two tones of brown ink has been done with a fine pen between thicker angular contour lines. The style of drawing is admittedly rather freer and more spontaneous than that in the drypoint prints, but the combinations of hatching are strongly reminiscent of those in the prints of the middle period [e.g. **79, 80**].

¶ The background of the drawing is covered with white bodycolor in which the lines of the drawing, even the hair, hands and the like, have been carefully left in reserve. The monogram of Martin Schongauer and the date 1460 were probably added at a later date. The sheet came out of a small album belonging to the Frankfurt collector Johann Friedrich von Uffenbach, into which were pasted mostly mediocre eighteenth-century landscape gouaches, along with a small drawing by Schongauer.[1]

1. The drawing was published in 1956 by Ernstotto Graf zu Solms-Laubach, 'Nachtrag zu Erhard Reuwich,' *Zeitschrift für Kunstwissenschaft* 10 (1956), pp. 187-92, esp. p. 192; see also Stange 1958, nr. 105.

126

127. Princess Cleodelinde, fragment of a design for a stained-glass panel, *ca. 1480-90*
Pen and black ink, 116 x 91 mm.

¶ This fragment belongs among the first drawings to be attributed to the Master and until recently that attribution has never been doubted.[1] It must be a design for a quatrefoil panel, in which four scenes were arranged within a circle around an escutcheon [see 139a]. This would have been the subject of the left lobe and it can be assumed that the right one showed St. George and the Dragon (for the story see 33-34). Princess Cleodelinde, meekly kneeling with a sheep to await her fate, is based on an engraving by Schongauer [127a]. In view of the format it is very possible that this is a fragment of an original design for a stained-glass panel.

¶ Although the emergence of this type of quatrefoil panel, on which secular subjects are usually painted [see 139], is generally linked with the Master or his circle, no examples have survived that can be attributed to him for certain.[2] This also applies to this sheet, which in itself is finely and carefully drawn with the pen, but of which neither the style of drawing nor the type of hatching are related to those in the prints and the drawings previously described.

¶ This is also the case with a double-sided design for two stained-glass roundels, also in Dresden, in both of which kings appear as supporters [127b]. This sheet has likewise long been attributed to the Master.[3] The drawing is fluently done with pen over a sketch in black chalk. It is admittedly livelier and sketchier than the fragment described above, but nonetheless too weak and careless to justify an attribution to the Master It may perhaps be a later imitation.

1. Lehrs 1899, p. 181; see further Storck 1909, nr. 2; Winkler 1932, nr. 17; Stange 1958, p. 30 as workshop; Becksmann 1968, p. 359, as by the second draftsman in the Housebook; Husband 1985, as anonymous, very close to the Frankfurt *Pair of lovers* [139].
2. See Schmitz 1913, pp. 101-16; further Husband 1985.
3. M.J. Friedländer, 'Zum Meister des Amsterdamer Kabinetts,' *Repertorium für Kunstwissenschaft* 17 (1894), pp. 270-73; Lehrs 1899, p. 190: not by the Master himself; Winkler 1932, nrs. 15-16; Stange 1958, p. 30: draftsman of *Bergwerk* in the Housebook; Becksmann 1968, p. 359, note 34.

127
Dresden, Kupferstichkabinett (Wilhelm Volck coll., Saarburg (Trier), 1898; inv.nr. C1898-24). With a Schongauer monogram added later; badly damaged along the center fold and at the top.
127a
Martin Schongauer, *St. George and the Dragon*, ca. 1470-75. Engraving, diameter 84 mm. B.51 and L.58.
127b
Design for a stained glass panel, *King as supporter with a page*, ca. 1480. With old inscriptions *1/2 S(?)* and *haulbeina*. On the verso a second design for a stained glass panel, *King as supporter with damsel*. Both: pen drawing over sketch in black chalk, on paper, diameter 144 mm. Dresden, Kupferstichkabinett (inv.nr. C.2093).

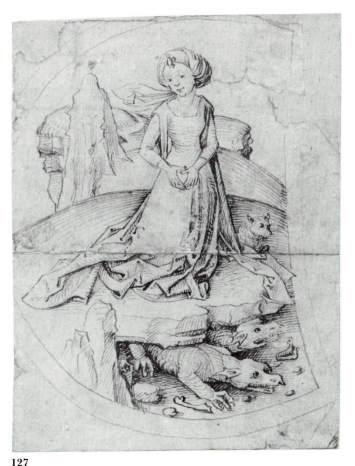

127

127a

127b

127b (verso)

131a
Freiburg im Breisgau,
Augustiner Museum (bought
in Speyer by W.B. Clarke of
Freiburg im Breisgau,
acquired by Museum in
1896; inv.nr. 11531a).

131. The so-called Speyer altar,
ca. 1480-85

131a. The Crucifixion
Panel (pine), 130.5 x 173 cm.

131b. Ecce Homo
Panel (pine), 131 x 75.6 cm.

131c. Christ before Caiaphas
Panel (pine), 131 x 75.6 cm.

131d. The Resurrection
Panel (pine), 131 x 75.6 cm.

131e. Christ washing the disciples' feet
Panel (pine), 131 x 75.6 cm.

131f. The Last Supper
Panel (pine), 131 x 75.6 cm.

¶ Of all the paintings that have been attributed to the Master, the six panels that must have formed the so-called *Speyer altar* have generally been regarded since the late nineteenth century as his main work.[1] The polyptych, of which the panels are now divided among various museums in Germany, is called the *Speyer altar* because the central panel with the *Crucifixion* [**131a**] was bought in Speyer by its nineteenth-century owner. Nothing more is known about its provenance or where it was originally. In view of their virtually identical dimensions, style and painting technique there can be no doubt that the panels originally belonged together, but it remains uncertain what the altar actually looked like.

¶ The subject of the polyptych is Christ's Passion, Death and Resurrection. The central panel with the *Crucifixion* [**131a**] has a gold sky and so do the *Ecce Homo* [**131b**] and the *Resurrection* [**131d**]; hence it is assumed that these two panels were to be seen

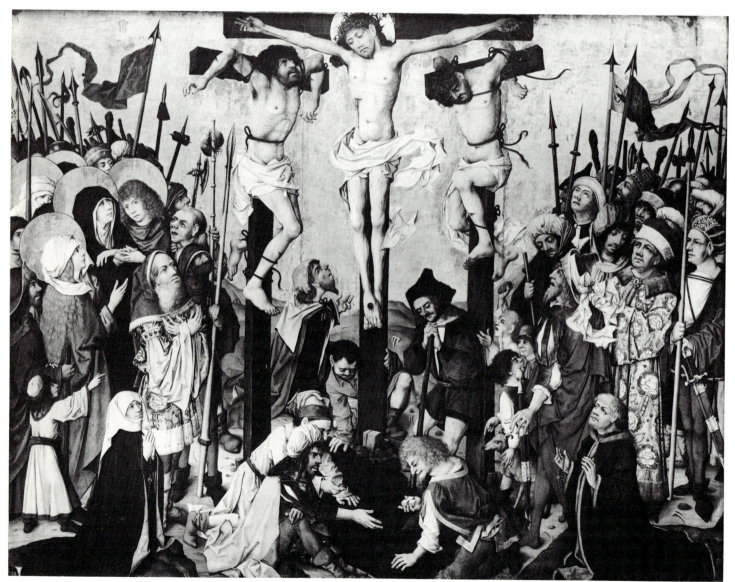

131a

on either side of the central panel when the altar-piece was open. However, since at least one of its panels must have been lost, it is not known what it looked like when closed. Probably *Christ washing the disciples' feet* [**131e**], the *Last Supper* [**131f**], *Christ before Caiaphas* [**131c**] and the lost panel with the *Agony in the Garden* or the *Bearing of the Cross* were to be seen side by side.[2]

There is no room here for a lengthy iconographical and stylistic analysis of the altar. Numerous details in the compositions evince a detailed knowledge of biblical and religious texts, indicating that the painter probably was advised by someone deeply versed in theology.[3] Stylistically and formally there is a great deal of influence from fifteenth-century Flemish painting.

The *Resurrection* [**131d**; *pl. VIII*] is a good example of this, as the composition is directly based on a panel by Dirk Bouts (or his workshop), which was already in St. Lawrence's in Cologne in 1464.[4]

The composition is broadly based on the Netherlandish model, as is the pose of Christ, who stands in front of the sarcophagus half naked, with a red mantle round his shoulders and the banner of the cross in his hand. In the varied poses of the soldiers still asleep around the tomb and the shocked reactions of those who have woken up, there is a greater realism than in the painting by Bouts. On the other hand, Christ's gold halo and the gold sky make a much more archaic impression. The most notable difference from the Flemish model, however, is that Christ has risen from a closed sarcophagus. This is evident not only from the unbroken seals, but also from the fact that one of the sleeping soldiers is resting the upper part of his body on it. This closed sarcophagus gives an added emphasis to the miracle of the Ressurection, which early Christian texts compare with the birth of Christ: the seals of the tomb are no more damaged than those of Mary's virginity.

131b and **131c**
Freiburg im Breisgau, Augustiner Museum (Hutter coll., Freiburg; Livonius coll., Frankfurt; acquired in 1905 from Suffragan Bishop Knecht in Freiburg; inv.nrs. 11531c and b).

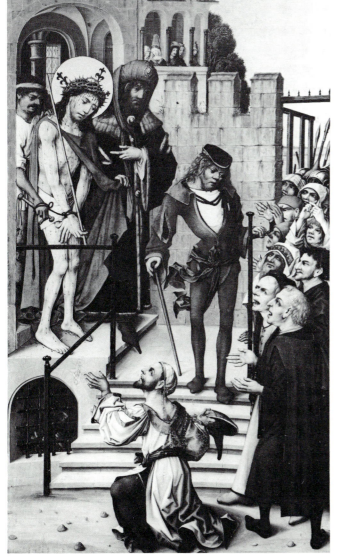

131b

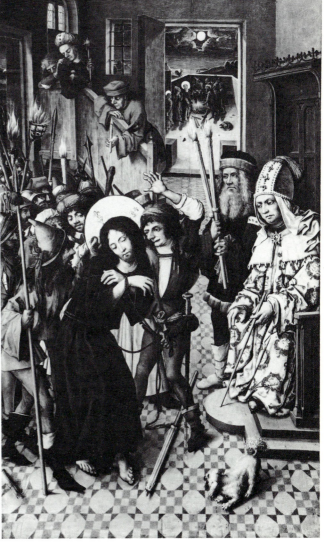

131c

131d*
Frankfurt am Main,
Städelsches Kunstinstitut
(Weyer coll., Cologne;
Sigmaringen coll.; aquired
in 1930).
131e
Berlin, Staatliche Museen
Preussischer Kulturbesitz,
Gemäldegalerie (Kaiser
Friedrich Museum, aquired
in 1930; inv.nr.2072).
131f
Berlin, Bode Museum
(Kaiser Friedrich Museum,
acquired in 1930; inv.nr.
2073).

Like the gold background, this iconographical peculiarity links the panel with German fifteenth-century art, in which the Resurrection is quite often shown with a closed tomb.[5]

¶ Spatially and compositionally the Resurrection is one of the most successful panels of the *Speyer altar,* perhaps thanks to the Netherlandish model. In other panels the spatial arrangement of closely packed figures looks decidedly old-fashioned. This is particularly the case with *Christ washing the disciples' feet* [**132e**; *pl.IX*], in which the large heads of the disciples and their massive haloes allow scarcely any room for depth. The Master seems here to be more interested in the individual characterization of the faces of those present. This can also be seen in the underdrawing and the way the panels are painted. Not only the faces, but also the garments and suchlike were drawn in an unusually detailed way with a brush in black paint on the white ground before a start was made on the actual painting (see pp. 295-302). And, although the folds of the garments, for example, are precisely indicated in the underdrawing, this

has been departed from in numerous details in the final paint layer. Starting from the underdrawing, the paint layer has been built up with care. Contours, hatching, white highlights and other details were applied with a fine brush over an underpainting done with a broader brush. All this is done in the same lively and varied manner as in the Master's drypoint prints. Only in the *Resurrection* does the paint layer seem quite smooth and flat, but this is probably partly due to the thick layer of yellow varnish. X-ray photographs of this painting reveal that the underpainting is quite broad, lively and impasted.[6]

¶ The color scheme in all the panels is lively and powerful. Alongside strong warm colors like red, green, orange and dark blue there are very cool colors, yellow, white, pale blue and purple. Much use has been made of transparent glaze-like layers of paint, through which the underdrawing can often clearly be seen with the naked eye.

¶ Differences in quality seem unavoidable in a work of this size, the proportions of the figures sometimes being awkward and the facial features

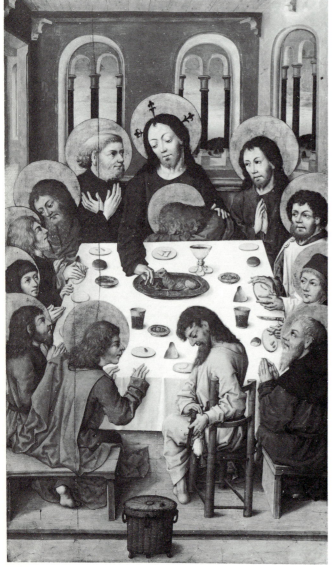

131f

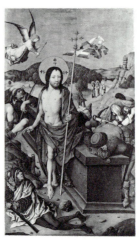

131d (in color on p. 232, *plate VIII*)

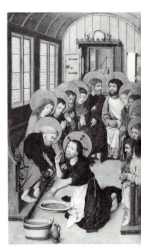

131e (in color on p. 233, *plate IX*)

coarse. Nonetheless the panels are of such an exceptionally high quality that they must all certainly be regarded as the Master's own work, although it is not impossible that a pupil or assistant also worked on the polyptych here and there. The work has often been dated in the 1470s,[7] but this cannot be right, as the stylistic similarities with the Master's drypoints relate to his mature work above all. The same type of elegantly dressed figures as those in the *Crucifixion* (often with beard and turban) are to be found in various prints (e.g. **7, 54**]. Thus the altar, which probably took several years to complete, is probably to be dated between 1480 and 1485.

Lehrs 1899, pp. 174-76, 182; Stange, vol. 7, pp. 98-101; Stange 1958, pp. 20-22; Frommberger-Weber 1974, pp. 53-59; Hutchison 1964, pp. 1-48.

For the reconstructions see Stange, vol. 7, p. 98; Frommberger-Weber 1974, p.53.

Hutchison 1964, pp. 1-48, goes into the iconographical peculiarities and possible models in detail. See also Frommberger-Weber 1974, pp. 53-56.

For the *Resurrection*, now in the Alte Pinakothek in Munich (WAF 74), see Friedländer, vol. 3, nr. 20; see Hutchison 1964, pp. 11-18.

See Hubert Schrade, *Ikonographie der christlichen Kunst. I, Die Auferstehung Christi*, Berlin and Leipzig 1932, pp. 56-59, pp. 193-200.

A. Wolters, 'Anmerkungen zu einigen Röntgenaufnahmen nach Gemälden des Städelschen Kunstinstituts,' *Städel-Jahrbuch* 7-8 (1932), pp. 228-32.

See Stange, as cited in note 1; Hutchison 1964, p. 9, points out the similarities, already noted by Lehrs (1899, p. 175), to the Master's mature prints, which make a date in the 1480s acceptable.

132. The so-called Mainz Life of the Virgin, *ca. 1490-1505*

132a. The Presentation of the Virgin

132b. The Annunciation, *1505*

132c. The Visitation

132d. The Nativity

132e. The Adoration of the Magi

132f. The Presentation in the Temple

132g. Christ among the doctors

132h. Pentecost

132i. The Death of the Virgin
All panels (fir), ca. 128 x 74 cm.

¶ The original form of this cycle of nine panels with scenes from the life of the Virgin is even more difficult to reconstruct than that of the *Speyer altar*. It is possible that the panels have been sawn apart and that they originally formed part of a polyptych (perhaps with sculpture in the center), but it is also conceivable that they may have hung side by side in a church, possibly the Lady Chapel in Mainz.[1]

132
Mainz, Mittelrheinisches Landesmuseum (probably from the Liebfraukirche, Mainz. Given to the Welschonnenkloster in 1729 by Elector Lothar Franz von Schönborn; ca. 1805 in museum; inv.nr. 429-37). 132d and 132e are in the exhibition in Amsterdam.

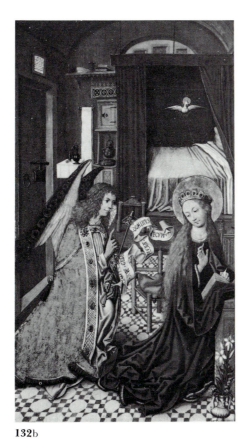

132a

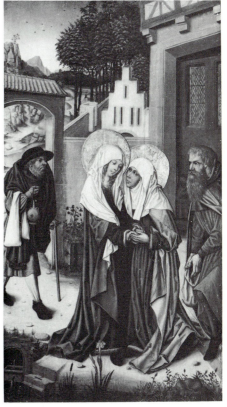

132c

132b

¶ The relationship between the cycle of nine panels and the Master's work was already noted by Friedländer in 1894, but since Lehrs shortly afterwards rejected the attribution to the Master,[2] little interest was taken in them until the fifties, when they were cleaned and restored. After the removal of the heavy overpainting Stange thought that the whole series must have been painted by the Master.[3] The close relationship between a number of drypoint prints [8, 9, 10] and various panels and the date 1505 on one of the latter gave rise to the suggestion that the cycle must be counted among his late work. Jane Hutchison rightly remarked that the panels are far from homogeneous in conception and execution, so that most of them must be attributed to one or more pupils or assistants. She suggested that it may have been commissioned by the archbishop of Mainz, Berthold von Henneberg, who died on 20 December 1504, so that the date 1505 on the panel with the *Annunciation* [132b] could be that of the completion of the whole cycle, which the bishop might have bequeathed to his parish as a memorial to himself.[4] Hutchison regards three panels as the Master's own work: the *Nativity* [132d], the *Adoration of the Magi* [132e], and *Christ among the doctors* [132g]. The first two of these form the nucleus of the series. When they are hung side by side, as was undoubtedly the intention, the two independent compositions form a single whole, since the architecture of the stable on the left panel joins up with that on the right one, the two halves forming a single two-aisled structure of which the perspective is carried through in depth. The model for this stable was that in Rogier van der Weyden's *Columba altar* [see 10b]. There are so many points in common with the drypoint of the *Adoration of the Magi* [10], which is likewise modelled on Rogier's *Columba altar*, that the paintings almost must have been done at the same time as the print. As far as the painting technique is concerned, one finds the same sort of bright and transparent use of color here as in the panels of the *Speyer altar*, although the color scheme is somewhat cooler. In the details the paint is often used in a very draftsmanlike way.

¶ Only in the figures of the scribes and the young Jesus in *Christ among the doctors* and in some of the apostles and the Virgin in the *Pentecost* panel does one find the transparent and draftsmanlike handling of paint characteristic of the Master. In the other parts of these panels and in the remaining panels the painting technique is far less subtle: the contours, often black, are heavy and the paint

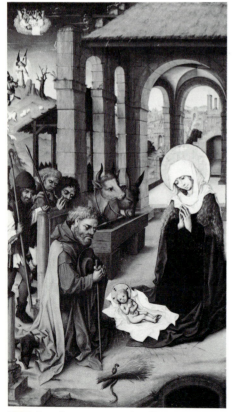

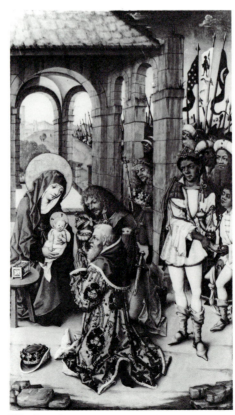

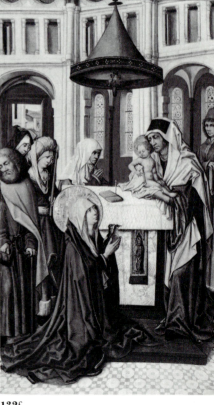

132d (in color on p. 234, *plate X*) **132**e (in color on p. 235, *plate XI*) **132**f

is thick and opaque and applied with little feeling for gradations. The proportions of the figures also differ from those in the other panels: they are elongated and the facial expressions are highly stereotyped.

¶ It is noteworthy that the underdrawing of the panels, made visible in part with the aid of infrared reflectography (see Appendix III, pp. 296-302), reveals comparable differences in characteristics between the various panels. Those by the Master show the same sure hand in the underdrawing as the panels of the *Speyer altar*: a careful, detailed drawing with modelling hatching, which gives the figures a certain volume. The remaining panels exhibit a completely different type of underdrawing: long, hesitant, unsystematic lines with little coherence. These panels also seem to be in a generally worse state of preservation: they exhibit more areas of damage, overpainting and the like than the autograph panels. This could indicate that the quality of the wooden panels was not so good, because less stringent demands were made on the joiner, but it could also mean that the painter of these panels had less technical skill, so that he did not build up his paint layers so carefully. This is an additional indication that the Master was not responsible for the execution of the whole series. It may be that the series was completed after the Master's death by a painter who was admittedly under his influence and made use of his models [**8, 9**], but who had a style and method of his own. His hand can also be recognized in other panels wrongly attributed to the Master: the *Adoration of the Shepherds* in Nürnberg (on loan to the Alte Pinakothek in Munich), the *Lamentation* at Dresden and possibly also the *Virgin and Child with St. Anne* in Oldenburg [**29a**].[5] The panels by the Master himself are probably his last paintings. Artistically they are of very high quality, but less arresting and original than the panels of the *Speyer altar*.

1. See Hutchison 1964, pp. 81-84.
2. Max J. Friedländer, 'Zum Meister des Amsterdamer Kabinetts,' *Repertorium für Kunstwissenschaft* 17 (1894), pp. 270-73; Lehrs 1899, p. 174.
3. Alfred Stange, 'Das Mainzer Marienleben im Werke des Hausbuchmeisters,' *Mainzer Zeitschrift* 48-49 (1953-54), pp. 89-92.
4. Hutchison 1976; see also Hutchison 1964, pp. 81-109 for a detailed analysis of the iconography and the models used.
5. See Stange, vol. 7, pp. 102-03, figs. 222-24; Stange 1958, pp. 22-23, nrs. 95-97.

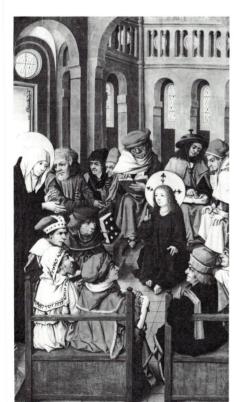

132g

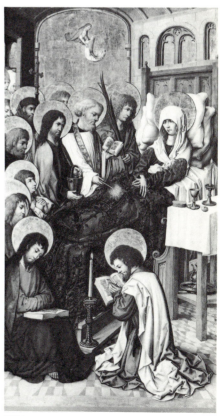

132h **132**i

134*
New York, Metropolitan
Museum, The Cloisters
(Sibyll Kummer-
Rothenhäusler coll., Zürich;
inv.nr. 1982, 42.1). The blue
glass is modern.

134. Virgin and Child on the crescent moon,
ca. 1485-90
*Stained-glass panel in black and silver yellow with lead,
30 x 21 cm.*

¶ This fine, carefully painted glass panel reflects the style and quality of the Master's prints better than any of the other stained glass attributed to him.[1] It has numerous points in common with the prints and drawing in the Housebook,[2] but the closest relationship is that with the drypoint engravings *Virgin and Child on the crescent moon with a book and a starry crown* [25] and *Standing Virgin and Child with an apple* [26]. The Child, the Virgin's features and hair and the deep angular folds of the drapery are very similar, but the Madonna and Child in the glass panel differ from those in the prints in having wide open instead of downcast eyes.

¶ The technique is extremely subtle. Careful modelling has been done with the brush in gradations which range from brownish gray to dense black. The shadows in the mantle are composed of various layers of parallel hatching, in which both a broad and a narrow brush have been used, while the hatching in the faces and the body of the Christ Child is drawn with a fine brush within heavier contour lines. In this brush drawing a further drawing has been etched in the glass with a very fine stylus. This can be seen particularly clearly in the Virgin's hair and crown.

¶ So subtle an application of this combination of techniques indicates that the artist was a prac-

ticed engraver. He must have been a practiced glass painter too, for he could only have seen the results of his work, in which the shadows are built up in various stages from light to dark, after the drawing had been fixed on the glass by firing in a kiln.[3] The dilemma in attributing the panel can be summed up as follows: did the Master make it himself or did a highly experienced glass painter translate a design by him into the glass painting technique entirely in his spirit?[4] Be this as it may, the panel is so close to the Master's mature work that the question of who made it is perhaps of minor relevance.

1. This stained-glass panel, which made its appearance in Paris in the fifties, was published by Hans Wentzel, 'Schwäbische Glasmalereien aus dem Umkreis des 'Hausbuchmeisters,'' *Pantheon* 24 (1966), pp. 360-71, esp. p. 366, who, despite the parallels with the work of Peter Hemmel (Strasbourg), placed it in the Master's circle. Becksmann 1968, pp. 359-60, attributed it to the same hand as the *Tournament* [135] published by him, namely that of the second draftsman of the Housebook, whose drawings there include some of tournaments; he dates both panels between 1470 and 1480. Husband 1985 attributes the panel to the maker of the drypoint prints in a detailed and well-documented article and dates it between 1480 and 1490.
2. See Husband 1985.
3. For the technique of glass painting see Jane Hayward, 'Painted windows,' *The Metropolitan Museum of Art Bulletin* 30 (1971-72), pp. 98-108.
4. See Husband 1985. The present writer is grateful to T. Husband and R. Becksmann for the way in which they have given him an insight into this complex material. Becksmann pointed out to me that a late date for the panel is unlikely in view of the development of middle Rhine glass painting, which started to exhibit all the characteristics of mass production in the 1480s, both technically and artistically. Thus he advocates a date in the 1470s for this and the following number.

134 (in color on p. 237, *plate XIII*)

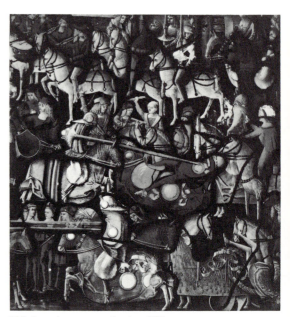

135 (in color on p. 238, *plate XIV*)

135. A patricians' tournament, *ca. 1480*

Stained-glass panel in silver yellow, iron red, lead black and brown, with applied green, blue, violet and red flashed glass and lead, fragment, 47 x 45 cm.

The most surprising recent discovery in the field of fifteenth-century German glass painting is this, admittedly fragmentary, depiction of a patricians' tournament.[1] Parts of the scene are probably missing from the top as well as from both sides, the original height and width being put at around 55 to 60 cm. Yet enough of the scene is preserved to enable us to form a good idea of the nature and course of the tournament.

A type of joust or tilt is shown in which the combatants charge each other on horseback with the aim of unseating each other by a blow of the lance on the opponent's shield without the lance splintering in the process.[2] The progress of such a tournament is rendered on the glass panel, starting at top left with five young musicians at the head of a procession heralding on their trumpets and drums the arrival of two participants, who are still just visible on the right. They are fully armored and mounted on horses draped and blindfolded by colorful caparisons. In the center we see the decisive moment of the combat: the horseman on the left on the yellow-caparisoned horse has struck his opponent such a blow that he has fallen over backwards. At the bottom a fight is going on between a horseman with a pair of spectacles as his device and an opponent who can no longer be seen. To the right we can see a rider who has just been knocked off his horse. The device on his caparison and shield consists of gold rays and drops. Between the horsemen are assistants, mostly clad in red, while the men in the center with rods in their hands are probably arbitrators.

The absence of aristocratic arms and devices among the colorful tournament attire and fanciful devices lead to the deduction that a patricians' tournament is represented. The tournament proper was reserved for the orders of chivalry even in the late fifteenth century, but this kind of jousting could also be organized by wealthy burghers. It was precisely in rich towns like Frankfurt am Main, where this panel comes

from, that patrician societies put on tournaments of this kind. From a description by Bernhard von Rohrbach [see 111] it emerges that on 4 January 1471 the Alten-Limpurg society, of which he himself was a member, held such a tournament in front of the town hall, in which three pairs of combatants entered the lists against each other. Since blunt lances were used in that instance, it must have been a different tournament from the one shown in this stained-glass panel, but the suggestion that a similar window was made for the Alten-Limpurg patrician society's house on the Römerberg sounds very plausible.[3]

¶ Technically and artistically the window is quite an exceptional piece of work; thirty individuals and twenty horses are depicted within a relatively small area, without much space being left around the figures, so that the color serves to clarify the composition to a significant extent. A great variety of glass painting techniques have been used in making the panel: applied green, blue, violet and red flashed glass, a fine grisaille tone in black, a modelling brush drawing in brown, silver-yellow stain and, finally, detailing etched with a fine stylus in the glass, the drawing and the areas of color. As in the case of the previous panel, one would think of an engraver or painter with a training in glass painting techniques rather than a specialized glass painter.[4]

¶ The great similarity between the stained-glass panel and the two drawings of tournaments in the Housebook (fols. 19b-21a; *pl. II*) has rightly been pointed out and it thus seems acceptable that they were both done by the same artist. Becksmann, who discovered this panel, is of the opinion, rightly in our view, that this artist is not the same person as the Master of the Amsterdam drypoint engravings.[5] What has not been noted before is the relationship between the facial types on the panel and those on the *Arms of the Rohrbach and Holzhausen Families* [111] by the Master b x g (see p. 221).

135*
Private collection, Germany (possibly from Frankfurt, Haus der Patrizier-Gesellschaft Alten-Limpurg am Römerberg).

1. The stained-glass panel was discovered and published by Becksmann in an exhaustively documented article in 1968.
2. Becksmann 1968, p. 355.
3. Ibid., pp. 355, 363, notes 13-17.
4. Ibid., p. 357.
5. Ibid., pp. 357-61. He identifies the Master with Nikolaus Nievergalt (see p. 54). See also Husband 1985.

136. St. Martin on horseback with two beggars, *ca. 1485*

Stained-glass roundel in silver yellow, lead brown and black and red damask with lead, fragment, diameter 36.5 cm.

¶ The four roundels reproduced here,[1] of which only the *St. Martin* is exhibited, are probably the best documented German stained-glass panels of the late fifteenth century. From the building accounts of the Mainzer Amtskellerei in Amorbach in the Odenwald we know that 'Meister Erhart der Moler... der Glaser von Meintz' arrived in Amorbach with his servant Wilhelm on 21 December 1486 with a number of stained-glass panels that he had made. In the ten days that followed he installed them in the 'Herrenkamer' of the Amtskellerei.[2] Both the arms of the archbishop of Mainz, Berthold von Henneberg (d. 1504) [136b],[3] and the representation of St. Martin, the patron saint of the archbishopric of Mainz, to which Amorbach belonged, make it extremely likely that these are the panels which Master Erhard, in the service of Archbishop Berthold, installed in the Mainzer Amtskellerei at Amorbach, where they are still displayed in the present Heimatmuseum.

¶ There can scarcely be any doubt that the said

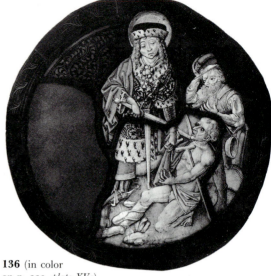

136 (in color
on p. 239, *plate XVa*)

Master Erhard is the Erhard Reuwich who at that time had just finished printing Breydenbach's *Peregrinationes in Terram Sanctam* [142]. This makes the roundels, which admittedly differ from each other somewhat in style, key pieces in the discussion of the possible identification of Reuwich with the Master.[4]

¶ The now incomplete *St. Martin* roundel in particular offers a good comparison with the drypoint

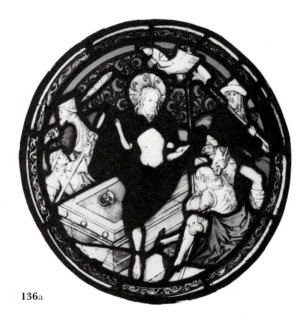

136a

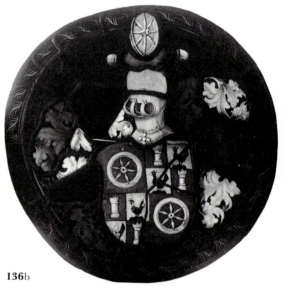

136b

print in which the saint appears on horse-back [38]. St. Martin and the crippled beggar certainly exhibits similarities with the figures in the drypoint. It is more difficult to link the style of the roundel with the Master's prints, although it is in itself quite carefully drawn and engraved. The proportions of the figures are distorted and the angular line is not very supple. By contrast to the two previous stained-glass panels, it is hard to see these roundels as the work of a great artist. In our view they rather suggest a craftsman who, with the aid of various models, executed his work in a skillful, but not very arresting way.

1. The stained-glass roundels were published by Karl Simon, 'Mittelrheinische Scheiben in Amorbach,' *Cicerone* 17, pp. 137-43, who points out the relationship with the Master, but feels that they are more likely to hail from his circle.

2. Walter Hotz, 'Der 'Hausbuchmeister,' Nikolaus Nievergalt und sein Kreis,' *Der Wormsgau* 3 (1953), pp. 113, 125 and note 103.

3. For a similar stained-glass roundel with the same arms see S. Beeh-Lustenberger, *Glasmalerei um 800-1900 im Hessischen Landesmuseum in Darmstadt*, Frankfurt 1967, nr. 242.

4. To Hotz (see note 2) the roundels could not be identified with Reuwich, but Ernstotto Graf zu Solms-Laubach, 'Nachtrag zu Erhard Reuwich,' *Zeitschrift für Kunstwissenschaft* 10 (1956), pp. 187-92, was of the opinion that the stylistic similarities between them and the prints proved the correctness of his identification. See also Filedt Kok 1983, p. 436, note 33 and Husband 1985.

137. St. Martin on horseback and the beggar, *ca. 1485*

Stained-glass roundel in lead black and silver yellow with blue foliate scroll damask and green glass and lead, diameter 39 cm.

¶ This stained-glass roundel[1] follows the drypoint print of *St. Martin* [38] fairly faithfully, as the horse, the pose and dress of the saint and even the stones on the ground all indicate. Just as in the *St. Martin* at Amorbach [136] the proportions are rather distorted and the faces in particular have lost much of their expressiveness. The brush drawing is rather heavy and there is quite a lot of etching.

¶ The bringing together of this roundel with the *St. Martin* from Amorbach in the exhibition will in all probability make it clear whether the two are related or even possibly by the same hand. Despite its difference in quality from the print, this roundel is attractive in its direct simplicity and illustrates how the work of the Master was popularized.

1. Ernst Schneider, Ingrid Jenderko-Sichelschmidt (ed.), *Stiftsmuseum Stadt Aschaffenburg* 1981, p. 27, as circle of the Master of the Housebook, ca. 1500. See also Husband 1985.

137*
Aschaffenburg, Stiftsmuseum der Stadt Aschaffenburg (inv.nr. 6751).

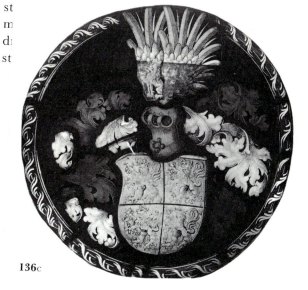

136c

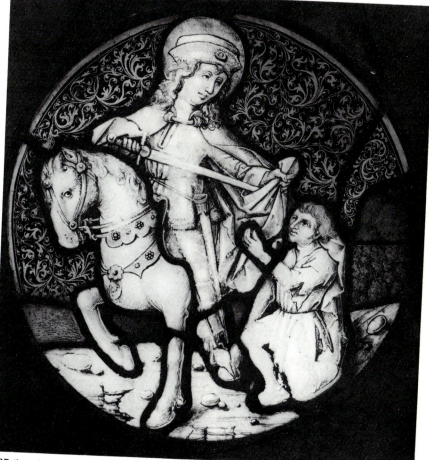

137 (in color on p. 239, *plate XVb*)

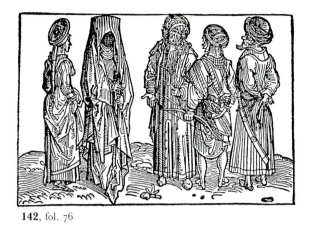

142, fol. 76

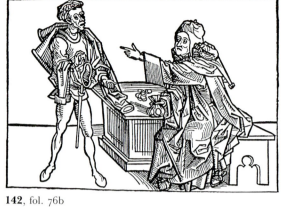

142, fol. 76b

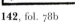

142, fol. 78b

142, fol. 80b

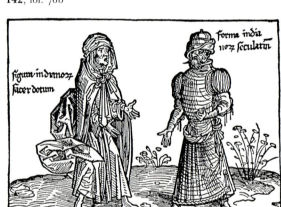

142, fol. 84b

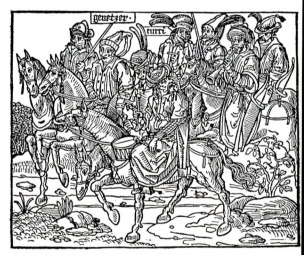

142, fol. 76

142, fol. 147b

1. Fuchs 1958, pp. 1163-69.
2. Ibid., p. 1168.
3. Ibid., pp. 1176-77.
4. Ibid., pp. 1160-61; Hugh W.M. Davies, *Bernhard von Breydenbach and his journey to the Holy Land, 1483-1484: a bibliography*, London 1911 (reprint Utrecht 1983).
5. A modern edition of the book with the woodcuts was published in 1961, Bernhard von Breydenbach, *Die Reise ins Heiligland*, Übertragung und Nachwort von Elisabeth Geek, Wiesbaden 1961. All the woodcuts are illustrated in Schramm, vol. 15. They are discussed in detail in Fuchs 1958, pp. 1179-89.
6. The links between the woodcuts in the book and the Master's work are discussed in detail by Solms-Laubach 1935-36, pp. 70-95, and Fuchs 1958, pp. 1192-99.

APPENDIX I: WATERMARKS IN THE PRINTS OF THE MASTER OF THE AMSTERDAM CABINET

M.D. Haga

Watermarks or parts of watermarks are to be found in the paper of seventeen of the 122 impressions of drypoint prints by the Master, but it was only possible to study the eight impressions in Amsterdam in the original. X-ray photographs have been made of these[1] and the distance between the chain lines measured.[2] A photograph taken in raking light was available of a ninth mark [**73**.3], so that with two of the four other watermarks, which are illustrated in Lehrs, vol. 8,[3] eleven marks in all are reproduced here. The remaining four are known only from short descriptions in Lehrs, vol. 8, [**7**.3; **26**.2; **63**.2; **74**.4] and since the impressions in question are laid down on their mounts, no further study of them was possible.

After the description of each watermark reference is made to the literature in which an identical or comparable watermark is discussed and illustrated. Four of the thirteen marks illustrated here are either of too unusual a form [**49**] or too fragmentary [**13**.2, **17**, **29**.2] to allow of identification. Hence of the seventeen watermarks now known in prints by the Master no more than nine can be more closely determined.

BIBLIOGRAPHY WITH ABBREVIATIONS

Briquet C.M. Briquet, *Les filigranes*, 4 vols., jubilee edition, Amsterdam 1968 (first ed. Geneva 1907).

Heitz Paul Heitz, *Les filigranes des papiers contenus dans les incunables Strasbourgeois de la Bibliothèque Impériale de Strasbourg* (pp. 1-34; nrs. 1-1330).

Lehrs, vol. 8 See list of frequently cited literature (pp. 9-10).

Piccard Gerhard Piccard, *Die Wasserzeichenkartei Piccard im Hauptstaatsarchiv Stuttgart*, Stuttgart 1961.

Piccard, vol. 2 *Findbuch*, vol. 2, 1-3, *Die Ochsenkopfwasserzeichen*, Stuttgart 1966.

Piccard, vol. 4 *Findbuch*, vol. 4, 1-3, *Wasserzeichen Buchstabe P*, Stuttgart 1977.

Schramm, vol. 19 Albert Schramm, *Der Bilderschmuck der Frühdrucke*, 23 vols., vol. 19, *Die Strassburger Drucker*, part 1, Leipzig 1936.

Schramm, vol. 20 Idem, vol. 20, *Die Strassburger Drucker*, part 2, Leipzig 1937.

Sotheby Samuel Leigh Sotheby, *Principia typographica: The blockbooks, issued in Holland, Flanders and Germany, during the fifteenth century*, vol. 3, *Paper-marks*, London 1858.

Fig. 61
X-ray photograph of water-
mark, *Visitation* [**9**.1]; small
oxhead with horns with
single curve, bar and star.

Fig. 62
X-ray photograph of
watermark, *Adoration of the
Magi* [**10**]: Paschal Lamb.

Fig. 63
X-ray photograph of bottom
of watermark. *Christ as the
Good Shepherd* [**17**]: fragment
of Gothic P.

Fig. 61

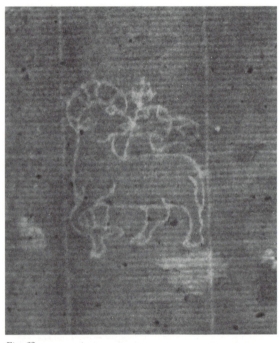

Fig. 62

Fig. 63

LIST OF WATERMARKS

7.2
Solomon's idolatry – Vienna
Small ox-head with horns with single curve, bar and star
Distance between chain lines 35 mm.
Mentioned, but not illustrated in Lehrs, vol. 8, p. 86.

9.1
The Visitation – Amsterdam
Small ox-head with horns with single curve, bar and star
Distance between chain lines 35 mm.

Comparable with:
Heitz, nr. 553 (pl. 22, pp. 20, 27): to be found in Aeneas Syl-
vius, *Eurialus und Lucretia*, an edition of 1477 printed by Hein-
rich Knoblochtzer (University Library, Freiburg im Breis-
gau); Schramm, vol. 19, p. 14, merely mentions eight undated
examples, including one in Freiburg (?).
Heitz, nr. 600 (pl. 24, pp. 20, 32): found in Nicolaus (Fal-
cutius), *Antidotarium*, n.d., an edition printed by Johann Prüss;
Schramm, pp. 25-26, mentions publications by this printer
dated between 1483 and 1499.

10
The Adoration of the Magi – Amsterdam
Paschal Lamb
Distance between chain lines 40 mm.
Not mentioned in Lehrs.

Comparable with:
Briquet 26: South Netherlands and Maas-Rhine area, 1467
and later. Sotheby, p. 57, nr. 5, in accounts entitled 'Borsselen
diversa, Cas. L.,' The Hague 1470.

13.2
The bearing of the Cross – Chicago
Fragment of top part of Gothic P with flower
Illustrated in Lehrs, vol. 8, p. 423, nr. 27.
Too small to determine.

17
Christ as the Good Shepherd – Amsterdam
Fragment of the bottom of Gothic P
Distance between chain lines 36 mm.
Too small to determine.

26.2
The Virgin and Child with an apple – Basel
Gothic P without flower
Mentioned, but not illustrated, in Lehrs, vol. 8, p. 103.

29.2
Holy Family in a vaulted hall – Hamburg
Fragment of bottom of Gothic P
Illustrated in Lehrs, vol. 8, p. 423, nr. 28.
Too small to determine.

42
St. Sebastian with archers – Amsterdam
Gothic P with flower
Distance between chain lines 44 mm.
Not mentioned in Lehrs.
Cf. Piccard, vol. 2, part 2, section III, nr. 287: Lobith 1476.

49
The elevation of St. Mary Magdalene – Amsterdam
Gothic P with flower
Height 72 mm. Distance between chain lines 41 mm.
Mentioned by Lehrs as indistinct.
Too unusual to determine.

53.2
Combat of two wild men on horseback – Hamburg
Small ox-head with bar and star
Illustrated in Lehrs, vol. 8, p. 417, nr. 14.
Cf. Piccard, vol. 2, part 2, section VII, nr. 244:
Heidelberg-Strasbourg 1486-88.

54.1
Aristotle and Phyllis – Amsterdam
Small ox-head with horns with double curve, forehead ring, bar and star
Distance between chain lines 37 mm.

Comparable with:
Heitz, nr. 606 (pl. 24, pp. 20, 27): found in Aeneas Sylvius, *Eurialus und Lucretia*, an edition of 1477 printed by Heinrich Knoblochtzer (University Library, Freiburg im Breisgau); Schramm, vol. 19, p. 14, merely mentions eight undated copies, including one in Freiburg (?).
Nicolaus (Falcutius), *Antidotarium*, n.d., an edition printed by Johann Prüss; Schramm, vol. 20, pp. 25-26, mentions publications by this printer dated between 1483 and 1499.
Virtually identical with **67**, **89**.1 and **89**.2.

63.2
Two peasants wrestling – Washington
Fragment of ox-head with bar and star
Mentioned, but not illustrated, in Lehrs, vol. 8, p. 141.

67
Stag hunt – Amsterdam
Small ox-head with horns with double curve, forehead ring, bar and star
Distance between chain lines 37 mm.
Virtually identical with **54**.1 (q.v. for further details) and **89**.1 and 2.

73.3
Card players – Munich
Small ox-head with horns with single curve, bar and star

Comparable with:
Heitz, nr. 553 – Strasbourg 1477.
Heitz, nr. 600 – Strasbourg 1483-99.
Virtually identical with **9**.1 (q.v. for complete details).

74.4
Turkish rider – Vienna
Small heart without cross
Mentioned, but not illustrated, in Lehrs, vol. 8, p. 152.
Possibly like Briquet 4192 (1467, Decize, near Nevers) or Briquet 4195 (1494, Metz, Var. sim.).

89.1
Coat of arms with peasant standing on his head – Amsterdam
Small ox-head with horns with double curve, forehead-ring, bar and star
Distance between chain lines 37 mm.
Not mentioned in Lehrs.
Although the nostrils are separate, virtually identical with **54**.1 (q.v. for further details), **67**, **89**.2.

89.2
Heraldic shield with peasant standing on his head – Coburg
Small ox-head with horns with double curve, forehead-ring, bar and star
Illustrated in Lehrs, p. 417, nr. 13.
Virtually identical with **54**.1 (q.v. for further details), **67**, and **89**.1.

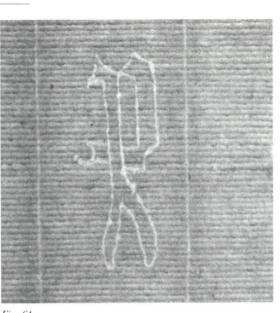

Fig. 64

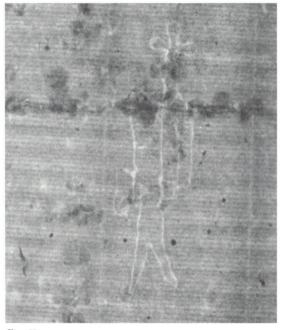

Fig. 65

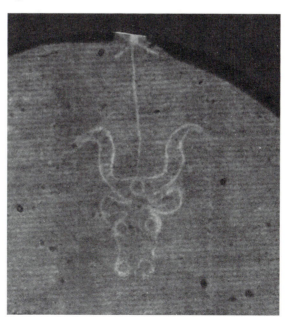

Fig. 67

Fig. 64
X-ray photograph of watermark, *St. Sebastian with archers* [**42**]: Gothic P without flower.

Fig. 65
X-ray photograph of watermark, *Elevation of St. Mary Magdalene with five angels* [**49**]: Gothic P with flower.

Fig. 66
Drawing of watermark, *Combat of two wild men on horseback* [**53**.2]: ox-head with bar and star.

Fig. 67
X-ray photograph of watermark, *Aristotle and Phyllis* [**54**.1]: small ox-head with horns with double curve, forehead ring, bar and star.

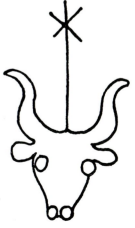

Fig. 66

Fig. 68
X-ray photograph of watermark, *Stag hunt* [**67**]: small ox-head with horns with double curve, forehead ring, bar and star.

Fig. 69
Photograph by raking light of watermark, *Card players* [**73**.3]: small ox-head with horns with single curve, bar and star.

Fig. 70
X-ray photograph of watermark, *Coat of arms with a peasant standing on his head* [**89**.1]: small ox-head with horns with double curve, bar and star.

Fig. 71
Drawing of watermark, *Coat of arms with a peasant standing on his head* [**89**.2].

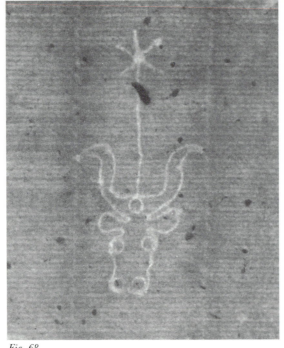

Fig. 68

Fig. 69

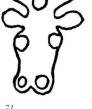

Fig. 71

Fig. 70

CONCLUSIONS

¶ Seven of the nine identifiable watermarks are in the form of an ox-head and can be divided into three types, all of which are known from Strasbourg. Two of the types (**54**.1, **67**, **89**.1 and **89**.2, and **9**.1 and **73**.3 respectively) both occur in two different incunabula, of which the first was printed by Heinrich Knoblochtzer in 1477 and the second by Johann Prüss between 1483 and 1499. The third type of ox-head [**53**.2] occurs in Strasbourg between 1480 and 1490. It strikes one in this regard that all the prints by the Master with an ox-head watermark are dated by stylistic analysis between 1480 and 1490. The other watermarks consist of a Paschal Lamb (**10**: usually dated between 1490 and 1500), comparable with examples used in 1467 and later in the southern Netherlands and the Maas-Rhine area and in 1470 in The Hague; and finally a Gothic P without flower (**42**: ca. 1475-80), used in 1476 in Lobith.

¶ Of the eight marks that cannot be more precisely identified, two are ox-heads [**7**.2 and **63**.2], which may belong to the Strasbourg group; two Gothic P's, the first without a flower; three fragments of Gothic P's [**13**.2, **17**, **29**.2]; and finally a small heart [**74**.4], of which Briquet may give two comparable examples, one of 1467 from the Nevers area and one of 1494 from Metz.

¶ Although there is scarcely any chronology to speak of, the Paschal Lamb and the Gothic P, both from the Maas-Rhine area, seem slightly earlier than the seven ox-heads from Strasbourg.

¶ Although seventeen marks out of 122 impressions (not quite fourteen percent) does not seem much and Lehrs does not mention three of the eight Amsterdam examples (ten percent of the eighty impressions there), it seems unlikely that many more will be discovered; the percentage in the remaining 44 prints is over twenty percent, twice as high as in the Amsterdam group, which is almost twice as big. The prints, of which the majority are small in size, are more likely to have been printed (perhaps deliberately) on the edge rather than in the center of a sheet of paper.

¶ It is still to be hoped that increasing knowledge of fifteenth-century paper will make it possible to arrive at a more precise dating of unwatermarked paper in the future on the basis of the distance between chain lines and laid lines.

1. Made by the Röntgen Technische Dienst in Rotterdam with the aid of reflection radiation (Compton effect).
2. E.G. Loeber of Hilversum gave valuable advice and encouragement on the making of the X-ray photographs.
3. A fifth mark from the impression in Dresden (**13**a, The bearing of the Cross) is illustrated (Lehrs, vol. 8, p. 419, nr. 17): *Large ox-head with horns with double curve, bar and double cross*, which is related to Piccard, vol. 2, part 3, section XI, nr. 256 (Crailsheim-Ulm, 1506-09).

APPENDIX II: **N**OTES

ON COSTUME

M.J.H. Madou

The grace with which the 'gilded youth' of the late fifteenth century is depicted by the Master automatically draws attention to the costumes of these young people. At first glance one notes mainly ribbons and fringes, shoes with excessively long points, an abundance of curls, folds and puckers, but a closer analysis reveals that although the costumes may appear bizarre initially, they are actually relatively clearly structured.

Before proceeding to more general considerations, we may conveniently begin by describing the men's and women's costumes.

The men wear very tightly fitting hose fastened in front by a triangular insertion meant to ensure freedom of movement, which at the same time accentuates the genitals.[1] They are shod in leather shoes with the tops turned over round the ankles and with exaggeratedly long pointed toes (poulaines).[2] Sometimes wooden pattens with even longer points are worn under the shoes [**58, 123**].[3]

The upper part of the body is clad in two or three garments. One of these is invariably a fine, very wide linen shirt, which in some cases has an edging of passementerie round the neck. The fullness of the shirt is gathered at the neck, while the sleeves, which are also much too wide and come to just below the elbow, can be seen through the slashed sleeves of the doublet [*fig. 75*; **56, 133**]. The latter is made of a minimum of material. It is only waist length and has a very wide and deep V-neck in front. There is no collar and the fronts are linked from shoulder to shoulder by a set of six laces or narrow ribbons, which run parallel to the neckline of the shirt and are held on either side by an oblong (precious) metal plate [**133**]. Some of the representations show the fronts of the doublet kept together by more laces over the chest [*fig. 75*; **56, 58**]. The sleeves are so reduced that the shirt-sleeves are left largely uncovered on the outside of the arm and here again crossways laces serve to join the edges of the wide split. Finally, it may be pointed out that the sleeves have vertical slashes on the upper arm [*fig. 75*; **58, 75**] and that, like the shirt-sleeves, they only come just below the elbow, leaving the whole of the forearm bare. Such a doublet, with the shirt billowing out, makes rather an untidy impression and this is further increased by the little cape of very simple cut, a rectangular piece of material with a shallow neck opening. It is draped over

one shoulder and fastened on the other by a plaited cord or lace, so that it hangs open at the side. It scarcely reaches the hips, so that it can be said to adorn rather than protect [*fig. 75*; **58, 72, 75, 122**].

Instead of a doublet and cape, some men wear a short coat or jerkin as their upper garment. This has a wide V-neck down to the loins in front, is completely open and has a short skirt over the hips. The skirt is often split and the flaps are crossed over each other to close the jerkin in front [*fig. 73*; **71, 72**]. At the back the fullness is arranged in what are known are organ-pipe pleats [**72**], while a narrow girdle accentuates the figure. The jerkin has no collar and the wide neck opening is kept together by means of a cord knotted on one shoulder [*fig. 72*; **121**]. The sleeves are slightly puffed at the top to widen the shoulder line, an effect that is further accentuated by the slashes through which the shirt can be seen [*fig. 72*; **121**]. Otherwise the sleeves are loose and slightly too long, so that they fall down to just over the hand in supple folds. Occasionally one sees a purse worn on the girdle as an accessory [*fig. 72*; **121**], but more often a dagger, which is sometimes fastened to a separate belt [**58, 70**] and always hangs down over the middle of the stomach.

The hair falls in long curled locks over the shoulder, with short curls over the forehead [**58, 75**]. The heads of some of the men are encircled by a metal band [**73, 75, 118**] or a wreath of green leaves [**70, 122**]. The caps, with tied-up ear flaps, taper to a point at the top, which is worked into a large tassel. This is made of the material of the cap itself cut into very thin strips, which are again bound up with laces. In an exceptional case the tassel is held together by a finely ornamented gold band [**133**]. In addition to the fringed cap, there also appears as a man's head covering a small hat with a domed crown and no brim, which is presumably made of fur. It is decorated with a wide draped ribbon or large ostrich feathers [*fig. 72*; **71, 121**] or sometimes with a single small feather [**70**] or a tuft of heron feathers held by a jewel [*fig. 72*; **121**].

The women wear an overgown with a fitted bodice, which has a low round neck at both front and back (*figs. 72, 73*). The fullness of the skirt is caught in by a series of short vertical pleats, which are presumably sewn in place at center front – under the bust – and back. The skirt flares out below the waist and falls supply to the

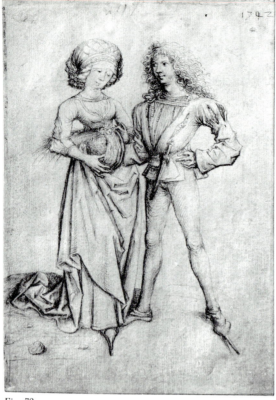

Fig. 72

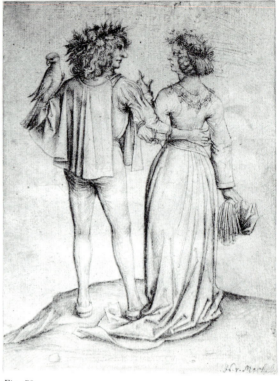

Fig. 73

ground. One gets the impression that two skirts are worn over each other: one which reaches the feet and one with a long train at the back (*figs. 72, 73*). The sleeves are relatively narrow over the upper arm, but widen out at the elbow and are so long as partly to cover the hand, creating the same effect of folds as in the men's jerkins. The women's gowns are collarless too and the wide necks are kept in place by six laces held on either side by a metal plate [**133**]. The décolleté is generally filled in by an ample shift, which can be decorated with gold thread and passementerie. In some of the female figures the shift appears to have as low a neck as the overgown, so that the bosom is visible [*fig. 74*; **55, 75**]. This deep décolleté can have three double rows of laces crossing the bust horizontally and attached to the neck opening. [*figs. 74*; **75**]. A highly unconventional feature for medieval women's costume are the sleeves, which leave the forearms uncovered and show the same style as those of the men's doublets, except that they are not slashed at the top (*fig. 72, 74*). These two types of sleeve on the women's gowns are all the more striking in that they are not, as in the case of the men, combined with different upper garments.

¶ The women's hair is always done up in thick plaits, which border the cheeks and cover the ears. At the back of the head the plaits are carried horizontally over the neck and decorated with a colorful fringe known in German as a *Gefrens*, which is secured by ribbons plaited into the coiffure [*fig. 73*; **72, 122**].[4] The thickness of the plaits suggests that copious use was made of false hair, something that is, indeed, denounced in contemporary texts.[5]

¶ As a head covering the woman wear a round cap composed of six or eight layers of linen on top of one another. This cap, which enlarges the forehead, is knotted at the neck behind [**106**]. As far as can be made

out, this was done by means of a separate narrow scarf, of which the end sometimes hangs down beside the face [**121, 133**]. An exceptional headdress is the kerchief decorated with a network of gold thread and pearls or jewels (*Haube*), with an additional small transparent veil over the forehead. The plaits beside the cheeks and the *Gefrens* always remain visible under the cap. The toes of the shoes and pattens peeping out under the them of the skirt are just as pointed and almost as long as those of the men (*fig. 72*; **75**).

¶ Both men and women sometimes wear a coat as an outer garment. In both cases this comes down to the feet and has long sleeves and a narrow turned-down collar. In the case of the men it is fastened down the front with buttons, in that of women it is completely open, but it does have lacing at the neck [**54**]. The women's coats flare out from the waist and, unlike those of the men, do not seem to be lined with fur.

¶ A number of problems are involved in the interpretation of the dress thus described. First and foremost, the geographical limits within which the Master worked have to be defined. A comparison with costumes that appear in German art of the last third of the fifteenth century[6] allows a line to be drawn that runs roughly from Mainz via Strasbourg to Colmar in the west and from Bamberg via Nürnberg to Augsburg in the east, the lines between Mainz and Bamberg and Colmar and Augsburg forming the northern and southern boundaries respectively of a region marked by related formal and artistic movements. An initial rapid survey also shows that within this region there existed a certain homogeneity in styles of dress which are virtually unknown in other parts of Germany at the period in question.

¶ The Master is known to have worked in the ambience of Emperor Frederick III of the Holy Roman Empire.

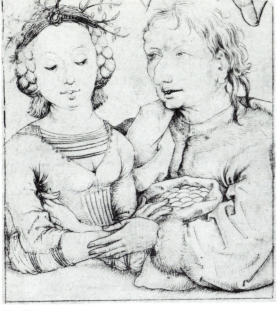

Fig. 74

Fig. 75

Fig. 74
Young girl and old man [**55**], drypoint print, ca. 1475-80.

Fig. 75
Young man and old woman [**56**], drypoint print, ca. 1475-80.

This Hapsburg monarch lived in Austria for preference,[7] but it is perfectly possible that German influence penetrated his court and the towns where he resided. Neither he nor his entourage appear to have set the tone in cultural matters or, one may take it, in the sphere of dress. The emperor was not energetic enough to figure as a leader,[8] while there was no centralizing power in Germany, so that the towns with their growing wealth and importance went their own ways in many respects.

¶ A second source of influence on the dress in the part of Germany in question lay in the Netherlands, where the court of the dukes of Burgundy had had its seat in various towns since the time of Philip the Good (d.1467). The culture of the whole of western Europe was dominated by the Burgundian court for the major part of the fifteenth century and the type of dress known as Burgundian, with or without local variations, was the accepted model for the upper echelons of society. However, on the death of Charles the Bold in 1477 Burgundian influence immediately lapsed and with it the only guideline in the field of dress in Germany.[9] This resulted in a certain stagnation in dress in the more conservative centers, which did not prevent the more ambitious German towns from wanting to be in the van of sartorial progress.[10] Their own combinations and inventions exaggerated and distorted Burgundian costume, giving rise to the highly bizarre dress familiar to us from the prints of the Master.

¶ A concise analysis may clarify on the one hand what really was a Burgundian inheritance in the costume and on the other what arose completely independently of the Burgundian tradition or resurfaced out of local peasant costume. Still totally Burgundian in inspiration is the strongly vertical silhouette of the men, with their short garments and the accent on the legs and the

long pointed toes of the shoes, the male figures closest to the Burgundian models being those dressed in jerkins. However, the German men fail to achieve the much stricter stylization of the body that was aimed at in the Netherlands,[11] while a complete departure from the Burgundian model is the general impression of laxity and casualness created by the numerous ribbons and laces, the slashed tops of the sleeves, the shirts billowing out on chest and arms,[12] the nonchalantly draped capes, the long curly hair and the caps with their many cuts. By comparison with the dress of the 1480s in the Southern Netherlands, the long pointed shoes, in which the foot is clearly modelled, look somewhat old-fashioned.

¶ The same divergent tendencies are to be noted in the women's dress. The long trained gown fits in with the Burgundian costume picture as far as the skirt is concerned, but the bodice is a total departure from it, with its low round neck and the way in which it is fitted at the waist by means of a series of short organ-pipe pleats at front and back. The forms of the sleeves are also different. In the Netherlands these are invariably very tightly fitting and they have a cuff that can be turned down over the hand. The plaited coiffure with the *Gefrens* and the layered round cap represent a typical German headdress, while the coat with long sleeves and turned-down collar is not found in the Burgundian lands either.

¶ A point that strikes one is that the German women borrowed a lot of the features of their costume from male fashion.[13] The organ-pipe pleats in their gowns are directly derived from those to be seen in the men's Burgundian jerkins.[14] The coat as an outer garment and the length of the pointed toes of the shoes suggest an origin in the male wardrobe too, while the elbow-length sleeves already mentioned, which leave the

forearm completely uncovered, were certainly unfeminine at that period.[15] No explanation can be given at the moment for this rather unusual state of affairs.

¶ To sum up, the German costume discussed here can be said to be as it were an exuberant paraphrase of Burgundian models, tricked out with German elements. The absence of a trend-setting center can be held responsible for this extravagance and blurring of stylistic distinctions.

¶ Now that we have placed the German costume under consideration in its geographical and cultural setting, only its social context remains to be discovered. This third problem is not the easiest. It can be defined as the question of whether the persons shown in the Master's prints moved in noble or bourgeois circles.

¶ Since dress is invariably a distinguishing mark it need occasion no surprise that ranks and positions in society affirm themselves in outward appearance, i.e. in their style of dress. Changes of fashion and an increase in luxury are always in part the result of rivalry within a given group or between different groups. Thus one sees burghers of the same town competing with each other, but it can also be taken that there was a rivalry between the burghers and the nobility. The nobles were, after all, the highest rank and as such they obviously set the tone, but, thanks to their wealth, the burghers were able to sustain a luxury in their dress which kept pace with that of the nobility and even surpassed it. Consequently town councils did everything they could to counter these excesses in dress by the repeated enactment of sumptuary laws.[16] What were absolutely forbidden to the burghers were the wearing of *Schnabelschuhe*, shoes with long pointed toes, the epitome of vaunting pride,[17] the wearing of scandalously short clothing by men[18] and low necklines and trains by women.[19]

¶ Now it is precisely these condemned and offensive features that are the most striking in the costumes of the figures in the Amsterdam prints. But are we to conclude from this without more ado that all these persons belong among the nobility? If we take into account the fact that the sumptuary laws enacted in the towns did not concern the nobility, it remains dangerous and irresponsible to give an affirmative answer to that question. In fact no decisive answer can be given to it on the grounds of costume alone. After all, since the sumptuary laws invariably contain the same prohibitions, it may be deduced that the burghers took little notice of them. Research into the history of costume is not yet far enough advanced for sharp lines to be drawn between bourgeois and noble dress – insofar as there actually was any distinction between the two.[20]

¶ At first sight the headdresses of the German women, who are actually young girls, look very homely and bourgeois, but that is not to say that noble ladies did not adorn themselves with such caps. It must also be remembered that fashionable costume in Germany in the late fifteenth century was influenced by local peasant costume.

¶ Dress itself is not the only aspect of costume that can point at a noble milieu. There are also the youth of the persons depicted and the activities they are engaged in. Whenever there was a radical change of fashion during the course of history it was invariably the young nobles who were held responsible for it and for the scandals it caused.[21] It is quite possible that the bizarre, undisciplined and 'scandalous' forms of dress in the Master's milieu were propagated by such fashionable young nobles, although at present it is not possible to offer absolute certainty on this point. A more convincing argument in favor of a noble company is afforded by the activities of the young people, in particular hunting – and in conjunction with this the falcon as the attribute of the young man [**70**] – since hunting was far and away the favorite pastime of the nobility. Card-playing, on the other hand, was not a typical noble amusement, although the scene [**73**] nonetheless evokes a noble atmosphere, thanks to the presence of a hunting dog and the view of a horse disappearing into a wood with its riders.

¶ If the persons in the Master's prints are to be found in noble circles, which may reasonably be assumed to be the case, it emerges that the German nobility differed from that of the Burgundian Netherlands in its way of life and dress. The constraining etiquette of the Burgundians seems to be replaced here by a greater laxity, gaiety and playfulness, albeit clearly tempered by a certain seriousness. It would be a fascinating subject for study to test more closely the all too easy comparison people are fond of making between the prints and the spirit of the waning Middle Ages, as described by Huizinga. However, this question goes beyond the bounds of the history of costume.

¶ Finally, the dating of the Amsterdam prints in the 1480s can be endorsed from the point of view of costume.[22] It is difficult to give more precise dates within this decade, since comparative material is rare.[23] Thus it is doubly interesting that we have at our disposal a few dated works in the Master's oeuvre, namely drawings in the University Library at Heidelberg [**118**] and the Kupferstichkabinett in Berlin [**124**].

¶ The drawing at Heidelberg, dated 1480, shows the Elector Palatine, Philip the Sincere. He is clad in a brocade gown, which can be called a very early example of the *Schaube*,[24] a garment that was extremely modern at that time. The wide collar falling over the back, the wide sleeves and the fact that the gown is calf length herald a horizontal line in costume that was to become characteristic of the dress of around 1500 and the early sixteenth century. The long *Schnabelschuhe* with the wooden pattens still represent the vertical accent of Burgundian fashion, constituting, from the point of view of costume history, a strong contrast with the lines of the gown.

¶ A closely similar brush drawing, included in the *Cronicke van Vlaenderen* and dated 1477,[25] shows the young Maximilian of Austria with his bride Mary of Burgundy. The Hapsburg prince and the young elector have the same entirely German hairstyle: long curling locks and a metal headband with a tuft of heron feathers in front. Maximilian is wearing pointed shoes, but his upper garment is totally different from that of Philip the Sincere. The former still has a Gothic silhouette, while the attire of the latter already suggests the Renaissance.

¶ We encounter Maximilian again in the two sides of the

drawing of 1488 in Berlin [**124**]. These show him attending the mass at Bruges on the morning of the peace banquet and at table at the banquet itself. He stands out amid the other, presumably south Netherlandish, figures by reason of his typically German dress. For the mass he is wearing a coat with long sleeves and a narrow turned-down collar, while at table he has on a cap with a cut tassel. In bothn cases he is the only member of the company who is still wearing pointed shoes and pattens. His dress conforms completely with that of the young men on the Amsterdam prints, but is a bit old-fashioned by contemporary south Netherlandich standards.

¶ All in all the Amsterdam prints are uncommonly rich and interesting documents for the costume historian. They confront us with a litte-known aspect of fashion in Germany. The great accuracy with which all the details of the costume are rendered vouch for its authenticity and invite a deeper comparative study of dress in the late fifteenth century.

¶ In the area in which the Master worked, the Gothic modes in costume were cultivated to extremes with a certain tenacity. They express the tension inherent in a culture that is coming to an end and has not yet found a new path. In conjunction with the deep décolletés and the 'masculine' sleeves with billowing shifts the restraint of the white caps is almost fraudulent. The excessive length of the shoes and shortness of the garments and the excessive confusion of the ribbons, laces and tassels give the men an air of bravura which nonetheless remains highly controlled. The only figure who emanates the more balanced self-consciousness of the dawning age in his dress is the handsome young elector, an almost Renaissance prince.

1. The hose were originally two separate stockings. The custom of joining these togheter at the top dates from the 1370s and was a consequence of men's upper garments becoming ever shorter. The triangular insertion or flap was to develop into a sort of pouch, the codpiece or *braguette*, at the beginning of the sixteenth century. See E. Thiel, *Geschichte des Kostüms: die europäische Mode von den Anfängen bis zur Gegenwart*, Berlin (GDR) 1973, p. 227-28.

2. New kinds of shoes, called *poulaines* and *cracowes*, with points 'as long as a finger, more like a devil's claw than human attire,' are first mentioned around 1362. See S. Newton, *Fashion in the age of the Black Prince: a study of the years 1340-1365*, Woodbridge 1980, p. 34. The points became shorter around 1420, only to lengthen again after 1450. They reached their greatest length between 1470 and 1480, after which the form was moderated somewhat, in the Netherlands at any rate. In certain parts of Germany this extravagant fashion lasted nearly ten years longer. See also Thiel, op.cit. (note 1), p. 231 and the *Sachregister* under *Schuh*, p. 691.

3. Pattens consist of a wooden sole with one or more leather straps above, through which the feet can be inserted. They served as overshoes and were worn out of doors to protect shoes from the dirt of the street and give added support to their thin leather soles.

4. See L. von Wilckens, 'Zöpfe, Bänder und Fransen,' *Zeitschrift für Waffen- und Kostümkunde* 1975, pp. 139-42 en A. von Rohr, 'Das Gefrens,' *Zeitschrift für Waffen- und Kostümkunde* 1976, pp. 65-68.

5. See L.C. Eisenbart, *Kleiderordnungen der deutschen Städte zwischen 1370 und 1700: ein Beitrag zur Kulturgeschichte des deutschen Bürgertums*, Göttingen 1962, p. 97. See also M. Scott, *Late Gothic Europe, 1400-1500* (The History of Dress Series), London and New Jersey 1980, p. 220.

6. See in particular A. Stange, *Deutsche Malerei der Gotik*, vols. 7 and 9, Munich and Berlin, 1955-58.

7. Although the emperor spent time in numerous towns in Austria, his real places of residence were Wiener Neustadt, Graz and Linz. See B. Sutter, 'Die Residenzen Friedrichs III in Österreich,' in exhib.cat. *Friedrich III*, Wiener Neustadt 1966, pp. 132-43.

8. The emperor liked simple dress best, albeit his robes of state appear to have been exceptionally costly. For more details of his personality see A. Lhotsky, 'Kaiser Friedrich III: sein Leben und seine Persönlichkeit,' *Friedrich III*, op.cit. (note 7), pp. 16-47 (for his dress see p. 36).

9. See E. Thiel, op.cit. (note 1), p. 240 and H. Hundsbichler, *Kleidung in Alltag im Spätmittelalter*, edited by H. Kühnel, Graz and Vienna 1984, p. 243.

10. Thiel, op.cit. (note 1), p. 240.

11. The figures in the Amsterdam prints may be compared with those in miniatures of the last third of the fifteenth century, illustrated in exhib. cat. *Karel de Stoute*, Brussels 1977, pl. III, pl. 6, 8, 9, 12. It must be remembered that the stylization of the figures may have been exaggerated by the miniaturist.

12. Slashed sleeves, the use of laces on sleeves and low necks appear in late Burgundian miniatures (see note 11) and in various men's portraits by Hans Memling. Judging from illustrations, the German exuberance nowhere appears in male portraits in the Netherlands, where everything is kept within bounds. As far as the Memling portraits are concerned, most of them show unidentified persons and it is justifiable to ask whether they might not be Italian. How far Italian and German costume may have been related in the late fifteenth century is something that has yet to be studied.

13. Scott, op.cit. (note 5), p. 214 , draws attention to this phenomenon without going any further into it. However, women's predilection for men's clothes must already have led to excesses in the fourteenth century. See the quotations from sumptuary laws of 1356 (Speyer) and 1492 (Strasbourg) relating to the wearing of men's coats by women in Eisenbart, op.cit. (note 5), pp. 96-97.

14. For organ-pipe pleats see F.W.S. van Thienen, *Acht eeuwen kostuum*, Hilversum and Antwerp 1967, pp. 35, 41.

15. A report of 1417 (Constance) mentions a townswoman being punished because her sleeves were too short, so that her arms could be seen up to the elbow. See Eisenbart, op.cit. (note 5), p. 47. In the Netherlands the sleeves of women's gowns did not finally become shorter until around the middle of the seventeenth century.

16. Sumptuary laws are ordinances promulgated by a town council or government. They often relate to the sumptuousness of dress and thus forbid certain expressions of luxury and extravagance. Some research has already been done on them in German-speaking areas. See Eisenbart, op.cit. (note 5); V. Baur, *Kleiderordnungen in Bayern vom 14. bis 19. Jahrhundert*, Munich 1975 and G. Hampel-Kallbrunner, *Beiträge zur Geschichte der Kleiderordnungen mit besonderer Berücksichtigung Österreichs*, Vienna 1962.

17. Eisenbart, op.cit. (note 5), p. 92. A panel painting of around 1480, in the Staatsgalerie at Bamberg (inv.nr. 62) shows how the population of that town threw all sorts of luxurious fashionable accessories, including pointed shoes, onto a bonfire, along with a backgammon set and playing cards, after hearing a sermon by the Franciscan penitential preacher Giovanni da Capistrano.

18. Fulminations were already uttered in the fourteenth century against short male dress, which came into fashion around 1345. Towards the end of the fourteenth century long upper garments for men became general again until shortly after 1450, when the short, tight jerkin appeared once more, so the 'kurtze rocke, dye hynnden und vorne nicht wol deckenn' were branded as 'unzüchtig und schandbar' in the ordi-

nances. See Eisenbart, op.cit. (note 5), pp. 95-96.

19. For décolletés which are 'da vornen also weitoffen, dass man in busen gesehen kann und die brustkernen gesehen mag' see Eisenbart, op.cit. (note 5), p. 94; for trains see zie Hampel-Kallbrunner, op.cit. (note 16), pp. 27, 74.

20. Obviously we are concerned with the higher ranks of the bourgeoisie here: the magistrates and prominent merchants. For the distinction between nobles and burghers on the basis of dress see H. Hundsbichler, G. Jaritz and E. Vavra, 'Tradition? Stagnation? Innovation? Die Bedeutung des Adels für die spätmittelalterliche Sachkultur,' in *Adelige Sachkulture des Spätmittelalters* (Internationaler Kongress Krems an der Donau, 22. bis 25. September 1980), Vienna 1982, pp. 35-72 (esp. pp. 39-49).

21. Scandal was mainly seen as a disturbance of the order in society. See H. Platelle, 'Le problème du scandale: les nouvelles modes masculines aux XIe et XIIe siècles,' *Belgisch Tijdschrift voor Filologie en Geschiedenis* 53 (1975), pp. 1071-96. See also Newton, op.cit. (note 2), pp. 6-8.

22. For this see Filedt Kok 1983, pp. 427-36.

23. This complaint has already been made by Scott, op.cit. (note 5), p. 208. Apart from panel painting, late medieval stained glass windows can sometimes afford very interesting comparative material. See *Vitrea dedicata: das Stifterbild in der deutschen Glasmalerei des Mittelalters*, Berlin 1975. R. Becksmann's contribution on the Lautenbach windows is very illuminating here.

24. The *Schaube* is a wide gown without a girdle, open all the way down the front, mostly with a wide collar and often lined and edged with fur. It was very generally worn in the first half of the sixteenth century and its form survives today in academic gowns.

25. The full title of this manuscript, preserved in Bruges, Stadsbibliotheek, 437, is *De Cronicke van Vlaenderen, Klacht van Marie van Burgoenie*. The brush drawing discussed here is illustrated in exhib.cat. *Vlaamse kunst op perkament: Handschriften en miniaturen te Brugge van de 12de tot de 16de eeuw*, Bruges 1981, pl. 34, nr. 10.

APPENDIX III: *T*HE UNDERDRAWING IN THE PAINTINGS BY THE MASTER

J.P. Filedt Kok

¶ The exhibition and this book show what a versatile artist the Master of the Amsterdam Cabinet was: he worked as a draftsman, printmaker and painter and probably also as a designer of stained-glass panels and book illustrations. The prints have been chosen as the starting-point for the study of his oeuvre, for although his drypoints are often rightly described as painterly, a strongly graphic, draftsmanlike element is characteristic of all his work in the various media. He was a born draftsman who, in the act of drawing, gave his figures volume and, through areas of tone, 'color.' In this technique, varied hatching plays a bigger role than contours. Up to now this aspect of the Master's work has been apparent from his prints, drawings and miniatures, but in the context of the exhibition it has been possible, with the aid of reflectography, to examine another – hitherto unknown – aspect, the underdrawing in some of his paintings. Underdrawing is done on a white ground as a basis for and aid to the actual painting above it. Virtually all the artists of the fifteenth and first half of the sixteenth century made use of such an underdrawing, which was done with the brush in black paint or in black chalk. Sometimes it is very sketchy in character, while in other cases it acts as a detailed preparation of the painting.

¶ Infrared reflectography is a scientific method of examination, in which use is made of a television camera with a tube sensitive to infrared radiation. During the examination there appears on the television monitor screen a detail of the painting, in which the underdrawing is in many cases wholly or partly visible, since the infrared light penetrates much of the paint layer. It is not equally successful with all colors – the eyes, hair and contours done in black paint can still be seen – but in many cases a good picture can be obtained of the underdrawing of the painting in this way. This picture has to be built up from photographs taken of the small details of the painting shown on the monitor, which are combined in a montage. Owing to the unavoidable differences of contrast in the photographs, one seldom gets an entirely even picture in the mosaic-like reflectogram montages and although such photographs can sometimes give a surprisingly direct picture of an artist's method, they still remain photographic documents which have to be interpreted with caution.[1]

¶ In the case of the Master the question uppermost in our minds was not that of the genesis and technique of the paintings, but that of the extent to which the graphic, draftsmanlike element known from his other work is also to be found in the paintings attributed to him. The X-ray photographs made in the Städelsches Kunstinstitut in Frankfurt are among the first ever made of any old-master paintings. X-ray photographs give a picture of the use of pigments such as lead white, with which the first paint layer – the underpainting – is often largely done. Wolters, who was one of the first to make an art-historical interpretation of these documents, interpreted the picture the X-ray photographs give of the underpaintings as 'frei, locker, pastos und characktervoll, bewegt' and confirms the attribution of the painting to the Master, whose drypoint prints are so lively and freely drawn.[2] This can be said with equal conviction of the underdrawing revealed by infrared reflectograms. Just as in the past, in assessing the X-ray photographs, it was above all the characteristic handling of the paint that became an attribution criterion, so the underdrawing exhibits details which, despite differences of scale and style, can be compared directly with drawings and prints and show a great relationship with them.

¶ Both the groups of paintings discussed in this catalogue were examined by infrared reflectography: the various panels of the so-called *Speyer altar* in Berlin-Dahlem, Frankfurt am Main and Freiburg im Breisgau [131] and all those of the Mainz *Life of the Virgin* [132].[3] Several infrared and X-ray photographs give us some idea of the underdrawing in the *Pair of lovers* at Gotha [133] as well.[4]

¶ The available reflectogram material of the fourteen panels that could be examined is so complex and extensive that only a limited number of examples can be reproduced and briefly discussed here. A detailed analysis of the characteristic elements of the drawings and hatching and their relation with the Master's other work is not yet possible at this stage. That would require a greater knowledge than we now possess of the structure of the paint layer in the paintings and of the underdrawing in the work of contemporaries. The exceptional opportunity which the exhibition offers of seeing and studying parts of both altarpieces side by side and comparing them with the work in other media will make it possible to analyze more thoroughly the

Fig. 76
Reflectogram montage of detail of the *Crucifixion* [131a], head of one of the bystanders with a wide-brimmed red cap with white scarf. Of the paint layer the eyes and the contour lines of the cap and scarf can still be seen. The drawing has been done with a thin brush: the modelling of the face is drawn with fine hatching, the hair indicated with slightly broader lines.

Fig. 77
Reflectogram montage of detail from *Crucifixion* [131a], face of dicing soldier. The long Roman nose is already present in the underdrawing, while diagonal hatching is used over the cheek to indicate shadows.

Fig. 78
Reflectogram montage of detail of the *Crucifixion* [131a], face of the donor. In the underdrawing fine modelling hatching creates a plastic rendering of the individual facial features. The eyes, mouth line, nostrils and some hairs done in black paint can still be seen.

Fig. 79
Reflectogram montage of detail of the *Crucifixion* [131a], group to the left of the cross: the Virgin and St. John. The underdrawing in the faces, in the Virgin's blue mantle and St. John's red one is rather sketchy in character: the shadows are indicated by parallel hatching, the folds by a number of lines placed by side. The contours of the hands are drawn in rather stronger lines and there are transverse hatchings over the fingers. St. John's nose was drawn rather larger, that of the Virgin with rather more of a point.

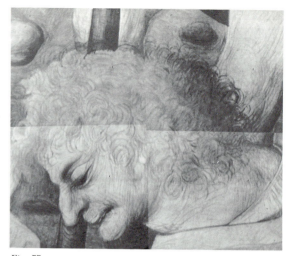

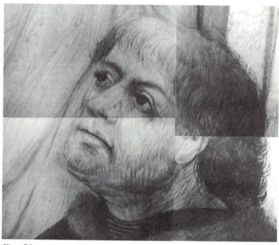

Fig. 77

Fig. 76

Fig. 78

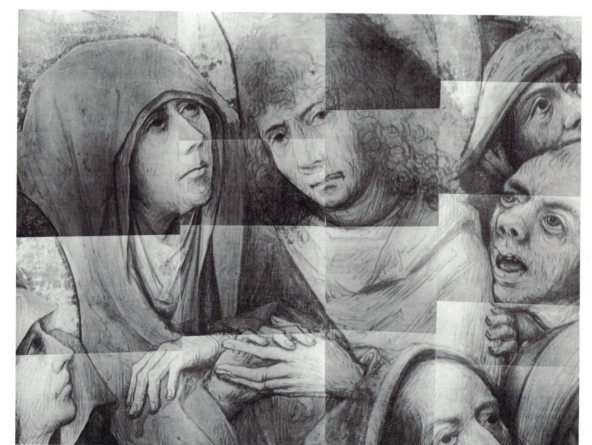

Fig. 79

material brought to light by scientific examination.

¶ In the various panels of the *Speyer altar* [**131**] one finds in all cases the same careful brush drawing, which prepares the painting down to its details. While the underdrawing of many contemporaries is limited to a few contours and broad hatching to indicate the shadows, here the volumes are indicated with subtle and detailed complexes of hatching. A large number of gradations are achieved with variations in density, cross-hatching and modelling hatching and these are used to build up tonal values which give the figures volume. In a number of cases the drawing seems to constitute a sort of undermodelling of the paint layer.[5]

¶ In the faces in particular the drawing is often done with great care: fine parallel lines follow the form of the face and hatching is carefully used to indicate shadows (*figs. 76-78, 82-83*). The hands are drawn with equal precision, with hatching over the long fingers (*figs. 79, 80*). The painting seldom departs from the contours of this underdrawing and then mostly only in details. Very direct parallels are to be found in the drypoint prints for the modelling hatching in the hands, the arms and above all the hose-clad legs (*fig. 87*).

¶ In the underdrawing of the garments of the figures there is a greater variation in the hatching used. Sometimes the folds are drawn with all their details and gradations of shadow in a network of fine hatching, often in various superimposed layers; in other cases the drawing is much more schematic in character. This probably has to do with the planned build-up of the paint layer. Christ's red mantle in the *Resurrection* (*fig. 81*) is an example of a detailed underdrawing which probably long remained visible during painting and served as a sort of undermodelling under the thin red glaze of the paint layer. In the wide yellow and blue sleeve of one of the bystanders in the *Crucifixion* (*fig. 80*) the underdrawing, which is covered by a fairly impasted paint layer, is much sketchier. Despite the fact that the main lines of the underdrawing are also followed in the carefully delineated folds of the garments, differences can be noted in many details.

¶ In the central panels of the Mainz *Life of the Virgin* [**132**] – the *Nativity* and the *Adoration of the Magi* – one finds a similar lively and detailed underdrawing. Hatching is used very systematically in many cases, with parallel and cross-hatching creating clear, sometimes rather angular planes (*fig. 85*). The way in which the legs of one of the Magi are drawn with modelling hatching is found both in the Freiburg panels and the drypoint prints (*fig. 87*).

¶ Just as in the panels of the *Speyer altar*, there are seldom any fundamental departures from the underdrawing, which seems to be quite a definitive guide for the painting. In the panel with *Christ among the doctors* too and to a lesser extent in the *Pentecost* one finds the same type of underdrawing. The line is lively and fluent, but seldom markedly expressive. There is no question of a style of the Master's 'old age' in this late painting, such as Glaser has detected in his late prints (pp. 49-50).

¶ As has been noted earlier in the catalogue, the other panels of the Mainz *Life of the Virgin* exhibit not only a different (less transparent) paint structure, but also a completely different type of underdrawing. This con-

Fig. 80

sists of long crabbed lines, which are sometimes combined to form hatching. There is no cross-hatching. The hatching indicates vague shadows, but there is scarcely any question of volume apart from that. The great differences between the two types of underdrawing confirm what had already been observed from the quality of the paint layer, namely that there was another artist at work here.

¶ The underdrawing in the *Pair of lovers* in Gotha [**133**], as shown in some infrared photographs of details, is much more difficult to interpret. The purely linear underdrawing to be seen in the face of the young man cannot be compared with the underdrawing in the town altarpieces by the Master discussed above, which played an obvious creative part in the genesis of the painting. That in the painting in Gotha seems rather to be based on a model and meant as an aid in the repetition of an existing composition. However, without a more thorough study of these documents in the presence of the painting itself, it still seems too early to drawn any conclusions from them regarding the attribution.

¶ From the reflectograms reproduced here it can at least be concluded that in the creation of his paintings too the Master remained a keen draftsman,. He prepared his paintings down to their details in the underdrawing, in which one finds a number of the characteristic

Fig. 80
Reflectogram montage of detail of *Crucifixion* [**131**a], the wide sleeve of a bystander with a brocade mantle in the group to the left of the cross. The hand on the left is drawn with a powerful brush, with little curved lines over the fingers. In the sleeve the underdrawing is much sketchier than elsewhere in the painting; the folds are indicated by angular lines, often several side by side, the shadows by swiftly drawn parallel lines here and there ; the right sleeve, which is in shadow, is largely covered by a dense network of hatching in the underdrawing. The exceptionally sketchy drawing of the sleeve is perhaps to be explained by the fact that the paint layer is applied in quite a thick and impasted way in yellow paint with blue shadows, so that there was no need of an undermodelling in the form of a detailed drawing, but only of a guide while painting.

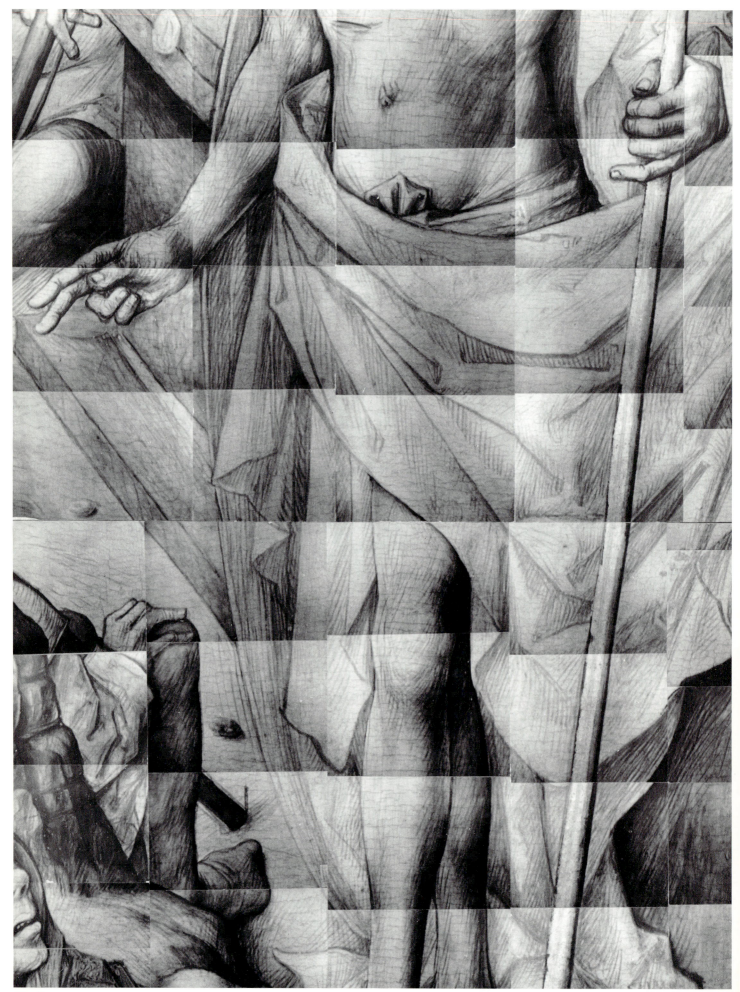

Fig. 81

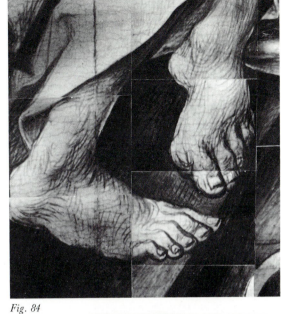

Fig. 81
Reflectogram montage of Christ's mantle in the *Resurrection* [**131**d, *see pl. VIII*]. The mantle has a very careful and systematic underdrawing: the contours and folds are indicated by broad brush lines, the shadows by parallel and cross hatching: the hatching is sometimes placed transversely on or over the contour lines, while the deeper folds are sometimes indicated by little curved lines. In the flesh tones long parallel lines predominate, these being more strongly concentrated according to the depth of the shadow. The shadows by the sarcophagus and the feet are also very carefully indicated by a network of parallel hatching.

Fig. 82
Reflectogram montage of the face of Christ in the *Resurrection* [**131**d, *see pl. VIII*]. The painted hair and eyes of Christ can be seen here as well as the underdrawing, which consists of fine parallel lines indicating the shadows.

Fig. 83
Reflectogram montage of the kneeling Christ in *Christ washing the disciples' feet* [**131**e, *see pl. IX*]. Here too the painted hair, eyes, nostrils and mouth line are visible. The lines of nose and eyes and the shadows on the face are very carefully drawn. The underdrawing in Christ's blue robe is very varied; the folds are indicated by angular lines, the shadows by areas of hatching often placed on top or alongside each other.

Fig. 84
Reflectogram montage of the feet of St. Peter in *Christ washing the disciples' feet* [**131**e, *see pl. IX*]. The underdrawing, which consists of curved lines that follow the forms, models the feet beautifully; this way of drawing recalls details in the drypoint of the *Dog scratching himself* [**78**, *fig. 25*].

Fig. 82

Fig. 84

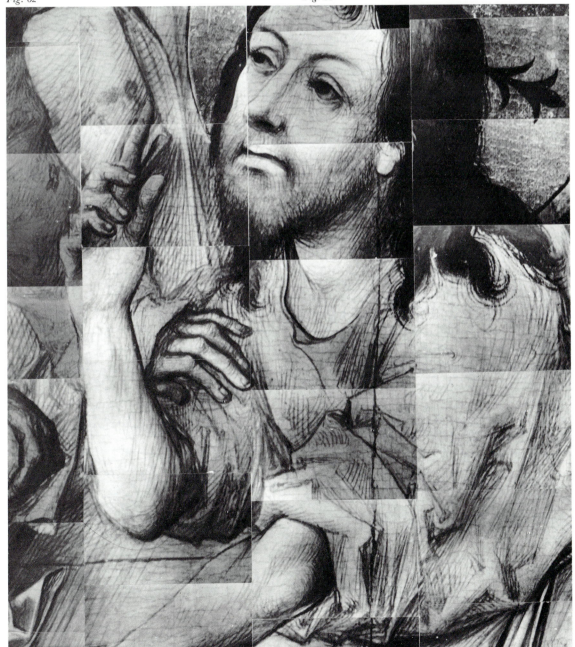

Fig. 83

Fig. 85
Reflectogram montage of
St. Joseph praying in the
Nativity [**132**d, *pl. X*]. In the
garments careful use has
been made of a combination
of areas of hatching, often
superimposed on one
another, which clearly lend
the form volume.

Fig. 86
Reflectogram montage of the
face of the Virgin in the *Nativity* [**132**d, *pl. X*]. The under-
drawing clearly structures
the face by means of fine
transverse hatching. In the
white kerchief folds are often
indicated by numbers of lines
placed side by side.

Fig. 87
Reflectogram montage of the
legs of one of the Magi in the
Adoration of the Magi [**132**e];
the legs are drawn with a fine
network of parallel hatching
in short, curved lines and
with strong oval lines for the
knee joints, in a manner to be
seen both in the *Speyer Altar*
and the prints.

Fig. 88
Reflectogram montage of
detail of the *Presentation in the
Temple* [**132**f]. The broad
contours and folds, which
appear as gray lines, do not in
general belong to the under-
drawing, but form part of the
painting. The underdrawing
is done in rather thin, crabbed
lines, which give little volume
to the flesh.

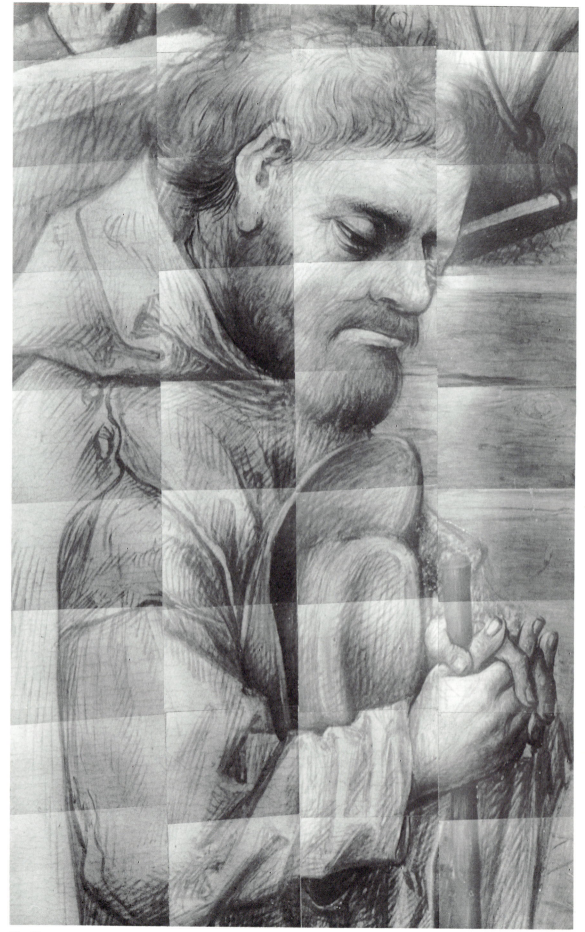

Fig. 85

Fig. 88

Fig. 86

Fig. 87

Fig. 89

ways of drawing and hatching also met with in his other work. Among the characteristics of his style of drawing seem to be the placing of several lines side by side in the contours, the long parallel lines placed close together which form the hatching in flesh tones and shadows, the angular lines of folds in the garments, against or across which bands of hatching are placed obliquely or at right angles, bands of hatching placed transversely over each other in the dark areas, hatching of little semicircular or curved lines to indicate curves in hands, faces and the like. Further research will be needed to show how far such characteristics also occur in the work of contemporaries[6] and to what extent they can be used as a firm stylistic attribution criterion.

Fig. 89
Reflectogram montage of the Virgin in the *Death of the Virgin* [**132**i]. The folds are drawn in rather unsystematic crabbed lines, with the hatching creating scarcely any volume. The folds in the painting are much more angular.

Fig. 90a
Detail of the *Pair of lovers*
[**133**].

Fig. 90b
Infrared photograph of the
same detail: the eyebrows,
nose, mouth and chin and
also some of the hairs are
drawn in a few rigid chalk
lines in a rather mechanical
way.

Fig. 90a

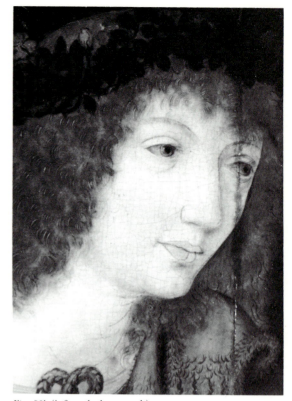

Fig. 90b (infrared photograph)

1. For the interpretation of infrared photographs and reflectograms and X-ray photographs see, for example, J.R.J. van Asperen de Boer, 'An introduction to the scientific examination of paintings,' *Nederlands Kunsthistorisch Jaarboek* 26 (1975): *Scientific examination of early Netherlandish painting*, pp. 1-40; and J.P. Filedt Kok, 'Underdrawing and other technical aspects in the paintings of Lucas van Leyden,' *Nederlands Kunsthistorisch Jaarboek* 29 (1978): *Lucas van Leyden: studies*, pp. 1-184, esp. p. 1-9.

2. Wolters, op.cit. (**131**, note 6).

3. The photographs were made in consultation with the present writer by Dr. J.R.J. van Asperen de Boer from a Grundig BG 12 monitor (875 lines) with the aid of a Grundig FA 70 television camera with a Hamamatsu N 214 infrared vidicon and a Kodak Wratten 87 A filter and Kodak Panatomic X film, 32 ASA.
The photographs of *Christ washing the disciples' feet* [**131**e] were made in Berlin-Dahlem in November 1982, thanks to the cooperation of Professor H. Bock and Dr. W.H. Köhler. The reflectograms were printed by G. Schultz in Berlin and mounted by the present author. The picture they give of the underdrawing in the painting and its relationships with the prints by the Master are discussed by the present author in a lecture at Colloque V – '*Le dessin sous-jacent dans la peinture*,' Louvain, September 1984; see note 6.
The photographs of the other paintings in Mainz, Frankfurt am Main and in Freiburg im Breisgau were made in February 1984; the reflectograms were printed by Foto van Rijn and the

montages compiled by Jarno de Haan. The photographs in Mainz were taken thanks to the cooperation of Dr. H. Reber, in Frankfurt to that of Dr. H.U. Ziemke and in Freiburg to that of Dr. D. Zinke.

4. The director of the Gotha Museums, Dr. H. Wiegand, was kind enough to make available to us infrared photographs of some details of the painting (made by Roland Möller, Erfurt, June 1982) and a number of X-ray photographs. The Museum in Gotha will in due course publish the X-ray photographs, which reveal some pentimenti that are hard to interpret.

5. No paint samples have been taken from any of the paintings, so that little can be said for certain about the structure of the paint layer.

6. The underdrawing is known in a number of paintings by Martin Schongauer, one of the Master's most important contemporaries; see A. Châtelet, 'Schongauer: premières observations,' *Le dessin sous-jacent dans la peinture*, Colloque IV (1981), Louvain-la-Neuve 1982, pp. 144-51, pls. 46-56. It is of a completely different character, being an obvious working drawing, in which the contours are the main indication and little use is made of hatching. In Schongauer's case too there are strong parallels between the underdrawing and his lucid, plastic style of engraving. See J.P. Filedt Kok, 'The development of graphic style in fifteenth-century northern printmaking and the Master of the Amsterdam Cabinet,' *Le dessin sous-jacent dans la peinture*, Colloque V (1984), Louvain-la-Neuve 1985.

*I*NDEX

The numbers in italics refer to pages on which the work concerned is illustrated.

Concordance with Lehrs's catalogue (Lehrs 1893 and Lehrs, vol. 7, 1932)

L*I*	L*II*	cat.nr.	L*I*	L*II*	cat.nr.	L*I*	L*II*	cat.nr.
1	1	**1**	47	47	**47**	MEESTER B X G		
2	2	**2**	48	46	**48**	90	6	**92**
3	3	**3**	49	48	**50**	92	7	**61d**
4	4	**4**	50	49	**49**	93	8	**61e**
5	5	**5**	51	54	**51**	94	9	**61f**
6	6	**6**	52	55	**52**	95	10	**61b**
7	7	**7**	53	56	**53**	—	11	**60a**
8	8	**8**	54	57	**54**	96	12	**61c**
9	9	**9**	55	74	**55**	—	13	**61a**
10	10	**10**	56	73	**56**	—	14	**64a**
11	11	**11**	57	52	**57**	—	15	**65a**
12	12	**12**	58	53	**58**	—	32	**75a**
13	13	**13**	59	61	**59**	—	38	**82a**
14	14	**14**	60	62	**60**	—	39	**83a**
15	15	**15**	61	63	**61**	91	27	**93**
16	16	**16**	62	65	**62**	97	16	**94**
18	18	**17**	63	64	**63**	98	17	**95**
17	17	**18**	64	66	**64**	99	18	**96**
19	19	**19**	65	67	**65**	100	19	**97**
20	20	**20**	66	68	**66**	101	20	**98**
21	50	**21**	67	69	**67**	102	21	**99**
22	51	**22**	68	70	**68**	103	22	**100**
23	22	**23**	69	71	**69**	104	23	**101**
24	21	**24**	70	75	**70**	105	24	**102**
25	23	**27**	71	76	**71**	106	25	**103**
26	25	**26**	72	77	**72**	107	29	**104**
27	26	**25**	73	78	**73**	108	30	**105**
28	27	**28**	74	79	**74**	—	—	**106**
29	28	**29**	75	80	**75**	110	33	**107**
30	29	**30**	76	59	**76**	111	34	**108**
31	32	**32**	77	60	**77**	112	35	**109**
32	33	**31**	78	72	**78**	114	36	**110a**
33	34	**34**	79	81	**79**	115	37	**110b**
34	35	**33**	80	82	**80**	116	40	**111**
35	38	**35**	81	83	**81**	119	42	**112a**
36	36	**37**	82	84	**82**	120	43	**112b**
37	37	**36**	83	95	**83**			
38	39	**38**	84	86	**84**			
39	40	**39**	85	87	**85**			
40	30	**41**	86	88	**86**			
41	31	**40**	87	89	**87**			
42	41	**43**	88	90	**88**			
44	43	**42**	89	91	**89**			
43	42	**44**	—	94	**90**			
45	44	**46**	—	58	**91**			
46	45	**45**						

Sources of photographs

The drypoints by the Master in the Rijksprentenkabinet are reproduced from photolithos made in the museum, directly from the originals, in actual size, by Litho de Lang BV, Zwanenburg. The enlargements reproduced as figs. 18-35 were also made in this way. The X-rays of watermarks (see Appendix I), taken in the museum in February 1985 by the Röntgen Technische Dienst, are reproduced as figs. 61-65, 67, 68, 70. Illustrations not included in the following list were made after photographs supplied by the Fotodienst Rijksmuseum.

Amorbach, Fürstlich Leiningensche Verwaltung, *pl. XVa;* **136**, **136**b, **136**c

Amsterdam, Dr. J.R.J. van Asperen de Boer, *figs. 76-89*

Aschaffenburg, Stiftsmuseum der Stadt Aschaffenburg, *pl. XVb;* **137**

Bazel, Historisches Museum (Foto M. Babey), *fig. 57*

Bazel, Kupferstichkabinett, **115**.3

Berlin, Staatliche Museen zu Berlin, Gemäldegalerie, **131**f

Berlin, Staatliche Museen Preussischer Kulturbesitz, Kupferstichkabinett, *figs. 46, 58, 61; pl. VII;* **31**b, **39**a, **42**a, **49**a, **52**a, **64**a, **64**c, **72**.2, **90**a, **92**, **96**, **111**a, **112**a.1, **112**b, **114**, **120** (fols. 8a, 14b, 44b, 160b), **121**, **123**, **124** (a-b), **125**

Berlin, Staatliche Museen Preussischer Kulturbesitz, Gemäldegalerie, *pl. IX;* **131**e

Boston, Museum of Fine Arts, Katherine Eliot Bullard Fund, **82**, **83**.1

Bremen, Kunsthalle, **12**a, **57**a

Brussels, Koninklijke Bibliotheek Albert I, *fig. 8* (Ms. 9278-80, fol. 45)

Cleveland, Ohio, The Cleveland Museum of Art, *pl. VIa-d;* **119**

Coburg, Kunstsammlungen der Veste Coburg, **49**b, **54**.2

Dresden, Staatliche Kunstsammlungen Dresden, Kupferstichkabinett, **13**a, **58**b, **60**a, **61**a, **61**b, **61**c, **84**, **103**.1, **104**.1, **127**b

Düsseldorf, C.G. Boerner, **8**b

Düsseldorf, Graphische Sammlung Kunstmuseum Düsseldorf, **26**.1

Erlangen, Graphische Sammlung der Universität Erlangen-Nürnberg, **41**a, **129**

Frankfurt am Main, Historisches Museum, *pl. VIII;* **31**c, **139**

Frankfurt am Main, Museum für Kunsthandwerk, **126**

Frankfurt am Main, Städelsches Kunstinstitut (Ursula Edelmann), **13**b, **21**a, **26**a, **38**a, **53**a, **75**f, **80**a, **80**b, **110**a.1, **110**b.1, **116**a-b

Freiburg im Breisgau, Corpus Vitrearum Medii Aevi Deutschland (Aufnahme R. Becksmann), **135**, **136**a, **138**, **138**a, **138**-detail

Freiburg im Breisgau, Augustiner Museum (Bildverlag Freiburg), **131**a, **131**b, **131**c

Gdansk, Stadtmuseum *fig. 40*

Gotha, Museen der Stadt Gotha, *fig. 90a,b; pl. XII;* **133**

Hague, The, Rijksmuseum Meermanno-Westreenianum, *figs. 6, 14;* **142**

Hamburg, Kunsthalle, Kupferstichkabinett, **29**.2, **53**.2, **63**a, **112**b, **113**, **116**, **121**a

Heidelberg, Universitätsbibliothek, *pl. V;* **118**

Karlsruhe, Badisches Landesmuseum, *pl. XVI;* **138**

Karlsruhe, Staatliche Kunsthalle, Kupferstichkabinett, **109**

Keulen, Schnütgen-Museum, **36**a

Leipzig, Museum der Bildenden Künste, Graphische Sammlung, *fig. 62;* **122**

Liège, Universiteitsbibliotheek, *fig. 13* (ms. Wittert 13)

London, The British Museum, *figs. 47, 52, 53;* **7**.3, **33**, **57**.1

Mainz, Bischöfliches Dom- und Diözesanmuseum (Foto Popp), *fig. 39*

Mainz, Mittelrheinisches Landesmuseum, *pls. X, XI;* **131**a, b, c, d, e, f, g, h, i

Munich, Bayerische Staatsbibliothek, *fig. 43* (Germ. 48); **140**, **141**

Munich, Staatliche Graphische Sammlung, *fig. 73;* **97**, **99**, **107**.1, **111**.1

New York, Pierpont Morgan Library, *figs. 3, 4, 11, 44*

New York, The Metropolitan Museum of Art, Department of Prints, **106**

New York, The Metropolitan Museum of Art, The Cloisters, *pl. XIII;* **134**

Oldenburg, Landesmuseum für Kunst und Kulturgeschichte, **29**a

Oxford, Ashmolean Museum, **54**.3, **101**, **108**.1

Oxford, Bodleian Library, *figs. 5, 10* (ms. Douce 93)

Paris, Bibliothèque Nationale, Cabinet des Estampes, *fig. 45;* **6**, **25**, **65**.2, **75**.2, **90**, **90**b, **94**.1, **115**.2, **128**

Paris, Musée du Louvre, Cabinet des Dessins, coll. Rothschild (Cliché des Musées Nationaux): *fig. 60;* **65**a, **82**a, **90**, **93**, **95**, **100**, **105**, **115**.2

Rotterdam, Museum Boymans-van Beuningen (Frequin-photo), **10**.a

Stuttgart, Staatsgalerie, Graphische Sammlung, **57**.1

Stuttgart, Württembergische Landesbibliothek, **59**a

Vienna, Graphische Sammlung Albertina, *figs. 16, 17, 41, 49;* **1**, **2**.1, **3**, **7**b, **9**.2, **22**a, **31**a, **54**.4, **55**a, **56**a, **58**d, **61**d, **61**e, **61**f, **61**g, **61**h, **61**i, **65**b, **74**.4, **75**a, **75**b, **75**c, **75**e, **83**a, **89**a, **91**a, **98**, **116**c

Washington, D.C., The National Gallery of Art (Rosenwald coll.), **63**.2, **64**b

Zürich, Marianne Feilchenfeldt, **130**

Private collection [**117**], *figs. 2, 9; pls. I-IV;* **117**: fols. 2a, 3a, 52b